FASCINATION OF SCIENCE

Fascination of Science

Herlinde Koelbl

of Science

60 Encounters with Pioneering Researchers
of Our Time

German interviews translated by Lois Hoyal

The MIT Press
Cambridge, Massachusetts
London, England

"What we see, we see and seeing is changing."
—Adrienne Rich, 1929–2012

Contents

Foreword

Anyone who wants to change the world through science has to be able to see farther than anyone else—beyond national borders and disciplines and into a society that wants to understand how the world we live in is changing, and how we secure what has been shaken by crises, such as climate change or the coronavirus pandemic. Both challenges show that research is increasingly central to what is going on in society.

In such times and situations, the public becomes aware just how important science is to them. At the same time, there is a growing desire to understand how research works, which mostly moves between the two extremes of cooperation and competition. Major projects such as the production of a vaccine, the discovery of gravitational waves, or the analysis of the world's climate require cooperation, usually even on an international basis, because climate patterns or viruses don't stop at borders. Several hundred research groups work on the creation of regularly published reports on the world's climate, while the publication of the discovery of gravitational waves by the LIGO Scientific Collaboration had well over 1,000 authors. In contrast, there are countless examples of discoveries that can be traced back to individuals. I'm not referring to work describing small, albeit important advances, as is the rule in science, but rather to unique, fundamental discoveries that define new fields of work and thereby change the world. Most of the time, such discoveries are often ascribed to chance, which, however, only falls into the laps of those who are properly prepared—and who look very closely ("the prepared mind").

The well-known photographer Herlinde Koelbl has made it her goal to find such people and to reveal their motivations and ways of thinking—through the eyes of an artist. This is important because in times of crisis, the public must learn what science means. Otherwise, people will lack the necessary trust in scientific advice, without whose implementation there can be no long-term future for our species. The "dancing procession of Echternach"— namely, three steps forward and two steps back—is unsatisfactory for solving societal processes. People usually want quick and clear answers. Instead, you need patience and staying power to achieve scientific breakthroughs in the complex processes for the issues at hand. This is precisely what the conversations here show. Time to take a closer look!

—Ernst-Ludwig Winnacker
Gene Center, Ludwig Maximilian University, Munich

Preface

"Becoming a scientist is a calling," says Nobel Prize winner Paul Nurse. I wanted to know how they think and with what insights they influence our lives, our future. To this end, I traveled halfway around the world to "research" these top scientists and to pass on their fascinating scientific results and life experiences—in other words, to bring science to life. Also, to inspire young people to see these impressive personalities as role models and to embark on this exciting path themselves.

I profiled the scientists in an unusual way. I asked each of them to write the essence of their research on their hand, be it a formula or a philosophy. There is something playful about this, which reflects the childlike urge to explore, which researchers must never lose if they want to be successful.

Since humans with problem-solving thinking emerged 2.7 million years ago as *Homo habilis*, they have strived to rise above the force of nature through observation and experimentation. They have been driven to improve their living conditions, and so over the millennia have created our current world.

Trial and error have remained. Origin or nationality are unimportant, curiosity counts, as does absolute passion. David Avnir sums it up, "After a successful day, you may have changed the world because you created new knowledge." This then makes them forget the many setbacks and, with obsessive commitment, extreme discipline, and willpower they always get up and keep on going. The happy outcome compensates.

Nobel Prize winner Françoise Barré-Sinoussi jokingly commented, "It's like entering a convent. You have to do without a lot of things in your personal life." She has made it in the still male-dominated world of science. The rivalry is intense, as recognition, not money, is the true currency here. Who will be the first to publish their result in a major journal? Publicity is important but researchers also have a responsibility to decide what kind of minds they release into society with their findings. Science and the future are interconnected. Anton Zeilinger agrees, "A continent like Europe, which has no raw materials, can only survive with research." My book deliberately ends with four emerging talents who are answering the call of science—their calling. The next generation is ready.

—Herlinde Koelbl

"BEING A BIT OF AN OUTSIDER IS MAYBE PART OF BEING A GOOD SCIENTIST."

Karl Deisseroth | Neurobiology

Professor of Biotechnology and
Psychiatry and Behavioral Sciences at Stanford University, Palo Alto
Breakthrough Prize in Life Sciences 2015
United States

Professor Deisseroth, when did you discover you had an unusual brain?
Every brain is unusual. My own unusualness has stood out a couple of times, though. I have a close connection to words. For me, it's easy to read words rapidly and remember them. I remember once in fifth grade we were given around forty-five minutes to memorize a poem. I looked at the poem, and within a few seconds I raised my hand and said, "I'm ready." When I got up there and recited the poem, the teacher thought, *Well, that can't be. He must have*

known that one already. So, she gave me another poem and, again, I memorized it almost immediately.

That's remarkable. What's your secret?

There may be a visual aspect to it. I tend to group words. In the same way many people can read a word or a phrase instantaneously, I can do longer chunks virtually instantaneously in a block. But it also helps that I feel so strongly about words. Feeling is part of memory, and memory is part of feeling. There's no reason to remember something unless it causes a feeling. I think that helps make the words memorable.

I once heard a story about a conference you attended. While the speaker was giving his speech, which you listened to, you also managed to read two of his books. True?

We think we're only aware of a single thing at once. There's this unitary aspect to consciousness, but it doesn't mean we can't process many things in parallel, even if we are only conscious of one thing at a time. I think many physicians become good at processing things in parallel, running many different streams of thought simultaneously. There are moments when you're on call, and there are multiple emergencies that all require your attention and engagement at the same time.

Dr. Dessert, when you first got into science, what did you hope to accomplish?

At first, I was trying to understand where feelings came from. This might be one of the deepest questions we may consider as human beings: How is it possible for an object to have an internal subjective sense, to have feelings? In some ways, this (perhaps unanswerable) question is still guiding me.

Weren't you the first person to make the brain transparent?

We developed hydrogel-tissue chemistry, a technique in which we build hydrogels inside the cells of tissues. This means we made gels part of the brain tissue. The technology allows us to reach into the brain while keeping it intact, and we can see with incredible detail all the molecules and cells that make up the entire system.

"SCIENCE AND ART, I THINK, ARE MAINLY CONNECTED THROUGH THE BRAIN."

You also made it possible, for the first time, to turn nerve cells on and off?

Right. That's a technology called optogenetics. It allows us to use light to turn brain cells—neurons—on or off by using light. A lot of people think about light as a way to collect information about something. Take microscopes or telescopes, for instance. They use light to collect information about the world. But optogenetics is the opposite. We use light to control biology, to put information in the brain and make things happen.

How does that work?

We take genes—very special bits of DNA—from algae, plants, or bacteria. These genes encode proteins that turn light into electricity. The proteins then absorb photons—light particles—and allow the charged particles, or ions, to flow across the surface of a cell. We take those bits of DNA and put them into the brains of animals. The neurons then start to make these proteins, which are light-activated regulators of ion flow. We can even tell some cells to make the proteins and others not to make them. This gives us great power, because only the cells that have the gene will be turned on or off by the light.

And what good is this?

It's a discovery tool. It's a way of probing the brain to understand how it works. We're learning which cells do what, how contradictions are resolved, where positive or negative feelings are situated. We've gotten ultra high-resolution crystal structures of these proteins, so we can see every atom in its place. You can ask simple questions that you were never able to ask

before. You know, "What does this cell do?" "What does this kind of cell do?" "How does this cell talk to that cell?" "How does it actually affect behavior?"

That's up until now. Where are things headed?

I think we'll see increasingly complex behavior studies. We can already test any aspect of mammalian or other animal behavior. In the future, we'll see ideas for new kinds of medical treatment. Once you understand how a system works, then everything becomes more precise. Once you know what causes a symptom, which is what optogenetics gives you, then you can design any kind of intervention or therapy.

Am I wrong in thinking that this could lend itself to abuse, such as mind control?

Even if we wanted to misuse it, we'd first have to know a lot more about the brain than we do at present. Right now, it's not a pressing issue because nobody is trying to do this sort of thing with human beings, but it's something we need to be mindful of. Could people one day be modified in such a way that changes their proclivities, capabilities, or priorities? It's theoretically possible. We do it with animals all the time. We can change anything we want to about what an animal wants to do or what it does.

When you were a graduate student, besides neuroscience and medicine, you took classes in fiction writing. What sparked that interest?

I wrote as a child and a teenager, and I joined writing clubs early on. In college, I also took writing courses. At the time, I still thought I would eventually become a writer. Even in graduate school and beyond, I went to a local community college and took writing courses. It's been a theme all through my life. It's a passion. With everything else going on, it would have to be a passion for me to find that much time for it.

Why are stories so important?

That's how human beings understand and relate to one another. My goal is to tell the optogenetics story, for example. It's a story of things that anyone can relate to: light and plants and feelings. It teaches people about the value of basic science, of understanding everything about our world for its own sake and everything that can come from that: the unexpected, the powerful, the transformative.

Do you see science and art as connected in any way?

Science and art are particularly connected, I think, through the brain. Just think about the feelings that words—artistic words—can stir in people. All that happens through the cells. The brain somehow turns art and words into feelings. In some ways, that's the essence of neuroscience. It's also the essence of art.

You remember many, many things. You must be absolutely brimming with emotion?

Early on, when I was teaching, I would be criticized for not being animated enough, that I wasn't jumping around the classroom enough. The students wanted to see more emotion. That was hard for me, though, because I had trained myself to be so stable. In much

"YOU NEED TO BE CERTAIN ABOUT WHAT YOU NEED AND WHAT YOU WANT IN LIFE, AND WHAT YOU WANT FROM YOUR PARTNER."

of my life, I play the role of psychiatrist, teacher, and professor. These are not traditionally emotional roles, right? They are roles in which it's actually better to be more of a blank slate, a solid rock.

Why do you continue to work as a psychiatrist?

Being a psychiatrist is part of my identity; it's part of who I am. I like hearing people's stories. I like helping them. I help reduce their suffering. It's just part of who I am.

In addition to your work as a psychiatrist, you're a teacher and a professor, are married, and have five children. You also travel a lot for work and your wife is a very successful scientist herself. How do you do it all?

My wife is an extremely successful scientist. She's also an MD-PhD and a serious clinician. She runs a pioneering laboratory as well, and travels all around the world. Of course, there are always things that go wrong. It's not like we don't have our defeats and our disasters. But when something goes wrong in one domain, we still have other domains that fulfill us.

Many scientists—mostly men, of course—tell me it's not feasible for a woman to be at the top of the science world and to also have kids. But your wife seems to manage just fine, right?

Full credit to my wife. She is an amazing person. She is absolutely at the top of her field and an extremely creative and productive scientist, and we've got five kids at home.

Any advice for young female scientists who would like to one day start a family?

I don't feel as though I'm the one who necessarily can give direct advice to young women scientists, except to say that it's definitely possible to make it all work. My wife's experience, I think, makes that clear. I think you need to be certain about what you need and what you want in life, and what you want from your partner, and be able to adapt to each other. Also, different rules work for different couples. I think it just requires honest communication and good planning.

When did you stumble onto your path to success?

In the beginning, people would see what we were trying to do and say things like, "This isn't going to work," or, "There are about ten different things that you'd have to solve and many of them are almost unsolvable." I didn't have an answer, so it was a stressful time before we were able to solve these other issues and make the whole thing work.

How bad was it?

I had physical symptoms during those first five years. I had sort of an illness, a nausea that persisted almost every day because of the tension and stress. I wasn't in a particularly great place. It was a challenging time.

What kept you going?

The hope and belief that what we were doing would matter. When life has brought you to a place where you can do something that matters, it's a privilege. It's not to be taken lightly. I knew this work was something that could be important for humanity. It was more like a responsibility to see what was possible. It took about five years of very serious stress to make it happen, but during that time the idea was that this was my calling. This was where life had brought me.

Was there a eureka moment for you when things finally started to work?

The clearest moment was in 2007. A PhD student in my lab did an experiment in which he put one of these

bits of DNA into the right part of a mouse's brain—the part that controls movement. As soon as we turned on the light, the mouse moved. When we turned off the light, it stopped. It was incredible. Not only were we using light and plant DNA to precisely control mammalian behavior, but also this experiment addressed in one fell swoop most of the questions and concerns people had raised about the project.

What's the most fascinating thing about being a neuroscientist?

Well, science is, in some ways, the root to a deeper understanding of everything—literature, art, history, law. This is especially true for neuroscience. We've already seen what it's done for computer science. The current revolution in deep learning and machine learning absolutely has its roots in neuroscience. It has changed every aspect of the world we live in.

Do you have any advice for young people considering a career in science?

It wouldn't hurt to have a perspective on the human brain and on neuroscience going forward. But I would also encourage people to take more risks. If you're doing work that's high risk, it's liberating. It's easier when there aren't expectations that things have to turn out in a particular way, or that the work will be productive on a certain time scale. In some ways, there's more pressure if you're doing something predictable because then it darn well had better work.

What kind of routine should young people have?

It's important to take breaks, to not work too hard, and to reset yourself, to have time in each day when you let yourself think deeply. We all have emergencies that occur, but you need to carve out time each day—at least an hour—when you can get to the bottom of things. That's vital.

When do you do your best thinking?

I have to be in a quiet environment, where my body is still, where ideally the room is windowless. It doesn't have to be dark, but it's best if things aren't changing in the world around me. It lets me enter a meditative state, where my mind can focus and go deep into questions.

Speaking of isolation, were you an outsider when you were young?

I was, yeah. I was a little introverted. I'm in good company; many scientists were not exactly the most socially popular kids when they were growing up. I was also much smaller than other kids in my class, since I was effectively two years younger than everybody else. That creates a separating influence. That probably made me live outside the mainstream for a while.

Have you ever been part of the mainstream?

Well, you don't always want to be outside the mainstream when you're a doctor. You want patients to get at least the standard of care. So, in that part of my life, yes. In other parts, probably not.

Do you think being an outsider makes you a better scientist?

I think being a bit of an outsider is maybe part of being a good scientist. If science is about new discoveries, that means you're going beyond the current paradigm. You have to be comfortable with that. It requires a certain impatience with the current paradigm, the current set of knowledge.

What is your message to the world?

One message is that we are living in a unique time. We are about to discover things about the world and about ourselves that will only be discovered once and that are very deep. This is a time when all people should be excited about discovery because it's happening in ways that will forever affect the human journey. We should all see the excitement and beauty in that.

"YOU NEED TO CARVE OUT TIME EACH DAY— AT LEAST AN HOUR— WHEN YOU CAN GET TO THE BOTTOM OF THINGS."

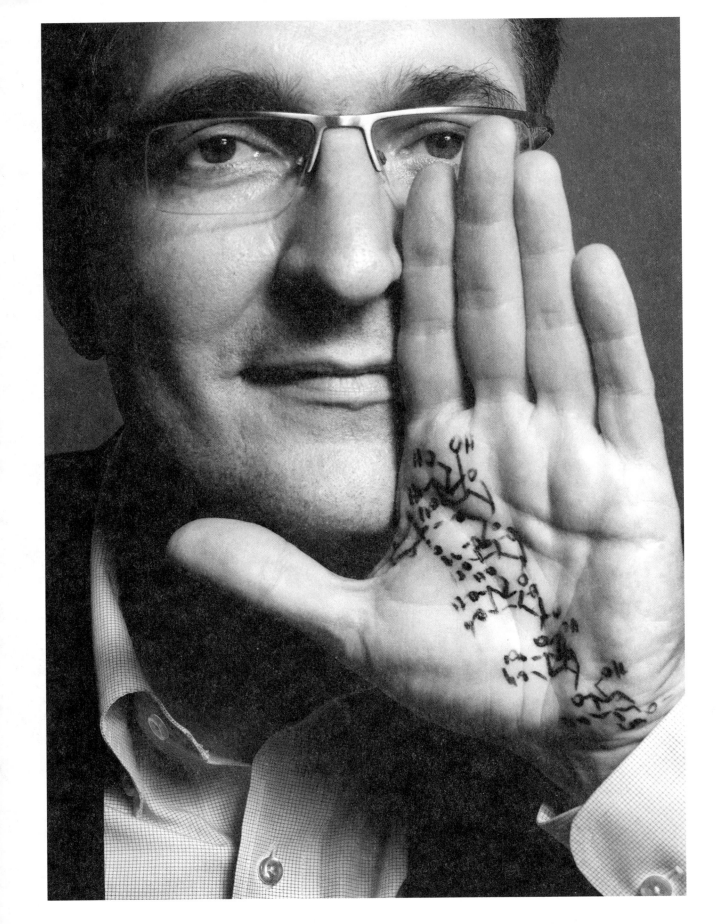

"I'VE BEEN COMPETITIVE ALL MY LIFE."

Peter Seeberger | Chemistry

Professor of Chemistry and Head of Department at the Max Planck Institute of Colloids and Interfaces, Potsdam
Körber Prize 2007
Germany

Professor Seeberger, will you tell us how you became a successful, respected scientist?
I'm fundamentally dissatisfied with myself, and I always think we haven't yet carried out enough research. It's probably not easy living with people like me. I always feel a great deal of internal pressure. I see the number of articles published and the prizes awarded as irrelevant; what always counts with me is what comes next. This dissatisfaction is my driving force.

Can you explain in simple terms what you're researching?

I research and synthesize sugars. Not the sugars that go in your coffee, but complex sugars—we call them polysaccharides. Sixty percent of the world's biomass, like plants and trees, is made up of complex sugars. We're surrounded by sugars. Polysaccharides are found on the outside of human cells, as well as on bacteria and other pathogens.

Is it correct to say that you're trying to produce a malaria vaccine by replicating the sugar molecule of the malaria pathogen?

A malaria vaccine is just one of our goals. There are already three sugar-based vaccines available in Germany today, which will, it is hoped, also be used for newborns. A vaccine works by showing the human immune system a molecule that is found only on the surface of a pathogen. When the immune system sees this molecule, it destroys whatever is attached to it—that is, the pathogen.

We use the sugars as the identifying feature for the pathogen. Until now, these vaccines have been made from isolated sugars, which meant that we first had to grow the bacteria, then harvest the sugars from them, and finally turn them into vaccines. This is an extremely complex process, which in some cases takes over twenty years to complete. For the first time, we were able to chemically reproduce sugars much faster.

How did the idea come to you about researching sugar?

There are three major classes of biopolymers: nucleic acids, proteins, and sugars. The first two have already been researched, so I'm working on sugars. Bruce Merrifield was awarded the Nobel Prize in 1984 for his revolutionary research on proteins. As a doctoral student, I thought to myself: *Come on, it's got to be possible with sugar, too.* So, I started researching the process of sugar synthesis.

Everyone thought it was impossible. We worked with five people on a molecule for two years, and then I realized it wasn't going to work like that. So, I came up with the idea of automating the synthesis

"WORKING ABROAD IN AN ENGLISH-SPEAKING COUNTRY IS AN ABSOLUTE MUST."

by combining methods developed from the research on proteins and DNA with those for sugar research. Three years later, during my first professorship at MIT, I managed to achieve automated sugar synthesis.

You studied in Germany and then earned a doctorate in America. Do you think it's important for a scientist to work abroad?

Working abroad in an English-speaking country is an absolute must. It's only when you look outside the box that you can see the strengths and weaknesses of the German system. As science takes place on a global basis, networking at these large institutes is also an important opportunity to establish contacts with colleagues, as well as with competitors. A stay in a foreign country, therefore, is an important step in one's career.

You once said that your stay in the United States taught you some tough lessons. Can you elaborate?

I always got very good grades, both at school and at university, and I even won a scholarship given to the highly gifted. I was awarded a Fulbright scholarship as one of two chemists in all of Germany that year. So, it was clear to me that I wasn't entirely stupid. But at the University of Colorado, I ended up in the biochemistry program, even though I'd studied chemistry in Germany. I ranked worst in the first tests given, and I also failed one or two later exams.

That was because my English wasn't good enough. I'd always thought I didn't need English to

do science, so that failure was a completely new experience for me. It got me so worked up that I really knuckled down. I have never in my life learned so much and worked so hard as back then.

So, you had to work harder in the United States than you did in Germany?

In New York, my boss would come into the lab at half past eight in the morning, and we often stayed until one the next morning, six days a week. Fortunately, as a practicing Jew, he couldn't work from Friday evening to Saturday evening; otherwise, it probably would have been seven days a week. However, working with him gave me the chance to go to MIT as a professor. I knew I had to accomplish a lot to get to the next level.

After fourteen years, you returned to Europe, to the ETH Zurich [Swiss Federal Institute of Technology], another top university. Were you frustrated by conditions in the United States?

I could have very well imagined staying in the United States for the rest of my life, but the working conditions demanded a 100 percent, exclusive commitment to science, and at some point that was no longer my sole motivation.

You didn't want to pay the price?

No, I thought that if Europe worked out, I'd stay there, but I was also arrogant enough to know I could go back to the United States at any time. The first two years after the U.S. were a culture shock. I was 36 years old, and I often came to work in jeans and a T-shirt. That wasn't customary for a professor at ETH, though. And I was used to working late and on weekends. Some of my Zurich colleagues had problems with these working hours. I had to learn to be more diplomatic and less direct.

Have you made many mistakes?

Our entire business depends on the people we hire. In chemistry, we need highly intelligent people who are also practically minded. At first, I looked only at their scientific qualifications. I had to learn that human qualities also play a big role. When too many of the best scientists, with Type A personalities, come together, it can quickly lead to problems. Since then, we've had good experiences with mixed teams that are equally staffed with men and women and that represent different nationalities. Combining different backgrounds is more likely to lead to success.

Why, then, are there still so few female professors?

It's striking that of the many women who graduated with me, very few wanted a professorship. Also, some of my best female PhD students have preferred positions at chemical companies. The reasons are the long working hours, and the poor pay at universities. Few women find that attractive. Many who worked for me probably thought, *I don't want to end up like Seeberger, without a private life.* Men become a professor first and then catch up with family

"WHAT INTERESTED ME WAS THIS OPPORTUNITY TO PLAY GOD BY MAKING NEW MOLECULES THAT HAVE NEVER EXISTED ON EARTH LIKE THIS BEFORE, I FOUND THAT HIGHLY ATTRACTIVE."

life in their forties. For women, on the other hand, that's biologically more difficult.

Isn't science also about being first?

Chemists often have this discussion. You want to be the first to create a molecule. Or the person who does it so perfectly that no one else will touch the project after that. Competition is good, though. I've been competitive all my life, first at sport and now at science. Many successful scientists are highly competitive—sometimes possibly even somewhat self-centered. And some are accused of nurturing a diva-like quality. I've seen behaviors that wouldn't be acceptable in any industrial enterprise.

Is it really so important to be the first to publish research results in the most prestigious journals?

There's an insane race in certain fields. Nowadays, it's all about the numbers. People look at how much someone has published and how influential the journals are. But at the end of the day, the question should be whether that person has created good science.

A president of the Max Planck Institute said that scientific aggressiveness was necessary. Do you agree?

I don't think that aggressiveness is a bad thing in this context. PhD students and postdoc people clearly have to face competition. At MIT, only 25 percent of the instructors get tenure, while 75 percent get pushed out. It's a fight for survival, and it's fought tooth and nail. Under the cloak of secrecy, anonymous reviews can appear, which don't treat the articles fairly. I'm all for fairness and open competition, not backstabbing.

The Talmud says that envy of scholars promotes science. Have you felt envious of others?

In 2007, I was awarded the Körber Prize, which is a great achievement. Then, for the next six months all my papers were rejected. People probably thought, *Hey, he's not that good after all*. I was talking to a colleague about this situation, and he told me about a Nobel laureate who couldn't publish a paper for a whole year after having received the prize. Others think, *I should've gotten that award, so now I'm going to cover my own back*. But now I'm in such a good position that I no longer have to be envious of anyone.

Do scientists also strongly define themselves by the place they hold in their community?

As well as self-perception and colleagues' perception of you, appreciation is extremely important. Prizes, special lectures, and invitations all play a major role. Who doesn't like to be highly regarded? That's true even if, as a well-known scientist, only about 500 people know you—after all, these scientific groups are usually no larger than that. But prestige is a great motivator to perform.

You let yourself be lured away from the ETH to go to the Max Planck Institute. In the years after World War II, twenty-four Germans have received the Nobel Prize and seventeen of them have been from the Max Planck Institute. Does Max Planck especially encourage unorthodox thinking?

The Max Planck Institute appoints from within universities and relatively late in someone's career. By the time you're in your mid-forties, the work that

leads to a Nobel Prize has already been completed. The Institute offers excellent research opportunities and shows trust in its appointees. We're given a budget, and a few years later have to show only what the money has been used for. For me, that's a leap of faith, which is a fundamental factor.

They're basically saying, "We'll give you the funds, so go for it." That grants someone the scope for unorthodox thinking. In the United States, I had to collect every single dollar myself. Then, my application for the automated synthesis of oligosaccharides was rejected, while other applications I found less interesting were approved. So, we put the money where it was needed. That frustration of long funding cycles in America doesn't exist at the Max Planck Institute.

What kind of aptitudes must a successful chemist have?

Chemists are a hybrid species. Logical thinking and spatial perception are important. You have to be able to imagine the molecules that will be created in three-dimensional space. Chemists carry out their own experiments until the postdoctoral stage, and this also requires practical skills. Ninety percent of that time in the lab is spent making something, or "cooking." And this really *is* related to cooking, in that we stir, shake, purify, and analyze. Personally, I find the combination of doing practical work and meeting intellectual demands interesting.

You've also founded companies. Have you gotten the financial side of business well under control?

I studied economics, as well as chemistry. A long time ago, my goal was to set up my own chemical company.

. . . and you wanted to get rich?

One of our new companies, Glycouniverse, in Berlin, builds synthesizers that we have developed over the years. There's nothing dirty about financial success when it's based on the development of new technologies. For young researchers, the field of science is also attractive because it's a way to earn good money. Of course, that's not the only reason to study science, but if you're going to pursue such a long and hard course of study, it's good to have a secure income at the end of it.

Why should people study science?

If you're curious about learning new things, then science is great. The other advantage of studying science is that having gained the logical thinking and an understanding of natural relationships, you can work well in many different fields. What interested me was this opportunity to play God by making new molecules that have never existed on earth like this before, I found that highly attractive.

And this feeling of playing God—what's that? Can you describe it?

It's a feeling of strength, and possibly also of omnipotence. You think about a molecular structure on the drawing board that could theoretically have the desired property you want. Then, if the created molecule demonstrates that function, it's a hell of a good feeling. The first time we produced a complex sugar—an oligosaccharide—on the machine, it was absolutely uplifting. Unfortunately, this kind of happiness lasts only a limited time. After all, most things go wrong in research, so a high tolerance for frustration is useful. Once when I complained to my doctoral adviser that only 10 percent of an experiment had worked, he said, "You're lucky; it's normally only 5 percent."

For many years, you had hardly any private life at all. When did you decide to change direction, and was it at the expense of your career?

By my mid-thirties I'd achieved everything that was scientifically possible by that age. Before that, I couldn't have led a private life. I find it difficult saying, "That's enough." I'm probably overcompetitive. Then, I realized that there would be little satisfaction in looking back on a life with only this one dimension, taken to excess. Now, fortunately, I have a family, and this has made my life richer. I'm somewhat proud that I managed to achieve that.

Have you changed your working hours because of your family? Are you still always the first to arrive and the last to leave work?

At the moment I'm doing regular hours at the Institute. I take the kids to school, then I'm at the

Institute from nine o'clock onward, and I try to be home by six o'clock for dinner. When the kids are in bed at eight, I start working again. I work until eleven-thirty, sometimes until midnight or even longer. During this time, I'm undisturbed.

What advice would you give a young scientist?

I think people should do what makes them happy. The start of your career is strongly characterized by experimental work, then after becoming a professor you have to write a lot. Basically, a professorship in the natural sciences is almost like running a small company. You have to bring in the money, find employees, acquire projects, and in the end have to produce something. I advise everyone to try out physics, chemistry, mathematics, or biology. You shouldn't commit yourself too early.

I learned at MIT that you can achieve a lot with hard work. For someone originally from Franconia, it was great to realize that I can also swim with the big fish in the big pond. Self-confidence is important when you start out on your own and you have to lead a large group of people. Of course, you need to keep both feet on the ground so you don't become arrogant. There's a fluid transition between self-confidence and arrogance. Something always goes wrong when you play God, so there's also a lot of disillusionment.

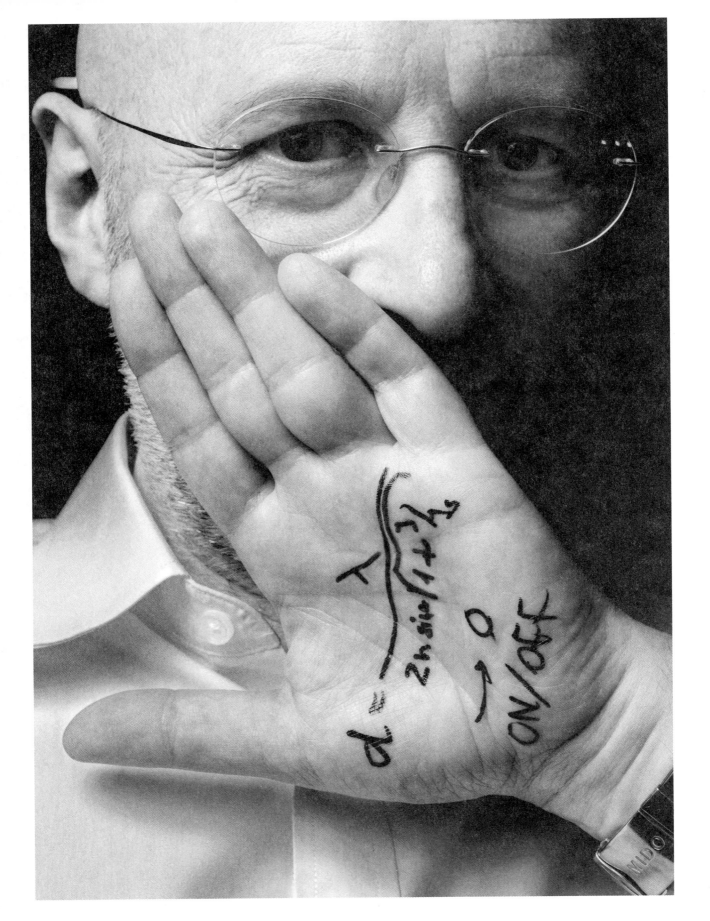

"I HAD VERY HIGH DEMANDS THAT I HAD TO MEET."

Stefan Hell | Physics and Biophysical Chemistry

Professor of Experimental Physics at the University of Göttingen
Director at the Max Planck Institute for Multidisciplinary Sciences, Göttingen
Director at the Max Planck Institute for Medical Research, Heidelberg
Nobel Prize in Chemistry 2014

Professor Hell, you were born into a Banat Swabian family in Romania and moved to Germany in 1978 at the age of 15. Despite having to deal with a foreign language, you were one of the best students in your school, right from the start. What motivated you to always come out on top?
Well, with the language, it was actually the other way around. It was precisely because we spoke German and *felt* we were German that it was so liberating to be able to build a new life in that country. My new national language was certainly no foreign language but, rather, almost my mother tongue. I didn't want

to be the best at everything, but I did want to be the best in math and physics.

For me, that was a way I could build my self-confidence. I was also the best in my German classes in the ninth and tenth grades—not least because I had enjoyed my excellent German classes in Romania. However, I was one of the last to be picked for soccer, even though I loved playing the game. That dented my ego, but I more than compensated for that with my achievements in math and physics.

Your parents placed great importance on education. How did that come about?

That also had to do with the fact that we were a minority in Romania—not a persecuted minority, but a disadvantaged one. Minorities anywhere have to assert themselves if they want to improve their way of life. And part of this assertiveness is to win the majority's respect. So, my parents told me that I had to be twice as good as the Romanians; then I couldn't be overlooked.

If I'd stayed in Romania, I'd have been a minority person all my life. But in Germany, that lower status was gone within one or two years. My origin no longer played a role—or if it did, maybe it was a positive one—not the least because postwar World War II Germany was full of German refugees and their descendants. The challenge for my parents, and later for me, was to build a new existence for ourselves. For that, I needed education and training.

As a child, did you often keep to yourself?

I certainly wasn't withdrawn or reclusive, but I was a bit shy with authority figures. My strength was—and probably still is—a better understanding of causality than most. And when I'm convinced that I understand something, I can formulate it confidently and concisely. I believe that the key to my success as a scientist has been that I always want to discover the essence of something, and I don't concern myself with more details than are necessary.

When did you feel you had reached the limit for your subject?

That's a nice way of describing my encounter with the Abbe diffraction limit, whereby the resolution of the light microscope can't be smaller than half the wavelength of visible light. In college, microscopy—as well as optics in general—hadn't really interested me. It was boring nineteenth-century physics. However, contrary to my normal inclination—and that's where my family background comes in—I wanted a topic for my dissertation that would make it easier for me to find a job later. That is, my father always expected to lose his job, and so lived with uncertainty. In the end, I chose a dissertation topic that had almost nothing to do with physics: how to integrate a precision mechanical stage into a light microscope.

I completed the dissertation, but I really suffered through it because the topic was so undemanding in terms of physics. After that, I wanted to do something more physics related. My PhD supervisor, however, didn't see me as a physicist; rather, he thought I was someone who had done some good technical work. So, he had me examine computer chips with an optical microscope—again, not real physics. I was in a really bad mood at the time, because I felt I was approaching my professional life in the wrong way—taking actions for the sake of economic security.

Out of desperation, I started wondering whether I could derive anything interesting from the subject. Then I realized there might actually be something incredibly exciting—namely, breaking through the resolution limit that had, supposedly, been set in stone. The thought of tackling something so fundamental, and maybe even being able to rewrite scientific history, helped keep me going. I realized that I might not be wrong with my idea—as far-fetched as it seemed at the time.

How did your discovery change your life at that point?

The idea of revisiting the resolution limit wasn't itself the discovery, but the choice of any problem to tackle does demonstrate whether you're adventurous or not. In my youthful exuberance—I was in my late twenties at the time—I was pretty certain: I can break through this limit if I just make an effort to think about it creatively. I tried to find funding for the project in Germany, but I wasn't successful because I wasn't part of the scientific establishment. That's why I went to Finland.

At the time, there were no opportunities for young scientists to work independently. You had to work for established professors, and if you weren't some sort of crown prince, you had a very hard time. I wasn't a crown prince, but I had my own ideas. Really, that was the only thing I had.

When you reached the stage at which you wanted to have an article published in *Nature* or *Science*, why do you suppose those journals declined your offer?

I already sensed that the idea for STED [stimulated emission depletion] microscopy was an important one, and I also feared that it might be stolen. Therefore, I submitted the basic idea to a less prestigious journal. The experimental results that followed a few years later would have been worthy of publication in *Nature* or *Science*, but both refused to even consider

the work. That often happens when you're traveling through truly uncharted territory.

You immediately applied for a patent. What was your thinking then?

I had the naive idea that I could earn money with a patent. I didn't have a secure income in mind—from a patent, that wouldn't have lasted for long—but I did think the patent would lead to research funds. I led a spartan life in Finland because, at the beginning, I thought I'd be there only for half a year. But after a few weeks I had the decisive idea for the STED light microscope.

A few moments into my brainstorm, I realized I knew something that probably no one else knew and that it could become important. But I was grounded enough to approach the idea with some sobriety. Even two days afterwards, I kept thinking for a few seconds that maybe it was wrong after all—because it just seemed too good to be true. But I could find no inconsistencies in the idea; it was conclusive. But it would be a rocky road to the end. And it also involved fending off competitors.. Envious people and enemies in the field can hurt you, but they can also spur on someone like me, who thinks, *I'm going to surprise you all*.

Before you ended up at the Max Planck Institute in Göttingen, you had applied in vain to twenty universities, true?

By this time, I was already 33, and there were no more fellowships for me in Finland. In this precarious situation, in 1996, I was lucky that the then-director of the Max Planck Institute for Biophysical Chemistry in Göttingen, the American Thomas Jovin, and his colleagues at the time, gave me a chance. But Göttingen had their doubts, too. In 2000, they were still saying that I'd have to look for another position. And all my applications to German and foreign universities went unanswered.

In 2001, you gave a lecture at King's College, London, and immediately afterwards you were offered a job there. How did you feel about that?

That was a total surprise to me. I almost dropped my fork at dinner when I heard the news, because I thought it just couldn't be the case. I'd applied

"THERE WERE COLLEAGUES WHO WENT SO FAR AS TO SAY, 'DON'T BELIEVE HIS DATA. HE'S PUTTING ON A SHOW.'"

everywhere and had gotten nowhere—did they really mean *me*? That's one of those moments in your life you never forget.

But it's true you stayed at the Max Planck Institute and made the leap from junior group leader to institute director, correct?

The Institute wanted to keep me, probably because by then they had finally thought I was doing something original. But I'd already mentally prepared myself to leave Göttingen; I'd always indicated that would be the case. In the end, I got numerous offers. I had overlooked Göttingen, but then I reconciled myself to staying at Göttingen and I accepted the position of director at what was one of the most renowned research institutes in the world. They told me could do whatever I wanted scientifically. For someone who knows what he wants to do, that sounds like paradise.

In the United States, would you have needed to start all over again? And would you have had the kind of security that the Max Planck Institute offered you?

In the United States, I also had competitors who wanted to prevent me and my ideas from gaining a foothold there. If someone does nothing important in the United States, then they can't be important. The same was true in Germany, but at least there I had the freedom granted to me by the Max Planck Society.

I could tell you some really bad tales. There were colleagues who went so far as to say, "Don't believe his data. He's putting on a show." There were even two colleagues who wrote in confidential reviews for professorships that my data weren't okay and that my science was a hoax. In the end, something like this happens out of envy. The truth is that only time will tell who is right. And that can take a long time . . .

Did winning the Nobel Prize justify so many years of struggle?

Strangely enough, no. The real satisfaction came when I realized that the idea worked. And if it worked, then it could come into the world independently of me. But that I was the first was also indisputable. After the Nobel Prize, I continued the work so as to reach a molecular resolution that can't be surpassed. Indeed, the resolution of our microscopes today is ten times better. My desire was to fundamentally revolutionize microscopy, not just improve it. I wanted to make scientific history.

Can you explain in simple terms why you were given the Nobel Prize?

It was previously thought that an optical microscope couldn't see finer details than one-fifth of one-thousandth of one-millimeter. But I discovered that it's possible to achieve molecular resolutions in fluorescence microscopy, which is important for biomedicine.

Why is science important for society and what can it do for us all?

People are always trying to improve their lives, and science is a direct consequence of that effort. That's why it can't be stopped. By gaining knowledge, I can expand my sphere of action and solve some of those problems. Of course, today's solutions may be tomorrow's problems. You can't get around this issue. And what's of advantage to one time can be of detriment to another. You always have to keep that in mind, but you can't stop the desire to gain knowledge. People have always found solutions, and I hope that will continue to go well for at least the next three to five generations.

You're an obsessive researcher; your wife is a busy doctor. How do you manage to have a family with four children?

I couldn't imagine life without a family. I got married at 38, which was a bit late. My wife is also ambitious in her field, but we don't just live for our work. In 2005, our two oldest children were born—twins—which of course distracted me from my research, but I wouldn't have wanted it any other way.

Regarding your work, have you been satisfied with your work results?

I've always been self-critical and full of self-doubt, and therefore not vain in the everyday sense of the word. On the one hand, my view of myself grounded me; it also has hindered me. When I discovered something great, it didn't make me feel I had to show others right away. That's why I was slow at publishing. But I had my high standards that I had to meet. And those standards were always very, very high.

What, in your opinion, are the ingredients for success in your field?

You need to enjoy what you do, and you have to want to succeed. Of course, you also need talent; you have to be able to do something better. I tended to ponder a problem until I thought I fully understood it—or, more precisely, until I thought I understood it better than anyone else who had ever dealt with it. That's why I focused on only one problem—that of resolution.

Why does scientific research in Germany lag behind that done in the United States—and in the future, perhaps in China?

There's a correlation between economic and scientific strength. In the twentieth century, America rose economically and politically, and was able to attract better scientists and pump a lot of money into research. You can't compare that to the situation in Germany, which is smaller, or in Europe, which is fragmented. The U.S. scientific community is large and well organized, and if you make your mark there, you're immediately global.

This may also apply to China in the future. With a knowledge advantage, the right economic and political decisions can be made. This is well understood in China, and there's a spirit of optimism there. Unfortunately, this spirit has faded in our country—for many reasons.

Would something have to be changed about Germany's educational system for it to catch up in the sciences?

Absolutely. As a father of school-age children, I have the impression there has been a gradual decline in standards over the last ten to fifteen years. We need to adapt our teaching to the new realities, free the system of ideology, and massively upgrade the teaching profession and the schools.

I also consider it a problem that many teachers have never experienced how competitive this globalized world is, yet they are supposed to prepare our children for that world. Another weakness of the school system is that teachers can only afford to teach canonical knowledge superficially, if at all. What good is a great idea if you don't have the tools to implement that idea? Ideas travel ever faster around the world, and in the end, the winner is the one who holds the outcome of that idea in their hands.

What problems does it pose for the future if a country's school system is so bad?

I fear we'll become dependent on those who have a massive knowledge advantage—just as it once was the other way around. This is neither "fair" nor "idealistic." It's a weakness of Western democracies that take countermeasures only when something has already happened, because there are usually no necessary majorities for tackling problems preventively. And as a rule, those who are the first to recognize problems get stigmatized. By the time everyone else realizes that action is needed, it may already be too late—several generations too late.

If you fail to recognize the valid causal relationships in nature or in society, you always will lose. Nature punishes harshly. But if you recognize the connections correctly, she's our strongest imaginable ally.

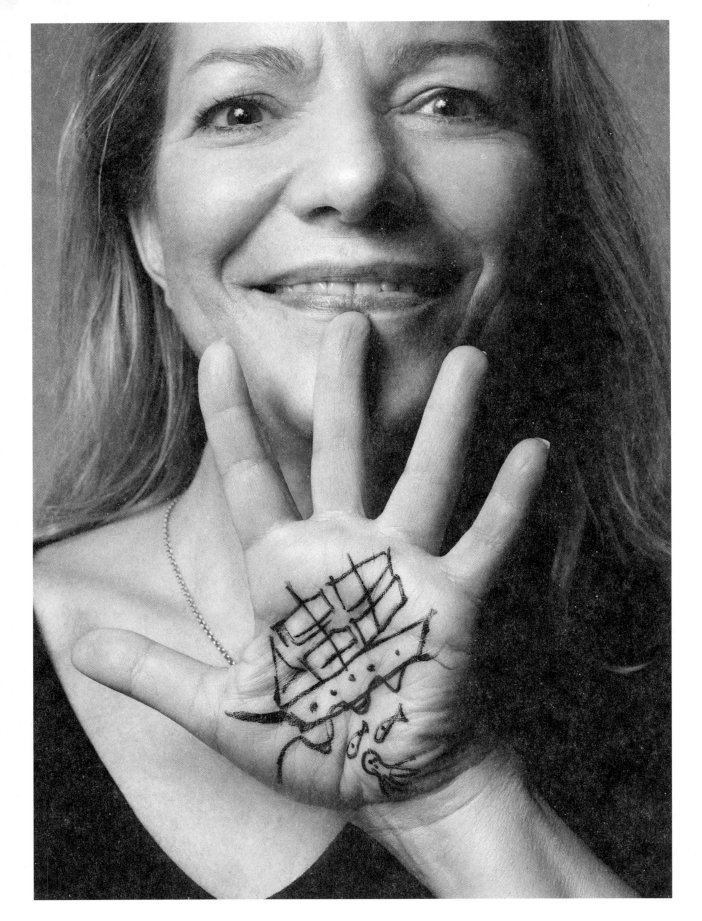

"YOU MUST GIVE OPPORTUNITY A CHANCE. THAT'S MORE OR LESS MY PERSONAL MOTTO."

Antje Boetius | Marine Research

Professor of Geomicrobiology at the University of Bremen
Director of the Alfred Wegener Institute, Bremerhaven
Group Leader at the Max Planck Institute for Marine Microbiology, Bremen
Gottfried Wilhelm Leibniz Prize 2009

Professor Boetius, why is the cold, dark sea so interesting that it makes you want to go down there? The deep sea is the largest habitat on earth. If you work out where life is found on our planet and take into account the seabed, which is still kilometers below the surface, it turns out that the earth is primarily deep sea, and we don't know it at all. That's why, even as a child, I resolved to become an astronaut of the inner earth and explore the deep sea.

You've said that your grandfather played a big part in your interest, telling you tales of his time as a

whaler and an adventurer at sea. What have you inherited from him in terms of your thinking and sense of adventure?

Above all, the love of sea travel. His stories about seeing the world by ship became so ingrained in me that I wanted to work in the open air with the sky above me and the sea around me. To this day, it's essential for me to have a clear, unobstructed view wherever I live. I live in an old apartment in Bremen and have a view of the Weser River from every room.

Your mother and your maternal grandmother were both strong women who taught you that girls can do anything. That wasn't a given attitude at the time, right?

That's right, when I was little there weren't many divorced parents around, and I tried to hide that from my classmates. But my grandmother raised four children during the war and my mother also brought up three children on her own after her separation, so I never questioned if there was anything women couldn't accomplish. We children were encouraged to achieve our dreams and be brave enough to just be ourselves.

As a child, I was already certain I wanted to be a marine scientist, mainly because my mother taught me to read at a very young age. I didn't like the outdoors as a kid, and during puberty I was a real loner. By the time I was 14 years old, I had devoured half of the world's literature, especially anything to do with the sea and sea travel. Then there were television programs by ocean explorers like Jacques Cousteau and Hans and Lotte Hass, which went hand in hand with my grandfather's stories. Oddly enough, even as a teenager I imagined that I wouldn't have any children, have no fixed anchorage in any one place.

Did you study biology directly after your graduation from high school?

All I knew was that I wanted to study marine biology, so I decided to go to Hamburg because there was a port and a university there, and I thought that the rest would fall into place. My grandfather taught me an old adage: you must give opportunity a chance. That's more or less my personal motto. It wasn't

"I NEVER QUESTIONED IF THERE WAS ANYTHING WOMEN COULDN'T ACCOMPLISH."

that I particularly enjoyed biology in school or at university, or that it was that interesting; I found it quite brutally boring. It wasn't until I started working as an assistant and was allowed to go on my first expedition that the subject sparked my interest.

Your big break came when, for a year, you went to the Scripps Institute of Oceanography, in La Jolla, California. What was that experience like for you?

It was the decisive step for me to get out of undergraduate studies, which didn't offer much research opportunity and wasn't right for me. Going to Scripps Institute was like winning the lottery a thousand times over. California was such an open place, and the university professors really cared about the students, getting them involved in their research. Since that year abroad, travel has been a very important part of my life.

You could have stayed at Scripps, but you met your life partner on an expedition and returned to Germany, right?

That was for two reasons. I wanted to become a deep-sea researcher, so I asked a professor for advice, who said that the best place in the world to study deep-sea environmental microbiology was in Bremerhaven, with marine biologist Karin Lochte. At first, I wasn't that excited by the prospect, but then on a trip in 1992 I fell in love with a sailor who was also from Bremerhaven. That's when both things fell

into place, and I decided to return to Germany. I lived with him for a long time, and we're still great friends.

You've now completed forty-nine expeditions and have lived aboard ships for almost thirty years. Was it difficult, in this area of male dominance, to assert yourself as a female head of research?

No, not at all. If anything, I received a lot of support and developed friendships. There were rarely any problems. When I was a very young student, I'd hear a few comments from older fishermen, along the lines of "What's going to become of you?" Once, some sailors wouldn't talk to me for a few days because I'd interrupted their work on deck and called the captain because of work safety issues. But even then, I didn't have the feeling that the men didn't take me seriously; it was just that they were offended because I didn't value their work. So, at sea I've never once had someone not respect me because I'm a woman. In science, on the other hand, I have experienced that.

What bad experiences have you had in that respect?

Natural science was and often still is a man's world. After my initial success, older female scientists warned me not to stick my neck out. At the time I didn't understand because everyone was always nice to me and had encouraged me. But then there was a dispute about the order of author names on an article to be published. It was my idea for the piece, and I'd written the first draft, but all of a sudden the older professors thought that my name should be farther back in line. Conflict arose, so I gave in. That really ate away at me for a while.

Have you experienced rivalry in your field of science?

With a few exceptions, the science field is pretty friendly. I like that there is healthy competition for ideas and creativity, which is fun and challenges me. When I know that other people around me are working on the same idea, it's a good basis for exchange. We compete, but we are also happy for each other when something works out for one of us. I'm spurred on by the recognition I have received from an opponent, which I also return.

From the start, I've always thought about where I would draw my line in the sand and when I would be willing to give ground. I apply this view, which I learned through seafaring, to my everyday life as well. That's probably why others are able to see where I stand.

Can you tell us about the difficulties you encountered at the start?

At first, I didn't have a good grasp of what really matters in science and how important it is to think through any research from idea to publication. But I grew to understand that research should mostly be about big, new ideas and not about detailed, laborious tasks. I also didn't understand at first that in science, the decision to aim for the top is made quite early on.

"I GREW TO UNDERSTAND THAT IT SHOULD MOSTLY BE ABOUT BIG, NEW IDEAS AND NOT ABOUT DETAILED, LABORIOUS TASKS."

The time between ages 30 and 40 is particularly important; later on, there aren't many second chances. It was late for me, but I still managed to make it. In my second postdoctoral position, I focused on a completely new idea and a change in the direction of research, and that pushed me ahead.

What do you consider was your first big success?

That was the discovery of a symbiosis of microorganisms that consumes methane from the ocean floor. The earth would be a completely different place if methane, a biogas, simply escaped from the sea into the atmosphere. If this little bit of life weren't down there, predominantly consuming this aggressive greenhouse gas, things would look very different for us. The article I wrote about this is still widely quoted.

Why did you change your field of research several times?

I always get bored after a few years in one field, and then I want to start something new. The great mysteries of microbiology that still exist revolve primarily around molecular processes. But I'm more of an ecosystem researcher—that's what my brain is made for. From microbiology, my next step was to deep-sea research so as to understand climate change and its impact on the deep sea.

I'm still active in this field, and I've added a number of other research fields, especially polar research, so I've made a subject leap every five to eight years. In particular, research on climate change has kept me very busy.

When you went to the Arctic in 1993 on board an ice-breaker, the ice you sailed through was three to four meters thick. Now it's just one meter thick. Does that alarm you?

The polar environment is changing so rapidly and this has consequences for life in the sea ice and in the deep Arctic Ocean. With thinner sea ice, more light penetrates the ice, and the sea algae in the ice grow faster from spring to summer. But when the ice melts during the summer to fall, the habitat changes too much for many species.

In 2012, during the largest ice melt observed to date, we watched the ice algae sink into the deep sea below. However, hardly any animals were able to use this new food source on the Arctic seafloor because many of the deep-sea animals are so strongly adapted to their traditional energy sources.

The fact that climate change is also changing life at the bottom of the ocean is an important, much-cited finding—and it really frightened me. From a scientific point of view, there's unfortunately less and less hope that we can preserve the planet as we know it. If we don't stop CO_2 emissions shortly, we can expect the first ice-free Arctic summers around 2040. This tipping point is so close, yet we're still acting like there's nothing happening.

Do natural scientists have a responsibility to speak up?

We're speaking up pretty loud already. We report how much CO_2 we humans are releasing and how much more we can still afford to release; we show which habitats and species are endangered. We've made appeals at many levels to the public and to politicians to tackle the complex task of changing our energy system in under ten years—not just in Germany but also as a global goal. We're already talking about a major environmental upheaval because 75 percent of the world's energy comes from fossil fuels. But I'm always optimistic and think that it's not yet hopeless. We need lots of solutions; one would be a price for CO_2 emissions, which would

make renewable energies far cheaper than fossil fuels. That's a string we could quickly pull.

The world is also struggling with the problem of plastic waste, which is polluting the oceans by the ton. How can science help alter the situation?

It's a catastrophe that in the North Sea, even in the Arctic Ocean, stranded porpoises and dead seals and seabirds are found full of plastic waste. We can't treat nature like this! A logical solution would be to produce our disposable articles only from decomposable materials. These disposable items don't have to be made of material that will last hundreds of years in the ocean. We need simple, quick solutions. In this way, science should collaborate more directly and systemically with politicians, governments, and society, but unfortunately there are no platforms for this.

What should politicians do about the implications of climate change?

They must create a framework that recognizes the value of nature and the environment for long-term human well-being. Time is running out: we've got just ten or fifteen years before there will be so much CO_2 in the atmosphere that we'll face big problems worldwide, including in Germany. That's why we need laws, rules, and prices to achieve better climate protection and nature conservation. Social justice must also be taken into account.

What's your message to the world?

Wake up, look around you, align your thoughts and actions.

Your whole being radiates optimism. Do you sometimes suffer frustrations?

There are always situations where slow processes, incredible stupidity, or hatred upset me beyond measure. Then I ask myself: What kind of world do we live in right now and how this is supposed to continue? But I also keep telling myself to be active, that I need time and strength to achieve something. That's why I won't allow myself to be pessimistic.

How would you describe your personality—in three words?

Smart, fast, cheerful.

You've been interviewed on television, mentioned in newspapers, and have served on committees. Do some of your colleagues resent that amount of public attention?

I tend to be encouraged and praised for not only representing science but also holding an unequivocal position, above and beyond that. Some people probably think I spend more time on TV and newspaper interviews than on my research, but based on my profile, my publications, and awards, you can't say that I've stopped researching or being highly productive. Especially in my research field—polar and marine research—there is a great need for communication, so I feel I have to be present in the media. But I also often wish for more peace and quiet, so that I could do even more, better research.

Why should a young person study science?

It's a profession that consists of always learning new things and of exploring and overcoming the limits of knowledge. Basically, it means staying a child forever. Because every child is born with this curiosity about the world, and a well-wired brain that wants to be filled, that wants to learn and do research; this is an attitude I can keep throughout my life as a scientist.

What would you say has been your contribution to society?

There are very few deep-sea and polar explorers. At a time when we're massively altering and/or losing so many habitats, what we find out today is the knowledge we'll have about what role these distant habitats played. That's why I convey the essence of this knowledge via my research and communication.

"WAKE UP, LOOK AROUND YOU, ALIGN YOUR THOUGHTS AND ACTIONS."

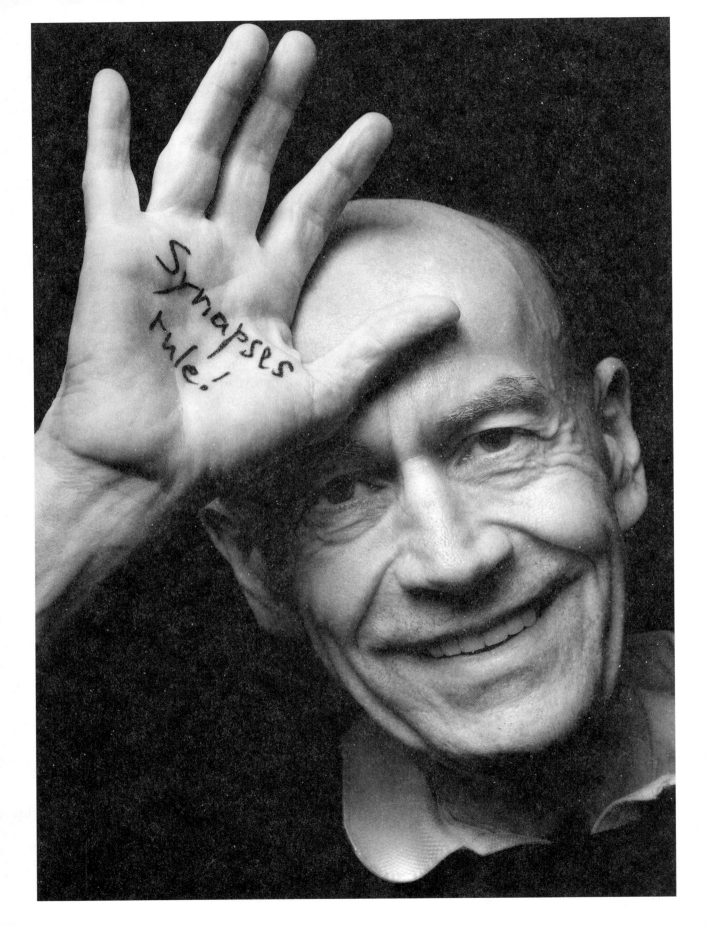

"THE BIGGEST PROBLEM IN SCIENCE IS THAT IT'S FAR TOO PRONE TO FOLLOW FADS."

Thomas Südhof | Neurobiology

Professor of Molecular and Cellular Physiology at the School of Medicine,
Stanford University, Palo Alto
Nobel Prize in Medicine 2013
United States

Professor Südhof, you were a real rebel in your youth, for whom freedom was the most important thing. Where does this need to be independent come from?
It would be tempting to say that it's an inherited trait, but I'm not so sure about that. In my childhood, nothing indicated I was less adaptable than others. I never felt comfortable in groups, though. I can perfectly understand how people love that group feeling, because we live largely via communication and like to agree with others. But I never particularly enjoyed being in groups.

You enjoyed your education at a Waldorf school. To what extent can your influences from back then be seen today?

My teachers were independent thinkers who didn't blindly follow an ideology. I benefited from their acceptance of my wanting to think things through for myself and then to confirm or deny them. It wasn't the Waldorf School per se that was decisive, but that the teachers there made it possible for me to develop my own world of ideas.

You've said that two women shaped your life: your maternal grandmother and your mother. Can you comment on that?

My mother influenced me in many ways. She was inward-looking and reserved, but with firm values. Like her, I was never overly concerned about achieving positions or making money. My grandmother was an unusual, strong woman and much more communicative than my mother. From her I learned more about intellectual life and culture.

You played the violin and the bassoon as a child, and once you said you learned more from music than you did in your classes at school. Care to explain?

I always had an instinctive love for music and would have liked to become a musician, but I just wasn't talented enough. Through music, I learned that I can achieve creativity only with a certain level of technical skill, and the same goes for science. Making music is about learning an instrument, which means practicing an awful lot. In science, you have to learn the subject matter, read an incredible amount, study, and try things out.

You hitchhiked through Europe when you were 14 years old. Why were you so keen to leave home?

Curiosity, and a bit of protest and rebellion, played a role. I wanted to see the world and be independent. It wouldn't be entirely fair to blame everything I did on my parental home and the fact that my parents were busy with other things, but it's true they didn't pay me much attention. At the time, they didn't even notice I was gone. I couldn't imagine that with my own children.

"INTELLIGENCE WAS LESS IMPORTANT TO ME THAN CONCENTRATION AND ENERGY."

After graduating from high school, you were looking for something to do. What did you choose and how did that work out?

At the time, I'd decided to study medicine, not because my parents were doctors but because I saw medicine as the best option among various educational paths. I didn't feel a desire to be a doctor or see my future in medicine, but it was a satisfying occupation. When I went to Texas after finishing my PhD, I intended to return to Germany a few years later and complete my residency at a university hospital. Ultimately, however, I decided to give up medicine in 1986. I felt that research was a greater challenge, also a more meaningful one where I could make a difference.

You had your own lab in Texas. Your postdoc colleague Nils Brose says he worked twelve hours a day and weekends back then, but you worked more or less around the clock. Did you sleep at all?

I still work a lot today, but I don't see it as a burden; it's part of life. Working often has a negative connotation, but I feel my position is a gift in many ways. My job is interesting, I enjoy working, and in my opinion, I don't work much more than many others.

What would you say is your style of research?

A lot of my work involves sitting in my office and processing information. I compare what others have already researched with my data, and I try to interpret and summarize the whole thing. Also, I talk to people a lot, in groups or one on one. The negative

aspects of my work, on the other hand, are the bureaucracy, which becomes a huge problem with its many rules and regulations. And I have to constantly try to get money for my work from somewhere. That's tedious and sometimes quite stupid, and it constantly takes more time.

You once said it's difficult to balance your own ideas of what's right and other people's views. Can you explain?

The problem can also be formulated as the fact that we human beings can never really judge ourselves well. We have an innate lack of ability to look at ourselves objectively, so we either overestimate or underestimate ourselves. That's why we need feedback from colleagues and families. Without that, we can't understand how we should judge ourselves. However, society is influenced by trends that don't

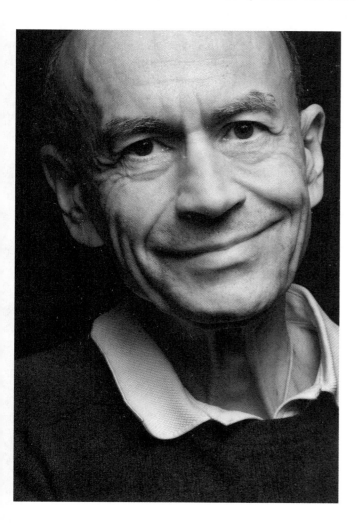

correspond to reality. The biggest problem in science is that it is far too prone to follow fads. Often scientists all do the same experiments, and then they all come to the same conclusions.

How did you find your own path in life?

Intelligence was less important to me than concentration and energy. In my U.S. phase, I learned how difficult it is to assert yourself and your own ideas. Sometimes it can take a long time before successes are achieved. I was lucky; many eventually give up. When I started running my own lab, I thought about where there would be opportunity to find out something crucial, something new that no one else was doing and that would expand our understanding of the brain. That's still the way I proceed to this day.

Can you explain in simple terms why you were awarded the Nobel Prize in 2013?

In the human brain, there are a huge number of nerve cells that constantly communicate with each other. Each nerve cell is simultaneously part of multiple networks, and the communication points between the nerve cells are constantly changing. These communication points are called synapses, and it's through these synapses that one nerve cell transmits information to another. The transmission is extremely fast, and it has to be, because the brain has to be able to process a lot of information very quickly. The speed of that information transfer used to be a big mystery, because it occurs at the synapse through chemical messengers that are released by one side and recognized by the other.

My research, which was awarded the Nobel Prize, explained how a presynaptic nerve cell manages to release messenger substances so quickly and precisely when it receives the signal to do so. This communication works because an electrical signal in the presynaptic nerve cell is converted into an intracellular calcium signal. This in turn activates a specific protein machinery, which then causes the chemical messengers to be released. The release occurs through the fusion of vesicles, which are small sacs filled with these messengers that fuse

"THE GREATEST DANGER I CURRENTLY SEE IS THAT FACTS ARE DELIBERATELY BEING DISREGARDED, TWISTED, OR DENIED IN ORDER TO SERVE THE SELFISH GOALS OF CERTAIN INDIVIDUALS OR NATIONS."

with the surface membrane. My contribution was to elucidate this process.

When you started out, was this a little-explored area of research?

At the time, it was completely unclear what occurs at a synapse. I decided to pursue the topic because I thought that these questions could be solved. Nowadays in science, there is always the demand to carry out research on aspects that either directly explain diseases or provide immediate insight into functions. In principle, this is a noble aim, but often diseases and functions can't be researched without first understanding the fundamental system properties—that is, a catalog of the system elements.

My first research goal was simply to describe a presynaptic neuron. I was criticized for this at the time because the information was purely descriptive and therefore didn't directly contribute to understanding. In science, research is often not funded because it doesn't lead quickly enough to applications or functional insights. The consequence is that you never arrive at a real result. Alzheimer's disease is a good example of this, because for decades the emphasis in research was on finding a cure as quickly and directly as possible, owing to an entirely incomplete understanding of the disease itself. After decades of research and billions of dollars spent, this has led to absolutely nothing.

What are you researching right now?

At the moment, I'm interested in how synapses between nerve cells are formed. This is important for many diseases, but I'm not primarily concerned with the question of disease. During brain development, neurons form and then connect to make huge overlapping networks where the neurons are linked by synapses. The networks are constantly remodeled throughout life as the synapses are restructured. I'm interested in why this happens and how the synapses are formed in the first place.

In Germany, a lot of emphasis is placed on the h-index—on your number of published articles and how many citations of your work are made in others' articles—while in the United States the number of patents issued carries more weight. How do you see this difference in the emphasis that research takes?

It's true that in America the number and quality of citations and the h-index play a smaller role, but patents are also secondary for academics. Publications are important, but in the United States, there's more emphasis placed on scientists doing research than on how that manifests itself externally.

I also think the enterprise of science itself is at risk because traditional methods of communication and publication no longer work well. Editors have way too much power. Too many articles are published that turn out to be completely wrong but are never retracted. The system is far too commercial; we need another system.

How do you deal with constant stress and the need to be available?

That's difficult. I hardly ever make any phone calls. I find emails the worst, because I have to deal with

them so much during the day. In the evening, it's less of a problem because I just turn off the computer and phone. Sometimes I slip up and check to see if anything important has come up, but I try not to do anything like that after a certain time of day.

Your father was in America when you were born, and he learned the news by telegram. Were you also an absent father during the height of your research?

I was certainly away too much, but I always did a lot with all my children. The children from my first marriage are now grown up. With my second wife, who is also a professor, I agreed that I would drive our children to school at half past seven in the morning, and sometimes pick them up or drive them somewhere in between. I'm always home by six o'clock or six-thirty at the latest to have dinner with my family. Afterwards, I help put the kids to bed and read to them or tell them a story. Sometimes I have to work for another hour, and then I go to sleep—that's my daily routine.

Your research is financially supported by the Howard Hughes Medical Institute. What's it like for you to have to undergo their examination for this funding every five years, even as a Nobel laureate?

I'm nervous, and it's one of the most stressful things I have to do in my life, because these exams are very stressful. I prepare for them, go there, and do my best. In the United States, it's no different for me than for anyone else, and I think that's right. I have to be able to justify why I deserve financial assistance. I now have a certain level of economic security, thanks to my position as a professor, but I also need that money because I have three small children. Even if I didn't want to, I'd have to keep on working.

Why should a young person study science?

Science is essential to understanding fundamental things: how a car drives, how a heart works, how our world functions. Science relates to all areas of life and to everyone, not just engineers and doctors; that's why every politician, lawyer, and so on should have a basic education in science. Becoming a scientist is another matter; it takes a genuine interest to discover something. I have enormous fun not only finding something out by myself but also understanding what others have found out. The most fun I ever have is when I've come across a genuine discovery.

Have you ever experienced a crisis in your life?

When I couldn't solve a scientific problem after trying so hard—that's very frustrating. Also, for many years I didn't get the recognition that others got who, in my opinion, had accomplished far less. I felt I was at a disadvantage. But from this experience I learned that it's completely pointless to worry about such things, because ultimately all processes and prizes depend not only on effort but also on luck and a bit of politics. I also consider the fact that I received the Nobel Prize to be rather a stroke of luck; there were others who deserved it.

What's your message to the world?

My main concern is that people agree on what is true, and that they act accordingly. Scientific truth is never fully defined, but as it has been defined, it isn't relative; it is as it is. If we give up that truth, we give up our European culture. The greatest danger I currently see is that facts are deliberately being disregarded, twisted, or denied in order to serve the selfish goals of certain individuals or nations. This has nothing to do with politics; it's pure ideology. No one can simply play with facts and deny them, just because he sees a possible advantage in it.

What role should science have so as to contribute to society's better future?

Science has to be objective. This means that scientists must put aside their personal needs and ambitions for the sake of truth. As scientists, we've made far too many mistakes and have failed to fulfill our responsibilities. There's more corruption than ever in the field of science. We should do a much better job of explaining to the public what is possible, rather than trying to get more money for research by making unfounded promises.

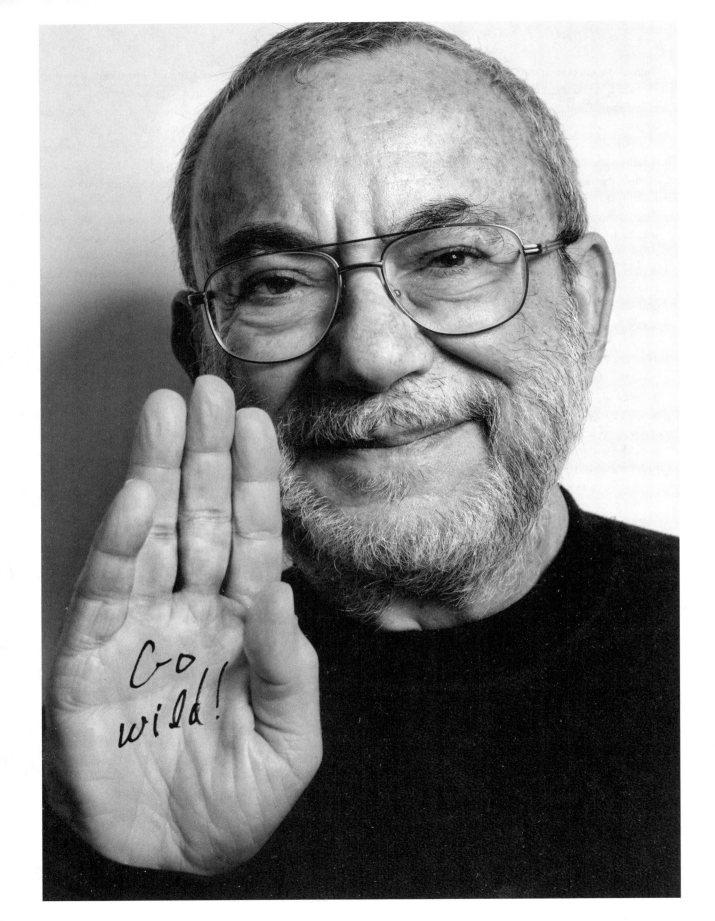

"AFTER A SUCCESSFUL DAY YOU MAY HAVE CHANGED THE WORLD."

David Avnir | Chemistry

Professor Emeritus of Chemistry at the Hebrew University of Jerusalem
Israel

Professor Avnir, why did you study science?
I was born a scientist. When I was 3 years old, there was food rationing in Israel. Our family had one chicken that laid one egg a day, and my role was to eat that egg. I understood that the chicken was extremely important to the family's well-being. Therefore, I took a feather, planted it in the ground, and watered it so that a new chicken would grow. This was my first scientific experiment, and of course it failed, which is an extremely important lesson.

When I was 12, I built a telescope from old eyeglasses. I looked up at the sky and I discovered that Jupiter was surrounded by three little dots, which turned out to be Jupiter's moons. Later I found out that these moons had already been detected many centuries ago by Galileo Galilei. But it became obvious to me early on that science was what I would do. It came from within.

What kind of mind does one need to become a scientist?

An endless and enormous curiosity to understand one's surroundings, and the enthusiasm to learn more and more. On the one hand, you have to acquire a solid background in the existing knowledge in order to be part of the system; on the other hand, you should be able to think outside the box, be able to create new ideas. And you must be unafraid of failure, because this is an ongoing process of searching and failing. If you are not willing to fail nine times out of ten, don't go into science; failures are an integral part of scientific progress.

As a carpenter, you might make a chair and at the end of the day go home happy because you have achieved something. In science, there can be months of going home with failure, day, after day, after day. Until one day it works. So, you have to be an impossible mix of being stubborn and being very flexible. That is how people define me.

"THE NOTION OF A EUREKA MOMENT IS FAIRLY ROMANTIC. DOING RESEARCH IS MORE LIKE CLIMBING EVEREST."

The Talmud amplifies the value of constant learning. Is this a favorable attitude for a scientist?

I think our culture of constant learning and of constant debating for the sake of debate, of not accepting anything at face value, is one of the main reasons there are so many successful Jews in science. And debate is never a negative thing. It is a way to sharpen an idea or totally discard it.

Did you have a particular moment when you reached an important breakthrough?

The notion of a eureka moment is fairly romantic. Doing research is more like climbing Everest. You do it slowly, step by step, and at last you reach the summit. There are no easy routes and no free meals. It is like when a fog slowly dissipates you begin to see a clear figure. Sometimes you wake up in the middle of the night with the answer to a specific question. But it is never the difference between the totality of scientific discovery and zero. It is gaining understanding one incremental step at a time—that is what you are looking for. So, the long road is much more important than the final achievement; and it is fun when, along the way, you have many brief moments of small satisfaction. And this is what keeps you going.

The way you describe it, becoming a scientist doesn't sound tempting. But surely it has its rewards?

But when you succeed, you are the king! After a successful day you may have changed the world. Can anything be more tempting than that? Can anything be more satisfying than creating new knowledge that can be used by others? This is the essence of being a scientist, and it is perhaps the most advanced activity society can offer an individual. But if you consider studying science as a profitable career, it will be a waste of precious years. Science is more than a career; it requires total dedication.

I arrive at the office in the morning, and I work until I cannot work any longer. It's all by choice. And don't forget that you also have to be a good marketer to attract funding grants. It's quite a lot of work to find the euros or dollars you need to do your research. So, your work is always at the back of your

mind. Even if you don't consciously think about it, there is some part of your brain still working on it. It is a never-ending story.

So, would you say you are obsessed with your work?

No. My motto is rather this: push to the limits and have fun while you are doing it. No, I am not obsessed; this is my way of life. The danger of obsession is that it blurs your ability to see the truth. Obsession takes you off the right track. So, if you meet an obsessed scientist, check twice what he is saying.

Is it true that more and more articles in publications turn out to have been intentionally falsified?

It is a marginal phenomenon, which is found especially in the life sciences. There, the temptation to publish early results can crush some individuals, because the Nobel Prize was often "just around

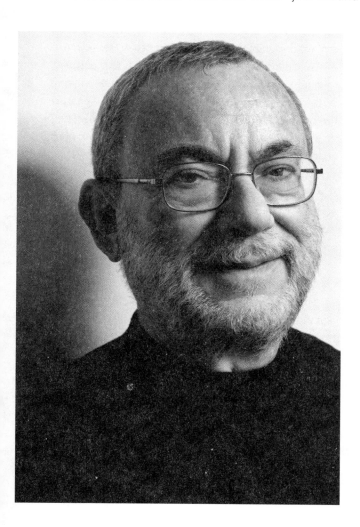

the corner." But if it is an important claim, many research groups will repeat those results; and if they are incorrect, the early publication will simply fade away, and not be cited anymore. So, in essence it's a self-cleaning system.

And what new knowledge do you feel you have contributed to society?

One of my main topics involves mixing the world of molecules that originate from living organisms with the world of inanimate materials. Today, we know about 40 million different molecules. The vast majority of them come from living organisms. To that category belong drugs, additives, plastics, textiles, and more. Then there is the substantially smaller family of glasses and ceramic materials, which have very little to do with the living world.

My idea was to merge these two fields to produce new materials with new properties. So, our first problem was how to merge the fields without destroying the organic molecules in the high temperatures needed for the formation of glasses. For that solution, we used a method of preparing glass at room temperature, which resembles the lower temperatures used in the plastics industry. And so today we have glasses that can do all kind of activities traditionally limited to molecules of the living world.

Could you give us an example of that application?

One product is a medication to treat acne. The current acne medication is aggressive and can cause skin rashes. So, we coated that specific drug, which is an organic molecule, with glass. The molecules slowly and gently dissipate out of the glassy coating onto the skin. This will be the first acne drug on the market that doesn't cause any facial redness. It is now being tested in several hospitals and probably will hit the market in a year or two.

When I submitted the first scientific paper on the topic of merging animate and inanimate materials, the editor of the journal asked me: "What is this good for?" I was young, so I ardently refused to answer that kind of question. The primary mandate of science is to create new knowledge without asking

"I THINK THIS CULTURE OF CONSTANT LEARNING AND OF CONSTANT DEBATING FOR THE SAKE OF DEBATE, OF NOT ACCEPTING ANYTHING AT FACE VALUE, IS ONE OF THE MAIN REASONS THERE ARE SO MANY SUCCESSFUL JEWS IN SCIENCE."

what it is good for. Because with the introduction of new ideas, applications fall like ripe fruit from the tree, such as the acne medication just described.

But don't you need to propose applications to foster understanding of why so much money is required for research?

The classic question is: What percentage of research eventually produces something useful for the marketplace? It is estimated to be about 5 percent. From my point of view, that is a very high percentage, as research is a pyramid. That is, you create a lot of knowledge at the base, which gradually narrows into a useful product at the top. For instance, there is a class of antidepressant drugs—tricyclic drugs. First, there was the basic research on how to build

molecules with three rings (cycles). And when this was possible, it was tested for its medical potential and then the anti-depressant drugs evolved.

So, you always need a lot of basic science, which refuses to answer the question, "What is it good for?" I understand that it is difficult to sell basic research to the taxpayers. What a responsible scientist can do is, if one sees some potential for an application, then push in that direction. But that is a long process. It took us twenty years for our basic research to be used for a product. Chemistry is extremely slow science.

In the scientific world, for your work to be cited in other publications is currency. So, how often is your work cited by others?

As of today, I have been cited about 35,000 times. To me, this is the main recognition, as it means people are listening and citing my work, and therefore I am not barking in the dark, as we say in Hebrew. Another aspect of recognition is awards. But actually, I would be happy to see science exist without any prizes, not even the Nobel Prize. That's not because the people who get them don't deserve them. They do. But so many other people, who have contributed no less to a project, do not share the award.

All my research activities are closely done with my students and postdocs. Publications are joint authored. There is a standard, which we follow, on how to order the author names on a paper. The person who did most of the work is named first, and the group leader is usually the last. In the middle are the names of the rest of the team.

So, years ago, I approached the publishing house of John Wiley, Inc., with the idea of publishing something without any author name given. I felt who created the knowledge should be secondary. But the idea was rejected, and rightly so. You *should* publish under your name because if you made a mistake, you should face up to it. So, this was a romantic idea.

Science is still very much a male world. How was it in your lab?

Up to the level of postdoc, it is about 50/50. The major decline in the proportion of women comes in

the higher academic positions. I think that one of the main obstacles women face in the sciences is the demand of totality. Women are still expected to raise the children, but total equality in that basic role does not exist. When I was head of our chemistry institute, I tried to correct this. I had two extremely good female candidates I wanted to hire. And at the last moment, both decided they would not devote the endless hours that are needed to become a successful scientist.

In our institute, there is a new law that forbids seminar lectures after 3 p.m. After that time, attendees can go home and take care of their children. So, people are trying to correct the situation, but we are still far from equality. Women could be more successful in science if their husbands were more supportive and gave up some of their own career objectives. My wife decided by choice to stay home for the first thirteen years of our marriage. I worked intensively, almost without rest, yet I went home at four or five o'clock to be with the children. And when I worked at home, my door was always open.

You lived almost your whole life in Israel. And then in 2017, the fact that you were born in a monastery, with the family name Steingarten, became well known. What is the story?

Avnir is the Hebrew translation of the German name Steingarten. And I knew that I was born in the Benedictine monastery of St. Ottilien, close to Munich, where Jewish refugees found shelter after the war. But my parents rarely spoke about it, to protect us. My father never talked about the Holocaust, and my mother only started to speak about it when she was in her late seventies.

My parents had fled Poland and met after the war in the camp at St. Ottilien. I was born there, like 450 other children in the three years after the war: we're known as the St. Ottilien babies. I am child number 363. And then, in 2017, a conference was organized for the St. Ottilien children to meet at the monastery, and this forced me to dig deeper into that chapter of my life. Now I have connections with some other St. Ottilien children, many of whom also live in Israel.

How old were you when you came to Israel?

When we came to Israel, I was 18 months old. It was a tough time, as those were the years of establishing the new state. Still, I do not have memories of poverty, simply because everybody around us lived similarly. So, you had only one pair of shoes and when they became too small, you just cut off the tip of the shoes so that your toes could stick out; this was normal.

What impact did that conference at St. Ottilien have on you?

I recognized that those three years after the war in St. Ottilien were some of the happiest times for my parents. I found photographs of them at St. Ottilien, and I never saw them as happy in later years. Those years were a burst of liveliness, a new start in life. My mother always thought that the years immediately after the war were an extremely interesting chapter in the history of the war, because of the mass movement of millions of people and the readjustment to everything new. Compared to the war years and the Holocaust, those early postwar times are hugely under-researched. So, that conference fueled my interest in what happened immediately after the war.

Would you say you are a happy man?

Yes. It did not take me a second to say *yes*, did it? More than happy; fortunate that society gave me the opportunity to do this work. And I am aware that it is not to be taken for granted. My original plan was to die at this desk at the age of 93. Recently I have had new ideas about doing completely different things . . .

"MY MOTTO IS RATHER THIS: PUSH TO THE LIMITS AND HAVE FUN WHILE YOU'RE DOING IT."

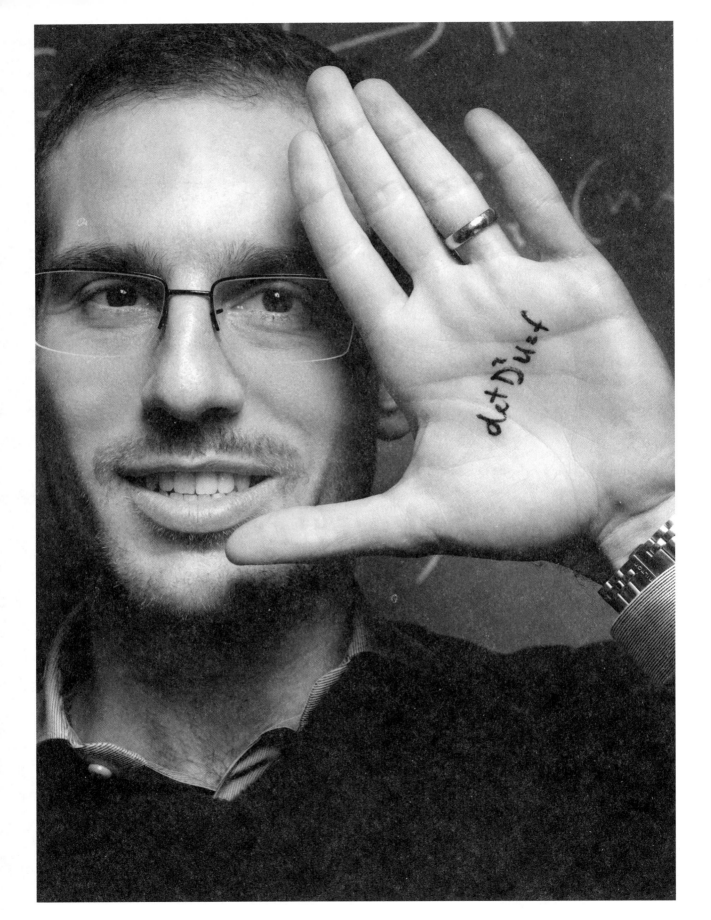

"IT WAS ONLY THROUGH NEVER QUESTIONING MYSELF THAT I MANAGED TO JUMP AS HIGH AS I WANTED."

Alessio Figalli | Mathematics

Professor of Mathematics at the Swiss Federal Institute of Technology, Zurich
Zurich Fields Medal 2018
Switzerland

Professor Figalli, you were awarded the Fields Medal, a prize for mathematicians that could be compared to the Nobel Prize. The others on your team remained in the shadows. What do you think about that?

That is unfair. But there is a huge list of top mathematicians that are recognized by the world's mathematical community, and they also didn't get the Fields Medal. There are not enough Fields Medals for everyone. It is awarded every four years to at most four people. And you have to be younger than

40 years old to receive it. I have been awarded the Fields Medal for several contributions, and they were all done with different groups. And in the mathematicians' groups there is not so much competition; it was a big success for everyone, and the people in my group were also extremely happy. We have a very good relationship that goes beyond work—we are all friends.

How hard was it to become so successful?

Life is not easy; you always have to fight. And it was not easy to get the Fields Medal. Sometimes I still cannot believe it. When I was a student, the Fields Medalists for me were almost god-like; they were Olympians. It seemed to me that they could solve every mathematical problem, and we were just the rest. After winning the medal, the accomplishment doesn't look so difficult anymore. It quasi-humanized the medal for me. In fact, I never thought about getting the Fields Medal until people started to make predictions that I could be the next Medalist. I was like, "Oh, my god. Do I really stand a chance?" And I got really nervous about the time when the next Fields Medalists are usually announced.

Do you remember the moment when you were informed about your award?

Oh, I will never forget that. My wife and I were at home. She wanted to go to the market, and I was checking my emails. And there was this email from Shigefumi Mori, the president of the International Mathematical Union, saying: "Dear Prof. Figalli, I would like to speak to you, could you please give me a contact, so that we can get in touch." I just froze in front of the screen. *Could it really be the case? But why else should the president want to speak to me?* My wife looked at the email, and she had to sit down.

I had to wait one very long night until the president called me, informing me that I was one of the medalists. For several days afterwards I still was dreading that they would call me up again to tell me, "Sorry, we informed the wrong guy." It was so incredible. And the worst thing was that I wasn't allowed to tell anyone else until the ceremony. That was really tough.

Did you have to be obsessed with math to be so successful?

Like most mathematicians, I am obsessed. I was absolutely dedicated the first ten years of my career. When I am that much focused on a problem, it is on my mind all day. That doesn't necessarily imply that I work more productively. Research is also a creative process, so actually you work better when you lead a balanced life—you learn to focus on the important things. But when you are young, you just try to do everything. Maturity helps a bit.

And would you say that you lead a balanced life?

Nowadays, my wife and I finally live together in Zurich, my life is much more relaxed. She is also a mathematician, and at the beginning of our relationship we had decided each of us would pursue our own careers. So, we lived in different places and had to commute all the time to see one another. That was really tiring. Now, I start working in the morning and continue until late in the afternoon, then I go home and we spend time together. On the weekends, we visit friends. For me, it is just a matter of being well organized. During the day I am rather efficient, so that when I work, I work exclusively, trying to make the most use of my time.

I guess that when you were in school, you had only the best grades. Were you sometimes called a nerd?

I wasn't competitive. For my classmates, it was even advantageous to have me there, because I could help them, especially during exams. Mathematics has always been rather easy for me. It just came to me, and this talent for mathematics simplified my life, so I could spend time learning other subjects as well, or preferably playing soccer. Actually, I was a normal kid—into video games and sports. I never thought about mathematics, and I never spoke about mathematics.

Maybe mathematics should be taught in a different way? Because almost nobody likes it as it is.

The problem in teaching mathematics is that we lack examples to make the kids see how it can really be fun. It would be difficult to change the way

mathematics is taught, but at least we could add more entertaining exercises. Like, what is infinite? Say, there is this story about a hotel that has an infinite number of rooms and an infinite number of guests. So how can you accommodate one more guest? Such mental games perfectly exemplify how mathematics can be interesting and deep.

Did your parents inspire you to study mathematics?

My father was a professor of engineering and my mother was a Latin and Greek [Classics] teacher. She inspired me by telling tales from Greek and Roman mythology during my childhood. I liked those stories so much that in high school I chose classics rather than mathematics as my major. When I turned 17, a friend of my father introduced me to the Mathematics Olympiads, which are high school competitions in which you have to solve non-standard problems by using your imagination. And that was the beginning of my love for math.

I also discovered that mathematicians really exist. That it is a real job! So, after high school, I applied to the Scuola Normale Superiore, in Pisa, where only ten applicants each year are admitted. I passed the initial test, but as I had studied classics, my background was poor compared to my fellow students. I was scared of being kicked out, and I felt I was the worst in my class. But I kept telling myself, *Maybe you will fail, but at least you have to try your best.* So, I gave myself a chance. And I just loved it!

What mindset do you recommend for students to get through hard times?

It was only through never questioning myself that I managed to jump as high as I wanted. Sometimes you are your worst enemy. By thinking all the time that you will never succeed, you actually will fail. So, I banished *I cannot do that* from my thoughts. And then I worked hard, sacrificing everything, sometimes even friendships. But if you don't really love what you are doing, you will give it up, sooner or later. I was lucky that I found my passion in mathematics. By studying mathematics, one learns to understand something fundamental about the mechanisms of our world.

Many people hesitate to study mathematics because they had a tough moment in school. They never think that just because things didn't work out once, they will never work in the rest of life. I learned that I have far more potential than I had thought. I have this talent for mathematics, but I never understood how big a talent it is.

Could you explain the difference between real mathematics and what kids are learning in school today?

There is this joke I tell when I am at a restaurant with friends. They keep asking me to split the bill. But my cellphone can do that much better. In school, you learn a lot of formulas, but everything is a bit abstract, and you can't see the reason why you have to learn those formulas. But at university, suddenly everything in mathematics makes sense and you realize that mathematics is a language we use to describe the world.

People discovered centuries ago that the world can be defined in formulas, and that is why mathematics was developed. Unfortunately, mathematics needs continuous knowledge acquisition. If you study history and you miss six months of class, in the worst case you don't know about a few kings. If you have a six-month gap in mathematics learning, upon your return, you will find everything afterwards super-complicated.

You have been quite successful. At the age of 27, you already became a full professor at the University of Texas, Austin.

Yes, what can I say? I moved very fast. During my first year at the university, in 2009, as an associate professor, I had to work harder than average to compensate for my gaps. And since then, I have maintained this pace of working, so I managed to reach full professor in only two years. From then on, it was like the domino effect. The faster you move, the more you attract attention. I was invited to join many places, and I started to travel a lot. But of course, this also creates pressure. People expect a lot from you, and you try to satisfy those expectations. But I can deal pretty well with pressure. And in Austin I

learned a lot, including how to apply for grants and how grant proposals are evaluated. I really had seven enriching years there.

Mathematicians in particular are thought of as rather eccentric people. Why is that so?

Mathematicians especially are presented as stereotypes. Yet most of us are pretty normal. I would describe myself as a rather easy-going and sociable person, and I really like collaborating with other people. Actually, a lot of mathematicians like to interact. There is much less rivalry in mathematics than in other areas; we have good relations in our community. We are lucky, too, that mathematics is objective. If you proved something, you proved it. Then you post it online, so there is a date attached and everyone can see that you were the first. It happens very rarely that two groups work on the same problem at the same time. Then, of course, it is a matter of who arrives at the solution first. And if it is an important result, and someone is faster than you were, you say: "Wow, he did it. Hats off."

Could you explain, in simple words, what you are researching?

As a mathematician I have several research fields. I am involved in the so-called phase transition problems, in which I want to understand the phase change, for example, from ice to water. And I have been working a lot on the "optimal transportation" problem, which is about transporting resources from one place to another in the most efficient way. This latter theory can be applied to many other fields—for example, to clouds. Clouds don't want to waste energy when they move through the sky, so this movement can be calculated as an optimal transport problem.

We also managed to understand some important new properties of the Monge-Ampère equation—at origin a differential equation describing the most efficient way of transporting—in order to apply this equation to achieve a better understanding for weather forecasts.

Can you give an example of how a mathematician works?

The optimal transportation problem has been on my mind since 2005. I tried to solve it and I failed, then I worked on something else, tried it another time, and failed again. That was the situation for many years. In 2010, I tackled it again with some collaborators. We were at a conference and decided to give it one more chance, completely open-minded. So, we chatted and tried different theories: "If we do this, we get this and, wait, if we do this, then we could also do this. . . ." And all of a sudden, all the puzzle pieces fell into place, like boom, boom, boom. "Wait! Did we do it?" It was mind-blowing. Of course, afterwards we tried to solve other big problems in the same way. Unfortunately, it never happened like that again.

How has your research contributed to society?

Mathematics is important for society, but there is always a delay in application. As my work has been mostly of a theoretical nature, it will take time for it to be applied in a productive way. Cell phones, computers, Google, GPS—everything is based on mathematics that has been available for a long time. So, I have to wait a bit until I can answer your question. But my research is contributing to the advancement of mathematics as a whole. I know that there are already some applied mathematicians using my theorems, but often we are not even aware that someone is working with our results. The results pass from one community to another, from mathematics to physics, or to engineers for computer applications.

Do you have a message to the world?

Mathematics has done a lot for our world, and it is still doing a lot. Presently, science is suffering from a lack of financing; most countries are worried about many other problems they face. But science is an engine for the future; it is as important for society as is education. So, my main message is: Don't destroy education! Just remember that it is fundamental for our society to function.

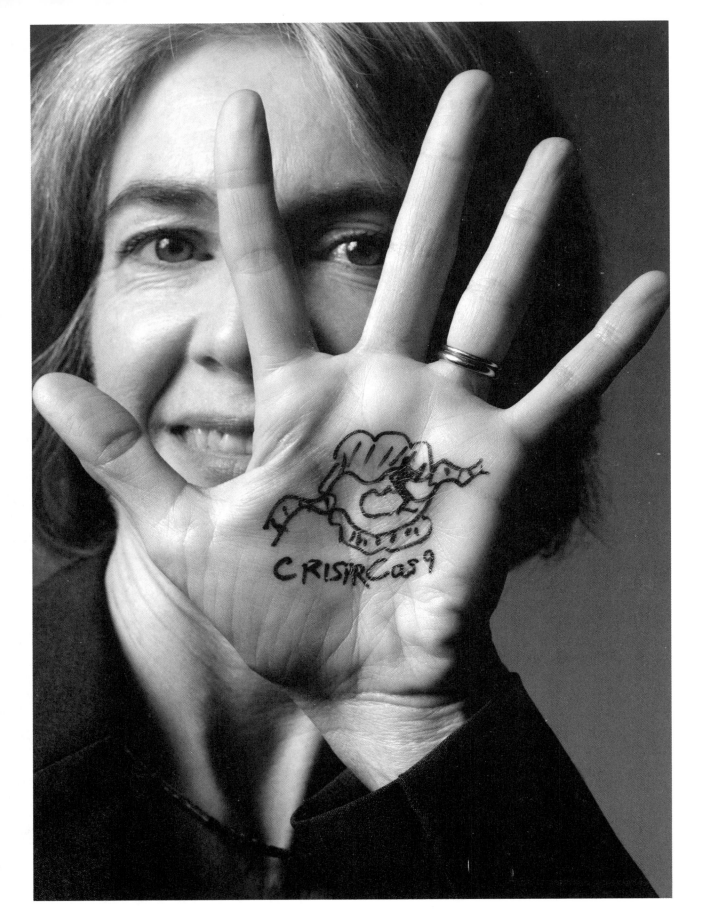

"WE KNEW THAT MANY PEOPLE WOULD BE INTERESTED IN USING THIS APPROACH."

Jennifer Doudna | Biochemistry

Professor of Biochemistry, Molecular Biology, and Biomedicine
at the University of California, Berkeley
Breakthrough Prize in Life Sciences 2015
United States

Professor Doudna, can you tell me a little about your childhood and where you grew up?
I grew up in the 1970s in Hilo, Hawaii. I was a schoolkid there. My family had moved from Michigan to the big island of Hawaii, and it was a complete transformation for me. I was in a new culture, I was surrounded by people with different backgrounds, and I both embraced it and felt completely shocked by it to be honest. I looked different; I was taller and my physical features were different, and I felt a bit like a foreigner in America. I had different eye color, different hair color.

It was challenging to be in that kind of environment, feeling in many ways like I was completely different from my classmates. It was an experience of realizing that not everybody looks the same and wondering what that meant in terms of where I had come from and where I was going to. And I think actually it did influence me in my approach to science. I was a bit of a nerd, excited about the natural world and chemistry. I loved chemistry, I loved mathematics; and those were subjects not associated with being a teenage girl in my school. The two characteristics were sort of like oil and water.

So, that kind of isolation really propelled you to study science?

In some ways it did. I was growing up in a unique environment in Hawaii, and I ended up with wonderful friends who were interested in different things, so I learned to value other points of view. And that's been important for me too—keeping an open mind and making observations. I think those are qualities that one wants to have as a scientist.

Did you have any mentors, or did you have to cut your own path?

I had many important mentors. I think the first was, frankly, my father. He really treated me as an intellectual equal. He was a professor of American literature at the university there. He and my mother just wanted me to pursue my interests. When my father saw that I was interested in science, he really encouraged that. We would often discuss things over the dinner table that had to do with the natural world, and that helped me a great deal.

"I WAS A BIT OF A NERD, EXCITED ABOUT THE NATURAL WORLD AND CHEMISTRY."

So, that helped to sharpen your thinking?

To sharpen my thinking—I like that phrase. Yes, that's true. So, there was my father, and then there were, of course, many other people who were also supportive. Very important, there was a teacher named Bob Hillier, who taught me English in high school, and in the process really taught me how to think, how to write, how to express my ideas. I often think back to my high school experience; it was critical for me.

How is it being a woman in a field that is dominated by men? Have you encountered a lot of obstacles along the way?

I don't think of myself as a female scientist or as a woman in science. I think of myself as a scientist, and I just try to operate as a person who, first and foremost, thinks about how I can do the best possible work. Sure, I've had people be skeptical of me, especially in my early years. My high school guidance counselor, for example, said, "Well, girls don't really do science." But I'm a stubborn person, and I replied, "This girl does science." And I just continued; I didn't let that stop me.

I think some of the things that we worked on—and CRISPR is a great example—were projects that I simply found interesting. I really felt that CRISPR [DNA sequence] was going to help us understand something fundamental about evolution. That's why I wanted to work on it in the first place, and even though there were people who said, "That's a crazy project. It's not very interesting. It's something that no one's ever heard of," I thought there was some interesting biology to be learned, so I worked on it anyway. And I'm glad I did.

Speaking of CRISPR, when did that idea start to interest you?

Well, my very first conversation about CRISPR was actually with a colleague at Berkeley, Jill Banfield, who was one of the first scientists to notice the CRISPR/Cas sequences in DNA and bacteria, and wonder about their function. And that led to my laboratory work on some of the molecules that are part of CRISPR/Cas immune systems and bacteria.

And then you met Emmanuelle Charpentier at a conference in San Juan, Puerto Rico, correct?

That's right. One of the things that's wonderful about science is that a lot of ideas and work scientists do is a result of collaboration, and this was absolutely the case for me and Emmanuelle. We discussed the CRISPR system that was operating in a bacterium she was studying, and we realized there was a fundamental question about the function of a protein called the Cas9 that was active in that type of organism, which neither of us could address individually. We really needed to work together to go after the answer.

You knew that you had to work together on this?

Yes, because that's always how I've conducted my science. I've often worked collaboratively with other

"I JUST TRY TO OPERATE AS A PERSON WHO, FIRST AND FOREMOST, THINKS ABOUT HOW I CAN DO THE BEST POSSIBLE WORK."

scientists, whether it's within my own lab or with external collaborators who bring different expertise to the problem. I work with people who are smarter than me and help me be the best I can be.

And how did it work with Emmanuelle? Where was she working?

She was in Umea, Sweden—near the Arctic Circle, actually. And that part of our collaboration was great because this was during the summer months and every day there were many, many hours of daylight. She would write to me at all hours saying, "Jennifer, I'm still awake because the sun is still up. I can't sleep and I'm thinking about this project!" So, we had a lot of fun working together. She has a great sense of humor and is very smart, and we had a lot of good exchanges of ideas. We worked together for probably about a year.

Did you immediately recognize the importance of your discovery?

Well, we knew it would be a fabulous way to trigger genome editing, because it could be useful in a new way. Of course, we had no idea at that time how rapidly the process would expand around the world, which it certainly did, with scientists adopting it. But we knew that many people would be interested in using this approach because it was so much simpler than other technologies for genome editing.

"WHEN MY SON WAS YOUNGER, I WAS THINKING ABOUT MY PROJECTS EVEN WHEN I WAS CHANGING HIS DIAPERS."

Could you speak briefly about what CRISPR actually is?

You can imagine DNA being like a two-stranded rope, including many chemical letters that encode all the information necessary to make a cell, or make a brain, or make an entire organism. Then CRISPR technology allows scientists to program an enzyme to go into a cell, pass into that rope of DNA, find a single place that is recognized by a chemical mechanism in the enzyme, and make a cut to the rope. The protein literally cuts both strands of the DNA. Then those broken ends are repaired by the cell, and in the process of sealing the ends together again, a change can be introduced into the code. This allows scientists to alter the DNA sequence precisely in cells in a way that was very difficult to do in the past.

Clearly, it's a powerful tool, allowing us to alter the basic characteristics of a human being. Considering the ethics involved, where do you think we should draw the line with such efforts?

The advent of genome editing—and especially with the CRISPR/Cas technology that makes genome editing accessible to scientists around the world—raises a number of ethical questions. And for me, there are really three major aspects that have societal and ethical consequences. One of them is in agriculture, in using genome editing to alter plants, which then triggers the whole question of genetically modified organisms. Another is an application of gene editing called gene drives, which means introducing a trait—a genetic trait—that would potentially spread quickly through all animals or organisms in a population. And a third area is in the clinical use of something called human germline editing; this involves making changes to the DNA in human embryos or germ cells, so that those DNA changes become part of the entire individual and can be passed on to that individual's children and then to future generations.

What is your attitude regarding such an application?

In November 2018, a scientist in China announced that he had applied a clinical use to human germ line editing, and that the work had resulted in the birth of twin girls who had edits to their genome. It was revealed that the editing he had done was not medically necessary and was not done in a way that would be considered safe or ethical. This led to an international reaction against that kind of editing, which I think had resulted in a positive outcome, in the sense that there are now being imposed far more restrictive criteria for any future clinical use of human germ line editing.

Do you feel you bear some responsibility for the proper use of science?

I think we scientists do have a lot of responsibility for the work we do. We have to be engaged in sharing it openly, for example. Science is global now. We don't all have the same opinions about how to use science and technology, so it raises the question of how we proceed. How do we control the use of science and technology? There are no easy answers to that question, but it has to begin with the active engagement of the scientific community, and especially of people who have been directly involved in developing these technologies. They need to discuss the work, explain what it does, and describe how it operates scientifically—but simultaneously thinking about the big picture.

Tell me more about the big picture. CRISPR is such a revolutionary discovery; what are the big questions we should be asking?

Why are we doing this? Are we trying to gain attention and publish high-profile papers in the scientific literature, or have newspaper headlines announced

our work—or are we doing this science to improve the quality of human life and human society? We have to address these essential questions.

What makes you so strong?

I think it goes back to my upbringing in Hawaii. As mentioned, I would give some credit to my father in particular, and to my teachers. They encouraged me to take chances and to trust my judgment. I was different from my classmates, and I just had to get used to that. It was hard, though. There were many times when I felt unhappy. I was isolated and alone. I had to rely on my internal voice, which somehow said, "It's okay to be different. It's okay to be interested in what you like to do, even if other people are not." So, I think a lot of it stems from that experience.

You must have an incredibly busy life. In addition to your scientific work, you're a wife and a mother. How do you manage to accomplish so much?

Well, first and foremost, I have the most wonderful, understanding, and brilliant husband you can imagine. He's Jamie Cate, a professor here at Berkeley, and he's an accomplished scientist. I always tell him he's better than me, he's smarter than me. He's doing really important work. He doesn't receive the kind of public attention I have right now, and he's fine with that. In fact, I think he prefers it. I couldn't do my work without that kind of support.

At some level, I'm always thinking about our science in the lab. When my son was younger, I was thinking about my projects even when I was changing his diapers or taking him to the park. I had to work at night, and I would often get up very early, at four or five in the morning; But at that time, I wrote a textbook, on top of everything else I had to do. But that was the only way to do it all.

And for younger people thinking about their future, what would make science exciting for them today?

It's a fabulous career. It's a career in which you're paid to play in the lab and figure out things about nature that nobody's ever figured out before. It's wonderfully exciting and it's a creative field. It also gives you the opportunity to work with other people who share your curiosity. And if you're in academia, you get to work with bright young students who are always coming in with new ideas, so it's also a lot of fun.

I always tell students to focus on their interests, pursue their passions, don't be afraid to try things that are different from what everybody else is doing. In fact, that's often where the most interesting discoveries are made. And I advise them to look for people who will be supportive as their career goes forward—people who are going to support them when they encounter moments of difficulty, as there always are.

And what about you? Do you never have doubts?

Oh, I've had plenty of doubts. There have been times when I've lain awake at night thinking, *This is never going to pan out! What should I do?* And that thinking often motivates me either to make a change if I need to or to double down on my efforts and say, *No, I'm having doubts, but I'm going to carry on because fundamentally I really have to know the answer to this question.* It's a wonderful time to be a biologist. We're experiencing exciting moments in research and clinical medicine.

That excitement extends to agriculture as well, where scientists now have the tools and technologies to do things that were impossible even just a few years ago.

Do you still see Emmanuelle Charpentier?

Yes, I do. We probably see each other three or four times a year. We'll always be close because of our CRISPR connection. Two women working together with our respective students—it was a great experience.

"I HAD TO WORK AT NIGHT, AND I WOULD OFTEN GET UP VERY EARLY, AT FOUR OR FIVE IN THE MORNING."

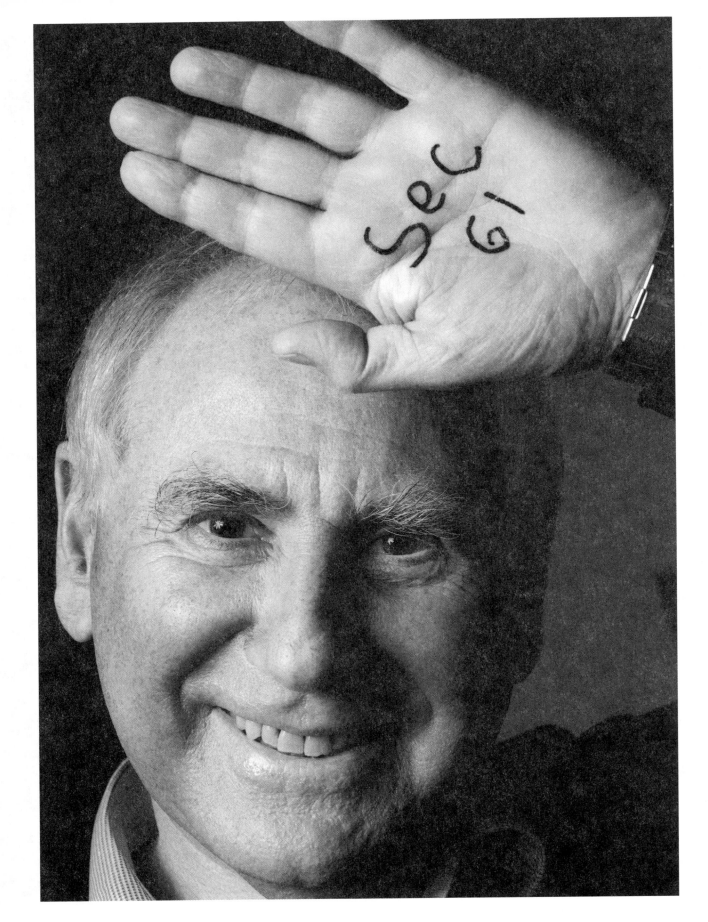

"SCIENCE COMES FIRST; IT HAS DOMINATED MY LIFE."

Tom Rapoport | Biochemistry

Professor of Cell Biology at the Medical School of Harvard University, Boston
United States

Professor Rapoport, you come from an unusual family. Your father was a biochemist like yourself, your mother was also a professor, and your brother is a well-known mathematician. Is such a family a blessing or a curse?
It's probably both. My father was a well-known biochemist in the German Democratic Republic (GDR), in Berlin. I had to prove myself more than my brother, who as a mathematician was far enough removed from my father. On the other hand, I benefited a lot from my parents. My father was my only

real teacher, and he taught me hard but good lessons. At the time I decided to become a biochemist, he was the director of the Institute of Physiological Chemistry of Humboldt University, where I was doing my PhD. That was a strange situation, and not necessarily an advantage.

Was your father tougher on you than on others?

I regularly submitted my publications to him, and it was always depressing when I got them back. Everything was red and crossed out, not a sentence left as I had written it. When we went through the articles together, it took hours. In the end, he'd always say that only small things needed to be changed, and in a way that built me up again. When I have to write today, I realize how much I benefited from his teaching me to write concisely. He was authoritarian. It was difficult to contradict him, and he only accepted those who managed to contradict him. So, I had to learn to stand my ground.

Why did you study biochemistry, knowing that your father dominated the field?

I saw that there were many unanswered questions in biochemistry, and I also knew right away that I wouldn't do exactly the same thing as my father, even though we worked together at times. It was also clear to me that at first many thought I would be sponsored by him. But I was able to show them that I could do it by myself.

Did you ever want to show your father that you were at least as good as he was?

There were moments like that. My father developed the first method of blood conservation, and I wish I'd done something that I could explain just as easily to anyone else. But I never considered my father a competitor, even though I'm a competitive person. I was competitive with my peers, but he stood way too high above me, almost like a guru. My father did so many different things, and always wondered why I worked in one field for so many years and had dug in so deep.

You've said that you've inherited your father's quick thinking—and his impatience. Is that still true?

"MY FATHER WAS MY ONLY REAL TEACHER, AND HE TAUGHT ME HARD BUT GOOD LESSONS."

My employees can tell you a thing or two about that. We can agree on an experiment, and just a day later I'm already asking what the results are. I'm always impatiently waiting for results. Speed isn't the most important thing in science, though; it's more important to think about the problems correctly and constantly. I wake up at night and can't go back to sleep, thinking about what I could do to solve a problem. I live for science, I have to admit. I work all day in the lab and preferably on the weekends because that's when I have the most peace and quiet.

You didn't really make any headway with your PhD until your father reviewed the experiment with you. Is it true that those were the two most instructive hours of your life?

When I was young, I used to be devastated when experiments went wrong, and I generally suffered from mood swings and was often depressed. I know from my mother that my father also suffered from these periods, but he never showed it. In my doctoral work, something elementary didn't work right at the start, and I thought I had to be really stupid. Then my father showed me one Sunday at the institute how to find the errors in a short space of time. I learned to consider which parameters could be variable, and then eliminate one possible source of error after another. And I learned something perhaps even more important: the professor mustn't come across as aloof to the students.

The key is to always ask questions. If you just sit in the office every day and don't talk to the staff and don't follow the experiments in detail, you don't stand a chance of achieving anything in science. Everyone is looking for something new; to actually find something new, you need originality and the ability to think outside the box. I'm quite good at that. I've managed to push forward new ideas several times; even in my old age, I still have the ambition to do something great.

As a small child, you made a pudding and painted it blue, after which your mother urged you to label everything precisely and create a protocol. Was that the start of your scientific career?

Yes, that's how it was seen by my family. My mother always encouraged my siblings and me to do science. I don't know what she was thinking at the time,

but she certainly wanted it to be scientific. When I dyed the semolina blue, she said, "Now you must label it, put stickers on it, and then write down how you did it. You have to keep a proper record, just as you're supposed to in the lab."

You once said that your mother was the center of your universe. You called her every day until she died?

She lived to be 104, and for her last two years I did indeed call her every day. Before that, the intervals were a little longer. But I always communicated with her regularly, and she knew precisely what was going on in the lab. She was the most curious person you could imagine; she was interested in everything, whether it was politics, or science, or culture.

When your father married your mother, he told her that, for him, his political work came first, then science, and then family. What about you?

Science comes first—it has dominated my life. Family does play a big role, but I spend most of my time in the lab, no question. My wife and I once carried out an experiment together, and after two hours she was really annoyed with me because I kept on coming over every few minutes and asking her if she had done this and that yet. Since then, we've never conducted an experiment together. She has retained her independence. She also used to work in the lab a lot and she taught for many years. When she had to give up teaching at the age of sixty-five, she started studying art history and threw herself into that.

The Berlin Wall fell in 1989, and you went to America in 1995. What was it like to start working abroad after so many years in the GDR?

It was completely different. However, conditions had already changed a lot after German reunification. In the GDR, we had practically no money to do research, there was limited research exchange with the West, and it wasn't easy to do science. On the other hand, a big plus was that the GDR border was shut and so almost all the good students stayed in the country; many ended up with me.

After German reunification, I had the title of professor, but no professorship. I had to reapply and

"IN THE UNITED STATES, PEOPLE LIVE BY THE REVIEWS OF THEIR WORK. THEY GET KICKED OUT, MERCILESSLY, IF THEY AREN'T GOOD ENOUGH."

was rejected twice. Because of that, I was pretty depressed and didn't even know if I would get a job again. Then, I went to Boston with eight of my students. We were welcomed with open arms, and so it wasn't that difficult to get back on our feet. The biggest difference was that in Berlin I was the star, so to speak, while in America I was just one of many good people. But I knew that, and I wanted it that way. It's scientific heaven here in Boston being able to talk to so many fantastic colleagues.

Was leaving Germany a decisive step in your life?

One drawback was that my family was suddenly split up. My two older children stayed in Germany and studied there. My daughter, who was 15 at the time, came with us, but then returned to Germany when she was 17. I tricked my wife slightly. She said that her condition for making the move to the United States was to work in my lab—otherwise she wouldn't come with me. I agreed, although I didn't want that at all; the staff would no longer have talked openly to me if my wife were in the lab. So, I told her she had to learn a few procedures first, and I offered her work with a colleague.

My ulterior motive, of course, was for her to get stuck in his lab. And that's how it turned out. It's still a problem, though, that in order to see my whole family, I have to fly to Germany. But scientifically, the move to the United States was a huge enrichment. I ended up on top at Harvard. In my eyes, the system in the United States is much more honest and tougher than in Germany. Once you've done something good in Germany, you can sit back and relax until you retire. In the United States, people live by the reviews of their work. They get kicked out, mercilessly, if they aren't good enough. I, too, as a Howard Hughes Medical Institute Investigator, have just had to be assessed again, at the age of 71.

In science, only the person who makes the first discovery receives the recognition. What's your experience been like here?

I honestly don't get it. Unfortunately, it often happens that two groups find something out at the same time; this has happened to me twice now within three months. But I'm firmly against keeping everything secret. My people know that if they tell me something, the next moment the whole world will know about it. I can't keep secrets. The good thing here is that other scientists also tell me a lot, and so in both recent situations I just mentioned, the competition told me about their experiments. In Germany, you often find rivalry among colleagues who don't even work in the same field. In the United States, there is more of a team spirit and more happiness when a colleague succeeds.

Could you describe what you're currently working on?

I have thirteen people in the lab, and although that's a relatively small number, we're working on five different projects. One of them is to discover how proteins emerge from the cell and are translocated into membranes. Another has to do with the reverse process; that is, how proteins are degraded when they are misfolded. A third has to do with how organelles—specialized subunits within the cell—acquire their characteristic appearance. Then we're also carrying out research on the importing of

proteins into an organelle called the peroxisome. If this import doesn't work properly, it can lead to diseases in children that are usually fatal.

We're wondering how it's possible for proteins to get in there, because when they're folded, they pass through the membrane, and that's not the case otherwise. The last project has to do with the question of how respiration works. The lungs are constantly contracting and expanding when we breathe, and in order for this expansion to occur, there have to be proteins that reduce the surface tension. This research may even lead to a practical application. For instance, often a spray is used in the trachea of premature babies to help them breathe, until they develop their own lung surfactant. In our opinion, the mixture used presently isn't very efficient, and we're trying to improve it. This may also have great significance for serious lung injuries in adults.

Why should a young person study science?

Being a scientist is the best profession imaginable: every day I get to follow my curiosity, I can come and go when I please, my colleagues and I see the world when we exchange ideas. I'd tell a student, if you feel the vocation and passion in you, get into science; there's nothing better. Once you find the field you're passionate about, you should get on with it and not look back. A high position or plenty of money is a trivial matter that comes automatically when you really get into it. I care a lot about helping the younger generation. I'm even happy when my postdocs manage to be better than me.

What factors made you the person you are today?

Coming from a family of scientists, I knew earlier than most kids what science really is. I sort of absorbed it from very early on. My brother once said that we already knew what a dean was when we were kids. But my parents' influence didn't just apply to science; we were also exposed to art from an early age. My parents made it a point that we took music lessons, and we were introduced to opera at a very early age. My brother and I could sing all the arias of *The Magic Flute* by heart, and I can still do that today. I'm also an avid concert and opera goer, both in Boston and in Berlin, and I sometimes go three days in a row.

Which country do you feel more at home in?

The United States has become home for me now; my best friends are here. But when I travel to Germany, it's home, too. I also still speak German more fluently than English.

Which of your accomplishments do you want to remain when you're gone?

I have no illusions: in science, no one is irreplaceable, unlike in art. What Mozart wrote will never be written by anyone again. But if I don't discover something new, someone else will. I also see this as a kind of liberation—that we're all actually contributing only one building block to the great edifice of science. In the end, individual names, except for a handful, will all be forgotten. If just a sentence of mine remains in a textbook, that's already good. In my case, it's already more than a sentence.

What's your message to the world?

There needs to be more rationality in the world, and therefore science should be made universally accessible and become a guideline for humanity to generate more justice, end poverty, and above all achieve lasting peace. We need to show more compassion to those who are less fortunate than ourselves. Even at the family level, it's not always easy to live in harmony with each other, and it's even more difficult among nations. That's why it takes great effort from all sides to achieve peace.

"I HAVE NO ILLUSIONS: IN SCIENCE, NO ONE IS IRREPLACEABLE, UNLIKE IN ART."

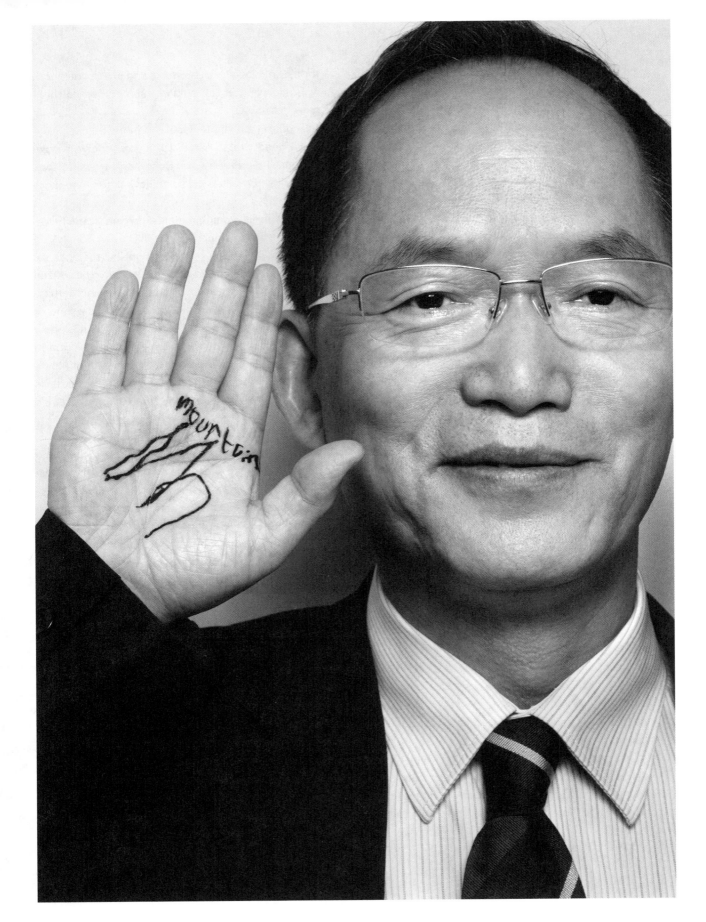

"THE WORLD IS CHANGING, AND WE NEED TO BE PREPARED."

Tandong Yao | Geology

Professor of Glaciology at the Institute for the Study of the Highlands of Tibet, University of the Chinese Academy of Sciences, Beijing
China

Tell me a little about your parents. What work did they do?
My parents were laborers. They worked on hydropower dams, which were built as part of the huge efforts in the 1950s and 1960s to develop western China.

What about their education?
Back then, education in China was poor and was particularly limited in the countryside. My father attended primary school, but as the eldest son in his family he didn't get the chance to go to middle school. My mother was illiterate; she didn't go to school, which was a common situation at that time.

67

But you went to primary school. What was that like?

I went to a local primary school, near my village. I then boarded during the week at middle school, which was the best middle school in the area, and I went home only on Saturdays. This was during the Cultural Revolution, when the whole of China was in chaos. In the cities, teachers were not able to teach. In the countryside, teachers managed to retain their authority, so I was fortunate in being able to learn in a stable environment.

And how was high school for you?

At the time, students who graduated from university had to work in the countryside. This meant that highly qualified teachers from Beijing and other cities taught me during high school. Essentially, I was able to profit from the limited situation.

Why did you want to become a glaciologist? Where and when did this interest start?

That's a good question! The first time I saw glaciers in the Tibetan Plateau was in 1978, when I was still a grad student. Our mission was to find the major source of the Chang Jiang [Yangtze] River, which of course is glacial meltwater. We tried to find the glacier that supplies the first drop of water to the river. I was so impressed with the glacier's beauty and the stunning landscape that I decided then and there to study glaciology.

You graduated from Lanzhou University in 1982 with a master's degree and received your PhD from the Institute of Geology and Geophysics, Chinese Academy of Sciences, in 1986. Why did you then decide to study overseas?

Before 1977, China was scientifically isolated; we could only read some foreign papers, although luckily my advisor at the Lanzhou Institute of Glaciology and Geocryology sometimes invited foreign scientists to give guest lectures. I was lucky in being able to study abroad. I had to choose between studying as a postdoctoral in France, where I could work closely with scientists at the top level of studies on the ice core or go to the United States to study and also improve my English. I discussed it with my director and professors, and they told me, "Go to

"WHERE THERE IS RISK, THERE IS ALSO OPPORTUNITY."

France. Science comes first. You can improve your language afterwards."

In total, you spent five years studying abroad. Was this an important time for you?

It was an extremely important time and a precious opportunity; I had to pass exams organized by the Ministry of Education and be nominated by an institute before I could study abroad. I was the first graduate student to be nominated as a postdoctoral scholar in my field. Studying abroad allowed me to widen my knowledge. At the time, the French laboratory for ice-core studies was the most important in its field, so I gained new ideas about how to study the ice core and how to approach scientific questions. It was the same in the United States.

Did you have a specific goal in mind when studying?

My mission was to go to the West and absorb as much scientific knowledge and as many ideas as possible, and to bring this knowledge back to China. I tried hard to absorb as much as possible. In France, people didn't normally work on weekends. Not me, though; I worked on weekends, and almost around the clock.

How did your studies overseas influence your later work?

In France and the United States, we discussed how to develop a study for glacier research on the Tibetan Plateau. In the United States, we decided to start a program for Tibetan ice-core studies and applied to the National Natural Science Foundation. That's why I entered a cooperative arrangement with Lonnie Thompson, professor of earth sciences and a senior research scientist with the Byrd Polar Research Center at Ohio State University. I still work with him today.

You then returned to China and set up your own research lab on the Tibetan Plateau. Can you tell me more about your research?

We've been continuing our work on the Tibetan Plateau for forty years now, ever since my first visit there in 1978. In that time, continuous climate change has had a big impact on the glaciers, impacting the lakes, rivers, streams, and ecosystems. Global warming at the Third Pole [Hindu Kush-Karakoram-Himalayan system] is twice as great as the global average, which has dangerous consequences for the region. That is, if the ice collapses here, it could damage roads, bridges, and villages, and potentially cost lives. When ice collapses, it travels at a speed as high as 100 kilometers per hour, so anybody nearby is in great danger. Three years ago, the ice collapsed and buried a lot of people.

Do you see a solution to the problem of global warming?
We have a Third Pole Environment (TPE) collaboration among scientists from many countries, including Germany, the United States, and China. There needs to be worldwide action taken to reduce the world's carbon footprint. But even that is not enough; if you only stop further production of CO_2, there's still more than enough already in the atmosphere to do grave damage. The immediate need is to inform the local people, get ready, and adapt to the consequences.

Do you feel powerless watching what's happening to our climate?
I'm always optimistic. Where there is risk, there is also opportunity. For instance, global warming is bringing wetter, warmer weather to the Third Pole, which is extending the world's farming periods by fifteen days. More greenery means more oxygen, too. I've just returned from the Tibetan Plateau, and the previously bare mountains are now covered with grass.

Climate change is widely acknowledged to be a worldwide crisis. I imagine you've had no problems attracting funding for your research?
China used to be a poor country, and we could achieve our work only with the cooperation of foreign scientists. Now the Chinese government is paying a lot of attention to environmental protection and is investing a lot in research into the Tibetan environment. The Chinese president, Xi Jinping, requested an environmental study be done of the Tibetan Plateau, and now the Minster of Science and Technology is investing 2.8 billion Chinese yuan (EU 357 million) in a program to study environmental change in the Tibetan Plateau. It's a huge sum of money, so we have to be cautious how we spend it so as to gain optimal scientific results. All Chinese scientists studying the Tibetan Plateau are involved in the project, which is also open to scientists worldwide. For instance, we're holding a workshop in Germany to talk about our future challenges and the planning required.

When do you predict that China's glaciers will disappear?
Some small glaciers will disappear soon, but larger glaciers will exist for quite long time yet. We project that the years 2050 or 2060 will be turning points; that's when those glaciers will retreat. Basically, more and more water is melting from the glaciers, increasing the flow of water into the rivers. In 2090, the glaciers will still be there, but will cover a very small area.

What is your message to the world?
The world is changing, and we need to be prepared. There are always two sides to everything; with danger comes opportunity.

Do you maintain a healthy work-life balance?
I'm busy because there's so much scientific work to be done regarding the environment, particularly with this new research program. I try to sleep at least five hours a night, and then I feel okay. If I sleep six hours, I have more energy.

Are your children also budding scientists?
My daughter studied electricity and information before majoring in geo-information technology, then moving on to remote sensing technology. She has a lot of different ideas, as young people do.

What is your dream, your greatest hope?
It's very simple: to always work on the Tibetan Plateau. I travel there seven or eight times a year, and I hope to keep working in this region, focusing on its glaciers and the changing environment.

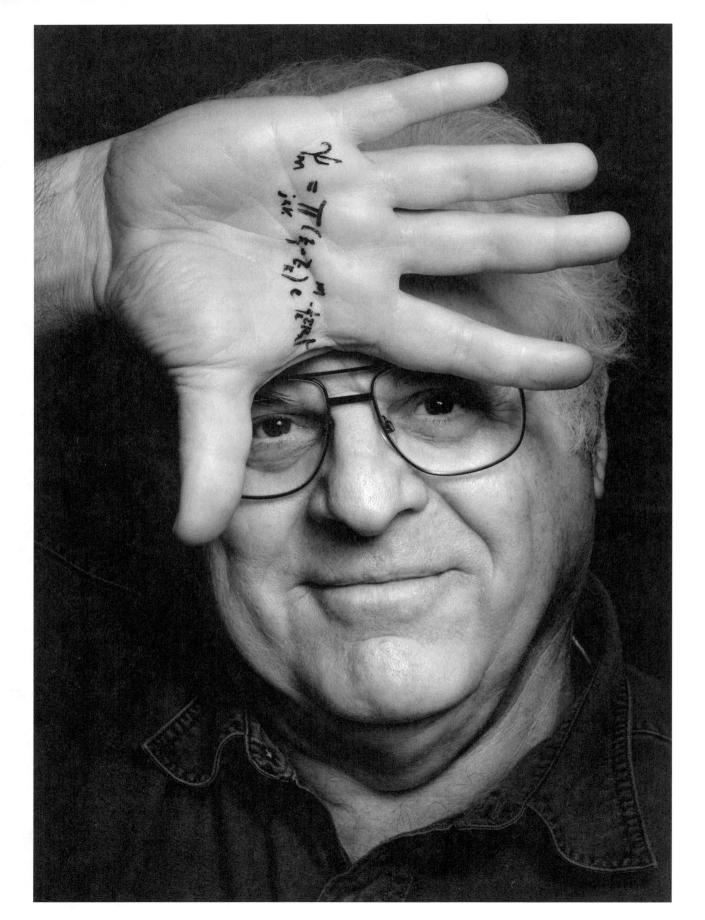

"IT TAKES IMMENSE AMOUNTS OF EMOTIONAL ENERGY TO GIVE BIRTH TO ANYTHING NEW."

Robert Laughlin | Physics

Professor of Physics at Stanford University, Palo Alto
Nobel Prize in Physics 1998
United States

Professor Laughlin, you once wrote that your drive to become a theoretical physicist had its origins in family dinnertime discussions. Can you explain?
There's a simple explanation: my father was a lawyer. Law is all about debate, using language. So, when I was growing up, during dinner we'd discuss various topics that interested him, such as science and electronics. I had to provide clear, persuasive, well-thought-out arguments every dinnertime. In contrast, my wife Anita doesn't like discussions at dinner; she prefers a calm, friendly atmosphere.

71

It turns out that many theoretical physicists come from families with lawyers. It boils down to similarities in the thought process. You know, Western law has its roots in religious principles, as does science. In Western culture, there's this concept that there's one true thing, and you employ conflict to find it: we fight in the courts to define the truth. Our science system is the same: we present our ideas in public, and then defend them against criticism to weed out what isn't true.

I gather there's often strong rivalry in the scientific world to discover the truth.

Yes, there's rivalry among scientists for truth, money, and recognition. Reputation has its own kind of value, and most research has a big cash value, too. It's a competitive world out there.

Is it true you've described yourself as an extremely reclusive, introverted boy?

Yes, and this turns out to be quite common. I once gave a talk in Helsinki and said, "When I was a high school student, I made explosives. We'd probably get into trouble today for terrorism if you admitted it, but how many of you made explosives when you were in high school?" And everybody raised his or her hand!

"IN WESTERN CULTURE, THERE'S THIS CONCEPT THAT THERE'S ONE TRUE THING, AND YOU EMPLOY CONFLICT TO FIND IT: WE FIGHT IN THE COURTS TO DEFINE THE TRUTH."

People like me like to be alone a lot to think up scientific ideas. I also write and am an amateur composer, and I'm also reclusive about that. With my work, it's good to spend hours alone thinking things through.

An elite school turned you down. Was that a blow?

In hindsight I'm glad, as it triggered a sequence of beneficial events. I ended up going to Berkeley, which was the perfect university for me—wild and immensely free. It's harder to frivolously explore intellectual ideas at places like Stanford or Princeton. I ultimately became a scientist because of my experiences at Berkeley. I was originally on track to become an engineer, but I fell in love with Berkeley's tremendous physics classes and switched majors. My father was horrified. He said, "You'll never get a job." It all turned out okay, though!

When you were 19, you were drafted to serve in the military during the Vietnam War. How did you handle that?

My number in the draft lottery was 19, the same as my age. In my discipline, you're meant to complete your best work before you're 30 or you'll be considered too old. Still, I'm a law-abiding person so I decided not to dodge the draft and I obeyed the law. I completed my military service in Schwaben, Germany.

You found military service to be a harsh experience, though?

I had to give up my own clothes and my hair was shaved off—a time-honored military techniques to remove your old identity and replace it with a new, more obedient one. It felt like a big step backward: moving from a free society, where we appreciated the artistic beauty of life, to a nuclear missile unit, a Cold War institution, which was a sad place. Nuclear warfare is abhorrent.

What did the experience of being in the military teach you?

It helped me understand fellow countrymen of my own age. It also gave me a basic understanding of Europe. You have to appreciate that where I live is as far away from Europe as you can get. We're the back door of the world, so we tend not to understand it very well. So, that experience was a superb education.

The United States in particular welcomes students from all over the world, with many from Asia. Does this rich cultural mix speed up scientific development compared with how it works in, say, Europe?

I don't think so; it's just economics. You pick the best people, and they are often foreign. There are racial issues, though, and visa problems.

How does Europe compare scientifically to Asia?

The science in Korea, Japan, and China is imported, and there is constant pressure for Asians to publish in Western journals, and to travel to Western countries, because Westerners are better at weeding out the wrong things through conflict. The moralistic core of science as we practice it today is a European invention, which stems from an old religious tradition. It's a way of looking at the world that most

Asian countries don't understand. My friends in East Asia would love to have the scientific center shift there, but I don't see that as possible.

What about China, which is investing billions in science? Will it overtake the rest of us?

I am less concerned about this than many other people. China has ownership and legal issues that hold it back, and China's political situation makes it risky to have new ideas. Of course, China is a big, powerful country, so you have to sit up and take notice. It also has a remarkable past record of technical invention—for example, paper and gunpowder. And there are some specific recent technical successes. For example, the Chinese solar cell companies have destroyed competition around the world. It was the same with the semi-conductor flash memory business, which migrated from South Korea to China while I was there in the early 2000s. But I don't expect China to be further ahead than Europe or the United States in the future.

Science is international, and when we make a discovery, we publish it—science isn't a secret. And the model for generating business in Asia often involves starting with a Western business model and then it's back-engineered, allowing one to make shortcuts. This means that the bridge from science to business is still weak in China.

Finally, science and technology are mixed together in Asia, so there's confusion about who owns any technical knowledge.

Moving back to your career, you once said that you felt betrayed by academic work. Why did you feel that way?

I think everybody experiences this feeling: you try very hard at something and when you don't succeed, you blame others. When this happened to me, it was the moment I realized that science was a socialist institution, ruled by committees. And usually there's some unholy relationship with business involved.

Let's look at your success. You were awarded the Nobel Prize in physics for your explanation of the fractional quantum Hall effect, correct?

I shared the Nobel Prize in 1998 with Horst L. Störmer, of Columbia University, and Daniel C. Tsui,

"IT'S A WONDERFUL EGO TRIP FOR THE PRIZE WINNER, BUT NOT SO MUCH FOR THE SPOUSE."

of Princeton University, for the discovery and explanation of the fractional quantum Hall effect. I'm a theorist, so I don't discover things; I just write them down.

While at Bell Labs, I published a paper presenting the idea that the Klitzing experiment measures a fundamental constant, which is the electron charge. After I left Bell, Horst and Dan wrote to me, saying they had carried out new experiments and found a von Klitzing effect at "fractional filling"—something that should have been physically impossible! Dan had understood that the electron must somehow have "fractionalized" in this experiment, but he was censored by the Bell Labs management from saying it in print because there was no known way that physics could ever do this.

So, can you describe your contribution to this project?

The experiment basically landed on my plate. My contribution was to write down on a piece of paper how the physics works—namely, what the electrons do in the magnetic field that causes the fractional quantum Hall effect. So, I created the equation to show how it all happened. The equation was just fourteen symbols long, which is the only thing anybody remembers. It taught me a valuable lesson—namely, that when you create something, it has to be simple to be memorable. I was 32 at the time, and I know that this equation will outlive me.

You were only 48 years old when you won the Nobel Prize. Did winning it change your life?

Not at all. I felt proud and still do, but it doesn't define me. The Nobel Prize didn't affect my family at all. It's a wonderful ego trip for the winner, but not so much for the spouse. And that's where my priorities are. I care more about my family than I do about my scientific reputation.

The main problem after winning the Nobel Prize is what to do next. My most important work since then has been on making energy machines. It's hard, because business acumen and large amounts of money are involved, but the Nobel Prize has helped me.

Didn't you feel out of this world, though, when you won?

No, basically because I married well. My wife Anita is a saint, who keeps me in my place and stops me from working too much, spending too much time on computers, or from being too introverted. I try to do what I'm told; otherwise I get into trouble.

You view climate change differently from other scientists, saying that it may be important, but the future is impossible to change. Why do you think that?

That's because I understand economics better than most of my colleagues. I like to be a man of reason, and with politics and rhetoric, that's very difficult. Discussions about energy are highly rhetorical in all countries; maybe they're basically such political factions fighting one another. In my experience, when money's involved, people are skilled at inventing reasons why what they're already doing is good, even if it isn't; and energy is about money.

I like numbers. One way to clear up a confused political conversation is to talk about numbers instead of concepts. I have, however, been misunderstood. My book editor took a chapter I'd written about the age of the earth, removed the references, and published it separately. Right-wing political parties in particular have misused that piece to show that this Nobel Prize winner doesn't believe in climate change. In fact, I'm extremely concerned about it. That is precisely why I've diverted my research efforts to energy.

What *should* be done about climate change?

Create technologies that can deliver non-fossil energy cheaply, with special emphasis on the "cheaply" part. Unless this is achieved, I think that no amount

of legislation will ever solve the problem. Legislatures cannot repeal either the laws of physics or the laws of economics.

The fundamental difficulty is that burning energy increases the gross domestic product (GDP). Everybody wants to stop harming the planet. But if you do that and someone else doesn't, you will grow poorer. Every government in the world understands this. That's why they're dragging their feet. Money rules the world. Poor people don't like to be poor, so they all want to burn more energy. The technical problem is how to do that without destroying the atmosphere.

You have described yourself as an artist, correct?

What I mean by that is that I'm a theorist. I make intellectual products for which I try to add value or create value where there was none before.

What would you say to a young person considering the study of science?

People who are good at science are born that way; they have a mix of talents that set them apart. They become scientists because they like science and they're good at it.

Another Nobelist was once asked what we could do to make Stanford better. His answer was, "Admit more nerds." You see, well-rounded students are often smart enough to realize that their value in business is greater than their value in science. What we want for our labs are late developers who haven't realized that yet. At the end of the day, you should do something you love and make your own career decisions.

Do you agree that science still seems to be a male-dominated world?

There's gender discrimination in all of science, particularly in physics. It's built into the culture somehow. We have to make it easier for women to climb up through the system. Women also just have to accept that it's a male thing they have to conquer. We'll help, but it's just like changing the culture of a country; it's not really possible to do that.

My theory is that the science culture involves fighting, and women don't want to be seen as fighters; it doesn't come naturally to them.

What hurdles did you have to overcome in your life?

Endless professional hurdles. It takes immense amounts of emotional energy to give birth to anything new. If you're interested in creating new things, you have to be willing to bleed quite a lot. It takes a lot of perseverance because defeat is the normal course of events. You get defeated and you think, *Oh, I'm no good*. But nobody can be successful at first. My success rate is about 1 in 10.

What would you say has made you strong?

Adversity shapes you. Two years ago, I lost one of my two sons. He died of pancreatitis, a malfunction of the pancreas. We scattered his ashes in the ocean by the Golden Gate Bridge. That's where I'm going to be scattered, too. I'm happy to leave behind no grave. Why should I use up land that billions and billions of people will need?

It's not supposed to happen. You're supposed to die before your children. As a parent, it's a failure of your most important investment—indeed, the greatest possible failure of all.

Time heals, but I think about him a lot. I constantly review how I could have prevented this from happening. But we're physical beings, and once your body fails, then all the theories don't matter anymore. It's necessary to move on and focus your time productively. So, even big defeats like that one are strengthening—if they don't do you in, I guess. You become strong when you have to.

How many of your earlier plans have materialized?

One out of ten, maybe even one out of seven. I'm constantly thinking about new things to make the world a better place. I want my son to keep on aiming high. If you don't have a few grand ideas that fail, then you're not trying hard enough. Creative life is manufactured using energy and effort, and I want my students to follow that ethic.

What do you view as your legacy?

I want to pass on my genes. I've just had a grandchild. I also want to do no harm, and try very hard to make things, and leave something behind that's of use to somebody else. If no one remembers who I was, I don't care; but if they use something that I made, then that would be wonderful.

"WHEN YOU'RE REALLY EXCITED ABOUT SCIENCE, IT BECOMES INCREDIBLY ENJOYABLE."

Bruce Alberts | Biochemistry

Professor Emeritus of Biochemistry and Biophysics at the University of California, San Francisco
Long-time President of the National Academy of Science
United States

Professor Alberts, why did you want to become a scientist?

My chemistry teacher at my Chicago high school was a wonderful man named Carl W. Clader, 35 years old at the time, and my homeroom each day for four years was his chemistry lab. There weren't safety rules in those days, and in the middle of one of the benches there was a well in which we'd put all sorts of dangerous chemicals, like concentrated sulfuric acid. We could mix concoctions that would explode, so I became really interested in chemistry.

I don't know if I would have chosen to be a scientist at that time, because I didn't even realize you could pursue a career as a scientist. I knew that medicine was a career that used chemistry. I had done well in high school, so I applied to the colleges my mother asked me to apply to and I got into Harvard as a premed student. Both of my parents were born in the United States to recent immigrants from Eastern Europe, and they always stressed the importance of education.

Beside causing explosions in the chemistry lab, what else did you do as a child?

I played a lot of softball, and I was a Boy Scout, which was a great experience because I had to overcome a lot of focused small challenges. Scouting has a system of merit badges, and you have to earn twenty-one of them to achieve the highest rank of Eagle Scout. You could choose from a variety of activities, such as learning to tie hundreds of different knots or building things. It was an active way of learning, and it had a big influence on how I think about education today.

Why is that?

I think children should be challenged to do things and not just to memorize facts. There are many things we could do better in education, but it's all about having active things to do and giving students some choice in what they do. In my first year as a premed at Harvard, I took many science courses, spending three or four afternoons in the lab every week. It was a huge amount of time, but extremely boring, because you had to follow instructions. It was like following a recipe.

Science is nothing like that. The independent projects we were assigned each year in middle school were a wonderful way to motivate kids because they really learned by doing. That's been a fundamental finding throughout my life. With those school projects I was testing myself and I learned a lot. These were teachers who had the vision to let us try to struggle on our own. If we needed help, they'd give it, but they didn't give us the answers and there was no one right product to produce.

Did you experience any failures in your career?

I've learned the most in life from my failures—and I've had many. The most important one for my scientific career was failing the PhD exam at Harvard in 1965, which was incredibly inconvenient. I had a 1-year-old child and my wife Betty, and I had already given up our apartment and bought plane tickets to Geneva for my postdoctoral work. Then, after a short discussion about my thesis, they said they weren't happy with it and that I'd have to stay another six months. From that experience I learned that in science, having a good strategy is everything.

Did that make you doubt yourself?

After failing the exam, I spent a month trying to figure out whether I had the abilities, talent, and motivation to be a scientist. I knew I enjoyed doing it. But everybody has this problem. It's the most important part of education. You need to figure out what you're good at, what you enjoy doing, and then aim for a career that enables you to make use of that. Graduate school is no different. Nobody can be a successful student just by memorizing things and learning what people have already done. Science is a creative endeavor, like painting. I tell every PhD student, "You are really testing yourself. You have to figure out what you're good at, what you'd like to do, and then give yourself the chance to succeed."

Were you a creative person and a freethinker?

My talent is the ability to see the big picture. That's why I write textbooks. I'm creative in designing solutions to problems, and I do that in different ways. That's useful in life because we have all kinds of problems, not only scientific ones. But once you learn to do science, it's very useful for everyday life because everything presents alternatives, and you need a strategy. For me, the PhD experience was hugely transformative. It taught me that I wanted to do imaginative, important science. I decided to develop a unique method, and I chose an important problem that people weren't working on. It was an approach that worked out well.

The key is to identify a unique field in which to work?

It can't just be unique; it also has to be potentially important. Doing the same thing as everyone else

has done is no fun, and it's not going to be a real contribution to humanity. You have one life to live—you might as well make a difference.

In a nutshell, what would you say was your contribution to society?

In 1953, Watson and Crick discovered the DNA double helix. It was an amazing intellectual breakthrough, solving a mystery that nobody knew anything about: Where does heredity come from? How is it possible? Physics, chemistry, and molecules could give you living cells and people, and heredity was one of the major puzzles. Watson and Crick solved this problem in theory, but not in practice. It was just the outline. If they were right, there had to be all this machinery to do this stuff.

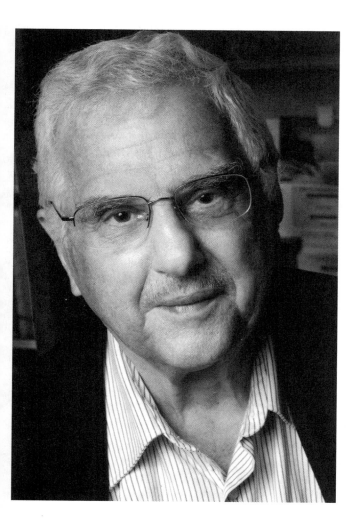

I became fascinated with a particular central part of the molecular machinery: how to copy the DNA double helix using chemistry, as a chemist. My whole initial career, and where I first became successful, was working out the parts of the machine, putting them together and getting them to work and copy the chromosome in a test tube. It took me and my whole laboratory ten years. We discovered a protein machine composed of seven moving parts that copies the DNA double helix, making two DNA double helixes from one and making two chromosomes from one—and that's the essence of heredity.

Have you been obsessed with your work?

I lived close to the lab, so I'd go home for dinner for an hour or so and then return to the lab. In biochemistry, you have to keep track of the proteins you are purifying and make sure the equipment is working, so that often meant checking it in the middle of the night. Eventually, when you get older, it's the graduate students who do that, but in the beginning it was me. I was always late for dinner, and I worked at least eighty hours a week.

When you're really excited about science, it becomes incredibly enjoyable. I've been obsessed with many topics. That was the first one, and I've moved on to others.

When and why did you start trying to influence the way science is taught?

I saw what my children were doing in school and the textbooks they had in biology; they were full of words and concepts that covered a little bit of everything. Middle school biology textbooks were the hardest I'd ever seen, but it was completely by accident that I went on to co-author textbooks for universities. Jim Watson wrote the first really good textbook in our field, *Molecular Biology of the Gene*, in 1965. Then, around 1976, he had the idea to combine two scientific fields: molecular biology—which is what I had been working on—and a field called cell biology, which I had never heard of.

A lot of beautiful work had been done in the nineteenth century in studying cells, using only a microscope because they had no other tools, thereby

"SCIENTISTS SHOULD PAY ATTENTION TO WHAT HAPPENS TO EDUCATION AT THE LOWER SCHOOL LEVELS."

creating a new research field called cell biology. Jim was a visionary and recognized that we could try to span the gap between molecules and just looking at cells by writing a textbook based on the same conceptual frameworks as he had developed for his 1965 textbook. He gathered a bunch of young authors and made an inspiring argument, saying "This will be the most important thing you'll ever do in your life; it will have more impact than anything else you do in your career." And it turned out to be true. But he also told us it would take only two months dedicated time. In reality, it took us six authors more than 365 sixteen-hour days, writing at periodic meetings spread out over five years.

Have you been able to impact education in your role as president of the National Academy of Science?

Initially I didn't want to be president because it meant closing my lab and moving from San Francisco to Washington, D.C. The selection committee had made me feel guilty if I didn't take this unique chance to use the Academy's influence to improve science education. They knew this was a passion of mine. At that point, we were already in the middle of producing the first-ever National Science Education Standards for the United States. I was on the oversight committee, and it was going terribly, so part of the motivation was to get that project back on track.

At that time, there was a huge project to develop national standards in all the academic subjects, such as math, science, and history—and that led to the Academy being assigned and paid by the Department of Education to develop the first-ever national standards for science education. We had never done anything like it before.

How does current U.S. policy affect the nature of the international science community?

The United States has been a unique success in the world because it welcomes immigrants and is inherently open to anyone from anywhere. The new immigration policies are a big threat and are counterproductive. It's frustrating to me because the success of America—and American science—depends on this continuous pool of talented people.

We're starting to see the effects. In our department, for example, there are two assistant professors who were born in Iran. They're talented people, but they can't go home and their parents can't visit them here. So, who's going to come from Iran to the United States anymore? It's not welcoming, and it makes no sense. We're losing not only Iranians but also many other nationalities with great talent.

Is China gaining the upper hand by investing billions in scientific research?

We all benefit from China's investments in basic science because the knowledge is shared around the world. I wish that our leadership, instead of complaining about China's investment in science and new technologies, would realize it's a smart thing to do here, too. The whole success of the United States has been based on our leadership in science and technology, and that in turn has been based on the ability to take in the very best people and support them in fundamental research with government funds. My hope is that the next U.S. administration will energetically try to reverse the U.S. image and immigration policies taking root now. China and the United States should *both* be investing heavily in basic science, and they could easily cooperate. More support for basic science means that we could all move faster to increase our knowledge of the world, on which all future benefits to humanity depend.

As the former editor-in-chief of *Science* magazine, what are your thoughts on the criticism from many

scientists of the review process for articles considered for publication?

A major part of the problem is that a lot of the people asked to review papers pass the task on to their students because they themselves are too busy. They look at the review only briefly before submitting it as their own. The motivation there is wrong. The post-doc and graduate students are trying to impress the professor; that's a big reason why we get these horrible reviews. We are killing each other. Scientists write critical reviews and then complain about the critical reviews they receive of their own papers.

I'm interested in the idea of open reviews. There are many experiments being carried out with that idea now; I also think we should explore the easy options, such as publishing the reviews anonymously. At any rate, I think we have to do better. Surely, we don't want to ruin science because of the review process. It's not a very complicated problem. We should be able to solve it.

What other changes would you like to see come to science education today?

I think that science education should be quite different from how it is now. Children need to learn how to solve problems. Science education should challenge them to work together to come up with solutions. For example, starting in kindergarten, the teacher could bring in a pair of white socks for every child and have them walk around the schoolyard where there are seeds on the ground. The children would then come in and pick off all the specks and dirt on their socks. Then it would be the job of the 5-year-olds to figure out which bits are seeds and which are soil. If done well, it's the children's ideas that they are all following, not the teacher's. We can do something like that for every year of school.

We don't train teachers to do that, and in some ways that's due to the educational standards movement I helped start in 1996, when we issued the standards from the National Academy of Sciences. To an extent, those standards inhibit good education. They weren't supposed to, but people take the standards so literally that it becomes impossible for teachers to be flexible. We have to do a smaller amount in more depth, and not push teachers to try to cover all the facts.

What solutions would you advise to bridge the gap between meeting the necessary standardization and encouraging closer coordination to fulfill the needs of the students?

It is critical that our school systems develop a much better way of incorporating the feedback from and advice of their best full-time teachers. We all need to deeply respect what our best teachers know. Ideally, a select, small rotating group of them could take on a formal advisory role in the governance of each school district. Their voices need to be heard, both by the public and by school leadership. We also need a similar professional teacher voice at the state and national levels. Creating such "teacher advisory councils" has long been one of my major goals.

How can scientists assist in that endeavor?

Scientists should pay attention to what happens to education at the lower school levels. In San Francisco, there is wonderful science education coordination among students, postdocs, and teachers. That kind of structure is needed all over the world if we're going to connect science with society. We also need to connect the schools to the real world around them. This involves using many more volunteers and opening up the educational process to the community as well.

We need to develop new kinds of systems, like when I was a Boy Scout leader in college. The Boy Scout system for earning badges includes volunteers who become experts in that endeavor. Today there is a great opportunity to create a series of challenges for kids in all areas and to have retired people and other folks work together to mentor the next generation.

What is your message to the world?

If everybody makes a small contribution toward improving things for the next generation, then—and only then—will humanity survive.

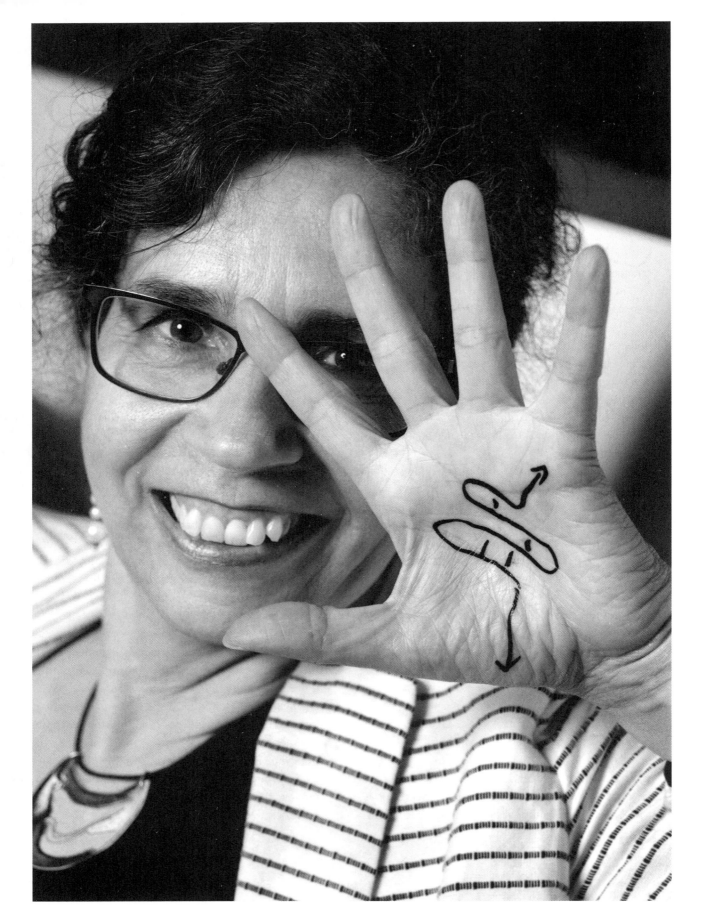

"I WAS REPEATEDLY ASKED, 'WHY ARE YOU, AS A WOMAN, SO PASSIONATE ABOUT SCIENCE?'"

Viola Vogel | Biophysics

Professor of Applied Mechanobiology at ETH Zurich
[Swiss Federal Institute of Technology]
Einstein Visiting Fellow since 2018
Switzerland

Dr. Vogel, you rose quickly in the scientific world and were even on Bill Clinton's team of advisors. How did you manage that in the male-dominated world of the natural sciences?
I was repeatedly asked, "Why are you, as a woman, so passionate about science?" I had to shrug this off so as not to lose my enthusiasm. I was always anxious to build consensus. As a result, my colleagues respected me from quite early on. But women, of course, are observed far more closely every step of the way. At the University of Washington in Seattle, I

was the first female professor in bioengineering, and at ETH I was the first on the materials science faculty. Now, already one-third of the professors in the Institute's newly established Department of Health Sciences and Technology are women. So, things are really changing.

Do you think women have a harder time in science?

None of us wants to be viewed as a "quota woman" by the outside world. In this respect, the issue has been firmly dismissed by most women, including me. But I can see that in an entire generation, the number of women in many technical professions and in leadership positions has hardly changed at all. Although much has been done to support women, from offering childcare, to fostering a greater understanding that should men help out, too, and that parenting is a shared responsibility. For me, that's the biggest disappointment—that all this has only minimally helped motivate women to take this route in the sciences.

Did you ever doubt that you would make it?

Continually, already during my studies when it got really difficult. I think women question themselves more quickly. When I started out, it was taken for granted that women would either choose science or have a family. The two didn't seem compatible. For me, the first priority was to build my career as a scientist. It wasn't until I saw in the United States that it was much more acceptable for a woman to combine career and family that I began to change my attitude and start a family.

How difficult was it for you to obtain a professorship?

The assistant professorship rank is the real bottleneck in an academic career. These positions are competitive, and at the time I applied, over 250 other people also applied at the University of Washington in Seattle. My decisive advantage was that I'd studied a rare combination of physics and biology. I had two children at that time and, as I look back, I am very happy about that decision. Before the children, I had tried to work through everything every day, until late in the evening. With my newborns, I

"WHEN I STARTED OUT, IT WAS TAKEN FOR GRANTED THAT WOMEN WOULD EITHER CHOOSE SCIENCE OR HAVE A FAMILY."

quickly realized I had to reorganize my schedule to make time for my family. I made a list of priorities each day, and I worked through it as best I could, and then I went home with a clear conscience.

Some things just weren't done right away. And I learned to say no. This gave me the capacity to focus on what was pertinent and to select only the most important and interesting work. The biggest challenge was, after sleepless nights with the kids, being able to stay focused on my lectures the following day. But it was extremely satisfying to realize that science isn't everything, and that having a family provides a balance that I really enjoy. And it has never damaged my career.

It's usually said that a good scientist must be obsessive about their work. True?

Even then, it's impossible to work twenty-four hours on one topic. The question is: How and where do we work most effectively? And for that we need thinking space, where we can find creative approaches to the solutions. When my children were little, I liked to play with them. I often had ideas that would probably never have arisen in the confines of an otherwise busy day. My family is a good way for me to recharge my batteries. My husband has also been extremely supportive. We look after the kids together and share all the chores, from feeding them to changing

their diapers. This has meant that I could continue to attend conferences, and he would be there for the children, and vice versa. This intense contact means a lot to him, too. However, he was bothered by the fact that, as the only man at the playground, he was often looked down upon.

Your father was a geologist, and as a child you moved around a lot. For instance, you spent the first years of your school life in Afghanistan. Did that experience shape who you are today?

We were usually in one place for three years. That moving about was challenging. I constantly had to make new friends. The most difficult time was returning to Germany from Afghanistan, because I'd had completely different experiences from the German kids. They weren't interested and often made

fun of me because I didn't know certain games or movies that everyone was talking about. So I was pretty much ostracized at first. But what doesn't kill you makes you stronger. I learned not to be discouraged, and that certainly prepared me for later life.

Where did the initial impulse to study natural sciences come from?

Teachers play an incredibly important role here. The enthusiasm for scientific subjects has to be sparked in school, otherwise you probably wouldn't choose that path. I had a physics teacher who really filled us with enthusiasm. We were the first class he'd ever taught, and he often used to show us experiments, even in the afternoon after school. And a good friend of my parents, also a physicist, gave me a lot of advice. For him, it was self-evident that I would make it. That really gave me a good feeling that I was on the right path.

Why should young people study science?

It's of human interest to want to know how things work—how the earth came into being, what life is, how we function. It's incredibly fascinating being able to make discoveries that enrich society. Young people should listen carefully to what enthuses them and not be afraid to choose absurd subject combinations, because often there is a great opportunity there to make a unique contribution.

It's important to think about what you should study with your abilities, with your interests, so as to make the most of your potential. In research, you need a lot of stamina. You have to read tons of publications, analyze loads of data, and repeat experiments umpteen times. To keep at it all, your primary feeling must never be that you have to go to work now to earn money; rather, you work at it because you're fascinated by the questions.

Where do you see the major challenges for tomorrow's scientific community?

Compared to past situations, the basic funding of professorships has fallen sharply and the competition for professorship openings and for research funding has increased enormously. This has two

"THE ASSISTANT PROFESSORSHIP RANK IS THE REAL BOTTLENECK IN AN ACADEMIC CAREER."

decisive consequences. First, to achieve scientific success and recognition, you need to be published in the best journals. Editors of excellent journals are promoted, and sometimes even paid according to how often the articles they accept are cited. So, they are more likely to accept topics that are currently hyped. And discoveries that are perhaps five or ten years ahead of the larger field are often not accepted. In addition, a willingness to pursue risky questions has waned because that's time-consuming, and sponsors of projects demand precise timetables.

Unfortunately, scientists today often promise far too much in order to obtain funding, even though it's foreseeable that their promise can't be met in the given time. This often raises false expectations and thus erodes the public's trust in scientists. Biology in particular has a major problem, in that a large percentage of the published data can't be reproduced.

What effect has the pharmaceutical industry had on funding and on the critical review of publications?

The pharmaceutical industry has tried to replicate published experiments and found that many didn't work as described. For them, this meant the research was a bad investment. Numerous journals have now reacted and are demanding much more detailed documentation.

What is your *h*-index rating?

I think 64 at the moment. The *h*-index is based on how often a publication of yours is cited. So, if you're working in a very large community, it's easier to get a high *h*-index than if you're doing research in a specialized area. So, the index shouldn't be overused. The Nobel Prize winner in physics, Donna Strickland, had an *h*-index of 12 when she was awarded the prize in 2018.

The chemistry professor Carl Djerassi talked about how much jealousy and rivalry exist in the field of science. What's your experience been in this regard?

This is a huge issue, especially in research areas where hordes of scientists are addressing big questions with similar methods. I've always tried to use methods from physics to ask novel questions that can't be addressed by methods from biology exclusively. In this respect, I've never experienced up close this all-consuming daily fear of competition, because we're always working on new approaches and with new technologies. Of course, at first glance, publications from other labs have implied that someone has beaten us to the results. And then students sit in my office in tears and see fading away their hopes of being able to publish their own work. But on closer look, the experiments performed are never quite alike, and by building on the work of competing groups we are often able to publish a much better study. So, in the end we have a win-win situation.

Can you explain in simple terms what you're working on right now?

Primarily, I would like to thoroughly research how the biological nanoworld works, so that we can manipulate it. This would make it possible to treat diseases better and more cost-effectively. Nanotechnology has always been of a passion of mine. And thanks to new ways to make and manipulate nanostructures, combined with super-high-resolution microscopy and supported by computer simulations, we're studying how microbes and mammalian cells use mechanical forces to turn the functions of proteins on and off, allowing them to detect the physical properties in their environment.

Proteins are our nanoscale workhorses that keep us alive. Imagine your hand is the cell, and when you

touch a surface with your fingers, you sense what properties it has as you push or pull on the surface. Cells also use forces to sense surface properties. They pull on the environment and they notice by the way the environment yields just what they have in front of them.

And what further things did you discover about nanostructures?

Our goal is to develop new therapies that use the mechanical functions of cells or have a regulating effect. We asked ourselves, How does a bacterium find a small wound on the skin through which it then enters the body? We discovered that it uses peptide threads, or nanoadhesives, to read the fiber tensions of human tissue. When tissue fibers are severed in a wound, they lose the tension of intact fibers. We then discovered that the *Staphlococcus aureus* bacterium can use its adhesive to preferentially attach itself to these severed fibers. We then synthesized the bacterial nanoglue and discovered that it also attaches itself to tissue fibers in tumor tissue.

Our next step will be to further develop these adhesive nanoprobes so that we can use them for imaging, or so that they can precisely deliver drugs and agents to diseased tissue. Much has been tested in cell cultures, and some has already been tested on animals. But without animal testing, there would be no new drugs, and of course we don't want to use humans as guinea pigs.

It all sounds so easy now. Has anything gone wrong?

The whole project started out with a supposed failure. One of my students came to me and said that the simulation hadn't worked. We had stretched a protein structure with attached nanoglue in computer simulations, and what we saw wasn't what we expected to see. But therein lay the discovery! Instead of questioning the student's work, we considered what this data could actually mean.

That's why in science, you need to think out of the box. We humans often tend to link observations in a linear fashion, and so sometimes have difficulty correctly understanding complex relationships in

an intuitive way. For us, it was an absolute highlight when we realized we'd discovered a trick of nature that was completely new to us. And something like that gives the entire team an incredible amount of energy.

As a researcher, where do you see your responsibilities to society?

This is an important point. We should all ask ourselves: In addition to our scientific goals, what else could be done with our findings? Science moves so fast. In the past, you often had ten or more years between a discovery and its implementation. Today, it's often only a few years. So, we scientists must also warn society as quickly as possible about the potential misuse of new technologies. At the same time, it is the task of society, together with scientists, to enact regulatory measures to effectively prevent any possible misuse.

"SO, WE SCIENTISTS MUST ALSO WARN SOCIETY AS QUICKLY AS POSSIBLE ABOUT THE POTENTIAL MISUSE OF NEW TECHNOLOGIES."

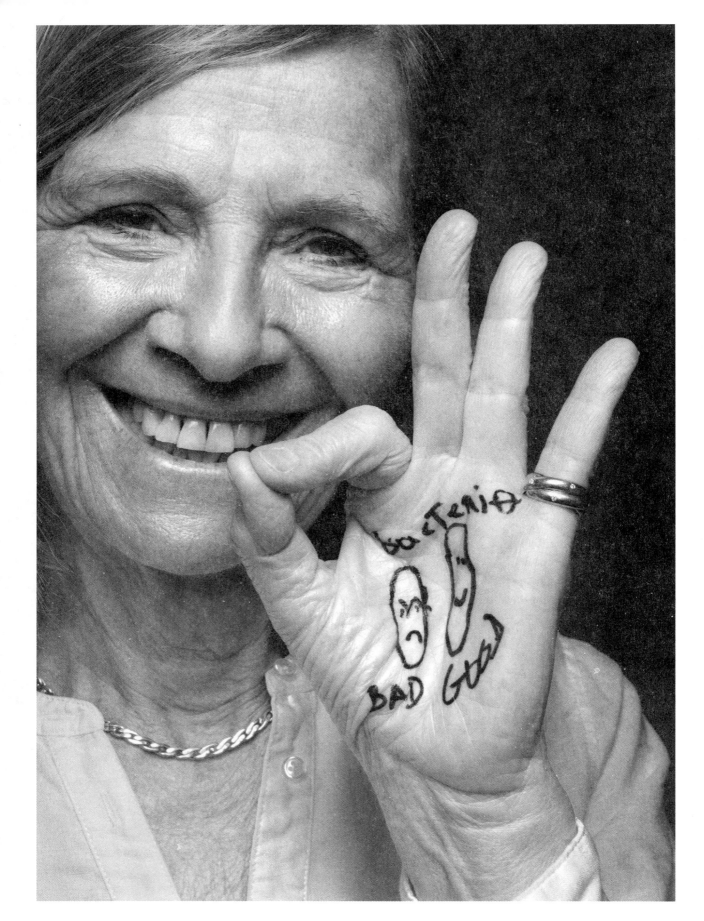

"I'M A TOUGH COOKIE. I MEAN I KNOW WHAT I WANT, AND I LIKE TO BE SUCCESSFUL."

Pascale Cossart | Microbiology

Professor Emeritus of Bacteriology at the Institut Pasteur, Paris
Robert Koch Prize Winner 2007
Balzan Prize Winner 2013
France

You grew up in northern France, after the war. Was it a happy childhood?
Yes, it was a happy and peaceful time. My father ran a flour mill that had burned down just when he was about to start work in place of his uncle. He rebuilt it, making it bigger and better. I was the eldest of five siblings, and my mother, a housewife, looked after us. We lived in a nice house with a big garden on the edge of a village, and my grandmother lived next door. It was all very traditional, really.

As mayor, my father was involved in village affairs. I sometimes felt that the village was more important to him than his family, but recently I realized that he was simply passionate about his job, just like I am, and I'm okay about that now.

At school, you ended up two grades ahead of others your age. Did your parents realize right from the start that you were bright?

My parents would say I was clever because I was accelerated, but this wasn't always an advantage, as I was constantly being told I was immature. Yet I was quite young to earn my baccalaureate!

Did you start your love affair with science when you were at school?

I fell in love with science when I bought my first chemistry textbook while in secondary school in Arras, a small town in northern France. I read it, loved it, and discovered a whole new world. I found out that nature was made up of molecules, which could be fused together. It was such a defining moment, an extremely important turning point in my life. Up until then, I'd specialized in classical studies at school but didn't know what I'd wanted to do with my life. I didn't come from a scientific family, and I hadn't even heard of chemistry before. But after I read that little book, I switched to the scientific stream.

Then after school you went on to study chemistry at university?

Yes, I studied pure chemistry before taking a master's degree in chemistry. Next came another pivotal moment in my life, when I discovered the chemistry of life—biochemistry— and decided to also take a master's in biochemistry. I then went to the United States for a master of science degree from Georgetown University. Funnily enough, just before I left for

the United States, I met the man who was to become my husband. So, I completed my master of science very quickly and a year later returned to France, got married, joined the Pasteur Institute in Paris, and stayed there.

You had three daughters during your marriage. Was motherhood a difficult decision for you?

No, having children was an obvious decision—I love children. Big families are the norm where I'm from in northern France. My parents both came from families of ten.

Was it tricky to juggle your work with your marriage and kids?

It helped that my three daughters all went to nursery school when they were 2 1/2 months old, which is perfectly normal in France. I was also fortunate in the way the Pasteur Institute wasn't sexist and didn't differentiate between male and female scientists.

In general, I managed everything by being well organized. I can accomplish lots, as I'm somewhat hyperactive and good at multitasking. I'm also blessed with good health; my sister says it's because my mother breastfed me for six months.

I got divorced early on, but this had nothing to do with my work, as I was just completing my PhD and wasn't working so hard at the time. After a while I met someone else.

How should a modern woman balance motherhood with a career?

It's important to strike a life balance between career success and having a family. Women who want children really shouldn't have them too late. Some women don't listen to their biological clock and they miss the boat.

I'm lucky because I never suffered career-wise by being a woman. I have been the head of my department and twice the president of the Pasteur Scientific Council.

Even so, you must be a tough cookie to have reached such a high level in science?

It's true—I'm a tough cookie. I mean, I know what I want, and I like to be successful. I like to answer questions. I do my own thing and I don't jump onto fashionable themes.

"YES, I'M A WORKAHOLIC, WHICH HELPS."

Yes, I'm a workaholic, which helps. It's no secret that if you want to be successful in science, then you must work incredibly hard. You need to think about science the whole time, read a lot, and stay strong if your own papers are rejected by the publications. Science is incredibly hard work, but on the other hand it's so rewarding.

How else would you describe yourself?

Well, I'm an optimistic and an active person. All in all, I enjoy life. I'm sociable, too, and like spending time with friends and making other people happy.

I have observed people a lot, so I can react to and have opinions about people relatively rapidly. In my opinion, first impressions are critical and lasting, which is why it's always important to be dressed appropriately for any occasion.

Besides that, I'm courageous; I was just born that way. And I always say what I think. Sometimes that can be a problem, but I've learned also to be diplomatic.

Did your children complain that you were always working too hard when they were growing up?

None of them has followed me into research because they think it's too much work for too little money, and they constantly tell me I work too hard. They didn't complain when they were little; I had my children quite early on, when I was 25, 27, and 32, so I wasn't a big scientist at that time and was not traveling. They started to complain when they were about 20 and they still complain today. On the other hand, when they ask me to take care of their children for them during weekends, I generally say yes.

What advice would you offer young people about science?

Of course, science is difficult at the beginning; you work hard and don't make a lot of money. But once you've passed that stage, it's pure paradise. You should pursue projects that interest you, not just trendy ones.

Why, in your opinion, should young people study science?

Biology in particular is amazing, as it helps us understand life. Science is fantastic. I've made friends all over the world. We're a big community, and we don't care about borders, Brexit, or wars; we're just scientists who enjoy life together.

I hear that you enjoy discussing scientific matters over a good meal and a glass of wine, yes?

Yes, I try to celebrate big events in a nice restaurant, as it's really pleasant and creates a good atmosphere. We also celebrate colleagues' papers when they've been accepted, and when people talk about movies and music, it helps remind us that there's more to life than science.

Would you say that scientists share a responsibility to the world?

People who understand things should share that understanding with those who don't. Microbiologists in particular share a strong responsibility toward the

"I RAN MY LAB AS IF IT WERE ONE BIG FAMILY."

rest of the world, as they're able to pass on knowledge about life itself. For example, we can convince people why it's a good idea for everybody to be vaccinated.

Your work has helped others by warning them of the dangers of *Listeria monocytogenes*. Just how harmful is it?

Listeria is a common food-borne pathogen, which you can get from contaminated food. If your immune system is immunocompromised—for example, if you are unhealthy, having chemotherapy, or are pregnant—*Listeria* may really be dangerous and can lead to not only gastroenteritis but also encephalitis, meningitis, or miscarriages; within 30 percent of cases, it can result in death.

When I started to work on the pathogen in 1986, there were about 1,000 cases of listeriosis per year in France. This has fallen to around 350, as people have become more aware of its dangers and we've helped spread the message. You're far more likely to get listeriosis if you eat unpasteurized dairy products, so we've advised pregnant women in France not to eat cheese made with raw milk.

What triggered your interest in *Listeria*?

At the Pasteur Institute, I was asked at some stage to work more specifically on pathogens. And being a chemist, I knew nothing about pathogens, so I decided to work on intracellular bacteria because they are still responsible for dramatic diseases. *Listeria* appeared to me as a good model, although very few people had heard of it at the time.

I first applied molecular biology and genetics to decipher *Listeria* virulence, and rapidly decided to switch over to cell biology to find out more about it.

It wasn't a scary step—I just knew I had to move in that direction.

What did you find so fascinating about *Listeria*?

Listeria monocytogenes intrigued me because it was intracellular, not too dangerous, and could travel from the intestine via the liver and the spleen to the brain. I've done a lot of work on crossings of the intestinal barrier by *Listeria*. Mostly we've looked at how the bacterium interacts with cell components when it enters the cells and how it moves within the cells using an actin-based mobility. We then used postgenomics to identify genes used by *Listeria* to harness infected cells for its own profit. *Listeria monocytogenes* deploys many different strategies to infect humans!

Over time, you've become the foremost authority on *Listeria*. What helped you become so successful?

Basically, I've always worked hard, and I've been lucky along the way. Plus, I jumped straight away on any good offers. For example, I was asked to start a research unit in another department, and even though I was happy where I was, I didn't hesitate for one second—I knew I had to move forward, not look back. It's not because I'd dreamed of being a group leader or head of a lab, as those were never my goals; my true goal was purely and simply to be successful in my enterprises, and to be at the forefront of my discipline.

It sounds like you've developed the habit of being in the right place at the right time. Am I right?

Yes, that's right. When I returned to France from the United States, work in molecular biology was exploding, as people found out how to manipulate genes. Then the Pasteur Institute received its first confocal microscope so we could use it to examine bacteria. Then DNA sequencing arrived, and I was the first at Pasteur to sequence a gene. Later I coordinated the sequencing of the *Listeria monocytogenes* genome and compared it with a nonpathogenic species, *Listeria innocua*.

What's it like being a female scientist in France, compared to the situation in Germany or the United States?

In the United States, there is more money for science in general. Women are increasingly recognized, but there are still difficulties in acceptance. In Germany, it's tough for female scientists, as the men more easily get the professorships. You don't see that in France. Here, you're offered permanent positions. A position isn't so much attached to the center but to the person, allowing someone to migrate from one department to another or from one institution to another. I've held my position at Pasteur for forty-eight years now, and I'm still happy.

Who have been your mentors over the years?

My most important mentor was Georges N. Cohen; I worked in his lab while earning my PhD. Julian Davies, my last boss at the Pasteur Institute, was a big inspiration for me, too. He enjoys life in general. In addition, he told me it's important to have a lot of money when you run a lab. He was completely right!

Have you always managed to secure enough funding for your research?

I've never had problems obtaining funds. I've always waited until a project was mature before asking for money, and I've never waited until I didn't have any money left before asking for more.

Did being a woman help you run your lab well?

Being a woman helped me notice all the little things. I ran my lab as if it were one big family and took care of everyone's psychological needs. A man would probably have done it differently, as men tend to think more about their own needs and are more self-confident. I personally didn't become self-confident until much later, when I was recognized as a successful scientist.

So, it's essential to hire the right people for your lab?

It's vital. For instance, once I hired a black sheep, and my lab started going to pieces. It taught me a valuable lesson: if there's a small problem, solve it immediately before it escalates into a catastrophe.

You want people to feel happy and in charge of their own project, not competing against each other. And you need to strike a healthy balance among the individuals you employ. I've always tried to achieve equilibrium between men and women, and I've even turned down excellent women to maintain that balance.

Do you enjoy working with others?

I like to collaborate with good people whom I can trust; I don't like to collaborate just for collaboration's sake. In an efficient collaboration, both groups have to be efficient: research is a race, and we want to be the first.

Are you still hungry for success?

I'm even more competitive than I was when I first started out, as I've gained a better idea of what's going on. I always want to decipher the big questions, and I'm not interested in the small details.

So, what are your plans for the future?

To be honest, I'm scared about the next stage of my life. When you reach 70, the Pasteur Institute closes your lab, which means I have to finish my work there soon. This is terrible, as it's my life, my identity. I'm trying to work out how I can carry on with my research. I don't want to waste the time I have left, and in addition I love my five grandchildren, so I don't want to move too far away.

Basically, I don't know exactly what's going to happen. I might take a sabbatical. I also hold a position as Secretary Perpetuel of the French Academy, which keeps me busy, but it still doesn't compensate for my not doing research. All in all, it's not an easy time for me. And my father died two months ago. One good thing is that I've been given a contract to write another book.

You've already written one book, I believe?

I'd always dreamed of writing a book, so in 2016 I was extremely happy to be invited by publisher Odile Jacob, daughter of Nobel Prize winner François Jacob, who was in my section at the French Academy. When I met Odile, we talked for hours about her father before she asked me about my book plans, then agreed to publish the book. I danced for joy and managed to write the book very quickly.

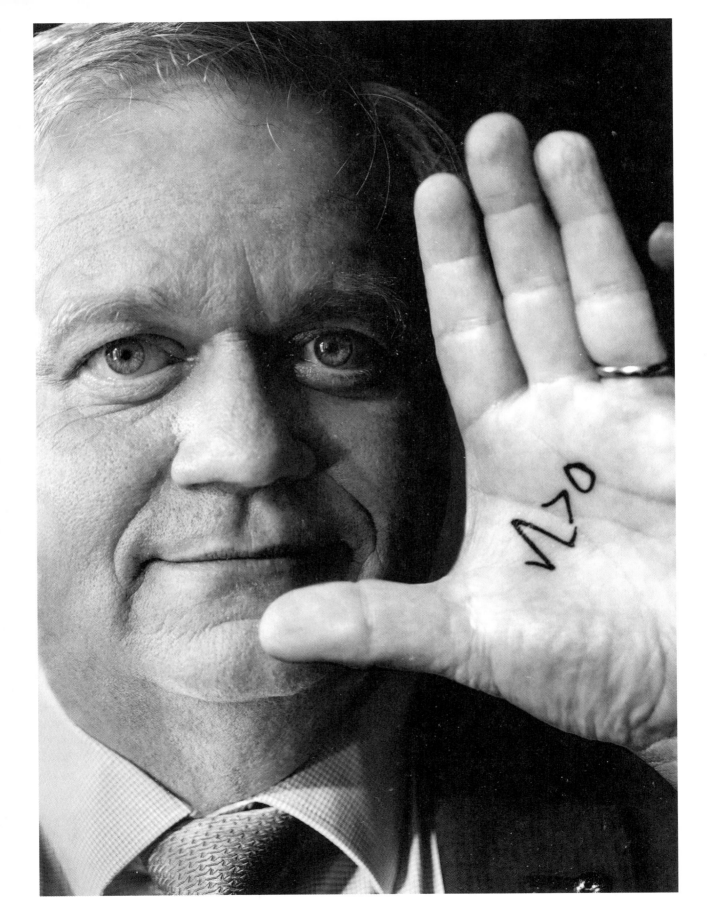

"YOU PROBABLY WON'T WIN A NOBEL PRIZE, BUT YOU DO YOUR BEST!"

Brian Schmidt | Astronomy

Professor of Astrophysics and Vice Chancellor of the Australian National University, Canberra
Nobel Prize in Physics 2011
Australia

Professor Schmidt, why did you study science?
I sort of grew up with science because my father was a biologist. He worked on fish and used to babysit me when he was working on his PhD in fisheries research. I could see everything that he did, and I just loved how he explored. He had a profound influence on my wanting to do it. As a young kid I already liked to understand how things worked. So, even in my youngest days I knew that I wanted to be a scientist, too. There was never really anything else on my agenda. I also had some great teachers, especially in

high school, and they helped me make my wish to do science become real.

You were almost always the best student in high school; you were the second or third out of 300. At your university, you were the first of 3,000, and you did very well at Harvard, too. Are you always eager to be the best?

I actually never worried about being the best. I was kind of proud about how I did in high school, and it was a bit of a surprise to me to finish at the top at the University of Arizona, but I never thought of my education as competition. It's not about being the best, it is about being good. So, you do the best you can, and that is the best you can hope to do.

In high school, I worked on everything. I was in plays, I did cross-country running, cross-country skiing, played the French horn in the orchestra. At university, I gave up a lot of those other activities and focused much harder on my studies. I started doing research, which was a quite unusual thing to do as an undergraduate in the United States in the 1980s.

In 1992, at the age of 25, you got your master's degree and you got married. Was it something special to take those two important steps within the same year?

Getting a master's degree is part of your PhD work at Harvard, so it was nothing particularly special. Marrying my wife Jenny Gordon was. We met in my first year at Harvard, where she was studying economics. She is someone who to this day is at the core of who and what I am. We learn from each other each day. As an economist, she thinks very much about how the actions of people and the government affect other people—how they influence not just our economy but also our way of life. As a scientist, I do not really worry about people influencing things but, rather, about understanding nature. She has put me in touch with the idea of fellow humans and our responsibility to both ourselves and to the greater world.

In 1993 you finished your PhD, and the following year you set up your research project with the High Z Supernova Search Team. Can you elaborate on that?

I had a job as a postdoc at Harvard's Smithsonian Center for Astrophysics, and I was trying to figure out what to do next. I was working on a bunch of projects that were interesting, but in the first half of 1994 it became obvious to me that we had the opportunity to look back in time and measure how the universe had changed and to study its expansion over time. That was something people had wanted to do for seventy-five years, and in 1994 the technology and knowledge now existed to make that possible. When I realized that, I decided to drop everything else and work on that—and nothing else.

At that time, your colleague Saul Perlmutter had been researching this topic for years. You were a young scientist who broke into his field of research and developed a rivalry, right?

Perlmutter and his team had been working since 1988, but many key achievements didn't happen until 1994. One of my colleagues from Chile whom I was working with figured out how to accurately measure distances with type 1a supernovae; Perlmutter's team had just sort of taken that for granted. It was also in 1994 that the Keck telescope—a ten-meter telescope—was developed. For the first time we had a telescope big enough to observe the supernovae. Not just to see how bright they were but also to identify them. But you have to understand that I had an astronomer's point of view, and Perlmutter's team represented a physics side of the discipline.

Our project started as different ways of wanting to do the work. When I set up the experiment, I looked at what they were doing and said, "I am going to change that, that, that, and that." And then Perlmutter's team looked at what we were doing, and they changed some of the things they were doing as well. So, it ended up as a race.

To be the first in the discovery was very important in this case, correct?

It was important because we were measuring the future of the universe, and we would not want to work for four years just to realize that the other group had got it right. I wasn't so worried about being first, but

I didn't want to be second. In the end, we got the results at the same time, and I was happy with that.

In 1998 you published your results in a top journal. Is the number of publications one has another chief area of rivalry in science?

It's very important how many people cite and refer to your articles. We went to one of the two top astronomy journals, and the other team went to the other one. We got published a little before them, but in the end, we received almost the same degree of recognition. Things got really heated for a while because they had been so far in front of us. And when we published before them, they were surprised how far along we had been. My colleague Adam Riess deserves huge credit for this because he really propelled us to get everything done quickly. When we suddenly came out with a solution, I think the other team was genuinely concerned we were going to get all the credit.

In 2011, you, Riess, and Perlmutter were awarded the Nobel Prize. The astronomer Robert Kirschner commented that the strongest force in the universe is not gravity, it is jealousy. You spoke about poor behavior in relation to that honor; want to elaborate?

At the awards ceremony in Stockholm, the behavior of all the scientists was pretty good, but beforehand it had been poor. Earlier, people in some circles were jockeying to make sure they would get the prize. A Nobel Prize can be shared with up to three people, and there were sixty people involved in this discovery. In the end, Riess, Perlmutter, and I were the right three to be given the award, but some people on either side had the horrid feeling of having come close and missing it.

Many young scientists work almost day and night, and their families don't see them much. How was it with you?

I worked pretty hard, especially during that crucial three-year period when we were doing the supernova research. I always try to be a good husband and good father, but work is all-encompassing. You need to make sure, though, that you work hard only when you need to. If I hadn't worked day and night in those three years, I probably would have not won the Nobel Prize.

In 1997 you were looking for a full-time job at Caltech, an elite university, but you didn't take the appointment because you thought that if you did, you would be divorced, correct?

I visited Caltech, and after several days there I realized it was the wrong environment for me and my family; it was just going to be too intense. My job at the Australian National University was finishing at the end of 1997, and I had nothing lined up yet, but I still made that decision.

In the end, your life is the most important thing you have. Never sacrifice your life or your family for a job. You need to find balance in life, and your job is not your whole life. Now I get happiness through my vineyard and winery, in going out and playing with my kids, talking with my wife, doing things as a family. If I had to choose between work and family, I'd choose family first and the research second, because there is no way I'd feel fulfilled as a person if I only had research.

You have said that it's important to ask the right questions. What are the right questions to ask?

Those questions that interest you, and also others. I know I am working on the right question when I really want to answer it and I stay up at night trying to figure it out. I have had about three or four of those moments in my life, and they have all been worth it. You need to keep exploring and looking around; you need to keep your eyes and mind open to the things that hit you.

In the current research climate, it is essential to take risks. If you do not take risks as a scientist right now, you have no relevance—for research, at least. The purpose of science is to move across the frontiers. As a research scientist, it is really important to have that passion. And although you need to be smart, you don't have to be a genius.

What do you feel has been your contribution to society?

Back in 1995, before I was a famous scientist, I was teaching other people the necessary skills to go out

and do interesting work. And from the work I did then, things are still being built, even today. By having all these people working on those foundations of knowledge, you occasionally get a little spark. The accelerating universe that I helped to discover was one of those sparks. My role in society is to be part of that spark and to feed it, and to change and motivate people to do lots of great things.

Could you tell a 6-year-old child in an understandable way what you are researching?

My job as an astronomer is to look up into the sky to see the billions upon billions of stars and to ask how long we have been here on earth. How long have the earth and the sun and universe existed? How did the universe begin and how will it end? These questions make equal sense to any 6-year-old, no matter if from Australia or Namibia.

How do you educate your own children?

My children now are 22 and 19. Therefore I am relatively hands-off at this point. I helped them like any normal parent, and I tried to make sure they work on something they have a passion for. One of my kids is quite academic and the other one is not so. But the fact that their dad is a Nobel Prize winner shouldn't come into it. They should have the ability to work on something they like to do.

Do you have a message to the world?

Science gives us the opportunity to work on all sorts of things, including topics we haven't comprehended yet. And it allows us to become experts at things that turn out to be really useful.

Most people have the view that they will never become a Nobel Prize winner; I certainly never expected to be one. But do not assume that you will not make one of the big breakthroughs! You probably won't win a Nobel Prize, but do your best! You will contribute to knowledge, to making the world a good place—and you might be the one who ignites the spark. Someone has to do the great things that help humanity make it into the future. And that might be you.

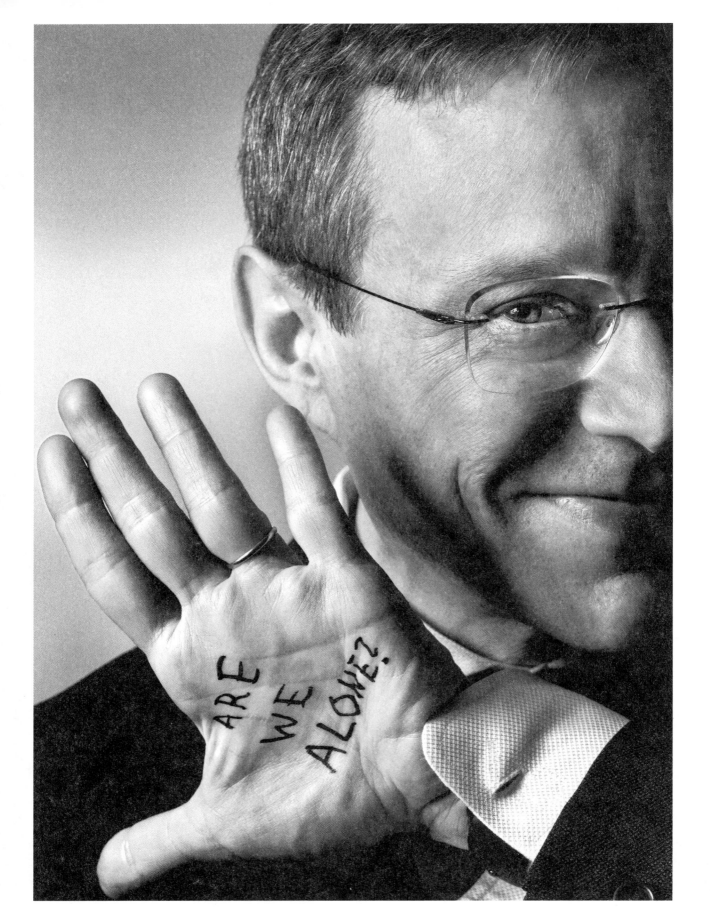

"I THINK IT'S VERY LIKELY THAT WE'RE NOT ALONE."

Avi Loeb | Physics and Astronomy

Professor of Astrophysics at Harvard University, Cambridge
United States

You once said that you wake up each morning inspired by a new idea. What's your thought for the day?

Today I was wondering if the proximity of one star to other stars could determine whether that star collapses. Most massive stars have companion stars, just like humans. The more stars there are, the greater the degree of instability. If you have a group of three or more stars orbiting each other, it's more likely they'll crash into each other, and you'll end up with a far larger star that could eventually form a black hole.

Why do you suppose it is that you have your best ideas in the shower?

Nobody disturbs me in the shower. It's relaxing there, and I have time to think. Being surrounded by nature also helps me think. That goes back to my childhood. I used to drive a tractor into the hills, where I would read philosophy books in peace and quiet.

You were born in Beit Hanan, Israel, in 1962. How did growing up on a farm there influence you?

I had a beautiful childhood. I used to play in the fields, play sports, and later when I was a teenager, I read about philosophy, alone or with my half-Bulgarian, half-Spanish mother. My intellectual interests stem from her. She abandoned her academic ambitions when she met my father, who was head of a factory processing pecans, and began a family on a low income, dedicating her life to her children. But she used to buy me books, talk to me about philosophy, and take me with her to classes after my two sisters left home. She completed her PhD when she was 50 years old.

My mother had a huge influence on my thinking. Like me, she was different. Highly educated, she came to our village from Sofia University, in California. She taught me how to think differently and to focus on intellectual activities. Sadly, she passed away recently. I used to call her every morning.

Your father was German. Did he pass on any of what one might consider German traits?

My father left Germany in 1935, before the war, but he still loved German culture and used to listen to Richard Strauss, buy Volkswagen cars, and visit Germany. I didn't inherit his German punctuality, but I did inherit his authenticity, his sincerity, and his connection to the land.

What principles did your parents pass onto you?

Honesty, not pretending to be somebody you're not, and seeking out friends you can trust. I always select people for my team whom I can trust. They have to be intelligent and speak the truth. With me, what you see is what you get; and I respect that quality in others. It's the same with marriage: the most important thing determining your health is whom you live with.

How did you meet your wife?

Our mothers knew each other and arranged a meeting. We fit well together; we complement each other and have lots of commonalities. We understand each other. It's a miracle.

My wife always tells me the truth and expresses her own opinions. I like strong people who don't necessarily agree with me.

What do you do when your wife or someone else criticizes you?

I listen and learn. I used to get angry, then I realized there was no point. You have to understand what the other person is saying and learn from it.

At work, I promote diversity, employing people from different backgrounds who all see problems differently. I don't want people who just echo me. I like people who are different.

You were always different. On your first day at school, you watched all the other kids jump up and down, but you decided not to join in. Why not?

I never do something without considering it first. The teacher thought I was well behaved but, really, I was just trying to work out whether jumping up and down made sense or not. It surprises me that other people don't think before they act.

I've always been different. It's not easy being different. People usually don't like you. You're bullied every step of the way. I've protected myself from pain by developing a strong internal will, so that I don't care what other people say. I've created a protective bubble, a cocoon around me, like a baby butterfly. It took me years to grow up. Once I was strong enough to be independent, I spread my wings and flew. It's only in the last few years, though, that I've started to feel satisfied about the way I am, without worrying about other people. It's taken me fifty-four years to become self-confident.

You spent eight years in the military in Israel. You also stood out there: out of thousands of soldiers, you were

one of only two dozen selected for the elite Israeli Defense Forces Talpiot training program.

I wasn't interested in running around with a gun. I wanted to do something intellectual. At first I parachuted, I drove tanks, and I served in each military unit. Then I was allowed to study for my undergraduate physics and math degrees. I actually wanted to study philosophy. I was the first to be awarded a PhD under the program, studying plasma physics at Hebrew University of Jerusalem.

And so, physics entered your life. Was it love at first sight?

At this point, I didn't know my future career would include physics. Then I led a project—the first one to be funded by U.S. president Ronald Reagan's 1980s Strategic Defense Initiative—that brought me to

Washington, D.C. On one of the visits, a prominent physicist recommended I visit Princeton's Institute for Advanced Study, where I was introduced to an astrophysicist, Professor John Bahcall, who offered me a five-year fellowship. I was told to apply for a faculty position at Harvard, and I got the job after someone else had turned it down; in 1993, I moved to Harvard as an assistant professor in the astronomy department. Three years later, I was tenured. As for it being a "love match," it felt more like an arranged marriage, in which you then realize that the person you married is the love of your life.

And so, your astronomy career began. Early on, you focused on the scientific version of the story of Genesis. What keyed your interest there?

I was interested in how the first light was produced. I was one of the first people to look at how and when the first stars and black holes formed, and what effects they had on the young universe. I like working on an idea by myself because there is a chance I'll discover something new.

Ultimately, that remains one of the most fundamental questions, something we don't fully yet understand: How did we come to exist on this planet? I don't think the scientific community should focus on searching for primitive life elsewhere in the universe. In my opinion, we should look for intelligent life forms instead. It's arrogant to presume we're special or unique. For instance, when my daughters were young, they thought the world revolved around them. As they grew older, they realized there were other kids out there. For our civilization to mature, it needs evidence of extraterrestrial civilizations. I think it's very likely that we're not alone.

You attracted attention for suggesting that the interstellar object Oumuamua, which recently passed through our solar system, might be an alien spacecraft?

Oumuamua was the very first object discovered near the earth that came from outside the solar system. Based on six different properties it displayed, we suggested that it might have originated in another civilization. Perhaps it's of artificial origin. Even

"I'VE MANAGED TO KEEP ON LIVING INSIDE MY OWN BUBBLE, DOING THE THINGS I ENJOY."

if it's of natural origin, it's worth looking into. We're looking forward to using a synoptic survey telescope in future to find more of this family of objects and to discover where they come from.

What inspired you to think about Oumuamua and other life forms in that way?

One factor was my work with Yuri Milner, a Russian entrepreneur in Silicon Valley, who suggested that I lead a project to send a spacecraft to the nearest star, which is four lightyears away. I told him I needed six months to work on it. Then he called me up, asking me to show him my conclusions. At the time I was in Israel with my family, on my way to a goat farm. I didn't want to detract from the family holiday. So, I got up at 5 a.m., leaned against the wall of the office where there was an Internet connection, gazed at the goats that had been born during the night, and typed up my presentation on my laptop.

Two weeks later, I gave the presentation to Yuri Milner at his home. My idea was to use sails—similar to a sailboat's sails—which would be pushed by light instead of wind. That would mean you don't have to carry any fuel and you can potentially reach a fraction of the speed of light. That inspired me to wonder if other civilizations did the same, using a powerful beam of light to push the sails on their vehicles. And that made me think more about what other life was out there.

Your Oumuamua suggestion attracted a lot of attention, some of it negative. Do you seek other people's approval of your ideas?

I'm immune to attention. I tolerate it because it's important to show the public how science works, that science is a human activity surrounded by uncertainty, and that sometimes scientists make mistakes. Many scientists are driven by their ego; I'm not one of them. I don't care what other people think. I just do what I think is right. When I was young, I used to propose new ideas, which were often ignored or rejected for being too original. After some time, I thought, *To hell with it. I'll just do things my own way*.

Actually, several of my earlier ideas have been confirmed in recent years. For example, about fifteen years ago, I thought that maybe there is a hotspot, a bright spot, around a black hole—like a flashlight—that we can observe. My colleagues rebuffed my idea, but I decided to pursue it anyhow. Then recently a German team from the Max Planck Institute developed an instrument able to monitor the motion of the center of light in a black hole that's at the center of the Milky Way—consistent with my hotspot idea.

Funny enough, in the meantime I've become highly respected because of the various positions I hold, such as chair of the Harvard Astronomy Department. As chair of the Advisory Committee for the Breakthrough Starshot project, we aim to launch lightweight spacecraft toward the nearest stars by using a powerful laser. I'm also founding director of Harvard's Black Hole Initiative, which is the first worldwide center dedicated to the study of black holes. Regardless of it all, if I lost my job tomorrow I'd be happy to go back to the farm and continue my work there, without any of the attention.

Like you, the late Stephen Hawking also didn't care what other people thought. I believe he came to visit?

Stephen Hawking came to our house for three weeks, during a time that included Passover. People bind themselves up in chains because of their social environment, paying too much attention to what other people say. But not Stephen Hawking. He had a lot of fun. He couldn't move physically, but he could think freely, without any limitations. It's the ultimate freedom.

Stephen Hawking said there is no possibility of God in the universe. Do you feel God's presence, maybe in nature?

I am always struck by how organized nature is, how everything obeys the same laws. That's a remarkable mystery to me. You could say that nature reflects God, but it's not the same God as advocated by religion. To me, it's about appreciating something bigger than you, bigger than anyone else. Nature to me represents that something, but whether you call it God or nature doesn't really matter.

When we're kids, our parents look after us. When we become adults, we want to believe there is a divine parent who will take care of us. As a scientist, you can feel much more at peace if you look at the universe as a whole, at the bigger picture, and realize that you're not so special.

What about the Jewish faith?

I was born Jewish, and I admire the richness of the Jewish culture and the Jewish religion that has survived for millennia amid harsh conditions. A few days ago, I had a haircut. The hairdresser pointed out my gray hair and offered to color it. I said, "No way. I am what I am. I'm proud of my roots." Likewise, I'm proud to be part of the Jewish heritage.

What else made you the person you are today?

It's a combination of circumstances, genetics, and environment. It's just like baking a cake: everyone starts out with the same ingredients, but you end up baking your individual cake. I'm happy with the reality I've created. I've managed to remain both authentic and curious. I don't dance to other peoples' tunes. In Princeton, I used to see businesspeople going to work, dressed up in their suits, looking like penguins. To me, doing the same thing as everybody else would be a terrible occupation.

I've managed to keep on living inside my own bubble, doing the things I enjoy. For example, I like chocolate, so half my daily calorific intake comes from chocolate, but without any sugar so I don't put on weight. I like nature, and I like to think up new ideas about the sky. The amazing thing is that I get paid for it. Imagine that!

If you look at seashells, you see that some start out with a beautiful shape, but waves keep eroding them until they end up all looking the same. Life is like that. There are a lot of waves trying to shape us, to make us look just like everyone else. I've managed to keep my shell—or my skeleton, if you like—unique.

Are you sometimes unhappy?

I'm mostly happy and the fraction of time that I'm unhappy is decreasing. Obviously, my mother's recent death made me unhappy. But death is an inevitable process. Those shells on the shore used to be living creatures but they aren't anymore. You leave behind a shell.

What else do you want to leave behind?

I want to leave behind important discoveries. I want to witness the first conclusive evidence of life elsewhere. I want to discover something new.

I get a kick out of thinking by myself without any interference, understanding nature in a way that nobody else did before me. I want to think about my life as a work of art.

Why should a young person study science? What would your advice to them be?

Science is a privileged way of keeping your childhood curiosity alive. As children, we're not afraid of making mistakes or of taking risks. As scientists, we can continue to ask questions about the world, and we are paid to figure out the answers. There's nothing more thrilling than that.

Our knowledge is a small island in a sea of ignorance, in an ocean of ignorance. Scientists' purpose is to expand the landmass of that small island of knowledge. It's like being an explorer, finding new lands that weren't previously discovered. My advice to young people is to seek the truth and follow what your inner compass is telling you, despite any resistance from the outside world. Care less about what other people say. The truth about the world won't be dictated by what is being said on Twitter.

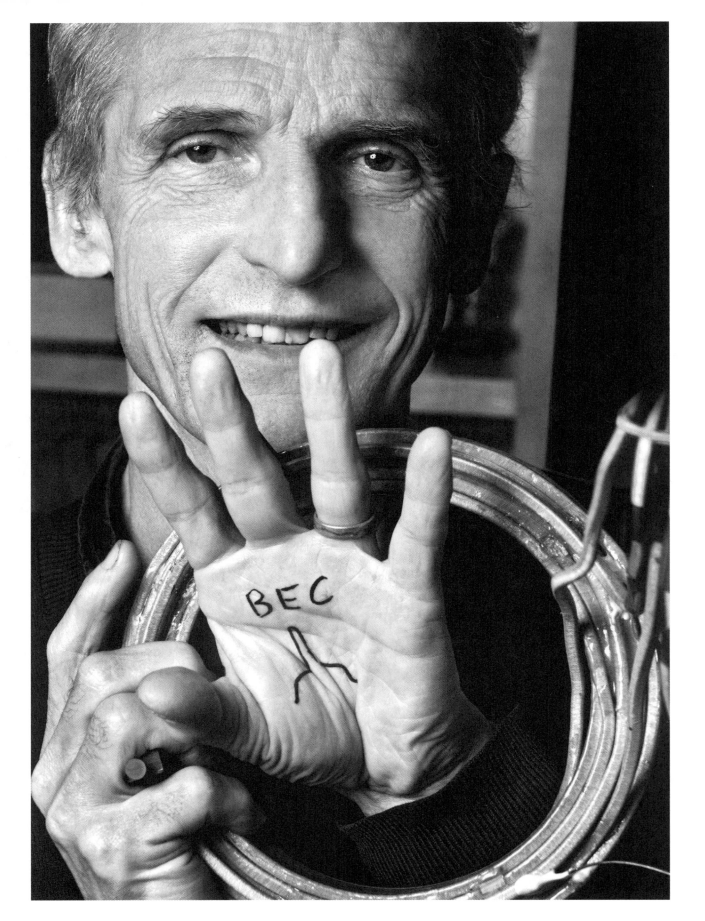

"I'D BET EVERYTHING ON AN EXPERIMENT, SO FIRST I HAD TO COPE WITH THE FACT THAT I'D LOST THE RACE."

Wolfgang Ketterle | Theoretical Physics

Professor of Physics at the Massachusetts Institute of Technology [MIT], Cambridge
Nobel Prize in Physics 2001
United States

You're considered hardworking and ambitious. Have you had these qualities your entire life?
Yes, I've always been hardworking, ambitious, and curious. Even as a child, I always enjoyed playing with science kits, and I found chemistry and electronics fun. My parents encouraged my curiosity, too. I built a swing out of Lego bricks and a wobbling monster with wings powered by a motor. When an appliance didn't work at home, I was the one who unscrewed it. And when my mother repaired a plug, I checked to make sure she had wired everything correctly.

Your life's journey seems to have been purposeful and goal oriented. Is that correct?

My path to the Nobel Prize followed a more haphazard course. Initially, I wanted to become a physicist in industry because I wanted to develop products more than just do research. In the second part of my studies, I grew interested in theoretical physics and also did my dissertation on it. After that, I decided I didn't want to remain in the ivory tower of academia, and I chose experimental physics.

For my doctoral thesis, I carried out research on molecules. I then went to Heidelberg to do applied research—combustion research with lasers in physical chemistry. I had a long-term position there, but I concluded that I wanted to work more on open-ended questions and so I returned to basic research. In 1990, at the age of 32, I came to MIT on a fellowship and worked on ultracold atoms. This was new territory, and there was a general expectation that there would be some action.

You once said that for you and your family, the move to MIT was a transition without a safety net. Why did you dare to take this step?

I knew what I wanted: a career in basic research. A decisive factor was that I had previously jumped in at the deep end as a postdoc in Heidelberg. In less than a year there, I'd become so well acquainted with physical chemistry that I was able to set new trends. So, I wasn't afraid of a postdoctoral position in the United States and was confident that I'd prove myself in a new field. And then things went better than I could have ever imagined. After three years I got a professorship, and after two more years I made the discovery for which I won the Nobel Prize, in 2001.

You've had a dream career, beating all your American colleagues. How did you, as a German, manage to overtake everyone else?

I wouldn't say overtake, but I'm right up there at the front. One of the most important aspects at MIT was that David Pritchard became my boss and mentor. In group discussions with him in the early weeks and months, I admired how fast he was and how much knowledge he possessed. My challenge was to be on the same level as him. Within a few months, with hard work, I managed to have discussions with him on that equal footing. But to be able to argue quickly, I had to have numbers and formulas in my head, so I developed a feel for them. I started keeping a notebook and learning the important numbers until I had them in my head.

You won the Nobel Prize for creating the Bose-Einstein condensate. Can you explain in simple terms what that is?

A Bose-Einstein condensate is a material whose atoms behave like laser light. There are two different types of light—namely, the light from a light bulb and a laser beam. With the laser beam, all photons travel in one direction and everything is coherent; with a light bulb, the light travels in different directions and everything is incoherent and random. Exactly the same can be said about atoms and molecules. In normal gases, atoms and molecules move in confusion, in all different directions; in the Bose-Einstein condensate, they literally march in step.

You shared the Nobel Prize with your colleagues Eric Allin Cornell and Carl Wieman, who also discovered the Bose-Einstein condensate. They were the first to make the condensate, so what was your contribution?

For several years, there was a neck-and-neck race between the scientific group at the University of Colorado, Boulder, and mine at MIT. In the end, they crossed the finish line first. We didn't copy their experiment, but we did the same experiment using different methods we'd developed. So, two different approaches were discovered within a few months.

In science, it's important to be the first to research and publish your findings. How did you deal with the fact that you weren't the first to do this?

I had some sleepless nights between July 1995, when the Bose-Einstein condensate was discovered in Boulder, and September, when we had our results. I'd bet everything on an experiment, so first I had to cope with the fact that I'd lost the race. But then we discovered our own Bose-Einstein condensate,

showing that our original idea had worked as well. It took only a few months longer to engineer our results and we were able to produce a hundred times more condensate ten times faster—so we were a thousand times better, in that respect.

Nevertheless, I decided to rebuild and improve our apparatus. In the spring of 1996, we had a dream machine that allowed large condensates that were reproducible. With these results and with great excitement I attended an international conference in France. I showed the new machine and the new concepts for the first time, and everyone recognized what we'd achieved. That was liberating—and at that moment I knew I was ahead. With that giant step forward, my group had taken the lead in a new realm of physics. That's probably why the Nobel Prize Committee decided to share the prize.

How did you feel when you received the call from the Nobel Prize Committee?

The research on the Bose-Einstein condensate had become more and more spectacular, and it was likely that there would eventually be a Nobel Prize for it. Of course, it was possible that only the colleagues in Boulder would win, and I told myself every year that there would be a percent chance we'd be in the running for the prize.

When the call came, it was between 4 and 5 a.m. my time, and I was jolted out of a deep sleep. I walked drowsily to the phone and was given the happy news. After hanging up, I took a deep breath, got dressed, and went for a walk around the block at dawn. The phone wouldn't stop ringing, but I just let it ring. I wanted time to let the news sink in. Then I woke up my kids and told them, made a few phone calls, and went to MIT. There was a huge reception there, of course.

Did you find anything particularly moving at the Nobel Prize awards ceremony?

The most memorable moment was my Nobel lecture, in which I was allowed to talk about my results for just under an hour. I worked on it in between all the ceremonies, thinking about how to make it not too technical, how to generate enthusiasm, and how to acknowledge all the people who had contributed to its success. In my life, I've made only a few speeches where I've felt a huge release afterwards. Following the talk, I was mentally exhausted, but went to the Nobel concert a few hours later. I've never experienced music that so resonated through my whole body as it did that evening. All the tension had been released, and the music was a dramatic experience.

Have you had to pay a price for all your hard work?

As a scientist, I find sometimes something remains stuck in my head until late into the evening and I can't stop thinking about it. Or I might go to the lab on a Saturday because something didn't work out during the week. I'm passionate about my work, and I feel a similar intensity for my family, but I know I can't always do everything full justice. Therefore, I need a partner who understands this. My first wife, unfortunately, took a narrow view of this situation and wanted to change me. My second wife accepts me as I am. She's a professor of history at Suffolk University and she knows what it means to work on a publication and have responsibility for students.

How badly did your family breakdown affect you?

The divorce from my first wife was a turning point and a crisis, but in the end, it was also a release. The moment things really fell apart was when I realized that my marriage had become a corset, restricting me. I realized I could start over again and felt optimistic again. The real upset came from the nasty tug of war over the kids, which made my life miserable for several years. But I was always certain it was necessary and also that it was right for everyone to have the opportunity to build a better life.

You've always tried to push the boundaries in your work. How far would you push your limits?

In science, I experienced a few years of breathtaking developments, and we were able to quickly push the boundaries of knowledge. Now, I notice that my younger colleagues often make faster progress. When you're younger, you can neglect some things,

but if I don't create balance in my life now, I'll never succeed in anything else. In this sense, I feel the limits of my own time.

In sport, as a marathon runner, I also pushed my personal limits for a long time. I wasn't necessarily highly talented, but I achieved some pretty good running times with the right training. In my late twenties and early thirties, I ran several marathons with a personal best of 2 hours, 49 minutes, but then I stopped running because of my family and job. I only started running again when I was over 50 but even then I managed a marathon time of 2 hours, 44 minutes. In recent years, however, I've reached my limit because of injuries. Suddenly my knees began to hurt, and I couldn't run at all for a long time. I have to accept that, even though I'm a fighter.

Have you ever been afraid of anything in your life?

There have been a few situations of great uncertainty. A year into my doctoral thesis, it turned out that my chosen topic wasn't feasible. Suddenly I was at a point where I didn't know what my next step could be. Or in 1995, when another group first made the crucial discovery and I realized that I might never get the credit for several years' work, I saw it as having been a big risk to put all my eggs in one basket.

In my personal life, I've faced the situation of standing in front of a divorce judge and knowing that I could lose part of my family. I was scared then because I realized that I was no longer in full control of things and that a decision could be made against me. But I always had to make the best of it, and in the end it all turned out well.

You graduated from high school in Heidelberg with top marks. Looking back, you said that you might have applied that hard work of getting good grades to something else. What did you neglect during that time?

I was an ambitious student, and I was proud of the praise I received from my parents and teachers. I was nowhere near as gifted at the arts and languages as I was at physics and math, but I pushed myself to the top of the class in almost every subject, nevertheless. Investing time in this meant I couldn't invest it in anything else, however. Maybe I could have developed my hobbies further, I could have played more sports, read more books, done other things. I have more interests than there are hours in the day.

What's your message to the world?

I'd say that there's almost always a good solution to a problem, often even a better one than you had imagined. The fact that surprising solutions can be found to seemingly unsolvable problems advances science. But in a family situation, it also helps to have the mindset that problems can be solved in small and large ways if you're willing to tackle them and make compromises.

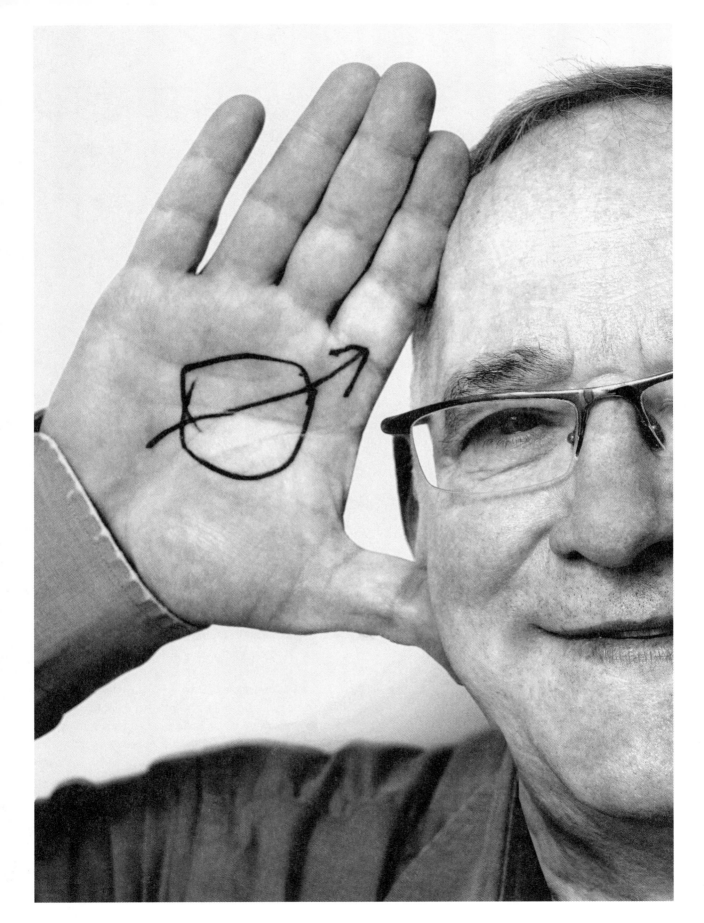

"I WANTED TO DISCOVER WHAT GOD IS TRYING TO HIDE FROM US."

Ron Naaman | Physical Chemistry

Professor of Chemical Physics at the Weizmann Institute of Science, Rehovot
Israel

Professor Naaman, why did you choose to enter the world of science?

I wanted to discover what God is trying to hide from us. I wanted him to do a "striptease." As a scientist, one's goal is to reveal what we don't know yet, to find the good things that nature is concealing from us. And if you find something that changes the way people think, you provide an immense contribution to our world. That's my triumph.

Isn't that also a great motivation for young people to go into science?

Yes! Because in science, you can achieve something that is rare. You can be the world expert in a particular subject! I don't think this can be achieved so easily in any other job. At the end of your PhD research, you are one of the best in your field of expertise.

If you want a big career, you are on the wrong track. But if you want to have an exciting life, it is the right track. How many people of my age run to work each morning, full of enthusiasm and anticipation? Of course, you can make fast money and already have an optimized life by the age of 30. But then what are you going to do with the rest of your life? As a scientist, you keep on creating and learning, and it never ends. And if you are good at what you are doing, you and your whole team will always be happy. That keeps you young.

And what kind of thinking does one need to be successful in science?

You have to know how to ask questions, to bear uncertainties, and be persistent. It's a delicate balance —between being stubborn and being persistent. I used to tell my students that doing science is like pushing a car uphill. If you leave it for a moment, it will roll all the way back down again, so you have to keep pushing and pushing until you reach the top.

Generally speaking, humanity can be divided into two categories: those that pick the normal way to reach their goals and those that always pick the non-normal way. If you want to be a creative scientist, you have to belong to the second group. That may be risky sometimes, but it is also exciting. You also have to be able to think differently, as you have to take a fresh look at a problem in order to come up with a new answer.

Is it a special gift that you think in a different way?

Maybe the Jewish tradition of stimulating children to become independent thinkers plays a role in my way of thinking. And if you come from a minority, you definitely learn how to handle criticism and to stay persistent. Just remember that Einstein's thesis was twice rejected! Most people give up after the second time, but he didn't.

Would you explain your research in a simple way?

There is the property of chirality (handedness) in molecules. All the main building blocks in nature, like proteins or DNA, are chiral. They have identical structures except that they appear in two forms that are mirror images of one another, like our left and right hands. So, they may look completely similar, but just like your hands, they are not the same. In nature—in plants, animals, and human beings—all the chiral molecules appear in only one form. However, if you synthesize those molecules in the laboratory, you get left- and right-handed molecules in a ratio of 1:1. But if we use a drug that contains both forms, it can create side effects and, in some cases, as in thalidomide, those effects can be disastrous. Therefore, the molecules have to be sorted for a purified version of one form. This is a difficult and expensive matter. Thanks to our research, this separation process became much cheaper and easier.

But how do you do that separation?

When a molecule gets close to a surface, the electrons in that molecule are rearranged, and the molecule has now a positive-charged and a negative-charged pole. Electrons—besides having a negative charge—have another important property: they rotate, clockwise or counterclockwise. This is called spinning. We found that when the electrons in chiral molecules are rearranged, those that "rotate" in one direction accumulate at one electric pole, and those that rotate the other way accumulate at the other pole. Which spin accumulates at which pole depends on the form of the molecule—namely, its handedness. If we use a magnetic surface, the molecules of one form will be attracted to the surface, depending on the direction of magnetization. This way we can separate the two forms.

That sounds like a groundbreaking innovation. Were you euphoric at its discovery?

At first, I couldn't believe it. When my students told me what they had discovered, I thought that cannot be true. There is no such physics. It took us two years before we believed our own results. We kept working on it, but even I didn't recognize its importance or consider it a huge breakthrough. But after we had checked everything ten times, we published a paper in the journal *Science*. (Actually, we sent the paper to *Nature* first and the editor sent it back with the remark that it was of no importance for most of the scientific community. I don't want to generalize, but many editors are mostly trying to push topics with buzzwords.)

How did the scientific community react?

A large part of the community didn't believe us. This was a hard time, because we were standing literally alone, in the cold. People were doubtful. The topic was just so totally new and different. Most didn't understand what our research really meant. We reacted by helping them carry out the experiments in their own labs, and a group in Münster, Germany, did support our results and showed that it's really a big effect. That happened in 2010, eleven years after we had discovered it. Only then could I understand its impact. Then we received a lot of money from the European Research Council to expand our research. After that, it was clear we had discovered something enormous.

But you were unsure of its importance for so many years?

It's amazing how long it took me to appreciate what I had discovered. All in all, I was too self-critical, and the responsibility was weighing me down. I had to be sure that everything would be 100 percent correct. I hardly slept at night, as I always worried something might be wrong. That was the case during the first ten years of this project. And it is why the results from the group in Münster, which confirmed our research, were so immensely important to me. Because, deep down, I had doubts myself. Things looked too crazy; to this day, there is no really good theory that explains what we saw. And in the beginning, that really scared me.

How confident were you as a child?

I grew up in old-time Israel. My grandparents had immigrated to Israel, so my parents were born there. When I attended first grade, I felt like an outsider, as I was the only kid who spoke Hebrew; everybody else had come from abroad. And, later, when my family moved around the world a lot, I was often again the stranger, so I soon adopted a façade of confidence. I had no choice. However, inside, I don't think I was ever confident. At the age of 11, I decided to stop crying, as I viewed it as a sign of weakness and I didn't want to be seen as weak. So, I never cried again. But, of course, you pay a price for that. If you don't show your weaknesses, people tend to sympathize less with you and that leaves you isolated.

But being exposed to the fact that things in the world are complex, and that you'd better learn to understand them at a young age, also taught me how to be alone. That's important in science, as you are often alone with your thoughts, with your work, and especially with your new findings. You have to be able to remain alone in the "cold." That's an important ingredient for work as a scientist.

I guess you have worked very hard. So, how has your work-life balance been?

I have four children, and as I married a second time, I gained another three children from my wife's earlier marriage. We have twelve grandchildren, and family life is extremely important to me. Even now, with my children grown up, I always want to be there for them. But when they were small, the only way to make this possible was sometimes to be awake almost around the clock. In the morning I woke the kids, made breakfast, sent them to off school, and went to work. I used to arrive home at around 6 p.m., have dinner with them, put them to bed, and go back to the lab. Then I worked all night and came back home again in the morning. You need a lot of energy to do that, and you have to know exactly how to manage your time.

Edward Teller, the father of the hydrogen bomb, said that scientists are not responsible for their findings, that it's the politicians who use those findings who are responsible. How do you see your responsibility?

Basically, I agree with Teller's comment. Because, as you know, the knife has killed many people, but you would not like to have a civilization without knives, right? We have to be a social system that knows how to use inventions in a clever and useful way. And you're happy when you find something that really helps humanity. For example, Ritalin is given to a lot of children with attention deficit disorder, but is expensive to purify. With our separation process, though, it is possible in principle to do this far cheaper. And so, I feel that I have really contributed.

How many women work in your lab?

I always have had women in my group, but it is a major challenge for women to have a dual life of raising children and being successful in science. The real problem is the number of tasks a scientist has to perform. We have to manage a research group, find the funding, do the research, write the papers, and give the talks. That doesn't leave much time for family, unless you really spend twenty hours a day awake. Many female students are not willing to leave their children for so many hours.

I call the successful women "superwomen," as the workload is impossible for an average person.

But as we all want to have more women in science, we have to change things. If you want to be creative in science, you have to think outside the box. By bringing people from different genders and different cultures into your group, you introduce new ways of thinking—that's essential. So, equal rights are important, not because we are generous human beings but because we need all this diverse input.

What is your message to the world?

We are facing the big issue of global warming. With the help of technology, we will be able to live with it. The technologies required to contain global warming already exist, but everybody has to participate.

Also, we must work toward the betterment of all people. Some don't realize that if we help the people in Africa become richer, there will be more work and that will result in a better life for everybody. It is simply not true that if somebody gains, somebody else loses. We can all win.

Are you a happy man now?

There is a Jewish joke: the worst thing you can do to a Jew is not give him a reason to complain. But actually, I don't have a reason to complain. I learned to never give up, that it is never too late to fix something that's wrong. I am much more confident now, and I know that we are going to make big waves again in science. So, even if somebody gave me $100 million, I wouldn't change my life one bit!

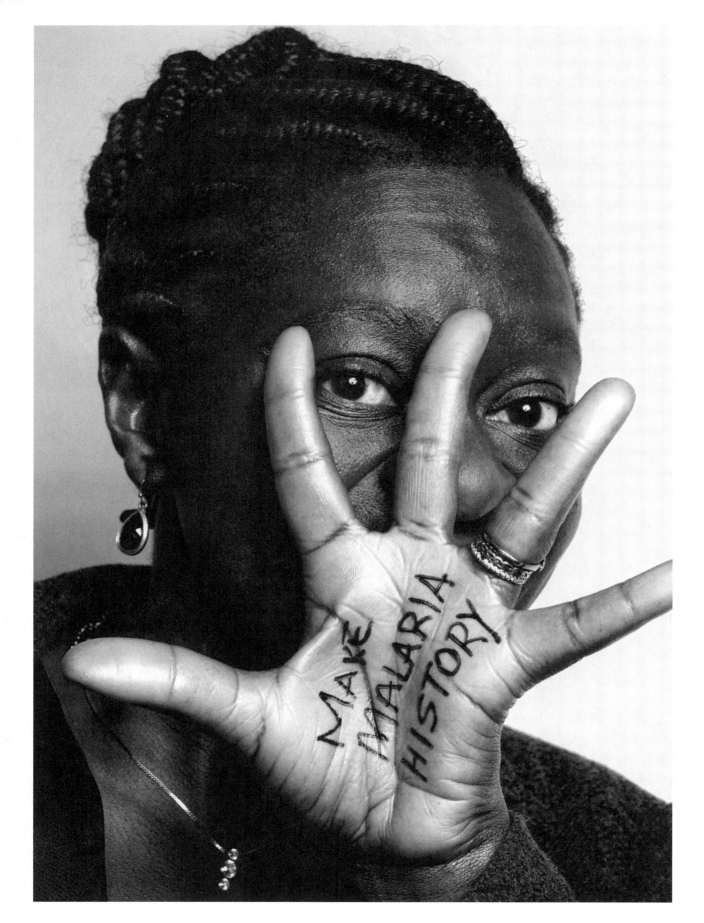

"I SEE MY ROLE AS INSPIRING YOUNG SCIENTISTS TO DRIVE CHANGE IN AFRICA."

Faith Osier | Immunology

Junior Professor of Medicine at the Ruprecht Karl University of Heidelberg
President of the International Union of Immunology Societies
Head of a research group at the KEMRI-Wellcome Trust Research Program, Kilifi, Kenya
Germany

You were born in Kenya and attended medical school in Nairobi. How difficult did you find medical school?
I found medical school quite hard. I was a star in high school, then in medical school all the clever people from around the country were brought together and I suddenly found myself at near the middle or lower end of the class. I had to find strategies to survive, such as focusing on my past papers.

You then took up an internship in Mombasa?

My older brother lived in the coastal city of Mombasa, and I had this romantic idea that I'd see my patients and then afterwards go for a walk along the beach. But it turned out that there were gangsters on the beach, so I couldn't even go there!

My internship in Mombasa was intense, too. Seemingly overnight, we went from following doctors around the ward to being the doctor on call with real patients—and having to assume all the responsibility that accompanied that. I heard about British doctors in a nearby town who specialized in malaria and were good at pediatrics, and as I'd been most interested in pediatrics during my training, I went to visit them. Eventually they offered me a job.

Why did you then switch to research?

Basically, I didn't want to spend my entire life treating patients in the sick ward. I'd be on call at night and might admit up to five children to intensive care, who could die at any moment. And the look in the parents' eyes when they carried the child's body home stays with you forever. So, the idea of work on prevention started brewing. I started to think, *What if I could prevent these people coming to hospital in the first place?*

But you doubted whether the money from research would put enough food on the table?

I come from a lower middle-class African family of six children, with many relatives who are also dependent on my parents. My parents felt they'd done their best educating me to become a doctor, so it was hard for me to tell them I wanted to study instead. Money was important for them; as a doctor, I could earn lots of money, whereas as a PhD student, there is no money coming in.

After I'd earned my PhD, I presented them with a special copy of my thesis. They said, "Oh, how wonderful" but I knew in their hearts they were disappointed, thinking, *We invested all our money so that we could reap some benefits, and now she gives us a book.* In the end they were happy, though, when I became a professor.

Can you tell me something about your parents?

My mother, who has sadly passed away, was an English teacher. I credit her for a lot of who I am. She was fun, warm, and sharp. She taught me the Queen's English and passed on her love of books. Back then, a teacher didn't earn much but did hold an elevated position in society. My siblings and I used to get annoyed when she would share everything she had with the rest of our village. I didn't have a nice pair of shoes until I was in high school because she'd bought shoes for everyone else in the village!

My father was an electrical engineer who worked with the airlines, and later at Kenya Power and Lighting Company, where he earned more and was given a company house. My father was a strict disciplinarian. He made sure we studied hard and he pushed us, particularly the older three children (I was child number two), while he was more relaxed with the younger three. Now we can laugh about it, but at the time we weren't happy at all.

My parents came from humble backgrounds. My father went to school hungry and without any shoes—a real hardship. They managed to break out of this cycle of poverty and produce six children who all are college educated and work independently all around the world. The family ties are still strong; we look after our remaining parent and meet every year in his house for a reunion.

So, your parents taught you to push yourself?

Yes, their drive helped me get where I am today. Plus, when I went to high school, a friend who's now a neurosurgeon in the United States pushed me, too. She would wake us up at 3 a.m., and we'd work for a few hours without interruption while everyone else was still asleep. So, it's become a habit: I still go to bed at around 9 p.m. and wake up at 3 a.m. to do my best work, because my mind is calm and nobody else is around. I can still turn on the discipline when I'm under pressure.

You had to repeat your postgraduate pediatric studies a few times before passing your exam. Why was this?

Yes, if I'd failed the practical part a third time, I'd have to start all over again, so I was desperate to pass. I studied in the UK, where there were a lot of topics we'd never covered in Kenya. I had to memorize the theoretical part, yet that took up only the top 30 percent of the exam. As for the practical part, it was challenging learning the British bedside manner for interacting with patients. I had to learn to make the children feel comfortable with me.

But you finally succeeded?

Yes, and as soon as I finished, I said, "Phew, I'm out of here!" By that point it was clear that I wanted to go into research. If that effort fell flat, I would work as a doctor, but not just as a junior doctor. So, in Kenya

I specialized as a pediatrician with the Kenyan Medical Association to ensure that I'd be a consultant, if I ever chose to work as a doctor.

Did you immediately go into malaria research?

I wanted to study immunology—the immune response to malaria. So, I decided to take a master's degree in human immunity at the University of Liverpool, UK, while working part time as a doctor in the emergency room to pay for part of my tuition. Afterwards, I applied for fellowship funding from the Wellcome Trust to fund my PhD, which involved spending half my time in Kenya and half in London. For my postdoctoral studies, I spent time in Oxford, in Kenya, and in Melbourne, Australia.

I then set up a lab to do malaria research at Heidelberg University Hospital, Germany, employing two new PhD students from Kenya to help me. I also had a female technician from Germany, which was helpful because of the language barrier.

What was it like setting up a new lab?

It was challenging and exciting. For the first time I had my own lab. In Kenya, we just shared one big lab. The main lesson for me, though, was learning the value of teamwork. If you decide you're going to do everything yourself, you just burn out, but if you've a good team who understands what they have to do, then they just do it.

What about funding the research?

At the start, when the research money was all ahead of me, it was okay. Three years later, that money has almost run out and the pressure is on to find more. I'm writing new research grants to bring in more money so we can continue our work. For example, I won a senior fellowship from the European and Developing Countries Clinical Trials Partnership (EDCTP) for work in Kenya, so I could hire people there. I also won two large grants from the Wellcome Trust to carry out malaria challenge studies. Now, I need more money for the Heidelberg lab. I was slow in applying, so I'm feeling the heat, but I think we'll get funding. I'm stressed, but not worried.

Malaria remains such a huge problem in Africa.

Yes, 200 million people in Africa are infected by malaria, and half a million are dying. Infants and young children are the worst affected. Teenagers and adults don't suffer so badly, so we're trying to understand what their body has learned to handle it, so we can pass that learning onto the young.

In the 1960s, researchers collected blood from malarial-resistant people, extracted and purified the antibodies, and used this to treat malaria patients: it worked. We've repeated the experiment, deliberately infecting Africans with the parasite. (The FDA has approved a parasite that you can use to infect humans for study.) Those people with a lot of antibodies didn't become sick, and this fills me with so much energy to find a solution. That is, people are walking around with the answer to curing malaria—the answer is right in front of us!

What does this mean for your work?

I now have to define the work at a molecular level. I need to understand the process of how humans become resistant to malaria so I can make a vaccine.

Infecting people for study is a serious business. The first time, we spent about two years just talking to people about it, explaining what it's like being bitten by a malaria-carrying mosquito, and that we would be infecting you with a parasite that we know we can treat. It wasn't easy breaking down this barrier of resistance to the idea. But it's now so exciting for me to have these blood samples and to know that these people possess the magic formula! That is, I need to find out what's in this tube so I can produce a synthetic version. I want to deliver a malaria vaccine for my village people and all the others who haven't had the same chances as me.

How far away are you from producing a vaccine?

It's difficult to provide an exact time estimate, but in five years I think I'll have a product. We already know which proteins are important for the parasite, and we now want to isolate the antibodies that bind to those proteins. Then we can inform other cells in the body with killing power, like white blood cells, to come and eat the parasite. I'm excited because

we've already overcome the infection hurdle in humans, and now I test whether we can make other humans react in the same way as those who carry lots of antibodies.

I expect it's a rigorous process.

You need to follow strict U.S. FDA and European Medicines Agency guidelines. After showing the results of animal tests, you can start the human test stages, first with a small trial involving a few people to see if it is safe and what the correct dose seems to be. It takes years for any new medication to be approved. If you make a mistake, and someone has a serious adverse reaction, you are in big trouble, so that's why they need to take all these steps to ensure you go slowly until you get it right.

Are others working on the same idea?

Yes, it's a real race. Those at the front of the pack are looking at the sporozoite stage. That is, when a mosquito bites you, it injects you with something and they're trying to stop that something from reaching your blood. The vaccine in trials in Africa right now is based on a protein from this stage. Analysis shows, though, that the vaccine protects only four out of ten people, which isn't good enough. In clinical trials next year, other groups will be testing a single antibody that targets the same sporozoite stage. I'm putting my money on the blood stage, where this approach of using antibodies has already been shown to work.

Other researchers are employing different approaches, but the bottom line is that nobody has got anything yet that is highly effective, so we're all at the same point in the same race. There's a lot of money in it for whoever succeeds in creating an effective vaccine for malaria, but it's the poor who suffer most from malaria, so the solution has to be cheap or somebody has to subsidize it. The most important thing is to first have a product that works and then we can find ways to finance it.

How does being in both Heidelberg and Kenya work for you?

It's a good combination; there's always the connection to the patients who have the problem and the

survivors who have the solution. We can leverage technology and resources to find out what turns a patient into a survivor, and then use this to develop a vaccine.

You've said that you want to stop the brain drain from Africa. Is this possible?

When I came to Germany, I found a new terminology that I like—brain circulation, meaning that people should move around. Science is international, and the time I've spent working abroad has been so enriching that I encourage scientists to not always stay in one place.

You once said women are "knocked down" by nature. Has that been your personal experience?

I've been seriously knocked down. When I started trying for a baby, I assumed it would all happen automatically, but I had repeated miscarriages. The first time the baby was delivered at eighteen weeks, and I held the infant until its heart stopped beating; they can't resuscitate at eighteen weeks. You think things will be better next time, but then it happened again, and again. I lost four pregnancies: two at eighteen weeks, one at eleven weeks, and once when the baby was born at twenty-five weeks. We were in Kenya at the time of the last birth, and there weren't proper facilities to look after this tiny baby, who died after a month in an adult-level intensive care unit.

Those were major blows. You have to deal with a sense of failure and psychological trauma, then after a couple of weeks you have to go back to work and face all your colleagues. I've met many women who've suffered from the same problem, but nobody talks about it. Now I tell other women, "Life can be hard, but the important thing is to not stay down but, rather, to pick yourself up and keep on going."

How did your husband react to those losses?

My husband is one of the kindest people on the planet. He'd say, "Oh, it's bad luck and we'll try again." We never thought about giving up. Then some new doctors told me I was probably getting an infection at some point during the pregnancy, triggering premature labor. They said, "Once you reach twelve weeks, and we know the pregnancy is okay, we'll start you on antibiotics, which you should take until the end." They monitored me the whole time, and this time it worked and the same was true for the two pregnancies afterwards.

Your husband wasn't allowed to work in the UK and join you?

My husband is Kenyan and works as a builder there. The UK requires different paperwork, which would mean his starting his training all over again. The dynamics weren't good—I was working, and he couldn't. So, when I received an offer to go to Australia, I told him, "I'll take the baby and go and you can carry on with your business in Kenya and visit us; I don't want to be responsible for you."

It was a difficult time. I was a single mom with a one-year-old, and I just wanted to work in the lab, but I was tired all the time—mentally not in a good place and wishing my husband was around. After two years, we returned to him in Kenya.

Then you moved to Germany?

Yes, the offer came up to go to Heidelberg, and my husband told me to go for it, so I moved there, this time with him and our three children. He agreed to look after the kids, so Mummy goes out to work while Daddy minds the kids. He'd rather spend time with his children than doing some useless job. And I travel so much. The kids understand that Daddy is the main person looking after them.

Are you jealous?

No, not at all. Sometimes my husband goes to Kenya for a month, and by the time he's back, I'm going crazy because it's all too much!

Have you encountered prejudice in the scientific world?

Well, I'd say that being a woman, and being an African, doesn't put you high on other scientists' lists. So, I find that people underestimate me and treat me as if I'm insignificant, but I don't fight it outright and I just let it be. Later they realize they can't mess with me. In the end, what brings me to the table is my science knowledge and skill.

The painful reality is that it's a man's world out there and men have dominated it for so long. It's not like they give you a hug when you arrive at an event; you're left sitting alone in the corner, while they're happily chatting away. I used to feel lonely, but I had to get over it; I wasn't going to sit there and cry because I wasn't in their club. There are negative people out there, but there are also positive, supportive people who cheer loudly for me, saying, "Keep going, we're so proud of you."

What attitudes helped you get where you are today?

Belief in what I'm doing and giving it my all. I climbed the science ladder, thanks to a simple experiment called ELISA [enzyme-linked immunosorbent assay], in which a malaria parasite protein can be used to detect and measure antibodies in your blood. I learned so much from that experiment, and I always tell young people, "You've got what you need in your hand. Put all your energy into it and this will open doors."

What's your message to the world?

My message is to keep on supporting science so we can find solutions to get rid of disease and alleviate human suffering.

How can the West best help Africa?

The West can provide training opportunities for African scientists and teach people to come up with their own solutions. The mentality from colonial times still prevails: look to our master. I want to see change, with a lot more homegrown solutions being driven by Africans.

What about your own future?

My future is bright. I've been given a unique opportunity to be an advocate for African science. I see my role as inspiring young scientists to drive change in Africa. If I can help champion that, then I'll have done my part, because I know that the next generation is going to make things better for the generation that comes after that.

"MY BEST TEACHERS WERE MY STUDENTS WITH THEIR PROBING QUESTIONS."

Helmut Schwarz | Chemistry

Professor Emeritus of Chemistry at the Technical University of Berlin
Long-time President of the Alexander von Humboldt Foundation
Germany

Professor Schwarz, you started out as a chemistry lab technician but then took a different educational route and earned your doctorate. Why did you switch paths?
Curiosity drove me. As a lab technician, I learned a lot of practical things, but the prospects were limiting. There was hardly any opportunity for asking questions. Chemistry, however, means taking an interest in change. That's why I sought independence, wanted to learn something new.

I was the only one of my siblings to leave home. It just wasn't expected in my family, but they never stopped me from going my own way. I grew up in the postwar period, when my parents had to work so much that they found very little time for their children. My father was a salesman, although he'd have preferred to be a pastor or learn Greek or French. A little of the drive to be outside of the ordinary was probably in my veins. You have to make your own luck and take things into your own hands.

Being a teacher also means being a leader. What have you passed on to your students?

At the end of my studies, I had a somewhat maverick academic teacher who told me, "If you work for me, I can give you space, but you have to fill it." I've tried to apply this principle with my students as well. As a researcher, you should also be a good academic teacher. I was often possibly too demanding and therefore put off many graduate students because I required them to be passionate about what they were doing.

My principle as a teacher was not just to repeat what was in the textbooks but also to incorporate things in beginners' lectures that had become clear to me just two weeks earlier. The limits of knowledge should be highlighted quite early on in a course. My best teachers were my students, with their probing questions; I was always both teacher and student.

You've mentioned you have had doubts. Where has questioning yourself led you?

Self-doubt is an integral part of me, and I can only be thankful for that. When I finished my PhD in 1972, I had good offers from the chemical industry and other organizations, but I wanted to stay in academia, even at the risk of failure. I wanted to do something I was passionate about, even if I sometimes doubted whether this decision was right. For example, I doubted myself when our publications weren't initially accepted. Today, I realize that I was always an outsider. Even in childhood, I was insubordinate. Later, I was never part of the mainstream. Security wasn't ever a priority for me. Only the dead fish move downstream; I like to swim upstream.

"TODAY, I REALIZE THAT I WAS ALWAYS AN OUTSIDER. EVEN IN CHILDHOOD, I WAS INSUBORDINATE."

You were a bit of a revolutionary back in 1968, but now you describe yourself as old-fashioned.

Yes, that's me on the face of it. Until recently, there was no computer in my office, and I don't own a cellphone. I need nothing more than a pencil, paper, and a discussion partner. My laboratory, however, is technically state of the art and one of the most expensive chemistry facilities around.

My principle is that you don't have to do everything yourself down to the last detail, and, rather, should encourage doctoral students and postdocs to develop their own spirit and give them the freedom to do so. At the same time, I also want to bring a group together and show them how productive and enriching it is to be part of a team.

How do you choose your PhD students?

For the first six months I have to be their guide, just like in mountaineering. After that, there is a transition period, and then after a year, the doctoral students become my guides. If that doesn't happen, we're not properly matched. By German standards, I've guided relatively few people to their doctorate—in over forty years, about fifty, and I had maybe forty postdocs. But almost all of those who "survived" those two years are real gems.

As a teacher, I've tried to mold them a bit and give them encouragement, because I myself have been severely criticized for some experiments and publications. As a young private lecturer, I once presented new research results at a conference. I had

hardly finished when an influential colleague jumped up and said that it was all rubbish. As a young person, you have to put up with being told something like that in public. In science, you need backbone.

When your articles were published, was your name listed first or last?

I was named first in very few papers; I was usually last. Being named last is important because that signals you're connected with the whole institution and the subject beyond the publication, and, yes, I was the one representing the institutional record for the whole unit. This doesn't diminish other people's contributions, and I've always left it up to my colleagues to choose the order in which they want to be listed. However, I have some distinguished colleagues who always put their names first, even if they've contributed only marginally; for me, it was always clear that I'd be listed last.

More and more universities are collaborating with large companies. Why are you still committed to basic research?

Collaboration is essential, but it should never lead to restrictions on basic research. Everything of practical significance can be traced back to research. There would be no GPS without Einstein's general theory of relativity, which from a practical point of view was completely irrelevant! Basic research is a common good, giving free space to think about things that don't immediately have solve a certain problem or be useful for society. There is an infinitely long chain of findings based on basic research, and for this reason alone this freedom to research must be protected and preserved.

You once had a "love affair" with soccer ball molecules. Can you describe that in simple terms?

When two fast-moving cars collide, they either fly apart or become totally deformed. That is, it's impossible for the two objects to retain their original shape after collision. But in the case of a soccer ball molecule colliding with a small atom, we managed to have the atom penetrate the molecular soccer shell and for the molecule to retain all its glory. This finding completely contradicted all known experiments.

I was more or less thrust into this field of study. In the early 1990s, a visiting professor from Canada showed me a small bottle of soccer ball molecules and asked if we would like to experiment with them. I was skeptical, but as it happens, my coworkers were experimenting behind my back. One day I found a piece of paper with symbols on it laying on my desk, and I immediately realized that something sensational had just taken place. The result of that experiment kept on going through my mind for weeks, then one night I experienced my eureka moment. I wrote everything down, the next morning I carried out some more experiments, and then everything became clear.

"I'VE ALWAYS NOTICED HOW FIERCE THE COMPETITION IS IN SCIENCE TO BE FIRST."

The colleague who had brought the black molecules was at a congress in America at the time, and we faxed him the results. After his lecture, he wrote that while he was describing the experiment, two colleagues left the room. It was immediately obvious that they wanted to replicate the experiment and quickly publish the results. Within a day I'd written a manuscript and sent it to the German Chemical Society journal *Angewandte Chemie*. Three weeks later, the paper was published, and two weeks after that, other journals published those two colleagues' work. I've always noticed how fierce the competition is in science to be first.

You've also been politically involved in the sciences, and for ten years you were president of the Humboldt Foundation. Why was that so important to you?

The post of president of the Humboldt Foundation is an honorary position, so I was able to remain a teacher and researcher. There was a political component I wanted to promote because I could leverage my particular standing as a scientist for the Foundation. I wanted to anchor the Humboldt Foundation in politicians' consciousness so that there would be continuous, adequate sponsorship and that the Foundation's principle of sponsoring individuals, and not projects, would, like a kind of statute, continue to be upheld.

Besides being a scientist, you love opera. Why opera in particular?

I find opera appealing because it represents the most complete synthesis of the arts. This mixture of lyrics, life, music, and theatrical performance exists only in opera. Just as how a professor delivers his lectures plays a major role in education, so I take inspiration for my lectures from the way Claudio Abbado conducted, or how Carlos Kleiber had only to lift his finger to create a spellbound atmosphere. I also enjoy reading poetry by Bertolt Brecht or Paul Celan, and I wouldn't want to be without Goethe's *Elective Affinities* or Thomas Mann's writings.

What made you who you are today?

My environment and the people I was curious about. I realized how much you can learn by opening up to other people, and then in return giving something back to them later. My principles are optimism, self-criticism, honesty, and respect.

Why should a young person study science?

Science represents one of the few opportunities to really create something new. Curiosity has always been my most important motivation. A scientist has to be interested in things he doesn't understand, he has to be prepared to live with setbacks, and he has to know that chance plays a major role. You also need a certain kind of obsession about not giving up too soon, as well as resilience—and of course, some talent and intelligence doesn't hurt, either. I would also advise against becoming dependent on any fads. The important question should always be: Am I interested? At the Humboldt Foundation, and in the network of research and sponsorship organizations, I've also learned that in this rat race, a certain lust for life doesn't hurt.

It's said you take your problems to bed with you. Do you get any sleep at all?

For decades, I got by on five hours of sleep. I went to bed between 11 and 12 p.m., and usually got up again around 4 or 5 a.m. Yes, I do take my problems to bed with me. Once I worked on a problem for almost three years, and I tried umpteen times to put it down

on paper, but it still didn't make sense. Around then, I went to a concert, the musicians looked bored and played in a bored manner, and I too was somehow bored, but I completely relaxed. And suddenly I knew the answer to the problem I'd been dealing with for over two years. I left during the intermission and immediately wrote everything down at home.

How many of your dreams have come true?

I definitely wouldn't ever have dreamed of all the things I'd go on to achieve. None of this came easily to me, but it could hardly have worked out better. Working at the Humboldt Foundation was the icing on the cake because science and the promotion of science were ideally combined there. I can also only be grateful that, as a teacher, I met an unusually high number of talented people who time and again made my own limitations clear to me. Sometimes I wished for an environment in academia that had a little more of the ideal university. The intellectual atmosphere hasn't left universities, but it was my decision not to go anywhere else.

Why didn't you leave? Didn't you have the guts?

There was a mixture of reasons. As a young lecturer in 1981, I was at a lecture at ETH Zurich [Swiss Federal Institute of Technology], with many colleagues whom I admired. I said in passing that this was one of the places I would walk over hot coals for. Twelve years later, an offer came from Zurich saying in essence, "Come on, then, you don't have to walk over hot coals, either; quite the opposite." But in 1992-93, the Berlin Academy had just been founded, and it was clear that I should play a role there.

In addition, the German Research Foundation [DFG] had awarded me the Leibniz Prize in 1990, with the condition that I spend a huge sum of money on research within five years, or it would be forfeited. And then the DFG told me that they would waive the five-year limit if I stayed. But maybe I was also a bit of a wimp, because the expectations for me would have been immense.

On the one hand, you're modest, but in some respects you're vain. How has your ego been stroked?

One time, a young woman from Heidelberg came to me and said she wanted to do her doctoral thesis with me. I had given a lecture in Heidelberg two years earlier, and after that she was clear: if she did a doctorate, then it would have to be with Mr. Schwarz. It's nice for the ego to receive a compliment. It does you good.

Chemistry is a conflicted domain, in that it can be used both positively and negatively. Where do you see your responsibility for the future?

There will hardly be a pivotal problem in the world in the next twenty years that can't be solved without the involvement of chemistry. But as chemistry deals with changing matter, and people usually fear change, chemistry doesn't have it easy. However, if we could make it clear that chemistry, together with other scientific fields, can really help solve problems, it would be a huge step forward.

What's your message to the world?

Have more trust in the meaning of what's new, more faith in what people are doing. To be open to the unknown and the unfamiliar.

What's your nightmare?

Forgetting. Dementia. Memory is what I'm most grateful for. To forget everything—who you are, how you became something, and what you became—that to me would be a personal tragedy.

What have you learned about yourself?

Sometimes I have had too much hubris, was too impatient, and expected too much of others. I've become smaller as I've grown, and that's been good for me.

"IN SCIENCE, YOU NEED BACKBONE."

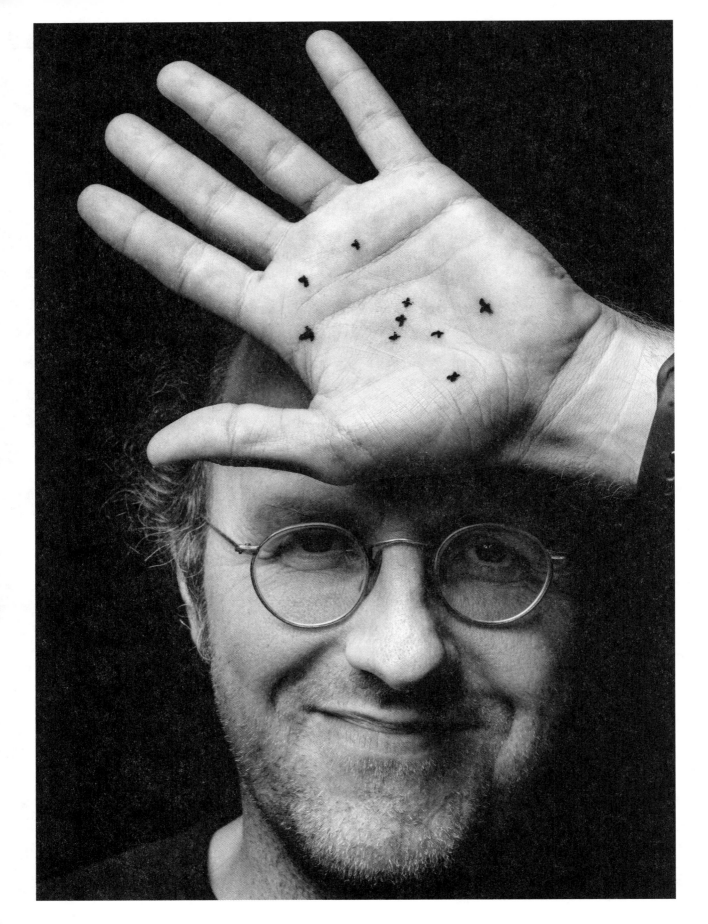

"YOU DON'T GET AHEAD IN SCIENCE BY DOING THE SAME THING AS LOTS OF OTHERS ARE DOING."

Bernhard Schölkopf | Computer Science and Artificial Intelligence

Director at the Max Planck Institute for Intelligent Systems, Tübingen
Professor of Empirical Inference at ETH Zurich [Swiss Federal Institute of Technology]

Professor Schölkopf, you studied physics, math, and philosophy. Why did you add philosophy to those fact-based subjects?

I started off with physics because like many scientists I wanted to understand what holds the world together. During my studies, however, I realized how much was still not understood and that, especially in quantum mechanics, questions of the measurement process, in which the subject interacts with the world, were still open. So, it occurred to me that the search for discernible structures in the world is just

as interesting as the fundamental questions of theoretical physics, and I ended up in philosophy.

Machine learning theory is the application of a branch of philosophy that deals with how we reliably discover structures in the world. In a way, we can discover structures only that we ourselves think are possible and, in that sense, are already within us. At the same time, it's extremely difficult to recognize my own structures. I also find it difficult distinguishing faces. Even as a child, I was said to be a bit absent-minded.

Were you also rather withdrawn as a child?

I was interested in astronomy and other scientific topics from an early age. I didn't grow up in a particularly intellectual environment, and I remember that some of my parents' friends called me "professor." But there were no negative remarks nor any pressure on me to develop in a particular direction, even though my father, who was a building contractor, might have expected me, my brother, or my sister to take over the company at some point. Which all three of us didn't do.

You worked in Cambridge, UK, and in the United States. Why did you come back to Germany?

I was given the opportunity to take up a directorship at the Max Planck Institute in Tübingen. I was still very young, and a colleague on the appointment committee asked me whether I wanted to do it and whether it wasn't too early for all of this. I asked him if he could promise me that they would make me the same offer again in five years, and he said: "Unfortunately, I can't do that." So, I said yes, and by chance and rather untypically for a scientist, I almost ended up back in my hometown.

You entered the field of artificial intelligence [AI] very early on. How did it interest you?

When research into AI was first carried out in the 1960s, there was great optimism about its future, but it soon became clear that the big promises weren't being fulfilled. The paradox is that computer science was derived from AI, but many computer scientists wanted nothing to do with the concept of

"SCIENCE INFLUENCES SCIENCE FICTION, BUT SCIENCE FICTION ALSO ANTICIPATES SCIENCE AND INFLUENCES SCIENTISTS."

AI for a long time. I didn't actually use the concept in my field of machine learning.

Machine learning has a lot more to do with pattern recognition, while AI is based on the thought that intelligence could be explicitly programmed into systems. It's unlikely that intelligence has been programmed into existing biological intelligence systems—namely, humans and animals. I prefer to think that learning plays a central role.

What are the key disciplines involved in machine learning?

We provide algorithms, but only a small amount of the information contained in the learned systems comes from these algorithms. It is mostly derived from observation data. In this respect, they are learning systems, even if we provide the decisive structure for how that learning takes place. It's pattern recognition through learning, and in many cases, this already works better than in humans. However, human biases and misconceptions flow into the algorithms, which influences the results. That's a problem. We still have a long way to go before we know how learning works in biological

systems. When it comes to transferring knowledge from one problem to another, humans are still far better than the existing machines.

What's your view on the increased and easier manipulation of the mountains of data that is collected?

The possibilities have increased with automatic processing of information, and with new methods, the machines are becoming more intelligent and thus better tailored to the individual. But this development began in the mid-twentieth century, and much of it was anticipated by science fiction author Isaac Asimov. We're now seeing what Asimov wrote about actually happen. Science influences science fiction, but science fiction also anticipates science and influences scientists.

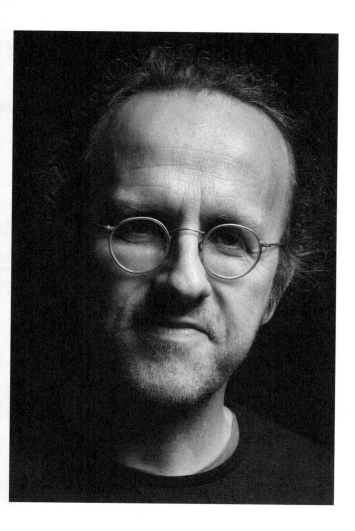

Even as a child, I liked reading science fiction. Sometimes it's easier to predict what negative things might happen, but I'm basically optimistic. The industrial revolution must have come as just as much a shock to people back in the nineteenth century, but I don't think many would want to go back in time. And in fifty years' time, when many diseases are more treatable by AI methods, it's hoped that our children's children will say that the way we treated cancer was antiquated.

In the future, many menial jobs will be lost, possibly giving rise to mass unemployment. Won't that lead to an uprising in society?

There is a danger of that. All technology leads to commercial gains, and even during the industrial revolution, there was unrest; people destroyed the power looms because they were afraid of losing their weaving jobs. At every major step in history there have been winners and losers, and that often leads people to move to other countries for greater opportunities. On the other hand, if you consider the invention of the car, it's amazing how much we have accepted its impact on human life. As a scientist, I can't predict what will happen; I can only try to do my bit.

As a scientist, do you feel any responsibility toward society?

Machine learning and AI can be applied to weapons systems. No one can really foresee how the technical possibility of such systems would affect warfare. That is, I don't know if AI will make warfare safer or more dangerous, or if wars will even become less likely, but I'm concerned about the application. Everyone should be aware that it's a dangerous development. Most people have a sense of responsibility not to risk other people's lives or to kill them. With autonomous weapons systems, it's conceivable that the killing threshold could be crossed.

Could a robot also lose control of its temper?

Not at the moment; but ultimately humans are complex machines. Every human behavior has some biological function, and so does losing your temper. Perhaps it's a reaction to defending your children in

a conflict. If AI were developed in such a way that it had to defend children in cases of doubt, it might also have to be able to go berserk. But the goal shouldn't be about building an intelligence that copies human intelligence.

Some people think we're on the verge of developing systems that are more intelligent than humans, that these systems will in turn build others that are even more intelligent, and that soon there will be a superintelligence and the game is over for us. I think that's naive; it's like the idea that a system smaller than a hand could easily build an even smaller system until we get to infinitely small systems.

To what extent is it possible to reproduce human social intelligence in a robot?

This would require more intelligent computers that learn not only from input-output examples but also culturally. We humans also learn by observing others, and there are all kinds of complex cultural cues we use to do that. For us, cultural learning is extremely important, and at the moment we don't really know how to transfer something like that to computers.

Sundar Pichai, the CEO of Google, has talked about AI changing human nature far more than did the discovery of fire or electricity. Do you agree?

Information processing is much closer to what makes us human than energy processing. We're changing the world so much because we're particularly good at processing information, not because we're stronger or faster than other animals. Machine competition in this field may therefore have a greater impact on our self-awareness than the earlier industrial revolution. Even with today's knowledge, it's difficult to say whether the invention of fire or agriculture was more essential for human development.

In 2017, start-up companies in China accounted for 48 percent of all global AI investments, compared with just 11 percent a year earlier. How do you view this development?

There's a lot of industry investment in the United States because companies are running business models based on data, and AI now provides a methodology to automate and scale up intelligent data processing. In China, the separation between industry and government is less clear. It's definitely a government strategy to develop leadership in this area of technology, but there are also clear economic interests, as China is as capitalist as the West—just in its own way. However, there is a legitimate concern that information processing will also be used to control people. Facial recognition is already pretty accurate. In the future, showing your face could be enough to reveal your identity.

Isn't Europe, and Germany in particular, falling further behind in this scientific race?

That is a concern. Germany was involved in the development of AI relatively early on, but more modern AI has been carried out in the United States and in the UK, and now more is being done in China. At the Max Planck Institute, I was the first scientist to research machine learning, and I was appointed to a biological institute at the time. This later gave rise to the new institute, which is probably the top address in Germany in the field of modern AI. But today's young scientists can easily use the internet to check the international status of research, and doctoral students go where the action is, so many head to the United States.

You didn't turn your back on industry, either. How did you come to work for Amazon?

I carried out essential parts of my doctoral work at AT&T Bell Laboratories, and later I worked at Microsoft Research. There's a lot of cutting-edge research being done in industrial laboratories, where many top scientists sit down together and intensively exchange ideas. We need more than just the Max Planck Institute and the university if we want to remain competitive. And it was at Amazon where this opportunity came to fruition. I want to work with the best possible scientists to really gain new insights.

Can you explain how your work has evolved?

When I entered this field, neural networks were popular, but it took a lot of testing to get them to work. Then I learned about statistical learning theory from

Vladimir Vapnik. The development of nonlinear systems had just begun, and this was important for complex data because the laws of the world are nonlinear. Through mathematical preprocessing of the data, the nonlinear case could be reduced to the linear one, and thus machine learning systems could be particularly well trained and analyzed. This then opened up the new field of kernel methods and parallel probabilistic methods, which have more to do with probability theory.

Owing to the size of the data sets, neural networks have recently become interesting again, providing good results. Causality, which is what I've mainly been working on in the last ten years, has emerged from classical AI. I'm now looking for causal structures that generate statistical principles but are more fundamental, more flexible, and more transferable to new situations. I'm also trying to develop machine methods that learn causal structures and not just statistical ones.

How would you describe yourself?

Thoughtful, reserved, and a bit quirky. I hope that maybe I'm also original in some way. You don't get ahead in science by doing the same thing as lots of others are doing. I'm more someone who tries to blend into a crowd, but also like to keep my hair long, for example. It may no longer be viewed as particularly original, and maybe even makes me more of a dinosaur nowadays. My children ask me why I don't just cut my hair.

You used to play the piano. Is that still part of your life?

I have a piano at home, but it's hard to maintain the same level of ability. My children are also learning the piano, so at least we can encourage each other. I also sing in a choir and think everyone should sing. The experience of music is fundamentally different when you're involved in its creation. We once sang a piece where, at the end, we unexpectedly experienced a completely different harmonic sphere. It evoked the same feeling as I had later when my first child was born. Music can open doors that are closed most of the time.

"FOR US, CULTURAL LEARNING IS EXTREMELY IMPORTANT, AND AT THE MOMENT WE DON'T REALLY KNOW HOW TO TRANSFER SOMETHING LIKE THAT TO COMPUTERS."

Did you ever experience a low point in your life?

I had health problems for a while, and there were also personal low points now and then. I realize it's not so easy being with a scientist, especially when he's sometimes a bit absent-minded, as I am. I think I fail to notice some things, and even at work I often don't prioritize the right things, although I have a good sense of what is important—though I don't always succeed in convincing others of this. But overall, I can't really complain. I'm driven by the sensation of discovering new things.

You're not only interested in astronomy but you've also discovered a star. How did that happen?

Years ago, I started working with astronomers in New York. We developed methods to search for exoplanets—planets orbiting other stars—and discovered a number of them. More recently, one of those exoplanets was found to be the first potentially habitable one, where steam was discovered. For me, astronomy and the perception of the starry sky is another gateway to reality.

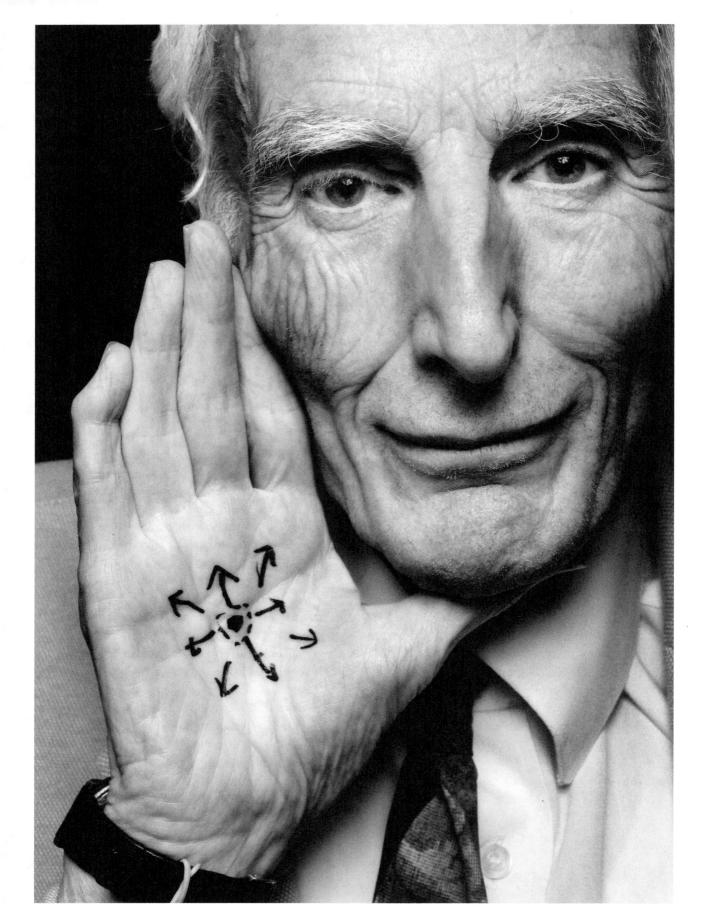

"TALKING TO NONEXPERTS CAN REMIND SOMEONE OF THE BIGGER PICTURE."

Martin Rees | Astronomy

Professor Emeritus of Cosmology and Astronomy at the University of Cambridge
Former President of the Royal Society
Great Britain

If you gaze into your crystal ball, what can you see about our future?
I can't predict all the exciting new developments that will take place in technology, but I'm confident that global population will have grown to about 9 billion by 2050, with around five times as many Africans as Europeans.

Will this population imbalance cause problems?
Africa can't develop its economy like the East Asian countries did, because robots are taking over manufacturing. The problem is that if Africa doesn't

develop sufficiently economically, there will be the risk of instability. Everyone in Africa has a mobile phone, so now they know what they are missing, which could cause grievances. Basically, it's in everyone's interest for the richer parts of the world to ensure that Africa doesn't get left behind.

Do you have any other predictions?

I'm sure the world will be warmer in the future, owing to climate change. The only way we can reduce carbon dioxide emissions is by accelerating research and development into all kinds of carbon-free energy—solar, wind, and nuclear—as well as developing new ways of storing energy, such as better batteries. If the costs of non-carbon-derived energy fall, then countries like India will be able to leapfrog directly to clean energy, but that's only if it's cheap enough.

Is one of your suggestions for a better future that meat be produced artificially?

If 9 billion people are to live a decent life on this planet in 2050, then we will need to deploy new technology to obtain clean energy and to sustainably produce our food. This means eating less beef and eating more vegetarian foods. We should invest heavily in artificial meat. There's already a low-tech version available, which involves making food that tastes a bit like meat. A high-tech version is being developed; the idea is to start with a single cell, without the animal, and to grow something that's chemically the same as meat.

These are just examples that show it's possible to provide a decent life for everyone using properly channeled technology and not using 20 tons of carbon dioxide per person per year, as we do right now. It's not too late to take the right steps.

What has changed since you began your career in the 1960s?

That was an exciting time, as in 1965 we had the first strong evidence that the universe originated with the Big Bang, and we found out especially about the radiation that pervades all of space. But the last five years have been just as exciting, with a huge rate of discovery about the planets around other stars, the first direct evidence of gravitational radiation, and

the ability to say with a few percentage points precisely what the conditions were throughout the history of the universe.

We have much more powerful telescopes in all wavebands at our disposal now and more powerful computers dealing with large data sets; one European satellite got data on 1.7 billion stars. In its virtual world, a computer can calculate what would happen if stars and galaxies crash into one another, for example. So, technology has given science a big boost.

And now they've taken the first picture of a black hole, correct?

We've had evidence of black holes for over forty years, but it's nice to get a high-resolution picture, and it's a huge technical achievement to bring together data from lots of different telescopes spanning the world, as this image of the black hole required.

Are you still fascinated by the Big Bang theory?

The big challenge now is to understand the more exotic physics that prevailed at that extremely early phase of the universe. In the last fifty years, we've gone from not knowing if there was a Big Bang at all to being able to discuss it, with reasonable precision, back to the first billionth of a second, and that's a huge step forward. It's not crazy to think that in another fifty years we'll make another great leap.

You came to astronomy quite late. Why was that?

I studied physics and mathematics at university, as I was good at those subjects. To be honest, I didn't have a particular commitment to astronomy. Then I enrolled in a PhD group at Cambridge, which was carrying out exciting work at an interesting time and in a good intellectual environment. Of course, when new things are happening in science, young people can quickly make an impact, so I was lucky in that sense.

Can you tell me a little about your childhood?

I was an only child, and my parents were teachers. I was lucky growing up in a nice environment in the country and I received a good education, which allowed me to go to university. It was a mistake to focus on mathematics, though.

Why was that, exactly?

Well, I'm not a natural mathematician, although I've managed to find some applications I could enjoy and benefit from. My style of thinking is more like that of an engineer—namely, trying to understand how things work. I enjoy speculation and explaining things to people, which is why my career has developed the way it has.

I've been very lucky in my career, too. I think people need to realize what important a role luck plays in everyone's life.

You mention luck a lot. Was it luck that guided your smooth career progression?

On the whole, I've been lucky—getting work as a research scientist in an exciting field and mainly in Cambridge. I've also been fortunate in having a

ringside seat and in participating in debates on astronomy and cosmology. When the history of astronomy will be written, the last fifty years will be one of the most exciting chapters in the whole of science. I'm not sure how much I've done individually, but I've been part of a community that has done a great deal to help us all understand how we got here and how the universe works.

So, you've never suffered any crises?

I've had several crises, but I surmounted them. The main thing is to persevere and not to give up if something goes badly. Don't be bitter about any disputes and try to reconcile things.

You're also a member of the UK's Labour Party, right?

I strongly support the Labour Party. It depresses me to see the public sector contracting, rather than growing. The UK needs to learn more from the Scandinavian countries and less from the United States.

I've always been interested in politics, and I have had the chance to get involved in some wider issues of politics and campaigning, as well as engage in public outreach, throughout my career.

What's your opinion of Brexit?

Brexit has been an unfortunate episode in British politics. I'm strongly opposed to it, as it's going to have a bad effect on the UK. We'll be perceived as less welcoming to foreigners, which is a pity because that's been one of our strengths in science. Moreover, we live in an unstable world, so it's the worst time to weaken Europe's unity. Our science will be strong enough, though; just look at Switzerland existing outside the EU [European Union]. We'll obviously still aspire to be international—after all, science is international. But if scientists don't have a guarantee that their families can come with them to work or study here, then they are less likely to commit.

You're a member of the Pontifical Academy of Sciences. How do you view the interplay of science and religion?

The Pontifical Academy of Sciences is an international group of seventy to eighty scientists of all faiths, as well as of no faith—only a minority is Catholic, and all members are just interested in the results of research. I'm glad to be involved, as it's had a

"TODAY'S SOCIETY IS FRAGILE."

benign influence recently, particularly in 2014 when many leading scientists and economists met to discuss climate issues. The content was included in the 2015 papal encyclical, *Laudato si'* [*Praise Be to You*], to wide acclaim; the Pope received a standing ovation at the United Nations. That document eased the path to consensus at the 2015 UN Climate Change Conference, in Paris.

How do you feel about scientists meeting with politicians?

It doesn't have much effect if scientists talk directly to politicians; the best way is to influence them indirectly, via the press and by energizing the public. The Pope has a billion followers, so it's a good example of how scientists can use a charismatic person to amplify their voice to the wider public. Realistically, politicians won't do anything in the long term unless there's no danger of losing votes.

Look at David Attenborough's 2001 TV program, *The Blue Planet*, which was watched by 7 million UK viewers. The program sensitized the public to the dangers of plastics in the ocean and that made our politicians realize they could legislate without losing votes. Politicians make decisions based on what voters want, which is why it's important for voters to be influenced by charismatic figures like the Pope. After all, it takes only a few determined people to change the world.

How important is it to maintain ethical boundaries— for science and for society?

We need ethical judgment regarding how science is applied. First, some experiments aren't ethical, particularly some experiments on humans and animals. Second, it's our obligation to harness technology's benefits and to minimize the downsides, as there will be future debates about ethics and what's safe, particularly in genetics.

Scientists have a special obligation to ensure that the public fully understands any experiment or dangerous phenomenon, particularly when there might be an ethical quandary. So, scientists might be the first to realize what's possible, but they shouldn't determine what's actually to be done or be arrogant enough to think they have special status to influence decisions.

Do you feel you hold much influence in the world?

I've been involved in conferences from the 1980s onwards, and have engaged in political discussions about various topics, such as climate and energy, so I'd say I've had about as much influence as the average politician. Until the age of 60, my only formal positions were in the domain of astronomy; but then I became president of the Royal Society, our national academy, and a member of the House of Lords, and I was also head of the biggest college in Cambridge. It was a bit of overkill, as it meant I didn't have enough time left for science.

What actions did you take as president of the Royal Society?

There'd been a trend under my two predecessors to engage more with politicians and the public, and to be more international, and I tried to continue those trends.

What's it like being a member of the House of Lords?

It's a part-time position, so I don't spend a lot of time in the House of Lords, but it's still a privilege to be there. I'm also more involved in general policy than I would be otherwise.

Do you recommend that your students read science fiction?

Yes, they could perhaps gain new ideas from science fiction; we need to stimulate our imagination to be original. There's always the danger that scientists focus on the small details, so reading science fiction and talking to nonexperts can remind someone of the bigger picture.

What about extraterrestrial life? Do you feel we are alone?

In the next twenty years, we may have an answer to that question. Scientists are working out how life

first began on earth. Darwinian evolution tells us how our present biosphere could have evolved from the first simple life, but we don't know the chain of chemical reactions that led to that first metabolizing and reproducing of the entities we regard as living creatures. When we know this, it will tell us if something improbable happened on earth, or if it was something likely to have happened in another similar environment elsewhere. It'll also tell us whether DNA and RNA chemistry is unique, or whether life could exist with a different chemistry—maybe even without water. Also, we'll explore other parts of our solar system where life might exist.

During the last couple of decades, we've realized that most stars aren't just points of light, that nearly all of them are orbited by retinues of planets. The next generation of telescopes will be able to tell us if there's a biosphere and some form of life on the planets orbiting those other stars.

You wrote in your book *Our Final Hour* that science threatens humanity. You also once gave us a fifty-fifty chance of survival. Please explain.

At the time of writing that book, everyone was familiar with the nuclear threat. Biotech, cybertech, and genetics offer tremendous potential, but they also have a downside: they don't require massive special-purpose facilities, as are needed to make a nuclear weapon. These technologies place power in the hands of many small groups of people, any one of whom could misuse it; that's one of my biggest concerns.

Meanwhile, overpopulation could trigger an ecological tipping point. It's also going to be hard to enforce regulations motivated by ethical concerns, such as human enhancement. Ultimately, all this means there will be a lot of tension among the forces of freedom, security, and privacy. Overall, it's going to be a bumpy ride ahead; we just don't know how bad the bumps will be.

Do we also run the risk of another pandemic?

Yes, another virulent form of the flu virus could develop, and the World Health Organization is monitoring that risk. Of course, a virus could also be re-engineered to make it more virulent. Today's society is fragile—we're far less resilient than people used to be, yet our expectations are higher, and we've become used to our comfortable lives where everything works. So, the consequences of any pandemic are far more serious than in the past. If there were a large enough pandemic for the world's hospitals not to be able to cope, then society could easily break down. In short, we are more vulnerable than earlier centuries to these kinds of threats.

I believe you've set up a new institute to research such risks?

Yes, in Cambridge, which is the number one scientific university in Europe. We owe it to people to deploy the talent and power here to address these issues. There's not enough research being carried out on a certain class of unlikely risks that are nevertheless potentially catastrophic.

So, you wanted a busy retirement?

I retired when I was 68, so I'm not in charge of anything anymore and I don't even have a secretary. It's the right system here, as it gives young people a chance. In the United States, they don't have a set retirement age, so it's really hard for young people to break in. Nowadays I travel, write books, give talks, think, and research, so I still work quite hard. Mental capacity declines with age, but I still learn more than I forget. Overall, the last five years of my life have been just as satisfying as my earlier years.

What's your advice to young people?

To choose an area of study where they think they can make a difference and to specialize in something they're good at. If it's science, select an area where there are lots of new developments taking place.

And what's your message to the world?

We need to think long term and realize the consequences of our actions on future generations.

How would you characterize your personality?

Curious, but angry at the disparity between what the world could be and what it is. I'm also keen to campaign, learn, and enjoy any social activities.

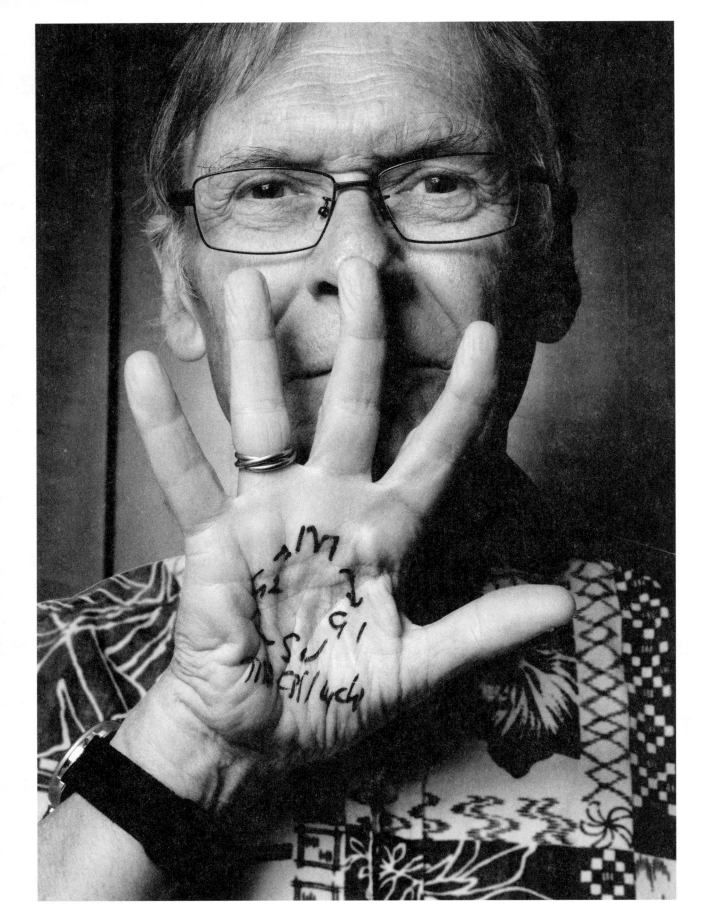

"THE MORE IMPORTANT THE DISCOVERY, THE LESS EXPECTED IT IS."

Richard Timothy Hunt | Biochemistry

Emeritus Group Leader at the Francis Crick Institute, London
Nobel Prize in Medicine 2001
Great Britain

Dr. Hunt, you once said, "If I can win the Nobel Prize, anybody can." Do you really think that's true?
Yes, I think that's probably true because it's mostly luck in my view. People think that to make a discovery you have to put on a white coat and pour things from one tube into another, but it actually isn't like that at all. Discoveries happen when something unexpected happens; that is the essence. The more important the discovery, the less expected it is. I was just very lucky. We don't know what we don't know!

So, making a discovery is just a matter of chance?

Of course, you have to be looking for something—but you're usually looking in the wrong direction! My great discovery came at a peculiar time. I stumbled on the fact that there was one particular protein that suddenly disappeared—and that, at the time, would have been considered impossible. But I'd been thinking about cell division, and so this was an amazing clue. I almost immediately realized that I had stumbled on something much more interesting, and much more important, than what I had previously been doing. The experience was a good example of Pasteur's dictum about chance favoring the prepared mind.

Weren't you were already known for taking some unusual approaches?

Well, I'm easily distracted. That's why I don't think I'm a wonderful scientist. Some people are fantastic—they cut through problems like a knife through butter. But I don't have that ability. One of the things you learn in science is it takes all kinds of people.

You once said that the discovery felt like it was 100 percent yours—was that what made it so exciting?

It's usually the graduate students who do the basic work, but in this case it was a real "discoverer's discovery." I was the one carrying out those experiments. And that was almost the only time when I had a real eureka moment—when I saw the result. Suddenly I knew something that was of fundamental importance—a protein disappeared—and I'd unlocked a whole set of clues, even though what I

"THE BEST THING ABOUT WINNING THE NOBEL PRIZE IS FINDING OUT WHAT IT'S LIKE TO WIN."

discovered was, according to the textbooks at the time, impossible. But the textbooks were wrong, as very often happens.

To realize that you had made this discovery, though, you had to be alert to that eureka moment?

No, it just was there, in black and white before my very eyes! You didn't have to be a genius. Although, actually, the first experiment I did wasn't particularly clear because I hadn't been paying attention to the way the experiments were done. The problem was that sperm contain powerful digestive enzymes that must be inactivated to get meaningful results. One procedure we tried was to boil the samples in detergent plus mercaptoethanol, a sulfur-containing compound. I think I lost my sense of smell because the lab was so full of the fumes from that wretched stuff. I could no longer smell roses after that—it was a bitter blow.

Paul Nurse was also working on cell division at that time. Did you have an open exchange with him?

We worked in different ways on different systems, but we did often talk. I would visit him, and we'd exchange notes. It was fun because we were genuinely puzzled. In retrospect, we were unbelievably slow; we should have solved the problem ages before, but it's hard to convey how foggy things are when you don't understand what's going on.

Has much changed since you were first doing your research?

In some ways it hasn't changed all that much, but some things have changed an extraordinary amount. Somebody was showing me a DNA sequencing machine, which is the size of a biscuit. You can virtually sequence a human genome with one run of this little chip. We had to teach ourselves DNA sequencing by a much older method, which was quite laborious and took weeks to work out. Now, people rely heavily on computers and other things, but I think that just puts you a little bit further from the stuff itself. And people believe in collecting tons of data that are not all equally reliable, and the truth is supposed to leap out at them. But I'm probably a dinosaur.

In 2001, together with Paul Nurse and Lee Hartwell, you were awarded the Nobel Prize for discovering key regulators of the cell cycle. Could you explain the importance of this discovery?

First, you need to realize the importance of DNA in life. The key thing about DNA is that it has all the instructions to make a human being, and all the instructions to make a perfect copy of itself, so the next human being can carry on and do the same. And this set of instructions has to be delivered faithfully to every single cell in the body. So, control of the cell cycle is key—it's about how to ensure that every cell gets a complete copy of those instructions.

It's a remarkable thing, and what became clear was that there was a master regulator of the process, requiring a complete change of state in the

cells as they start to divide. That change of state is catalyzed by the enzyme, half of which I discovered and half discovered by my fellow laureates. The act of discovery was incredibly satisfying. The extraordinary thing was how few people had worked on this before, because they simply couldn't see how to do it.

And how was it to win the Nobel Prize?

I always tell people that the best thing about winning the Nobel Prize is finding out what it's like to win—not the actual winning.

Did you know all along that you were a born problem solver?

Oh, I don't know about that. I like problems—little tricks to do things. The amazing thing is how you get clues from hearing somebody give a talk, or reading a book about something completely different, or hearing a throw-away remark. That's happened to me several times. And gosh, you make so many mistakes! You just try not to make the same mistake twice—that's the key. And that's what makes changing fields a scary business, because you know that you're not really an expert in a field until you've made every single stupid mistake there is to make.

Still, you emphasize the importance of having fun and being lucky, right?

With the scientists I admire, there's a certain playfulness to them. And yet you must stay grounded in this business. I tell people to keep their feet on the ground, their eyes on the horizon, and their nose to the grindstone.

Was this attitude shaped by your childhood? You grew up after the war, correct?

Well, life was quite hard then. You were taught to eat everything on your plate because that's all you were going to get. I can remember a time when we didn't have a refrigerator. What a thrill it was to get our first fridge, as this enabled my mom to make ice cream! The house had no central heating, only coal fires. I remember once when it snowed, we had to take the baby's pram down to the coal depot and fill it with coal to bring it home.

"I LIKE PROBLEMS— LITTLE TRICKS TO DO THINGS."

But my childhood was good, and I always had friends. I was a happy little boy. I have golden memories of running down to the Port Meadow to go fishing. One nice thing was that the house was always open. My mother was a sociable person, and the kitchen was always full of people. My dad had lots of scholarly friends, and those foreign medieval historians would come and have lunch. One of the things I discovered from this experience was that it's far better to be completely open and honest with people. If you tell them everything, they will also tell you everything.

Do you feel that your experience growing up in a religious household had a lasting effect on your life?

Well, we went to church every Sunday, and the extraordinary thing is I can remember a time when I really did believe. To me, the virgin birth of Christ was something one had to take as an article of faith. I lost my faith as a teenager, but in retrospect there were experiments I did that were very much inspired by my religious upbringing. For example, I'd read a book about sea urchin eggs, and I thought, *This is virgin birth in sea urchins!* But actually, it's very hard for biologists to believe in God. It's much easier for physicists because they take a more mystical view of the universe.

And you were already interested in biology when you were younger? I understand you did an experiment on your brother's pet?

My youngest brother had a pet rabbit that died, and I took it to school so that we could dissect it. It was a revelation because we saw something truly fresh. The kidneys looked completely different from the liver, and we couldn't believe how much guts there were. It was terrific.

I always wanted to be a scientist. In fact, I would really like to have been a physicist or an engineer, but I discovered early on that I was not good at physics. I had a friend who became an award-winning physicist who worked on laser light scattering—it just came naturally to him. Whereas, what came naturally to me was a biological way of thinking about things. Physics was beyond me—much too difficult, everything counterintuitive. In fact, I was rarely, if ever, at the top of my class.

Did your professors give you a lot of freedom when you were working in the lab?

Yes, I never really had anybody telling me what to do. Sometimes that was good and sometimes maybe not so good. It meant I was wholly responsible for what went on, and that was a little bit nerve-wracking. In my early career, I would quite often think, *Oh, my God, that's it, I've solved that problem, now what the hell am I supposed to do?*

Something always does finally turn up, but there can be quite a long period of misery, and serious depression. When I was writing my thesis, I had just split up with a girlfriend and that was awful. A lab is a social place, but when you're writing a thesis, you have to sort of sit in a room and just write. I suppose it took me about three months to write that wretched thesis, and it was extremely painful.

It's a hard life. The highs are very high, but the lows are quite low. It's important to have mates who will help you along when things aren't going well, and with whom you can celebrate when things are going well. But it really depends on having a good problem that yields to your investigations. You can always think of problems, but either they're trivial or they're ones you couldn't possibly solve.

Finding a good problem is hard. You have to be able to tell yourself, *I will bring all the weight of my experience and energies to bear on this one particular thing, and I will try and persuade others about the need to do so, too.*

And during your career, did you ever have regrets?

I think I have been lucky in life. I have few regrets. I did what I did. It's all just bricks in the great edifice of

understanding. I think I've made one of two contributions, but to be honest, if I hadn't done it, somebody else would have, right? That's the slightly mysterious thing about the whole business.

In 2015, you were at the World Conference of Science Journalists, in Seoul. At that time you made some controversial comments. You said, "Let me tell you about my problems with girls. Three things can happen when they are in the lab: you fall in love with them, they fall in love with you, and when you criticize them, they cry." After this, you were asked to resign from your position at the university. I imagine the episode was difficult for you?

I was in pieces, actually. Particularly at having to withdraw from the Scientific Council of the European Research Council (ERC), because that was something I cared very much about. I cried at that point. It was awful. But I was sort of stupid. I gave an interview over the phone, in the airport departure lounge, and it would have been better to have kept quiet at that point. Actually, I did several interviews without realizing what was brewing in the background. When I landed at Heathrow, my phone rang and my younger daughter said, "Dad, are you all right?" And I said, "Of course, I'm all right. Why?" "Well, you're on the front page of every single newspaper." "What?" I had no idea.

Do you regret having made those comments?

Well, I had to admit that I had said what I said. But the sense of it was wildly misinterpreted. They said, for example, that I favored single-sex labs, which was ridiculous. I meant that people do fall in love, and it is a problem if somebody falls in love with you and it's not reciprocated. I think you should be able to discuss these matters openly.

And your university asked you to resign, or . . . ?

Or they would fire me. It was ridiculous. On the other hand, they still like to boast that I was a Nobel laureate—so they can have their cake and eat it, too.

The whole episode must also have been painful for your family?

It was particularly painful for my wife and for my younger child, who was a teenager at the time. But a lot of people rallied to my support. I got one or two hate emails, but for the most part everybody was saying, "You were the most wonderful teacher, and you really inspired me," and that kind of thing. I was very moved. Fortunately, I had a good friend, Fiona Fox from the Science Media Centre, who was helpful. She said, "Don't read anything, and don't say anything." So, that's what I did.

Did you feel isolated from society as a result?

Well, I became quite toxic, yes. There was just one moment when I thought I might kill myself, because it really wasn't worth it. But that moment passed. I'm still alive, and I just sort of carried on as before.

Was your professional life ruined at that point?

Yes, but it was over already, so it didn't really matter. My wife is provost at the Okinawa Institute of Science and Technology, which means she has to do all the dirty work. I do the housework. I get up early and walk the dog. I make lunch, I make dinner. It's a simple life.

So, you're not filled with bitterness?

No, I'm not. I keep in touch with friends and occasionally, if I read a paper I like, I send an email to say, "Gosh, that was a nice piece of work." There were periods in my career when things were quite competitive, and I didn't like that. I think collaboration is a hell of a lot more fun than competition. If competition means you have to look over your shoulder all the time, then you're not focusing on the matter at hand. I think that's a nasty place to be, and yet there are some people who really thrive on it. It takes all sorts.

"COLLABORATION IS A HELL OF A LOT MORE FUN THAN COMPETITION."

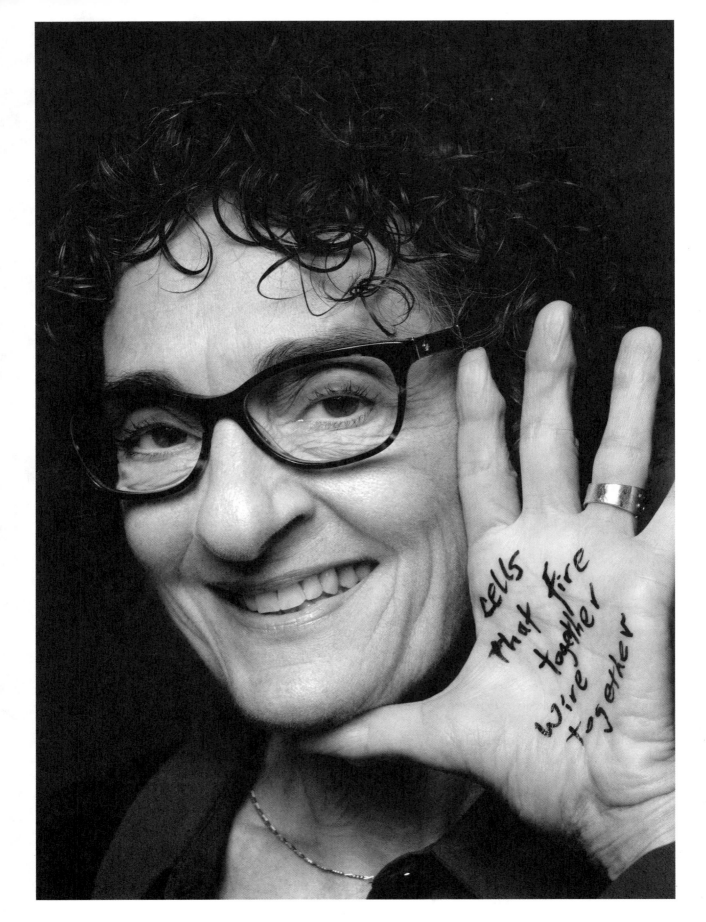

"YOU NEED TO HAVE A REALLY BIG QUESTION THAT YOU WANT TO ANSWER, ONE THAT WILL KEEP YOU GOING."

Carla Shatz | Neuroscience

Professor of Biology and Neurobiology at Stanford University, Palo Alto
Kavli Prize Winner in Neuroscience 2016
United States

Professor Shatz, can you tell me a bit about your formative years?
I think I'm still in my formative years. The wonderful thing about being an academic is that you're always learning, and as long as you can continue to incorporate new knowledge and even redirect your life, it's never boring.

My family was intellectual. My dad was an aeronautical engineer. He became interested in systems analysis and control, and he was involved in the space race. That got me really interested in

astrophysics—in fact, I thought I might be an astrophysicist until I went to university and discovered that it wasn't my cup of tea.

My mom was a painter. She received a master of fine arts degree. She took that incredible skill and talent, and she turned it toward raising me and my brother. So, she really developed my love of the world and my visual perception. I think that's what got me interested in trying to understand something about how we see, and how our brain analyses and resynthesizes the visual world for perception.

One of the things my parents told us was to not worry about what other people thought. That was good because it allowed me to become a scientist. The slightly negative thing about that was that I really was a nerd. And like most young nerds, it was a little lonely. It was wonderful, though, when I went to university because I found so many other people like me.

But before that you felt like an outsider?

Absolutely, I felt like an outsider. The intellectual life was a major encouragement for me when I was little. Dinner-table conversation was not trivial. We had intellectual arguments. Mostly my father won them. And I'll never forget the time we had an argument and my dad looked at me and said, "You know what? I think you won this one." That was really important.

When you were young, there were different expectations for women. They were supposed to marry and have children, right?

"WE HAD INTELLECTUAL ARGUMENTS. MOSTLY MY FATHER WON THEM."

I married. It was love, but it was also to make my parents happy. And that was true for my ex-husband, as well. I thought—actually, we both thought—*Let's wait until I get tenure to have children*. We decided to have a family when I was in my mid-thirties. And then we discovered that I couldn't have children. That was a traumatic time in my life; I lost my voice for about half a year. I had constant laryngitis. My body knew more than I did, consciously.

Nowadays, a woman has so many options. You can get your fertility status checked when you're young. You can have knowledge, you can plan. And there are many options for infertility treatments, as well. But that wasn't true when I was going through this. And I think the tension and stress it put on our relationship led to our divorce. I have to say that I'm glad my ex has happily remarried, with his own three biological children.

So, did you think you paid too high a price for your career?

Absolutely not. When I look back, I think I could maybe have better managed the challenges in my personal life. And by that, I mean I probably could have had more coaching. That's a really important issue about mentoring, because I really only had men-tors. I didn't have any women-tors. There were no women.

The people I modeled my career and life after were amazing. They include David Hubel and Torsten Wiesel, who were my PhD advisers, and they received the Nobel Prize in Physiology or Medicine. Both had wives who were in a much more supportive role. I think that what those women did for their husbands is fabulous. But it didn't serve as a role model for me. I do know that women—I see this even now—are much more likely to support their spouses, even if they are superwoman. And they're much less likely to engage in a lot of controversy about it.

Even though I don't have family, the scientific children I've had—my students—have been amazing. There isn't a single student whom I haven't learned something from.

You were the first woman to receive a PhD in neurobiology from Harvard Medical School. You were the first woman to earn a tenured position in basic sciences at Stanford. And you were the first woman to chair Harvard's Department of Neurobiology. How did all of that happen?

Yes, I was the first woman to get a PhD in the Department of Neurobiology at Harvard Medical School. People often ask me, "Did you feel any different?" or "How were you treated?" And I have to say that the department was amazing. I did not feel I was treated any differently from any of the men who were also in the PhD program at the time.

In retrospect, I've learned two things. The first is that there were dedicated faculty members who made sure the department could train a diverse group of young students to go out into the world. And I think that's why they admitted me in the first place.

The second is that David Hubel told me, many years later, that they had a big debate about whether they should admit a woman to the PhD program. This was the late 1960s, early 1970s. They questioned whether it would be a waste of their time to train this great mind, only to have her just go and have kids. But they agreed to admit me, so that was a first big step.

When I came to Stanford as an assistant professor, again there had been no women. But that same year, another woman came as well—a basic scientist who was a famous muscle stem cell biologist. Her name is Helen Blau. We were both hired at the same time, as an experiment. But we didn't know; nobody told us. But it turned out that the departments got an extra faculty position if they hired a woman. We didn't know that, either. And then I progressed and did well; I became the first woman to be tenured in the basic sciences at the medical school.

Helen was promoted shortly thereafter, and it became known that we were experiments. And we both became members of the National Academy of Sciences. Now we joke that it probably wasn't too risky to invest in us. But I'm grateful because we were given that opportunity.

Do you think women have to work harder to achieve the same level of success as men?

I completely agree with the assessment that we, as women, have to do more to achieve success. I think there is, or has been, a higher bar. But it has to do with attitude as well. It's having a more optimistic attitude. Instead of getting polarized and angry every time I had to jump over a hurdle, I thought, *Oh, I did it! Now, onward.*

I think students are often surprised by what my generation of women had to deal with. In other words, they take so much more for granted. When my colleague Helen Blau started her family here at Stanford before she got tenure, there was no

"THEY HAD HAD A BIG DEBATE ABOUT WHETHER THEY SHOULD ADMIT A WOMAN TO THE PHD PROGRAM."

maternity leave for women pretty much anywhere in this country. To have a child, you had to go on disability. When I tell people this now, they're blown away.

You became famous for your discovery of neuron and sight development prior to birth. Can you tell us how that happened?

What we discovered is that, even in utero, the baby's brain is communicating eye to brain, eye to brain, all the time—tuning up the circuits almost like a rehearsal for vision. And that tuning process involves neurons communicating with nerve cells in the brain. And so that leads to this idea: cells that fire together, wire together. What we discovered is that cells are firing in waves of activity generated in the eye, and those waves are sent to the brain for early circuit tuning and testing of the circuit. That was totally unexpected. It happens in every baby's eye to brain during development. And when the baby is born and its eyes open, it goes away.

Obviously, we can still learn and remember as adults, but what is different about the developing brain? Why is it so plastic? And that's the question that really motivated me. My PhD thesis advisers, David Hubel and Torsten Wiesel, already had a clue about that, because they studied the phenomenon of childhood cataracts. That is, if you get a cataract as an adult after you've had perfect vision your whole life—say, one eye has vision problems because your lens is clouded—the ophthalmologist can do a simple procedure now and take the old lens out and put in a clear new lens. And immediately, you can see through that eye again, even if you had that cataract maybe for ten years. But in a child born with a congenital cataract, if the cataract isn't fixed right away with good optics and a new lens, that child can be permanently blind in that eye. And that's weird, right? How is it that if you can correct the vision—the optics of the eye in the child—the child can't see again but the adult can? And that motivated Hubel and Wiesel to study the brains of animal models for childhood cataracts. And what they found is that there's a critical early developmental period when the brain has to learn how to use both eyes together.

So, there's a mystery here. We have two eyes. Each eye sees the world perfectly. But we don't see double unless there's some pathology. Why? Because the brain learns to fuse the images of the two eyes to create a single view of the world. And that happens during that critical developmental period. It's really a use it or lose it thing.

But you've also studied learning in adult brains?

What is different about the adult brain? When I started my career I was really interested in the developing brain. And my big joke was: How come as an adult I can't learn French without an accent? What is different about the child's brain that allows a child to learn not just French but also English, German, Chinese, Mandarin, whatever. Children under the age of puberty are like sponges; their brains are able to acquire enormous amounts of information, store it, and execute it effortlessly.

I wondered, could we make a pill that would reopen this critical developmental period so I could learn French without an accent? So, we started to look for molecules that might be required for this developmental plasticity during this critical period of development, and maybe even close it in the adult brain. Maybe then we could reopen it.

This is a good example of a completely unexpected outcome of an experiment, where we

searched for these molecules and discovered a candidate that wasn't supposed to even be in the brain at all. It was a famous immune molecule called an MHC-1 [major histococompatibility class 1] gene. These are proteins that are essential for the functioning of the immune system. And we made the unexpected discovery that they are also used to regulate the synaptic connections between neurons.

And when we knocked out one of them, removed it from the brain of the mouse, we discovered that the mouse's critical period never closed and there was persistent juvenile-like plasticity in the adult. In other words, the mouse could "learn French" even as an adult. So, when we realized this is happening, not only in the mouse brain but also very likely in the human brain, where we found the same molecule, we asked ourselves whether this kind of knowledge might help us think about the context of Alzheimer's disease.

Memories are stored at the synapses that are so critical to the way our brain functions; they are the connections between the neurons. We create new synapses to store new memories. And in Alzheimer's, those synapses are lost, probably through pathology that drives the loss of those synapses. And since memories are stored at synapses, this is a serious problem. So, we really wondered if we could use our knowledge in some way to prevent the loss of those synapses in Alzheimer's disease.

Have there been situations when you felt your funding was insecure?

In America, funding for our labs is dependent on our ability to compete for external funding. So, we are always competing. These are possible chinks in the armor, and this creates insecurity. And it also creates a kind of anxiety that we're all subject to. I feel it intensely now, especially as I get older. When I look at colleagues of the previous generation, who worked when there was enough funding to go around, and even very senior scientists, they could be confident about continuing their work. But that's no longer true, not even for my Nobel laureate colleagues.

What would you say was the highlight of your scientific life?

A major highlight for me, and my brother and sister-in-law, who are my close family right now, was when I received the Kavli Prize in Neuroscience. This is one of the highest recognitions one can earn internationally—it's sort of the Norwegian Nobel Prize. At first it didn't really sink in just how wonderful this prize was, until I saw the magnificent reception and great recognition they wanted to bestow. It really made me think about what I had contributed to the world.

What would be a personal nightmare for you?

I'll tell you what it is, because I worry about it. Loss of my memory and myself. Getting some kind of dementia would be the ultimate nightmare. I think that's true for many, many people.

What advice would you give to women who want to make a career in science?

To be passionate and follow that passion. You need a really big question to answer, one that will keep you going. The other thing I would say is that it's important to resolve the two-body problem with your spouse or your partner. That is, to balance your career and your family, you have to have an ongoing conversation. Listen carefully to the other person and also listen to what is not being said. And you should absolutely know your fertility status, so you know when. If and when. It's not a joke. We laugh, but it's really important. You're a scientist, so find out.

"LISTEN CAREFULLY TO THE OTHER PERSON AND ALSO LISTEN TO WHAT IS NOT BEING SAID."

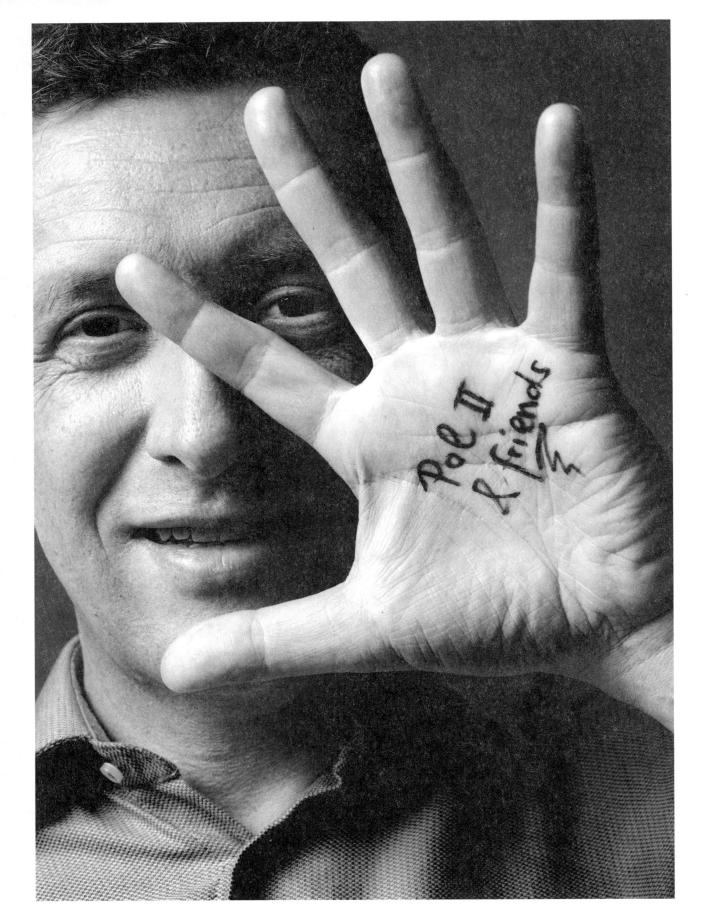

"THE SECRET IS TO NEVER GIVE UP YOUR CHILDLIKE CURIOSITY."

Patrick Cramer | Molecular Biology

Professor of Biochemistry and Director of the Max Planck Institute for Biophysical Chemistry, Göttingen
Germany

Professor Cramer, you went to Bristol in the 1990s because you felt restricted at German universities. Did you also need a lot of freedom as a child?

As a child, I had a different hobby every year. I was rather difficult, very provocative, and always wanted to do everything by myself and understand how the world works. Without having a clue, I would try to build a radio or repair a broken model train. One day, my parents gave me a chemistry set, and that's when my interest was really sparked. I also had a chemistry teacher who was always willing to talk to

me during breaks because I had all kinds of questions. One summer I had this pretty bizarre hobby of trying to collect all the elements on the periodic table. Iron and copper were easy to find, but back then the teacher added silicon to my list.

As a kid, did you spend a lot of time outdoors?

I was always the explorer on Sunday walks with my parents. At the start, when I was more interested in chemistry than in animals and plants, I was fascinated by molecules and atoms—this smallest, invisible world that holds all the answers. But at some point in my studies I realized that nature's molecules are much more beautiful, larger, and more complicated, and they can also yield more than inanimate matter. That's where my interest in biology started.

Born in 1969, you're considered to be part of the new scientific generation, described as self-confident, performance oriented, open-minded, and global in perspective. Is there truth in that?

I'm pleased to hear that, as they are all qualities I need to be successful, starting with the strong self-confidence I was given by my parents. I also have felt a rift existed between me and the previous generation. As a student, my professors didn't really see me as a future scientist. There were 193 students in the first semester at Stuttgart, and during the first lecture we were told that only fifty or sixty of us would continue. There was a big selection process, and the young students were viewed more or less as just skilled labor. As a professor, I tried to apply what I'd learned in the Anglo-Saxon world: to pay attention to individual students early on and to immediately give them the self-confidence they need so they can contribute to science.

Scientists are often judged by how often their work is cited in publications. What do you think of this rating system?

It particularly appeals to those looking for simple judgment criteria. Thanks to the h-index, it's easy to decide who's entitled to more money. However, it's also easy to overlook highly innovative thinking and those people who think completely outside of the box, who have no followers yet. At the Max Planck Society, we also try to determine whether someone is working on an important issue and whether they have a novel approach. If we think a major breakthrough could be made in a few years, that's more important to us than those quantitative parameters.

It's considered crucial to always be the first to the finish line. How have you experienced this rivalry?

This situation has put a lot of strain on me personally. Up until a few years ago, I took hardly any vacations during which I didn't have to work on someone's manuscript or other, sometimes even on my cellphone, in order to win a scientific race for first publication. The authors had spent the best years of their lives competing for the gold medal and couldn't be allowed to fail just because I was on vacation. Journal publication still makes or breaks careers, and one publication can determine a job position.

You're said to have done significant work at Stanford with Roger Kornberg on the transfer of genetic information from DNA to RNA, for which he won the Nobel Prize. Can you tell us a little about that?

I went to Stanford in the late 1990s when I learned that Kornberg and his group were able to crystallize RNA polymerase, which are molecules that can read genes. I was young and had nothing to lose. With the help of so-called crystal shrinkage, and with new types of heavy element compounds, I was actually

"JOURNALS STILL MAKE OR BREAK CAREERS, AND ONE PUBLICATION CAN DETERMINE A JOB POSITION."

able to successfully clarify the structural question, which many colleagues at the time thought was technically impossible. We published three papers in 2000–2001, and that was the end of the matter, as far as I was concerned. I never expected to win Nobel Prize honors.

Kornberg's group had carried out preliminary work for over a decade, without which I couldn't have done my part. I also learned a lot from Kornberg, especially that in scientific work everything happens in your head: which experiment I carry out, what the open questions are and how I address them, and ultimately, the crucial thought process, or what the data mean and how the information can be communicated to people.

Can you explain what you're researching at the moment?

The best way to explain what I'm doing is to use an example that everyone knows. Life results from a fertilized egg cell, and in the beginning, this egg cell has all the necessary information to create and sustain an entire organism for many years. One ovum then divides into different cell types, meaning that the same genetic material is capable of producing a wide variety of cell types. And that's only possible because different genes are active, which leads to the core issue of transcription. It's the first step in gene expression.

There are many different molecules that bring about this complicated process of transcription, and the regulation of this process is important, not only for the development and maintenance of the organism but also for an understanding of diseases. We know, for example, that in tumors, gene transcription really goes haywire.

How do you deal with uncertainty when something doesn't work out?

My formula has always been this: if I'm not willing to endure years of frustration, I'm pretty sure I won't find anything groundbreaking. In my private life, I've taken a lot of risks. I've moved fifteen times and both of our children were born abroad, when my wife and I were living only on scholarships, so it wasn't an easy time. We had no idea if we'd ever return to Europe. Today, I have a permanent job and hardly any personal risk in my career.

You've written that your research has led to many sleepless nights. Are you sorry about that?

There have been those lovely sleepless nights when I was so fascinated by the research results we achieved the day before that my brain wouldn't switch off. I would sometimes then write things down at night or realize early in the morning which experiment I had to perform. But then there are the other sleepless nights I sometimes now have because I'm on various committees, reviewing people and trying to please everyone.

"IF I'M NOT WILLING TO ENDURE YEARS OF FRUSTRATION, I'M PRETTY SURE I WON'T FIND ANYTHING GROUNDBREAKING."

Have you ever had a crisis in your life?

Yes, I have. At the University of Munich I took on a great deal of responsibility. I had a total of nine functions, and I wanted to do them all well. But in the end it was just all too much. After a decade, I needed a change of location and a new environment; I had to rethink what I wanted to do with the next ten years of my life—like hitting a reset button. It was perhaps a bit early midlife crisis. Letting go helped me a lot, though. This gave me the freedom to start something new in Göttingen, and that's how I overcame the crisis.

Have you ever felt sublime pleasure in your research?

When working at Stanford, I often worked nights at the synchrotron, a huge particle accelerator located in the hills above Silicon Valley. One night I got a result and the second it appeared on the screen, I realized: I've cracked this. So, I jumped to my feet, like a child, and ran out of the particle accelerator and up onto one of the hills. There I looked down at Silicon Valley, over which the sun was slowly rising. I knew then that it would take another year or two, but that I would solve the problem of what the molecule that activates our genes looks like. That was such a sublime feeling.

What would you say characterizes a successful scientist?

The secret is to never give up your childlike curiosity. Being open all your life makes life worth living. A certain degree of determination is also part of it. But as a human being, I would never presume to think I could understand or recognize everything. On the contrary, I always feel humble—small and insignificant—when I see how wonderfully everything around us in nature works. However, only those who can deal with other people will succeed in science. In my lab, I take a close look at every employee. Some need a lot of support to reach their best, while others require the maximum freedom and feel limited if I provide assistance too often.

What characteristics made you the person you are today?

The important thing for me was experiencing different scientific systems: the British system in Cambridge, where at tea time I could casually chat with Nobel laureates; the American system, which though relaxed still entails intensive work; the international nature of a European research laboratory and the comparison between university setups and a non-university system like the Max Planck Society. I try to combine the best of all systems.

You once said that digitization is at just its beginning and that one day we'll all be digital beings. Do you really believe that?

I'm not a great believer in progress per se. I'm critical of Europe's excessive anxiety about new technology. We should always think about what good technology could do for humankind and then actively help shape it, rather than reject everything and wait until it has been developed in Asia or the United States. My fear is that Europe could become a kind of Neuschwanstein, that nineteen-century castle that the rest of the world regards as a museum, and where a gigantic history of knowledge can be admired, but which no longer has its finger on the pulse. As researchers, we have a special responsibility to communicate our knowledge to the rest

of society, which then has to consider what to do with it.

Why should a young person study science?

The most beautiful thing about science remains its ability to reveal something that no one has ever seen or understood before. Being the first to address an unanswered question and experiencing that wonderful moment of accidental discovery make all the hard work worthwhile. That's why I would advise young people to do what they're passionate about. The ability to perform is only achieved through motivation.

The scientific world is still very male oriented. How can more women get into top positions in science?

I proactively look for young female scientists who are excellent in their field, and I try to recruit them as new colleagues. Unfortunately, this isn't always successful, as the best scientists are highly courted and can decide to go to other institutions. But my tip is still to look for the best female scientists and to sponsor them early on. Nominations for prizes and research funds are especially important because they increase visibility. We all need to nominate more.

You got to know the American system as well as the German one. From an American point of view, scientists with a permanent professorship in Germany are set for life, while in the United States they're repeatedly examined. True?

Both systems have their advantages and disadvantages. It's quite rare for someone with a German professorship to take it easy, because everyone is put through their paces beforehand to find out what their driving force is. There's also, of course, a German inspection system.

As director of the Max Planck Society, I'm reviewed every three years, at which time I have to stand like a schoolboy in front of the blackboard and report what I've done and what I want to do in the future. The American scientists are under more pressure because part of their salary is linked to their performance evaluations. They fall correspondingly low if they lose their grants. But this system has the advantage that everyone has to constantly question themself, and the disadvantage that the time allocated for big projects is often too short. Sometimes scientists need ten or fifteen years to complete a project, and they can't survive in the American system.

When it comes to the number of Nobel Prize winners, the balance is clearly tilted in America's favor, yes?

There are many historical reasons for this, as well as cultural ones. We should all be far happier when a colleague receives a prize; the United States possibly has a better culture in that respect. We could also do even better in Europe in terms of corporate identity. Those attending Harvard are proud of it and see Harvard as on their team. That's why every Nobel Prize for Harvard scientists is also a small victory for them. For many people, it's important to be part of a successful organization, and you find that much success and energy only in the bigger organizations.

What is your view of the future for science?

We need more personalities who are capable of participative leadership. The trick is not only to win employees over to my cause but also to involve them creatively, and thereby surpass what I could do by myself. The traditional hierarchic structure has become completely obsolete because it can't fully exploit people's creative potential.

"MY FEAR IS THAT EUROPE COULD BECOME A KIND OF NEUSCHWANSTEIN."

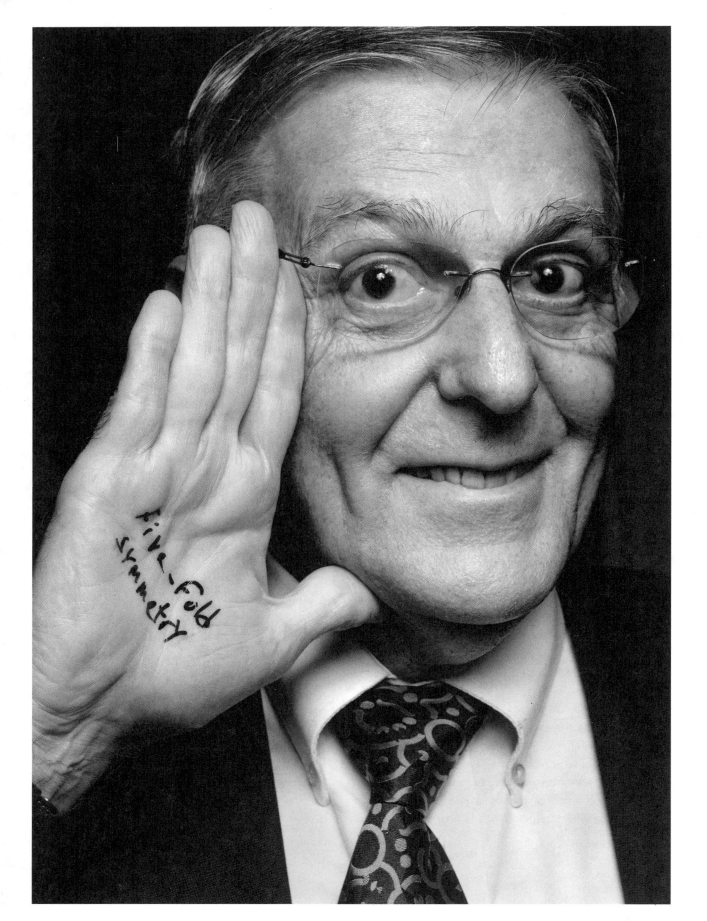

"I'M NOT FRIGHTENED EASILY, ESPECIALLY WHEN I'M SURE THAT I'M RIGHT."

Dan Shechtman | Physics

Professor Emeritus of Materials Science at the Technion, Israel Institute of Technology, Haifa
Nobel Prize in Chemistry 2011
Israel

Professor Shechtman, you stress that social skills are important for a successful scientist. Why?
Regardless of education, the most successful people have good social skills. They know how to explain their cause, how to convince others that they are worthy of attention, and how to sell you something. When I give a talk, I try to catch the eye of everyone in the audience. Sometimes it's a thousand people. I would like each person to feel that for a certain while I am talking to them.

Listening to people is also important. When somebody is talking to you, don't think about your next reaction. Listen! You have to create trust and confidence. People will like you if they can look up to you and trust you. My wife is a psychotherapist, and she always corrects my behavior by telling me: "You did this well" or "That wasn't the right thing to say."

You have four kids, and your wife is also an academic. So, how did you support your wife in her pursuit of a career?

My wife dedicated our first years together to raising our children and therefore gave up her career for that period. She worked as a counselor in a primary school, so as to be back home when the children returned from school. But I always encouraged her to get higher degrees. When I spent those first years in the United States for my postdoc, she studied for a master's degree, and when I did my sabbatical, she was doing her PhD. People keep saying: "Oh, she raised the children alone," but when she was getting her degrees it was me who took care of the children.

It was only when the children were relatively grown up that she started her academic career. At university they told her: "You are too old now." But she just said, "Let's see." And she was promoted faster than anybody else because she knew about real life.

Are you like a colorful bird of paradise within the scientific community?

I like your term. Yes, I think I am colorful. I do many things that are not directly related to my expertise in science. Thirty-two years ago, I established a new

"GERMANY IS A LAYERED SOCIETY WITH A STRICT HIERARCHY."

class at the Technion in Haifa, called Technological Entrepreneurship. Already then, I knew that the future would be in high-tech start-ups, so I wanted Technion graduates to have all the required knowledge, from where to get money to how to deal with authorities. And it was the largest Technion class ever. Many students were sitting on the floor. One-fourth of them were later involved in start-ups. It was a smashing success. Three years ago, I handed it over to another professor, but everybody at the Technion knows that this is Danny Shechtman's baby.

I said in a radio interview that we should teach science in kindergarten already, so we can convince kids at an early age that science is wonderful. We will need as many kids as possible to go into science. People say the world is moving very fast toward a situation of terrible unemployment. Wrong! You will have a problem only if you are uneducated. This brave new world will be wonderful for engineers and scientists. But if a country doesn't have enough of them, it will lag behind.

So, every country needs to promote research more strongly?

Not only that. We also have to encourage new ideas. And in regard to that, there are major differences between Germany and Israel. Germany is a layered society with a strict hierarchy. If an engineer has an idea, he can talk to his immediate boss, who will pass it on to his immediate boss, and so on. By the time the idea gets to the CEO, the name of the engineer will be forgotten. In Israel, it is totally different. You can call the CEO directly, and if he deems it a worthwhile idea, he may say, "I'll give you one million dollars; go ahead and develop your idea." And if you are successful, you may become a major partner in a spin-off start-up. This is intrapreneurship— innovation within the organization.

Who inspired you to study mechanical engineering?

When I was young, I read many books. I knew whole encyclopedias by heart. And I very much liked adventure books. One of them was *The Mysterious Island* by Jules Verne, about five men stranded and

surviving on an island. The leader was an engineer, and he could make everything from what was available on the island. I wanted to be like him. And that's why after my military service, I went to the Technion, in Haifa, to study mechanical engineering. But just as I graduated, there was a big recession in Israel, and I couldn't find a job. So, I thought, *I will do my master's degree for a couple of years, and in two years I certainly will find a job.* And during these two years I fell in love with science—and that sealed my fate.

On April 8, 1982, you changed the world of crystallography by discovering quasicrystals. Tell me about this moment.

I was on a sabbatical in the United States, working on a project to develop new aluminum transition metal alloys for aerospace applications. I started to

"MY GROUP LEADER, FOR EXAMPLE, TOLD ME THAT I WAS A DISGRACE TO HIS GROUP AND THAT I SHOULD LEAVE IT."

prepare aluminum-manganese alloys of different compositions by rapid solidification, very systematically, every day a different alloy.

On the afternoon of April 8, I inserted an aluminum–25 percent manganese alloy into the transmission electron microscope, took a few pictures, and saw something strange: a tenfold rotational symmetry diffraction pattern, which was supposed to be impossible. I thought it might have resulted from a phenomenon called twinning, which means . . . forget it, it's not interesting. I looked for the twins all afternoon, but since I did not find any twins, it became clear to me that this had to be something special.

From the very beginning, the reactions to my discovery varied. On the one hand, I had support mainly from my host, John Cahn; but on the other hand, I encountered total rejection. My group leader, for example, told me that I was a disgrace to his group and that I should leave it.

Could you explain a bit more about your discovery?

Most of the metals and ceramics we use are crystalline. That means the atoms that build those metals and ceramics are arranged in a way that is ordered and periodic. What is periodicity? This means that there are equal distances between any two atoms in any direction. All crystals studied until 1982 were structured that way, but I discovered something that was considered impossible: crystals that are not

"POLITICIANS, VOTERS, SOCIETY— ALL OF YOU HAVE THE RESPONSIBILITY. NOT US."

periodic. These crystals have a special order, called quasi-periodic. It is a nice order, but it's not periodic. Thus, my discovery caused a paradigm shift in crystallography.

Soon after the first publication of the discovery, several groups repeated my experiments and obtained the same results. In a very short time, a large community of avant-garde young scientists in many countries around the world took my discovery and made it into the science of quasi-periodic materials. I received many prizes for the discovery, including the Nobel Prize in 2011.

Still, Linus Pauling, also a Nobel laureate, kept saying that you were talking complete nonsense. True?

Linus Pauling was arguably the greatest chemist in the United States in the twentieth century. He was a Nobel laureate twice. But the difference between God and Linus Pauling is that God doesn't think he's Linus Pauling. Linus Pauling, however. . . . And he wasn't wrong only about the quasicrystals; he was wrong several other times in his life.

It's okay to be wrong, but if you are famous you must be more careful about what you say. For ten years, he fought me and the whole community of scientists of quasi-periodic material. He started in 1984, when I published the first paper with my colleagues, and continued until 1994. He only stopped because he died. I once gave him a one-hour talk about quasi-periodicity at his home in Palo Alto, California. At the end of my talk he said, "Doctor Shechtman, I don't know how you do that." That's because he didn't understand electron microscopy. He might have been a great chemist, but I was the expert in electron microscopy.

How did you react to this hostile atmosphere?

I am not frightened easily, especially when I'm sure I'm right. In the first grade of primary school, the whole class was against me, and I stood tall and said, "You're all wrong." And they were wrong. The whole class. But as I check myself many times before I say something, I can trust myself.

I don't follow the crowd. Maybe it's in my genes. My grandfather came to what is now Israel in 1906, as a pioneer to build a country. He was a stubborn person, with his own firm principles. You couldn't feed him nonsense. What I took from him is to not believe anything others are telling me. In essence, form your own opinion and stick to it. You have to be knowledgeable and you have to be a no-nonsense person. That was my grandfather's character; however, I am much milder than him.

You once said in an interview that female scientists are much more dedicated and less competitive than male scientists. What made you say that?

Some of them are competitive, but usually I trust women as coworkers. I have worked with quite a few women and know them well. To give you an example, I have an administrative aide who is trustworthy. I trust her to take good care of all my travels and all my communication. I know that if I say the word, it will be done right.

"BUT AS I CHECK MYSELF MANY TIMES BEFORE I SAY SOMETHING, I CAN TRUST MYSELF."

What advice would you give to young scientists?

If you are a young scientist performing experiments, write everything down in a logbook because it may be important later on! And if you want to succeed in science, you need a broad knowledge of biology, chemistry, physics, and mathematics. Then choose whatever subject you want and become an expert in that. Try to be the number one in something, and I promise you a wonderful career in science. I was an expert in electron microscopy. Preparing good specimens takes some people a very long time. I do it in five minutes, but it took me many years to achieve this.

What do you see as the responsibility of scientists?

We don't owe any responsibility to anybody. Scientists are totally objective. We try to understand the world, and we develop and give tools to create applications for society. Society's leaders have the responsibility. Politicians, voters, society—all of you have the responsibility. Not us. That's my opinion.

There are some lines I would not cross when it comes to ethical questions. Experimenting on humans isn't right, unless it is strictly controlled and guarded. I think nobody has an objection to taking tissues from dead people. I wouldn't mind if they take parts from my body for studies, as it will rot anyway.

Are you a religious person?

I'm not religious, but I respect my heritage and I celebrate holidays in a traditional way. I also have a Bible in my office, which I know quite well. When I was very young, I envied religious people because when you believe, you are stronger, as you have a defined code of behavior.

I was never like this, though. I always hesitated about which way I should go. Over time I have developed my own code of ethics, just like my colleagues. We listen to people, and we make sure we don't harm other human beings. And this is what modern society should do. People should internalize a code of behavior, of what's good and what's bad.

Is there something about your life you would like to change?

I think this question can't be answered. Our lives are governed by chance. People don't realize it; they think they are in control. I can trace back everything that happened in my life to certain turning points, to something like a one-minute conversation that changed my course. And this happened several times. If I had chosen another way, I wouldn't be sitting here. I recognized these turning points, and I keep telling people they have to recognize them, too, if they want to change something. Life is an extremely rare gift, and you should live wisely because it has an expiration date.

Do you sometimes think about death?

Yes, but I'm not afraid of it. I have had an amazing life and I have been so lucky. The gift that was given to me was enormous, and it was not always easy. I had many difficulties, especially early in my life. When I was young, I had asthma. It is a terrible disease; you feel like you are choking. I was convinced that I'd better not have children, because they might inherit it and I didn't want to see them suffer. But my asthma disappeared one day, as if it had never been there. It was the day I got married.

Leaving my mother had been the cure. I don't know if this is really the reason, but this is how I explain it. For ten long years, I still carried my medication with me, just in case. But it was totally gone, and none of my children inherited it.

"WHEN YOU BELIEVE, YOU ARE STRONGER, AS YOU HAVE A DEFINED CODE OF BEHAVIOR. I WAS NEVER LIKE THIS."

Ubiquitin
We are
made of
proteins
and
SPIRIT

"I DON'T BELIEVE ANYTHING THAT OTHERS TELL ME. I ALWAYS GO AND CHECK IT FOR MYSELF."

Aaron Ciechanover | Biochemistry

Professor of Biology at the Medical Faculty of the Technion, Haifa
Nobel Prize in Chemistry 2004
Israel

Professor Ciechanover, how is it you chose to study science?
Actually, I never studied science. I studied medicine, as this was my mother's dream. It was extremely difficult to get into medical school. You needed to be a genius, and in the middle of my medical studies I realized that it may not be the right thing for me, because I would be attending to disease, which means I would look at the end of a process. But I was much more interested in understanding the mechanisms that had caused diseases. So, I decided to do biochemistry for one year.

I instantly fell in love with biochemistry and wanted to become first a scientist, then a professor, and then to achieve things. That is what life is about—moving from experience to experience. So, let us enjoy that until we die. And the lucky ones among us are even able to add something to society.

That is what you did. Could you explain the research for which you were awarded the Nobel Prize in 2004?

What we discovered could be called the body's "garbage collection truck." Our body speaks its own language—the language of proteins. And proteins may get harmed by different agents, like irradiation, mutation, temperature, or oxygen, and therefore they have to be disposed of and replaced by new proteins. That is because an accumulation of damaged proteins can lead to illnesses such as cancer or brain disease. Also, healthy, functioning proteins that have completed their function and aren't needed anymore need to be eliminated. An example is the antibodies that fought the flu virus in winter. Once the virus has been defeated, we need to stop production of those antibodies and turn off or remove the faucet—the factory that makes them, which is also made of proteins.

This mechanism of removing proteins is what we discovered, and it led to the development of several successful drugs against cancer that have been on the market for several years now. These drugs have saved the lives and certainly improved the life quality of a myriad of people worldwide. And this is just the tip of the iceberg. We are still at the very beginning, and new drugs for other diseases are in the pipeline.

Was there a moment when you said, "I did it!"?

No. There were moments of victory, but the process itself is endless, just as nature is endless. As Israel is a small country with limited resources, we decided not to ride the highway with our research, not to go where all scientists go, but rather to select our niche in biology where it wouldn't be so crowded. We were led by an initial question, the importance of which we didn't even fully realize in the beginning. And then we started to peel away at the problem like an onion, layer by layer. What we completed was a marathon that ran for four or five decades. We are no sprinters.

Success doesn't just emerge; you have to work hard to achieve it. So, how was your work-life balance?

I was working like hell. It is actually more than work. As a scientist it is embedded in what you are doing. And you need to have a unique life partner for that. I happened to be lucky that my wife understood my needs. I did part of my work in the United States, so she ended up taking care of our newborn baby, and she had her own career as a physician as well. She was always complaining to me, "You may have heard what I have been telling you, but you never really listen." She was right, I was consumed by my work.

I am a bit obsessed—actually, more than a bit. Science is my world. I always compare it to a cake, decorated with cherries and whipped cream. The core of my cake is science, and the decoration is made of music and toys, and probably even people, food, history, philosophy, and religion. I think that the world has a lot of things to offer beyond science, and I have a great hunger for knowledge and for swallowing the world.

Did you expect to win the Nobel Prize?

Yes and no. At a certain point, people were spreading rumors about it, as we had been already awarded some other prestigious prizes, the drugs were on the

"IT'S LIKE YOU ARE PLAYING CHESS AGAINST GOD AND TRYING TO OUTSMART HIM AND EVOLUTION."

market, and we were invited to all the important conferences. So, there was noise about, and we felt that we were in the big game, but we were also afraid to think about it because the disappointment would be enormous. So, we tried to distance ourselves a bit.

Few women have received a Nobel prize, and not very many women are in science. How do you feel about that?

That is true, but I think we are getting better. But we should be careful not to throw out the baby with the bathwater and say, "Okay. From now on, only women will get the Nobel prize!" Women should not get recognition because they are women. They should get it because of their important achievements.

Could you describe the moment when you were informed of your Nobel Prize?

It was during a holiday, so I was at home. And I wasn't expecting a call anymore. You should know that the committee has a firm procedure. In the first week of October, the laureates are announced: for medicine on Monday, for physics on Tuesday, and for chemistry on Wednesday. And the prize for medicine had already been awarded. My students had walked into my office on Monday and declared regretfully, "No, not this time." And I didn't think about it anymore. But then I got the call on Wednesday, the day for chemistry. I guess the committee sees chemistry in a bigger way.

Did the prize change your life in any way?

We were the first in Israel to get the Nobel Prize in science, so it definitely heaped responsibility on us. But as I didn't lose my curiosity for research, nothing changed much. People keep telling me, "Now that you have got the Nobel prize, you can sit back and enjoy life." But I am continuing my journey through science and I am even busier now, as I travel more than before. And I meet interesting people, like the Pope. These people have different visions, and it is wonderful to exchange ideas with them.

In 1977, I had a long meeting with the unbelievably charismatic Rabbi Menachem. This was several years before we made our discovery. He was also an engineer, and he wanted to understand the philosophy behind our discovery. So, I explained to him what we found. I called it "destruction for the sake of construction." He was interested why evolution—for him it was God, of course—developed this way, that our bodies balance between destruction and construction. I think it is extremely important to enhance your understanding by meeting these influential people.

This meeting with Rabbi Menachem was special for you?

Yes, because I am a proud Jew, and I am a very proud Israeli. And it's not that I believe in God, in the simple sense of the word, but Rabbi Menachem was an influential moral leader. I met him on an important Jewish holiday, and I remember how everybody

"PEOPLE KEEP TELLING ME, 'NOW THAT YOU'VE GOT THE NOBEL PRIZE, YOU CAN SIT BACK AND ENJOY LIFE.'"

was celebrating and there was noise around him—singing and cheering. He devoted several hours to me, whereas typically his followers got about ten seconds with him. There was a line of 1,000 people every day in front of his synagogue in Brooklyn.

It is amazing to see such strong leadership. And you recognize how important it is and how much we lack it nowadays. For me, Angela Merkel was the last true leader in this world. Part of the strength of the Nobel Prize is that it gives you a high position, because it is so well recognized. People listen to you, so I use this power. But I don't know if I am a leader. I try to do my best.

I have read that you are a nonbeliever. Is that true?

Of course, I am Jewish. But there are so many gods in the world, so probably there is just one god sitting above us. Religion gave us the means to act morally, like the Ten Commandments. But it also brought upon us the greatest bloodshed in the world. So, I usually tell kids that God should be in our hearts, and we should believe in whatever we like. As long as we don't use violence to enforce our opinion on one another, we are okay.

But I am a great nonbeliever in the Talmudic sense. I don't believe anything that others tell me. I always go and check it for myself, and it is okay only when I convince myself. Casting doubt is

fundamentally important for a scientist. And the Talmud teaches Jews to become question askers.

So, asking the right questions and having doubts are also main principles in science?

Definitely. And you need to love what you are doing—passionately. Persevere and be ready to fail repeatedly, because it is a long-term game. But it is also unbelievable fun. It is rewarding. It is like you are playing chess with God and you try to outsmart him and evolution, which is not easy. But when you accomplish it, it is rewarding.

Of course, I have to stay humble and realize that we managed to crack only one small secret. We add our knowledge, and somebody picks it up if it is important. It is like a very complicated million-piece puzzle.

Why should young people study science?

If you want to make a mark, do what you are really passionate about. I keep telling young people, "Don't listen to your mother. Close your eyes and ask yourself what you are good at and do it. You can be anything." And for me, science is the answer!

We live in a world that is so fascinating and I have the urge to understand what is behind everything. Our lives have become much more comfortable, thanks to science. We have prolonged human life from fifty to eighty years over a period of a hundred years, due to science, X-rays, drugs, food, diet, vaccination, antibiotics. Everything is science.

Unfortunately, progress is a double-edged sword, and it can also be used to develop destructive tools. Therefore, we should be careful about how we use science. I think democracy is an optimal tool for regulating that as it has developed certain control mechanisms.

Let's talk about responsibility. Edward Teller, the father of the hydrogen bomb, said: "We don't have any responsibility. The politicians are responsible." Do you agree?

I think he was partly right. We shouldn't say, "You as a scientist are responsible." That is too much of a burden. Think about gene editing, about all the new

technologies. Scientists cannot take responsibility for all the consequences, but of course throwing the responsibility to the politicians is also too narrow-minded. We need to shape our future and control what is going on as a society, which is made up of politicians, clergy, sociologists, psychologists, legislators, and scientists. Insofar as we are part of society, we do have responsibility. And as we are the people who understand what is going on, we should explain the pros and cons so as to prevent foul decisions—like what's happening in the United States concerning climate change. So, science is not an independent, isolated ivory tower without responsibilities.

Have there been moments of failure for you?

There have been more moments of failure than of happiness. One of the recipes for success is having a good attitude about failure. Mine is a positive one. I don't call it failure—I call it a lesson. Go back to the board and analyze what happened. Change the previous step and move on again. It is an ongoing process, and by going back and forth, you are progressing. I think that without failure there will be no success.

How do you see the future of science?

In biology and in medicine, the upcoming topics will be the curing of cancer and the diseases of aging—brain diseases like Alzheimer's—which are diseases that are going to be a great burden on society. And with the new technique of gene editing, the moral issues we face are huge. To what extent are we going to manipulate human beings? Will we only correct mistakes, like devastating diseases, or should we improve human ways? The latter is very close to racist theories like those of the Nazis. So, genetic engineering should be limited. But if it's possible to avoid having a mentally retarded child, then we should take advantage of this technology to correct the defect.

Do you think most people are afraid of genetic engineering?

Well, people need to be educated about the facts. God is in the details. If you do not know what is going on, it is better not to have an opinion. I don't opine on the music of Beethoven because I don't understand it. I enjoy it, but I don't understand it. If a genetically engineered tomato can grow with a tenth of the normal supply of water, or can withstand insects, many more people will not starve. So, people should be educated about what they are saying before they determine the fate of hundreds of millions of people in India, China, or elsewhere.

What message would you give to the world?

We are living in a cruel era. I would like to see a world of peace. First, we should stop killing one another. And second, we should care about the needy. One-third of the world's population doesn't have running water or enough food to eat; that is a real problem. The achievements of science and technology are going only to the privileged. Why do we do science if only a minority of the world's population benefits from it? Why do we have this huge inequality? So, I would say: first, stop killing; second, talk more and provide the elementary needs for everyone. I am not talking about Mercedes cars. I am talking about food, immunization, mosquitoes, water. That is the world I would like to see.

"WHY DO WE DO SCIENCE IF ONLY A MINORITY OF THE WORLD'S POPULATION BENEFITS FROM IT?"

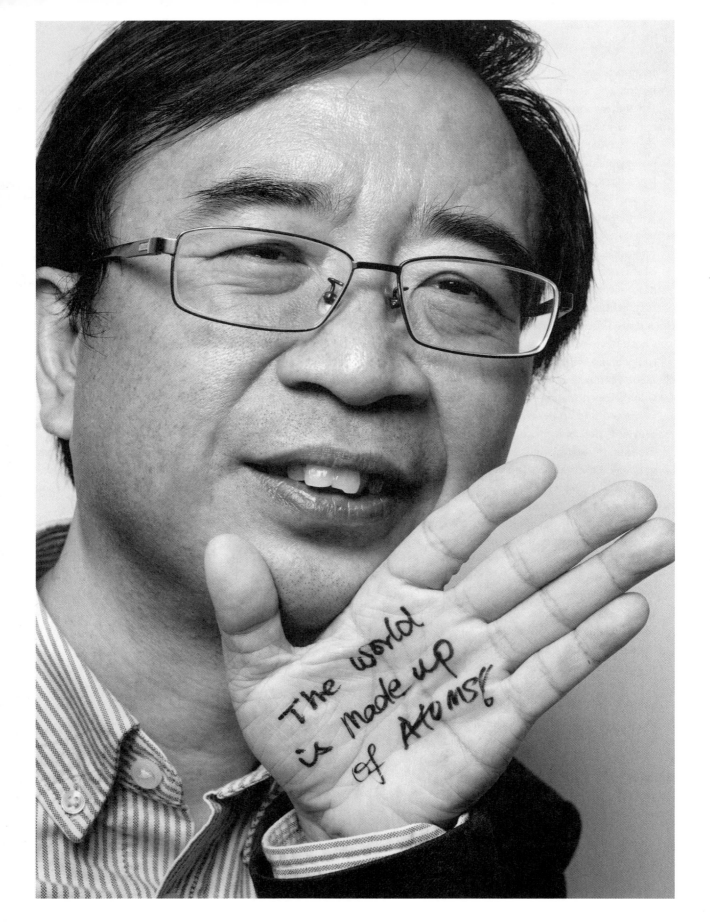

"WITH BETTER EDUCATION, PEOPLE WILL BE MORE OPEN, MORE PEACEFUL AND MORE LOVING."

Jian-Wei Pan | Quantum Physics

Professor of Physics at the University of Science and Technology of China [USTC], Hefei
Zeiss Research Award 2020
China

You lived in German-speaking countries for twelve years, yet you don't speak a word of German. How did this work out for you?
I only understand a little bit of German, which is a pity. I moved to Austria in 1996 and received my PhD from the University of Vienna. Anton Zeilinger was my PhD supervisor, and he tried to persuade me to learn German, but I was working day and night in the laboratory and simply didn't have the time; I wanted to devote all of my time to scientific research. I stayed on in Vienna as a research associate, before

moving to the University of Heidelberg to start my own research group.

At the end of 2008, you left Germany and returned to China. Were you happy to be home?

I really loved Germany, but I was happy to return to China, which is only natural if you're given a chance to do something even better in your home country. I love science and I love physics, and contributing to the future development of my country is even better. It's an ideal combination.

Your family remained in Heidelberg when you first returned to China. Was it hard to be without them?

It was really hard for the first few years. My daughter had to stay in Heidelberg to go for regular health checkups at the hospital, so I used to fly to Germany every couple of months and spend a few weeks there. I called them every day via Skype, and I would make up my own bedtime stories to tell them over the phone.

By 2011, my family also moved back to Shanghai and still lives there.

Did your children attend school in Germany?

My daughter was 6 years old in 2010, so she went to school in Heidelberg for one year. My son was only 4 years old when he went to live in Shanghai, so he was too young for school in Germany. Both children were born in Germany, though. and we sent them back every summer so they could learn German. My daughter can speak fluent German.

When you took your PhD, Anton Zeilinger was one of the leading scientists in the field of quantum physics. Now you're called the "Father of Quantum." How did he react to that?

At the beginning there was a bit of a misunderstanding, and we competed a lot when I set up my independent group. We soon realized, though, that collaborating made more sense. I remember flying to the United States to attend an American Physical Society meeting in March 2007 and making an appointment to meet with Anton Zeilinger. I said, "We should probably work together in some form or other on the free space experiment," and we planned to set up ground stations in both China and Vienna.

Anton Zeilinger is a brilliant scientist in fields such as multiphoton entanglement. My team demonstrated five-photon entanglement in 2004. After sharing that technology, my Austrian colleagues soon developed six-photon entanglement. Ten years later, in 2017, we had achieved good results for intercontinental quantum key distribution, thanks to our collaboration.

Still, did he accept that his student went further than he did?

Well, that's the spirit of science, right? Science can only develop if the students are better than their supervisors.

Can you tell me a little about your upbringing?

I was born in Dongyang, Zhejiang, the youngest of three children, with two older sisters. My mother was a math, chemistry, and physics teacher and she encouraged my interest in these subjects. My father worked for a government-owned company, but earlier had been a teacher and had taught my mother Chinese at school. He taught me a lot about literature, culture, and the Chinese language.

Did your parents push you to do more?

Mine wasn't a traditional Chinese family; my parents didn't push me at all. I had a long conversation with them when I was deciding on my university. At the time, the economic situation in China was starting to improve, so I asked them, "Should I go and earn some money? Should I learn economics? To be honest, I'd really prefer to study physics as it's so interesting." They simply encouraged me to do what I wanted, saying, "If you like physics, then you should study physics. Don't worry about the money."

Why did you want to study physics in particular?

I found learning different languages really difficult, as you have to memorize so much. It was the same for chemistry; you have to remember lots of formulas. On the other hand, physics and math were easy for me; I just needed to understand the principles and the theorems, and not memorize much. You can deduce wonderful things from calculations, and I feel that is so simple to do. That's why I chose to major in physics.

You were born in 1970. What was your experience of the Cultural Revolution?

By the time I started school, the Cultural Revolution was over. When you're young, you don't really experience much, but afterwards I started to understand what a terrible time it had been.

My paternal grandfather was quite rich, while my mother's family was extremely poor; my maternal grandfather passed away when he was still young, leaving my grandmother to take care of two children by herself. So, during the revolution we swapped our surname with my mother's maiden name to protect our family. Afterwards, I changed my surname back to Pan.

I imagine you're a rich person by now?

Professors in China are well paid, it's true. I'm also Vice President of the USTC, where I also received my bachelor's and master's degrees. The position entails special requirements for my patents, so I'll probably have to wait until my retirement to earn money from those.

What inspired you to develop the quantum satellite *Micius*?

We developed *Micius* to boost long-distance quantum communication, as after a few hundred kilometers the signal grows weak and can't stretch any farther, owing to huge photon loss. On the one hand, this makes quantum communication secure, as the signal can't be amplified; on the other hand, it's limited in terms of distance.

We started performing free-space, satellite-based quantum communication, as the vertical atmosphere is only 5 to 10 kilometers of horizontal atmosphere. We found that most of the light from a satellite could penetrate the atmosphere and reach our ground station. We started the project in 2002, with support from the Chinese Academy of Sciences [CAS], and after almost ten years of ground tests we developed *Micius*, the world's first quantum-enabled satellite, which was launched in 2016.

What is *Micius* used for?

The first satellites were used for scientific rather than practical applications; at the time, we didn't know whether we could really succeed. For the time being, we're performing fundamental research with *Micius* and are also using the satellite to investigate the interface between quantum physics and gravity.

What about the cost of this? I should imagine it's been expensive.

It's true; *Micius* cost about 70 million euros (US$80 million). We're also considering launching several small satellites, which only cost 2 million euros per small satellite platform, to form a quantum constellation and provide realistic, practical applications for users. Our colleagues in Germany are developing something similar, but they are far better funded for the same work.

So *Micius* can't be hacked? That must make it attractive for military applications and economic purposes.

Yes, in principle it does, although as I mentioned my sole interest is in developing the scientific technology. We share all our knowledge with our international colleagues, so of course, the Chinese or U.S. army, for example, could develop a similar system. That's out of my control. Secure communication doesn't represent a weapon; rather, it provides unrestricted privacy.

Would you like to provide unrestricted privacy and secure communication?

For me, it very much depends on the prevailing political policy. I guess the government won't enforce full, unlimited privacy protection and will run all future quantum key distribution companies. It will allow access to only those persons who have been approved. If the technology falls into the wrong hands, then it'll be beyond government control.

Mass surveillance and facial recognition cameras afford the government a lot of state control. Will this change in the future?

I'd like to imagine that everyone will be dressed in black, wearing masks, so that no one walking down the street can be identified. That would, of course, also be boring. There's always a good and bad side to science.

Does China see quantum information technology as a future market employing your technology?

It's still in the early days; we're yet at the stage of basic research. People expect too much of quantum technology. Quantum communication is a preliminary mature technology, but it will take some time before quantum computation and quantum metrology can really be used.

Who do you cooperate with for *Micius*?

We collaborate with the Austrian Academy of Sciences and have collaboration plans in place for similar organizations in Italy, Germany, Sweden, and Singapore. We'd be willing to cooperate with the United States, if they have a ground station.

So far, though, we've encountered difficulties with international collaboration, particularly with our U.S. colleagues. I personally think that science should benefit everyone, so I would like all scientists from around the world to work together to push forward development. Quantum technology will have a good future, but it's too early to stop attempts at collaboration now; there's still a long way to go.

In the past, Europe and the United States were dominant in the quantum field. Now China is a rising star. Do you expect to see a worldwide quantum race?

The United States has its National Quantum Initiative and Europe has started a European Quantum Flagship project. In China, we're still being evaluated and are waiting for official approval from the central government. So, even though we were probably the first to start, we're currently a little behind Europe and the United States, both of whom are strong in superconducting. I believe we will start a national project in China very soon, though.

In a way, it's a worldwide race, but we still need to collaborate; nobody is clever enough to develop all the necessary technology. Closing off a country from the rest of the world would spell disaster for scientific innovation, particularly for China. I worry that in the last decade, countries have started isolating themselves; it's not the right direction for the future.

In your work, do you cooperate with industry?

Normally our university encourages scientists to engage in technology transfer, rather than setting up their own companies. In China, though, you can form companies that are partly owned by the government and partly by scientists and private companies, which is healthier for future development. Our company, Quantum Communication Technology, is run together with CAS, USTC, and private companies and is currently doing very well.

Which will China consider the most urgent matter in regard to climate change—the environment, medicine, or sustainability?

China is facing the same environmental problems as the rest of the world. I think the main focus is on energy; if we have sufficient clean energy, then we can also solve other environmental and climate problems. Our university's main focus is on energy, medicine, and information technology. Our priority at USTC is fundamental research, which is the basis for solving problems in all fields.

What is your message to the world?

The world should pay more attention to education. With better education, people will be more open, more peaceful, and more loving. I still believe the world has a bright future with the help of good education and science.

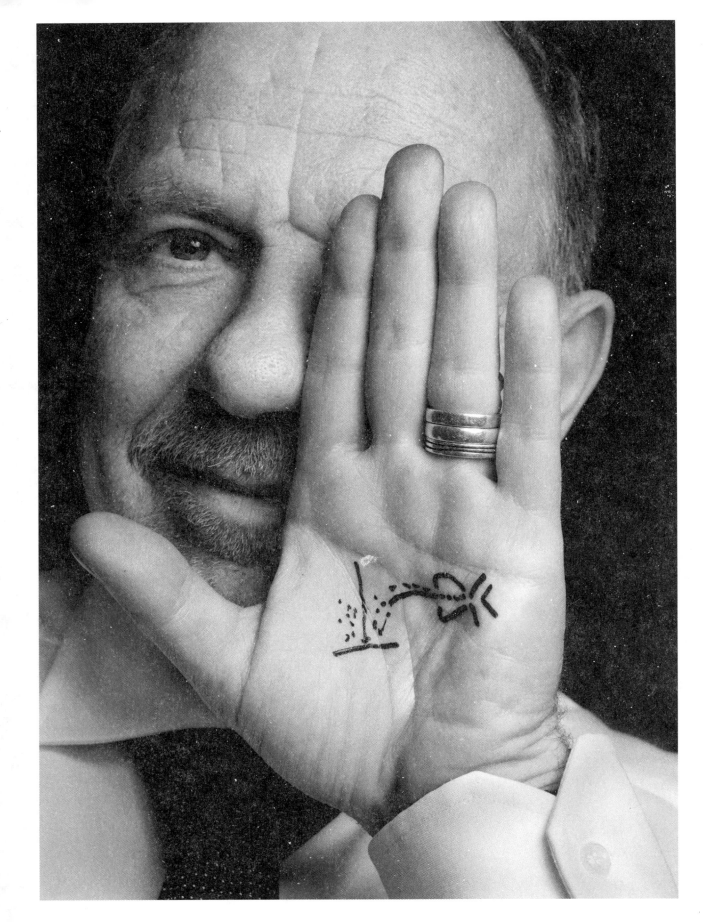

"BEING A RESEARCHER CAN'T BE LEARNED; IT'S INTUITIVE."

Detlef Günther | Chemistry

Professor at the Laboratory for Inorganic Chemistry at ETH Zurich [Swiss Federal Institute of Technology]
Vice President of ETH Zurich
Switzerland

Professor Günther, you refer to November 9, 1989—the fall of the Berlin Wall, as your second birthday. Why is that date so important to you?
November 9 was the beginning of freedom. Suddenly I could see the whole world, and I really wanted to. I'd always dreamed of seeing the Grand Canyon, and now it was within reach. It was a big celebration for my whole family.

Even as a child, you loved freedom. How did your father channel that urge so that you didn't attract the wrong attention?

He showed us how to conquer the world. Even in GDR [German Democratic Republic, or East Germany] times, we traveled through Czechoslovakia, Hungary, Romania, and Bulgaria with a great joy of discovery. We were only conspicuous in that we had Western relatives, but we didn't break any laws. Once, when I rode home on my moped after a few beers, I got a tremendous scolding from my father because he was afraid he could be blackmailed for his children's misconduct. My parents wanted to protect us, and they always showed a united front.

You studied chemistry in Halle and received a scholarship from the German National Academy of Sciences Leopoldina. But you turned it down and instead went to Memorial University in Newfoundland. What drove your decision?

I didn't know any English at all, and I knew that I'd never be able to express myself in the scientific community if I wasn't fluent. For instance, I wouldn't have been able to easily give lectures and defend my results. That's why I decided to go to Canada. There, I had a boss who triggered a paradigm shift in me with the wonderful phrase, "I think you can do it," instead of, "You have to."

That comment shaped my whole later life. Thanks to my professor's confidence in me, I realized I could do something myself. He awakened my inner motivation for research. From then on, I started working fifteen hours or more a day and getting up in the morning when everyone was still asleep. My professor challenged me, but he never pushed me. I also knew that as long as he was around during the day, I could ask him questions at any time. He was my scientific father.

You went from Canada to the ETH, where you've been Vice President for Research and Economics since 2015. In addition, you have your own research group. Is that a bit too much to handle?

For me, the ETH is the Taj Mahal of chemistry. I've always thought that I should give

something back, out of gratitude that I'm allowed to teach and research at this university. Whenever

"'I THINK YOU CAN DO IT,' INSTEAD OF, 'YOU HAVE TO.' THAT SHAPED MY WHOLE LATER LIFE."

a task was needed to be done, I gladly accepted it, and sometimes my plate was quite full. With my own research group, however, I make better decisions because I'm even more directly involved in science, and that gives me strength. I don't want that to be taken away from me either, even though it's not accepted by everyone.

Science remains a passion for me. Sometimes there are situations in which everything seems to go to pieces, and my private life suffers because I can't maintain my friendships. But I've never neglected my family and I was always there for my children's important moments.

What has been the most important aspect of your research?

The most important thing was that I believed in a method from the very beginning, when no one assumed it would ever gain such importance. We vaporized material with UV laser radiation and then measured it with inductively coupled plasma mass spectrometry. We were able to analyze almost the entire periodic table.

Setting up the first UV laser system for quantitative trace elements in Zurich, and fundamentally investigating it, we showed what could be done with it; that was our great contribution to science. I relied on trust. For over a year, money flowed into the laboratory without our producing any results. It was such a relief when everything we'd worked on actually worked out.

Were you more readily accepted at ETH as a young scientist than at German universities?

Yes, definitely. I didn't have to get in line in terms of hierarchy; I was immediately integrated and accepted, first in the Earth Sciences Department and then in the Laboratory of Inorganic Chemistry. When I received my first awards, my colleagues were so happy for me that my joy was multiplied.

As vice president, I make an effort to personally write to and congratulate the awardees. Science is getting increasingly better at freeing itself from its ego. Talented young academics should be accepted far sooner as colleagues. We scientists should show more respect for each other and learn to share the honors. It's understandable if I want to be the best in my field. But why shouldn't I contribute some of my expertise to something bigger?

Should Germany's many science organizations carry out more combined research?

Nowadays, the complex issues make it imperative that individual research areas consolidate. There's always a need for the basic sciences to produce something new, but there's also a need for applied research and cooperation with industry to accelerate the implementation of research results. In this respect, Germany should perhaps reconsider the current division of tasks. Today, we can't set up a new nutrition concept without an energy concept, and we can't do anything for climate without considering nutrition concepts for a growing population. Everything is closely interlinked.

Why can't Europe manage to agree on common goals?

The heterogeneity and different histories of the European states have held back the development of an academic identity. Things are getting better, but the economic differences are still large, and every project introduces another debate about whether everything is being fairly allocated. Europe still lacks self-confidence, even though it has made many breakthroughs and is extremely strong in basic research. Europeans should think carefully about the areas in which they want to be strong in the future.

Doesn't cooperation with industry create certain dependencies?

Research is never an end in itself, as the current digital transformation shows, and much long-term research can be implemented with industry at some point. Contracts are structured such that our autonomy isn't called into question. The ETH alone determines which projects it wants to carry out with funding from industry, and there are various ways of then sharing the benefits. We also have an ethics committee that evaluates projects. There were proposals like facial recognition for military applications that we definitely didn't go for because, we said, that's a clear red line for us and we shouldn't cross it. However, we've been working with Disney for over

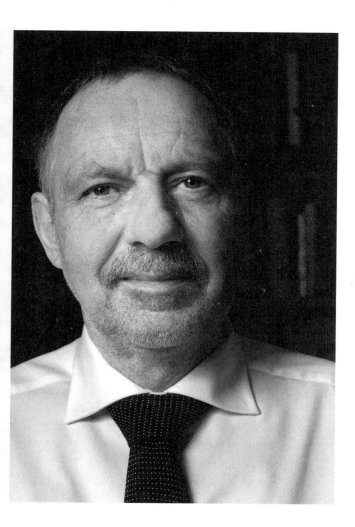

"EUROPEANS SHOULD THINK CAREFULLY ABOUT THE AREAS IN WHICH THEY WANT TO BE STRONG IN THE FUTURE."

ten years—for example, in areas involving animation and facial recognition.

You cooperate with many other countries, including China, and you yourself held a professorship in Wuhan. What do you expect from Chinese science?

In China, you have to work far harder to stand out from the crowd. Whether this results in better ideas is another question, but force is mass times acceleration. There's a lot of creativity in my field, which has only increased, thanks to better equipment. The Chinese are not only industrious but also strategic. Fifteen years ago, when I prophesied that they'd be tomorrow's inventors, I was laughed at. In some areas, they'll take the lead.

You once said that a new age has dawned and that a great upheaval was taking place. Can you define that upheaval?

Digitization will radically change all areas of our research and society. It's not a question of if but, rather, how quickly. In addition, today's generation is making entirely new kinds of demands. A sense of well-being and a healthy work-life balance play a major role in this. As scientists, we have to be even better role models so that students don't lose their enthusiasm for research.

What value system are you instilling in your children?

I've never just gone ahead and financed something big for them without first emphasizing that they're also responsible for how much they can afford. Work comes first, and then you can think about what to do with the results. My parents taught me that. My father was happy to contribute, but we children had to take the first step.

What other values did your parents pass on to you?

With my father, I was never allowed to be late. Once he didn't let me go to an important soccer game because I came home five minutes late. I watched the bus leave without me, after my father stood at the door and said that I wasn't going. That's stayed with me my entire life.

Honesty was also very important. No matter how bad something was, my father could live with everything except lies. I was also influenced by the way he went to farms as a veterinarian and treated everyone with the same respect. I learned that myself when I was still a student, working in a shop for agricultural machinery, where arrogance and condescension would have been unheard of. Today, if one of my doctoral students were to hand in an urgent order and not pick it up for three days, or not say thank you, he'd be in trouble not only from the shop but also from me.

You have to juggle a large group of people, many with strong egos. How do you do it?

The most important thing is personal interaction—the way I approach people. I learned the art of conversation from my father. When he had to convince thick-skulled farmers that he was the right person to treat an animal, he didn't immediately talk about diseases. He first asked how the harvest was and what the children were up to. And I try to heed this gentle approach when dealing with scientists and their egos.

What has your work taught you about yourself?

My patience wears thin—more than I've made out. I sometimes get impatient when something takes a long time, but I can pull myself together sufficiently to not immediately lose my temper. I've learned not to want to win all the time.

You once said that you couldn't work for someone else. Why did you find that so difficult?

I didn't want to be confined again, like in the GDR. And I didn't want to put my cumulative ideas into practice for someone else—just for the team in my research group. I wanted responsibility, no matter how high the risk. Being a researcher can't be learned; it's intuitive. And I was the person who was always ready to raise my hand to volunteer for other tasks as well.

What has helped you satisfy your own quest for recognition?

In 2003, at the age of 40, I received the European Plasma Award, and in the same year I was awarded an associate professorship at ETH. This had never been part of my life's plans, and for the very first time I felt deep gratitude. Another crucial experience was my first plenary lecture in America, where I was allowed to open a conference for a specialist area in front of a packed hall. That's when I felt truly accepted.

As vice president, you help determine the direction of research. What are your goals for such research?

We have three areas of focus at ETH: cyber security and data, energy and the environment, and medicine. ETH has a research commission that evaluates new projects, and it considers where better infrastructure is needed, and which research areas need to collaborate more. I can direct that somewhat in my position. But there's always a dialogue with the departments, the professors, and the research commission to determine whether we're just dealing with hype or whether a project could develop into something bigger.

You place a lot of emphasis on ETH spin-offs. Why are you so proud of them?

We don't have a Silicon Valley culture. There, many young people are willing to take risks to implement their ideas by setting up their own companies. But at ETH, the number of spin-offs has also been increasing for years, and in a different way its people also are following the path from rags to riches. We

have about 220 invention disclosures a year, from which 80 to 100 patents are generated, of which 30 ideas are turned into companies. These numbers are steadily increasing and strengthening ETH's reputation as an innovative university.

How much does a researcher get for a patent, and how much does the university get?

All intellectual property belongs to ETH Zurich. The inventors, the research group, and ETH usually receive one-third each of the licenses. That's a fair division. The reasoning behind this is: If we give them nothing at all, no one will register a patent anymore, but if we give them too much, they'll no longer care about the university.

The pressure to deliver results can lead to cheating. How should science respond to this situation?

We need a central point to handle such accusations, and deal with them in a transparent process. Some young scientists today aren't even aware of the consequences of going down the wrong path at any point. The entire scientific community learns about the cheating within a matter of seconds, and the young scientist never gets a foot in the door again. Doping isn't allowed in science, either.

What's your message to the world?

Education safeguards the future! We'll not be able to solve our other problems without exemplary teaching and research in science. We want the next generation to enter a rational world, with basic values, such as esteem, respect, empathy. We can do that only if we set an example now.

"I WANTED RESPONSIBILITY, NO MATTER HOW HIGH THE RISK."

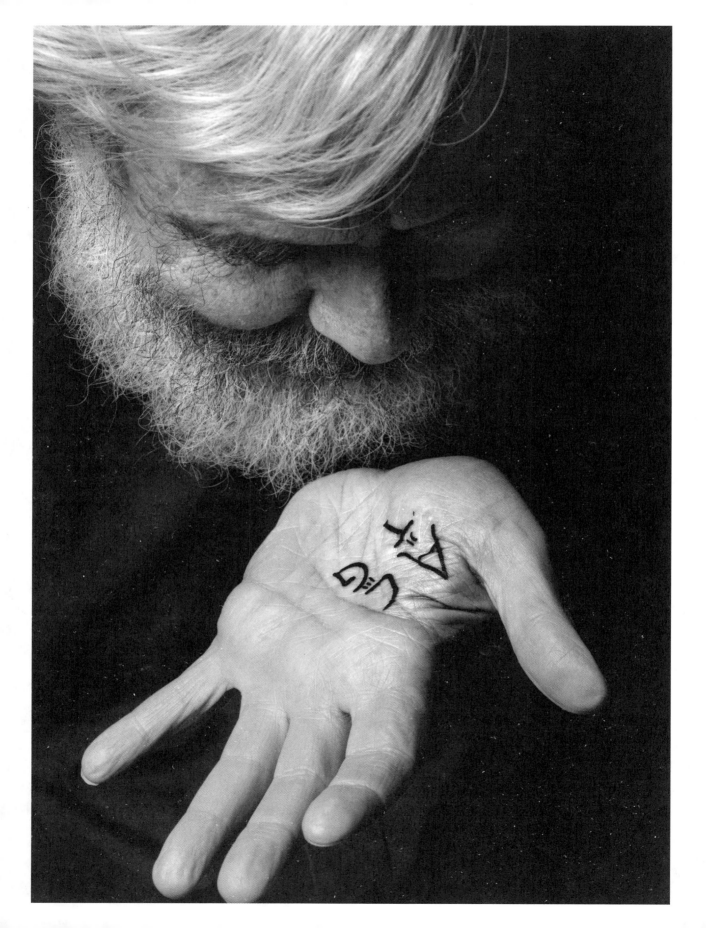

"I'D LIKE TO CREATE A WAY TO REVERSE AGING, SO THAT WE CAN BECOME MUCH YOUNGER."

George M. Church | Genetics

Professor of Genetics at Harvard Medical School, Boston
Professor of Health Sciences and Technology at Massachusetts Institute of Technology [MIT], Cambridge
United States

Your colorful personality makes you stand out within the scientific community. What would you say characterizes you as different?
To be honest, I've always been a bit of an outsider. There were actually a few things wrong with my brain when I was younger: I had obsessive-compulsive disorder and attention deficit disorder, plus I was dyslexic and narcoleptic. I did my best to fit in, but as soon as I opened my mouth, people would realize I wasn't normal. I used sophisticated vocabulary, which I'd picked up from my mother, and that didn't go down so well in semi-rural Florida.

My main strategy was just to keep quiet, and that gave me more time to watch and listen, which made me a good observer. And, of course, observation is a key component of science and engineering. I still think you shouldn't care too much about other people's opinions, but you should listen to people to figure out where they are coming from and try to understand them.

You're also extremely adventurous, yes?

Nowadays I take fewer risks with my body because society has invested too much in me for me to just throw it away. But I'm still very adventurous in the realm of technology! I do things other people think are impossible, but I'm not that brave in the sense that I've figured out that those things are actually quite easy.

Easy for you, maybe but extraordinary for everyone else. What about the mini brains you're building, for instance?

Right, we're building miniature brains, or brain components—that is, turning my skin cells into stem cells and then into brain cells. It's a strange feeling, looking at your own cells outside of your body, and they are doing useful things and taking on new forms, some of which have never happened before. It's gratifying to give part of your body to society. Then there's a feeling that if I were to die, these cells would outlive me.

So, what's the idea behind these mini brains?

The purpose is to develop a test bed for new therapies. So, whether it's small molecule therapies, or gene therapies, or cellular therapies, or transplantation, we can test these on human brains rather than animal brains, the latter which is neither humane nor a perfect replicate. So, over time and with some effort, these human brains made of human cells will more and more faithfully represent a human being.

Do you plan to make a complete human copy of yourself one day?

Making a copy of oneself is still firmly in the realm of science fiction. Our work is pathetic compared to an actual human brain. Artificial intelligence doesn't hold a candle to real human intelligence.

So, you're steering clear of science fiction for now?

Well, some people already consider many of the things I've done to be science fiction! For example, being able to read a human genome for almost nothing, when the original estimate was over $3 billion.

Can you explain the big price difference in genomic sequencing?

Back in the 1980s, we published the first direct genomic sequencing method and helped initiate the Human Genome Project to determine the full information on a person's genome. At the time, this cost roughly $3 billion for a bad genome. I felt that we had to bring the price down to make it affordable. Some of the technologies I was working on just took off around 2004, so that today we can get a great genome for $300, which is then delivered to the consumer for free—the system simply absorbs the costs. So, we've gone from $3 billion for a bad genome to zero dollars for a really great genome.

What motivated you to create a map of the human genome?

I wanted to generate a technology in which we could sequence everybody's genome, compare those genomes, and find out which bad diseases a person could avoid through techniques such as genetic counseling. By lowering the price, we now have a million genomes, so we can really seriously start delivering diagnostics and therapeutics.

We'd also like to be able to fix or prevent diseases, and that involves a synthetic component. Synthetic biology allows you to create whole new

"SYNTHETIC BIOLOGY ALLOWS YOU TO CREATE WHOLE NEW THINGS THAT NEVER EXISTED BEFORE."

things that never existed before—it's like a creative art employing future technology.

At the time, your discovery made big waves throughout society. Have the waters calmed now?

We need to increase awareness and lower the costs to allow everybody interested to get their genome sequenced. Just 1 million out of 7 billion people on this planet have done so up to now. That's a big wave relative to zero participation a few years ago, but it's a small wave compared to the 7 billion genomes that could be sequenced.

What about those people who don't want everyone reading their DNA on the internet?

Well, we've been developing a way to do this work on a computer in an encrypted form so that nobody else can read the results apart from those whose genome is involved.

How do people normally react to seeing their own DNA sequenced?

Some people are interested in finding out more about their ancestry; often Americans are surprised to find out they have a completely different racial history from what they originally thought. Most, though, are motivated by the medical aspects. They want to find out their risk factors for certain diseases and how they can immediately improve their quality of life to avoid problems.

Only a small subset currently benefits from preventive medicine but, of course, you never know if you're going to be part of that subset; and if you see something, that information could have a huge impact on your life. We now have over 300 serious genetic diseases affecting kids, and those diseases are avoidable through preventive medicine.

Do you welcome the interest from Big Pharma and the insurance companies?

It could be a win-win. It's in an insurance company's best interests for everyone to live a long, healthy life, but on the other hand, we don't want those companies to discriminate against people based on their genetics—which is why the United States has laws against that.

Big Pharma could create better drugs, thanks to knowing the genomes. In fact, many new drugs have a diagnostic component, as well as a therapeutic aspect. But there's also the possibility that they might not deal with a particular illness because it's too rare. The U.S. Orphan Drug Act essentially encourages pharmaceutical companies to charge a lot for rarer drugs, and that could be a problem in terms of any equal distribution of new technologies. Gene therapies are now the most expensive drugs in history, costing up to a $1 million for a single dose. We hope we can bring that price down, but if the drugs remain expensive, we've all got a problem.

And you're also trying to stop the aging process?

I'd like to create a way to reverse aging, so that we can become much younger. I've been working on aging

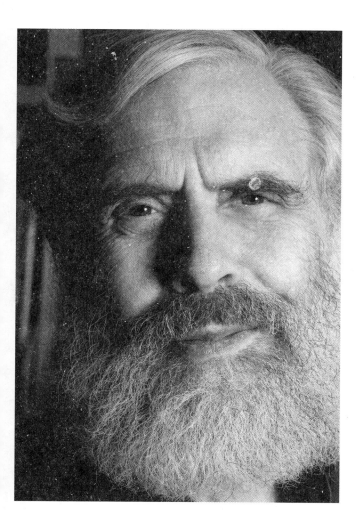

"MY SCIENCE HAS COMPONENTS OF FAITH IN IT, AND MANY RELIGIONS HAVE A FACTUAL BASIS."

for over a decade. For instance, I've been looking at components of mitochondrial functions and these are already in clinical trials in humans. In a certain sense, humans are just atoms. We don't want to hurt the atoms that are responsible for our memory and our experiences, but we do want to work on those atoms that have the impact to extend our quality of life.

How do you feel about extending your own life?

This isn't really about me; I'm trying to help everybody else. But I think many people, including me, would at least like to get to see their great-grandchildren and live into the next century, and to witness the world become a better place. It's hard to say when you would be willing to quit a life like that; if you feel young and happy, why would you want to commit suicide?

Aren't you worried about unintended consequences?

Well, some people worry that extending life will create a population crisis, but the way I see it we're going to need a lot of people to populate the universe—that's a big vacuum to be filled.

You're also carrying out experiments to make pigs suitable for organ transplantation. Can you explain that?

Actually, that's a very old idea, but now its time has finally come. In fact, that's true for a lot of ideas that seemed like science fiction. The idea is old, but the hard part was working out how to do it. Right now, we're currently testing pig organs in monkeys, before we can move onto humans. We still hope to be able to successfully transplant pig organs into people.

It's crazy when you think that what was unimaginable twenty years ago is happening right now! How do you feel about that?

Right. It's an exponential curve, meaning it just gets faster and faster in multiple-related fields, like computers, electronics, DNA, and developmental biology. And that's partly due to my work.

Anything else you'd like to create?

If one could create ways to eliminate diseases related to poverty, we might also reduce poverty itself. I'd like to create strategies to adapt humans for new experiences, like space travel. And I'd also like to build better computers—maybe bio computers.

What are your thoughts about the scientist who created a gene-edited baby in China? Do you think that's a line that should not be crossed?

Every new therapy crosses a line that hasn't been crossed before. People need to look at the data, rather than listen to their own expectations. Assuming that the data isn't fake, and there are real babies, I hope we can learn something from the experiment.

Where do you think a scientist's responsibility lies?

I'm on the cutting edge of technology, so I have to report from that frontier and speculate on what could go wrong.

But don't you ever feel like you're playing god?

Never! I'm an engineer. Most humans throughout history have either been engineers or have benefited from engineering—that's who we are. We don't create new universes; that's way beyond our capacity. We do little things with the universe we have.

Do you believe in God?

I had a strong religious and spiritual upbringing, and I've always shown a natural curiosity about religions. We had only religious communities around when I was growing up, so that made a big impression on me. I was interested in moral dilemmas, such as if your parents tell you to kill somebody, which do you obey? The "Honor your father and mother" commandment or the "Thou shalt not kill" commandment? Working through these types of paradoxes as a child provided me with an ethical framework.

The older I get, the more I see the confluence of science and faith. That is, my science has components of faith in it, and many religions have a factual basis. Many scientists will deny this, but we have faith that what we're doing is a good thing but just that it hasn't yet been proven. There's a lot of awe in the world; my feeling is that there's more awe when you understand it than when you don't.

So, are we part of something bigger?

Certainly; the imaginable universe could be bigger than the actual universe. Even if there is only one universe, one Big Bang, it's still hard for us to fathom that, so I think it's both bigger and smaller than our imagination.

Did your parents have a big influence on you when you were growing up?

My mother was an extraordinary woman, who was both a lawyer and a psychologist, and she had a huge impact on me.

I had three fathers—the first was an air force pilot, the second was a lawyer, and the third was a physician. There were big gaps in the times when my mum was a single mum. I didn't have much chance to really get to know my fathers—they worked hard and traveled a lot, and then I left home when I was 13 years old.

My birth father was with us for six months. It took a long time to process the way he was—charismatic and so at ease with other people. When I was 13, he invited me to San Antonio, where he was an announcer for a water-skiing show. He wasn't scared of public speaking, but I was absolutely terrified! I was watching the first show when he suddenly announced, "Here's George Church in the audience. Please stand up." So, I stood up while he made up some story about who I was.

I was with him at the end, just before he died; he'd been in cognitive decline for some time, so he didn't even know who I was.

Can you tell me a little about your early education?

It was an incredibly poor one! Up to the age of 13, I lived in Florida, where they didn't seem to value education and taught hardly any science. Basically, I wasn't intellectually challenged until I moved to Boston.

Were there any good points about growing up in Florida?

I had access to lots of wild, natural surroundings and had lots of risky experiences. We'd go out looking for poisonous rattlesnakes and water moccasins, and we'd swim to nearby islands through shark-infested waters. I almost got struck by lightning once! In those years, I just wanted to live for the moment. Most of my hobbies involved some element of risk, like rock climbing and ice swimming.

There were lots of hard knocks, I take it?

I actually steered clear of hard knocks, although I did literally get hit a couple of times! Some bullies gave me a black eye, and once one hit me so hard he even broke his hand on my face. But I never hit back; I'd just look at them with a surprised expression and then they'd stop. I'm still extremely anti-violence. I'll do anything to stop violence. Just as I'll do anything so that everyone has access to equal opportunities.

Do you take good care of yourself?

I sleep for about five and a half hours on average, and I eat a vegan diet. I also walk to work because I'm narcoleptic, so I can't drive.

Care to also discuss your financial health?

My own personal needs are small, and I'm blessed with having adequate financial resources. I need money to support my research, so I plough any money we make from my companies straight back into my research.

What else, apart from science, is important to you?

Just science, our species, and my family, basically—that's it.

Why would you encourage young people to study science?

I think science is infinitely fascinating; you're not just watching things, you're also changing things—and you can help other people. And there are plenty of opportunities for taking risks.

Any words of wisdom you'd like to pass on?

Follow your heart and follow your passions. Otherwise, care for other people, think deeply about the future, and learn from the past.

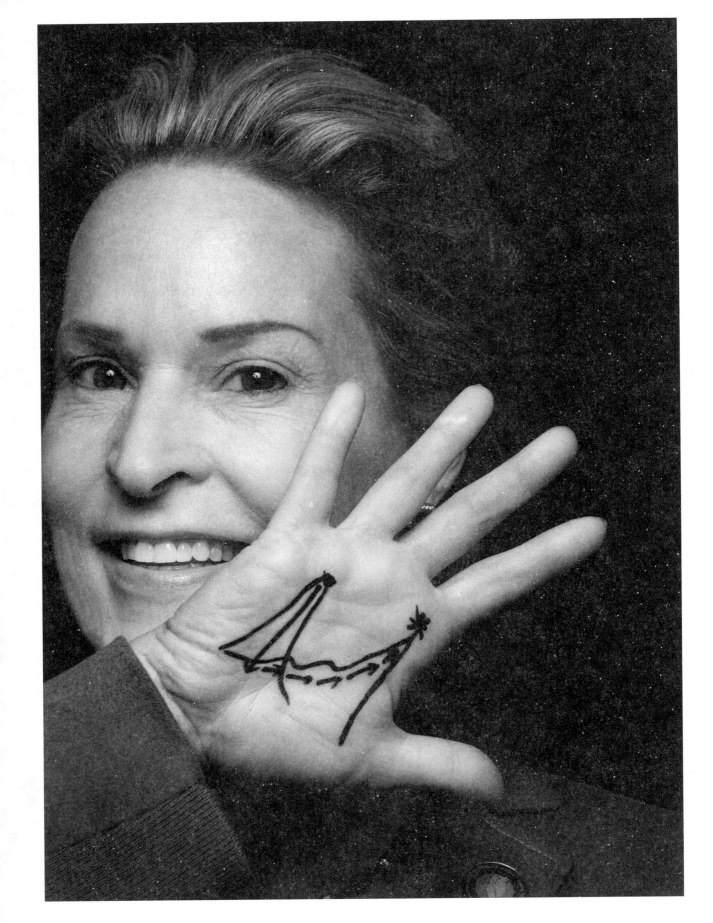

"EVOLUTION TEACHES US THAT UNLESS WE HAVE DIVERSITY, WE GO EXTINCT."

Frances Arnold | Biochemistry

Professor of Chemical Engineering and Biochemistry at the
California Institute of Technology, Pasadena
Nobel Prize in Chemistry 2018
United States

Professor Arnold, how did growing up with four brothers and a father who was a nuclear physicist toughen you for the work in science?

I think I toughened my brothers. My family life early on was imbued with physics and mathematics, and I just assumed I would do something with that. It was friendly competition. I won, of course.

In the late 1960s, U.S. cities were burning: civil rights protests, antiwar protests. There was a whole generation of young people who didn't believe what their parents were telling them. My family was torn,

because my parents had four other children and thought I was a bad influence on them, with my protests and hitchhiking, and doing various other things they didn't want my brothers to emulate. They told me I should either behave myself or I would have to leave. And I said, "I'm leaving!"

I wanted to find my own way in life. I was 15, but I knew I could make a living. I worked in a pizza parlor, I was a cocktail waitress, I drove a taxicab. And I found that independence was what I needed.

I love adventure. I was never afraid to do things or go places by myself, whether moving to Italy when I was 19, or later traveling through South America on local buses, staying at dollar-a-night hotels, and eating street food. (I got food poisoning any number of times.) I wanted to see the world. Curiosity and a sense of adventure drove me, but a lack of fear was also important.

How did you embark upon your career path?

I started off as a mechanical engineer because it had the fewest requirements at Princeton. For a long time, I didn't know what I wanted to do. I had no intention of becoming a mechanical engineer, but that subject got me into a very good school. And I saw no reason to switch my major because I could take different courses that interested me, like Russian literature, Italian language, economics, art history.

But then I found myself with a degree in mechanical and aerospace engineering, and that was at the beginning of a realization that people needed to learn how to live sustainably. The United States was experiencing major disruptions in the oil supply in the 1970s, and many engineers were coming to the recognition that we would have to invent new ways of generating energy, as well as live less wastefully. President Carter set a national goal of reaching 20 percent renewable energy by the year 2000. I wanted to be part of that. I took a job at the Solar Energy Research Institute, but that only lasted a year owing to a change in administrations and, with that, a change in government focus. After President Reagan was elected, I moved farther west to attend graduate school at UC Berkeley, in California.

This was the beginning of the DNA revolution, when the world was waking up to another important realization: that we could manipulate the code of life. I became a biochemist—actually a biochemical engineer. But I had never studied chemistry and I didn't know anything about biology. So, I threw myself into these new fields as a graduate student.

And then you earned a faculty position at Caltech. At the time, it was unusual for a young woman to be in this field. How did your colleagues react?

In my faculty position at Caltech, I was rare, but not the only woman. There were other female professors in chemistry and in biology. But I was only the ninth ever to be hired. I was young (30 years old), but I had a tenure-track position as an assistant professor and the first woman in chemical engineering. It was a bit of a battle to stay at Caltech, but I had enough supporters to win that battle—and the rest is history.

Apparently you once said you wanted to do your experiments "cheap and fast." What did you mean?

Frustratingly, my first experiments didn't work. I tried it the "gentlemanly" way, attempting to reason which changes would be beneficial. My colleagues were trying to understand how biology works by taking the science apart; they weren't making anything better. Getting a little desperate, because I was going nowhere fast, I decided to let the system tell me what was important. I did this by making mutations at random and searching through them very quickly.

I wanted to be an engineer of the biological world, to reconfigure the molecules of life to serve human purposes. I wanted to build new proteins—those big, complicated biological molecules that catalyze the reactions of life. Some of my biochemistry colleagues didn't like the way I approached the problem, though. Biochemists were taking a "design first" point of view—but no one knew how to design. I argued, instead, from the engineer's point of view. That is, that how you do something doesn't matter as much as whether you can do it. And whether you can do it quickly so as to be useful. So, that means you do it quick and dirty. Later on, you can figure out how you did it.

At that time, did you work day and night?

I worked hard then. But in 1990, after four years at Caltech, I had my first son. Anyone who's had a baby realizes that you cannot have a baby and work twenty hours a day. I had to be more efficient with my time, and I had to give more power to my research group—the students who had signed up to work with me—so that I could go home to my husband and my baby, and then be back in the lab in the morning. I found staying at home was harder than going to work! I was always back in the office with a baby in my arms within a week or two of each one's arrival.

In the 1980s, there was a change in attitude about women in science having children. With more women competing for key scientific and other careers, there weren't as many traditional marriages. And without a wife at home to take care of the kids, the men struggled, too. But there also were more childcare options available.

We have to welcome women into the sciences and engineering, and if you're going to welcome women, you're going to welcome mothers. You're going to welcome young fathers, too. I think that attitude has been hugely beneficial to women—and to men, because raising a family is more of a partnership than perhaps it was in the past.

You've won many awards. You won the National Medal of Technology, for example. You were the first woman to receive the Millennium Prize for Technology. And in 2018, you were awarded the Nobel Prize. How has this acclaim affected your life?

The last nine years have been a whirlwind, but for me that time is not marked by the prizes. It's marked by the science we have done and the things that have happened in my personal life. I am still the same person, and I do the same things as I did before those awards. I work here at Caltech, I teach classes, and I run a research group, just as I did before. Perhaps I travel a bit more, but that is because my sons are grown up now.

You got the Nobel Prize for your work on "directed evolution." Can you explain what that is?

It's like breeding, but at the molecular level. A farmer can breed a better apple variety, a dog breeder can breed a new dog variety. In my research, we created new biological molecules by breeding the DNA in a test tube. Directed evolution uses the tools of molecular biology to create better biological molecules, like enzymes.

In the past, if you wanted to breed a better racehorse, you had to be really good in choosing the two horses to breed, and then you hoped there would be a winner among the progeny. But today, if I want to breed at the molecular level, I can have three parents. I can mix DNA from thirty-three parents. I can mix species. I can make random mutations and control the level of those mutations. I have control over the underlying evolutionary processes—that's

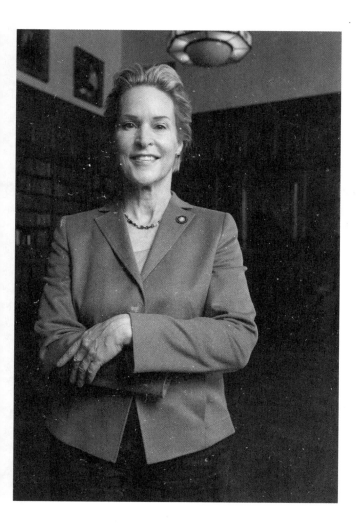

an ability no one had before these technologies became available. The questions then became: How do you do it and get something that's better than what you started with? And how do you do it on a timescale that matters?

I suppose I received the Nobel Prize for figuring out how to do it. We've made lots of enzymes that are used in industry, and students from my group have started companies that work on sustainable chemistry, such as making jet fuel from renewable resources. Some make nontoxic modes of agricultural pest control, and others make useful chemicals without generating much waste.

The rest of the world has adopted these methods to make pharmaceuticals in a clean way, to take stains off clothes in better laundry detergents, to reduce the energy requirement for making textiles, and to do a better job with clinical diagnostics. Directed evolution makes better enzymes for those applications and many more, new uses.

Why did you also start your own business?

Everybody says, "Oh, my technology is useful." But if nobody uses it, it's not useful. So, how do you get people to use your inventions? One way is to get them into people's hands. And if no existing company wants to do that, you can start a new company and provide that technology.

My first big-time foray into business was my work with a friend of mine, Pim Stemmer, who started the company Maxygen as a way to do directed evolution. I was on the initial science advisory board, where I learned from people who knew how to start a company. And now I start companies. We began our first one in 2005—that was fourteen years ago—and have done a few more since then.

You must be very well organized?

I am hyper-organized. I'm usually up at five or six in the morning. I work at home in the mornings, and I try to get a lot of things done. There are a lot of telephone calls, editing of papers, and writing letters, and then I come into Caltech and spend the afternoon talking to students, having research group meetings, meeting visitors, teaching class. Then I go home, have dinner with my family if someone is home, and relax for a little bit, listen to books on tape, take a walk, do yoga. And then I go to bed. I don't work at night. Maybe I did for the first year or two, before I had children. But once I had children, starting in 1990, I rarely worked at night.

In your private life, you went through some tragic times. Do you want to elaborate?

Well, we divorced five years after getting married. The marriage didn't last because he had to move to Switzerland and I didn't want to go to Switzerland. It was a difficult time because I had a small child. I met a wonderful man soon after, however, and had two more sons. That was lovely for as long as it lasted. He died in 2010.

Your second husband committed suicide. That must have been very hard.

Yes, it was. He suffered very badly from depression. It's something I don't understand. I think the last time I was deeply depressed was when I was twelve. I now realize that I have control over my own self, and that's the only thing I have control over. We had split up two years before he committed suicide, and he left me with three little boys to raise on my own.

But then tragedy struck again—your son died in an accident.

Yes. That broke my heart. And I miss him every day. He was very loving and outgoing, and a wonderful, talented person. He was twenty years old.

Have you had bright moments to compensate?

I had three of my four brothers, their wives, my two sons, and my son James's wife, Alanna, all together at the Nobel Prize ceremony. Actually, we were together almost a whole week in Stockholm. Former students came, and friends and colleagues as well. I could see the pride and happiness in their faces. I was as happy as I've been in a long time.

You were once described as pushy, aggressive, all those things men normally don't have to be.

I was pushy and aggressive, but I had to be. One time the president of Caltech asked me, "Why are you so

arrogant?" I said, "Oh, my goodness, Mr. President. If I weren't, I wouldn't survive." It was a survival skill back then; I believed in what I was doing, even when others did not, and I would not let them push me around. That attitude served me well at that point in my life, but now it doesn't have to. That is, I don't have to defend myself anymore. I try to smooth the rough edges. Of course, I had to be stubborn then; otherwise, I'd have to give up. And I'm also a somewhat impatient person, but I've been working on that, too.

The tough edges are made up of resilience. I don't feel sorry for myself—that's useless. So, when I got cancer, or when my son died, I could've said, "Boo hoo, poor me." But instead, I said, "Okay, boo hoo, poor me, but let's move forward."

I like life. I like my family. I like my students. I like my work. I think it's important to focus not so much on the bad things but, rather, on the good things, of which I have many. No one is guaranteed an easy time in life. When you live to be a certain age, you've been through it all. You've lost loved ones. You've lost things that matter a lot to you. Do you give up? No. If you've got children watching, if you've got students watching, how can you give up?

Some women have had to deal with sexual harassment. How did you deal with it?

There were certainly unwanted advances, but I always felt in control. If I didn't like what some older professor was saying to me, I'd tell him to go jump in the lake. And then, of course, I also had more favorable attention as a woman. Because there were so few women in science, that could be a benefit. So, I just turned it on its head and said, "I will use this to my advantage rather than let it be a negative." For example, when I had to speak to an audience that had never seen a woman engineering professor before, they were automatically wondering, "What's she doing here?" So, yes, I had to do it better. I had to perform to a higher standard than men. And I made sure that when I opened my mouth, the men would listen to me—and keep listening beyond the initial curiosity.

If young people—especially women—are considering studying science, what do you tell them?

To do whatever they want to do. I tell them that I find science a great career. It's flexible, especially academic research, which is great if you want to have children. In fact, that flexibility is something I value very much, but not everybody is cut out for academic science. For example, being an academic can be stressful. Not everyone wants to be responsible for running a group, coming up with ideas, and obtaining the funding.

Everyone's different—that's also what I emphasize. If you follow the same path as the others, don't forget your own path as well. That lack of diversity stymies innovation. Evolution teaches us that unless we have diversity, we go extinct. And the way to be innovative or the way to find what you love to do is to try different things. Trying different things served me very well.

What is your message to the world?

Take care of the people around you; it will bring you strength and happiness that will then propel you to do creative things. And stay curious.

I've seen many people come and go, and what I would like to remain of me is to be in the good memories of the people who are still here. I'd like to be remembered the way I remember my grandmother. And I'd like to be remembered the way I remember my son. Leaving some positive influence on others that makes people happier.

What have you learned from nature?

That biology can do anything. That nature is the best chemist on the planet (and probably the rest of the universe). Not only did she invent all these wonderful life forms and the chemistry that makes them, but she also invented the design process of evolution. And this is the magic trick that gives nature its huge advantage. Now I have it, too.

I'm not a creator; I'm an evolver. I'm a breeder. Nature creates. I take what nature creates and make it do new things that we want.

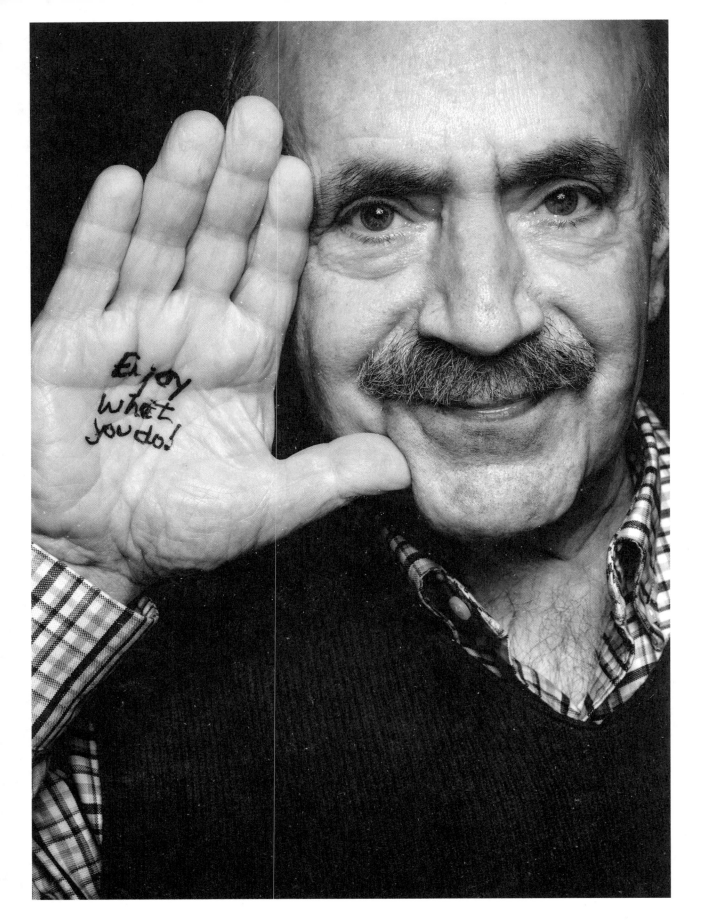

"DIFFERENT MOLECULES AND GENES THAT MAKE LIFE POSSIBLE CAN ALSO THREATEN ITS TOTAL COLLAPSE."

Robert Weinberg | Molecular Biology

Professor of Biology at the Massachusetts Institute of Technology (MIT), Cambridge
Robert Koch Prize 1983 and Otto Warburg Medal 2007
United States

Dr. Weinberg, you had an important idea one day, years ago, regarding how normal cells become cancerous. What exactly happened that day?
I was in Hawaii for a conference and was playing hooky with a colleague. As we drove up to a volcano and started walking down into it, we said, "You know, there should really be a set of underlying principles by which one could understand many kinds of human cancers, even though outwardly they're diverse and seemingly have no resemblance to one another."

...a perfectly normal thing to say while walking into a volcano?

Well, I think there are many informal situations, whether one is walking in nature or through a crowded city, when certain ideas pop into one's mind, all of a sudden. Clearly, we had been thinking about this topic, and this was an occasion when we allowed ourselves to think out loud.

That conversation also snowballed into a successful academic article, did it not?

I had been invited to write an article that would appear in the first issue of the new millennium for the journal *Cell*. I told Doug Hanahan, my friend and colleague, "This would be a golden opportunity for us to describe what we imagine are the small number of underlying principles shared in common with all kinds of human cancers." The article we wrote was titled, "The Hallmarks of Cancer." Most articles like that drop out of sight like stones thrown into a quiet pond, but this one, totally unexpectedly, attracted great attention.

It's been nearly two decades since you published that article. How has your work changed since then and, briefly, could you describe what you do now?

We now understand an enormous amount about the details and the molecular defects inside cancer cells. We've learned much of that in the last two decades. Currently, my lab is interested in figuring out how cancer cells that arise in a primary tumor, in one tissue, wander to distant tissues in the body, to distant organs, and to form new tumors there, which are called metastases.

With so many scientists working on cancer, it's hard to realize that so many people still die from it.

One has to realize that cardiovascular disease, for instance, is essentially one disease. Cancer, on the other hand, is 200 or 300 distinct diseases, and each form of cancer behaves slightly differently. Cancers are also constantly changing, like chameleons, and so a tumor that might initially be responsive to treatment can subsequently develop resistance to that treatment.

Is there any cause for hope?

"THE HUMAN INTERACTIONS IN THE LABORATORY ARE JUST AS IMPORTANT AS THE SCIENTIFIC INTERACTIONS."

There have been big gains in certain areas of cancer treatment. Take the death rate from breast cancer: it has decreased by 30 to 35 percent. Of course, death rates from lung cancer, pancreatic cancer, or stomach cancer haven't changed much. We still don't understand how to attack those tumors effectively.

Why did you decide to study science and, eventually, to focus on cancer?

Some people have a long-term goal in life. I'm not one of those people. I went into my undergraduate studies thinking I would become a doctor. Then I heard that doctors need to stay up all night to treat patients. I needed my sleep, so I decided that was not for me. I became a biologist instead, and in the years that followed I studied viruses. Ultimately, I studied cancer-causing viruses, which gradually morphed into a study of cancer cells that are created by agents other than viruses.

But why cancer?

I didn't go into cancer research in order to help humanity. I did not go into cancer research in order to free humanity from this scourge. I went into cancer research because it's a complex and interesting scientific issue that deserves attention and that requires one's energies.

When you were growing up, did anyone inspire you to go into science?

I came to MIT as an'undergraduate and moved sideways into biology. Then I had one inspiring course early on at MIT on molecular biology. I realized that by learning about DNA, RNA, and proteins, one could understand the entirety of the biosphere. This was an extraordinary insight for me.

Your parents came to America before the Second World War. What was it like growing up then?

I grew up thinking of myself as almost more European than American. I had the impression that the people in Pittsburgh, Pennsylvania, where I grew up, were provincial compared to my cosmopolitan and sophisticated parents. My mother knew French and a bit of English, and my father knew a bit of English. I am told that during the war we were careful when we walked down the street not to speak German, simply because the war was on. I grew up bilingual, which I think was a great advantage.

What impact did the war have on your family?

It was quite traumatic to learn about some of the experiences my parents had between 1933 and 1938. My grandfather had lost five siblings during the war. My parents used to say that it didn't matter whether someone was successful or not, wealthy or poor; everyone was sent to the concentration camps. So, I grew up with a sense that somehow life and existence were precarious.

You recognized the thin veneer of civilization?

Indeed. I wouldn't say I was suspicious or paranoid, but maybe I was overly careful. My father always said to me, "It's alright to be successful, but don't stick your head above the crowd, don't be too visible."

How did that affect your behavior later in life?

I worked hard. I was driven to do interesting things in science. But I was always careful not to become a blowhard. People in our family who took themselves too seriously were not respected. My parents valued two qualities in other people: intelligence and a sense of humor. Even if somebody wasn't that smart, having a sense of humor compensated for their lack of high intelligence.

Do you look for those qualities when you are interviewing people for your lab?

The most important thing I can do in running a lab is to choose the right people: people who are motivated to work and who get along with one another. The human interactions in the laboratory are just as important as the scientific interactions. It's

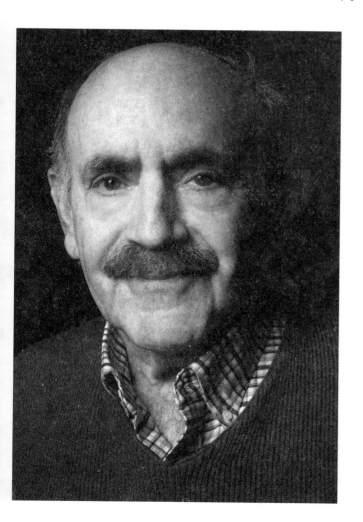

"I GREW UP WITH A SENSE THAT SOMEHOW LIFE AND EXISTENCE WERE PRECARIOUS."

"[SCIENCE IS] A BIT LIKE A PROFESSION FOR MANIC-DEPRESSIVES; THE SUCCESSES AND ONE'S MOOD ARE ALWAYS GOING UP AND DOWN."

worthwhile investing a little bit of time in a decision that one will have to live with for many years.

Did you keep that in mind when you decided to get married?

Sometimes you have to close your eyes and make the leap—the existential leap. I met a woman I found very attractive and who was clearly right for me. That was more than forty years ago, and I've never regretted the decision. Choosing someone for a lab group isn't as important as deciding on a life partner, but it can come close. Sometimes people come to work in my laboratory and stay on for five, six, seven years, and I have to see them almost every day.

What kind of boss are you?

It's important for me to impress on people in the lab that I care about what they're doing. I like them to know they're not simply an anonymous pair of hands, that I'm involved intellectually in their work. Sometimes they'll come into my office, and we'll just sit and schmooze for half an hour; I'll ask them what they're doing and what problems they're having.

Are you able to sometimes take a step back from your work?

I'm not totally obsessed with my work. Sometimes my wife and I go up to our cabin in the woods of New Hampshire, and when I'm working in the cabin, the garden, or the woods, I can go for days without thinking about biology. I'm a reasonably good carpenter, plumber, and electrician—I like to work with my hands.

Biology was never the totality of my existence. One day, when I'm dead and gone, they're not going to write on my headstone, "He published 483 papers, many of them in *Cell*, *Nature*, and *Science*." Nobody really cares.

Are you a happy man?

No one is ever totally happy, but yes. Look, you either enjoy what you're doing, or you don't. The compensations of fame, fortune, and recognition are rather minor in comparison if you don't enjoy what you're doing. I've always enjoyed what I'm doing, and I have no regrets.

Did you ever wonder, *Am I on the right track? Am I doing the right thing?*

I've had minor doubts here or there, but since I've always more or less enjoyed what I was doing, I wasn't consumed by them. Science can be it for some people, but not for everyone. It's a bit like a profession for manic-depressives; the successes and one's mood are always going up and down. But that's life. It's not an uninterrupted sequence of successes.

Have you ever had any major, long-term goals?

No, I've never had any long-term goals. In science, I may have had goals for the next one or two years, but never five or ten years ahead. Like I said, I grew up thinking life was precarious and that you can't always predict the future. I've always thought in an opportunistic way: *What can we do next that would be interesting?*

What did you do after learning you had won the Breakthrough Prize, which came with a cash reward of $3 million?

Right away, my wife and I put $1 million into a charitable foundation, and then quite a bit of the money

"CANCER IS ENTROPY, CHAOS."

went to taxes. We've always lived reasonably comfortably, so believe it or not, all that money didn't really make a big difference for me. I've never been interested in money as long as there was enough of it. I'm not a good businessman, never have been.

The recognition was nice, but after that was over I had to confront the realities of running a lab once again. At MIT, everybody is reasonably well accomplished. Fortunately, there's not a culture here of worship and adulation of successful people. We have a bunch of Nobel Prize winners floating around here and we call them by their first names.

At the same time, your work has had quite the impact on society, yes?

Some of the work that my lab has done has been important for treating breast cancer patients and for creating the modern field of cancer research. I feel good about that. But many in my lab have worked largely on problems that were not immediately applicable to cancer patients. Some of our findings took ten or fifteen years to become useful and applicable.

You have to be willing to pursue curiosity-driven research, which can produce products, bounties, and advantages for society as a whole that one can't always anticipate.

What would be your message to the world?

Try to do something you enjoy and that's interesting; and if you can, make a difference in the world. Do something that truly keeps your mind working, keeps your hands busy, and allows you to interact with lots of people and enjoy their company. It's useful to try to help other people and to support them.

What about CRISPR/Cas9, the method used for editing genomes? Might this be the magic bullet to beat cancer?

Right now, the answer is absolutely no. The problem with all kinds of gene therapy and gene re-engineering is that if you have a tumor that is, say, a centimeter in diameter, it already has a billion cells. If you want to change the behavior of the tumor by using CRISPR/Cas9 to change the genes in those billion cells, you need to change the genes of each individual cell. Right now, that is vastly beyond our ability. We can't change the genes in cells that are scattered throughout living tissues, including living tumors. But the method does allow certain laboratory experiments to advance more quickly.

You once said the genetic mutations that allowed humankind to evolve could also be the source of its demise. What did you mean?

Well, certain changes in our genomes over the last 100 million years have created more sophisticated organisms, but they also have created risk. Our cells are constantly dividing, and every time they divide, there's a little danger that cancer might develop. We coexist with this intrinsic danger. Life is a double-edged sword: the different molecules and genes that make life possible can also threaten its total collapse.

So, basically, if people live long enough they'll get cancer?

Yes. If you live long enough, sooner or later one cell or another in the body will become a cancer cell. If you don't die from heart disease, and you don't die from an immune disease, and you don't die from an infection or accident—that is, if you live long enough—sooner or later you'll get cancer. Cancer is entropy, chaos; sooner or later, with enough age and enough cells, you'll develop cancer. Cancer is an inevitability of being a complex, long-lived, large organism.

Do you think a lot about dying of cancer?

Not that much. It could happen, but one has to be a little fatalistic. I've been told I'm not going to live forever.

"THEY'RE NOT GOING TO WRITE ON MY GRAVESTONE, 'HE PUBLISHED 483 PAPERS.'"

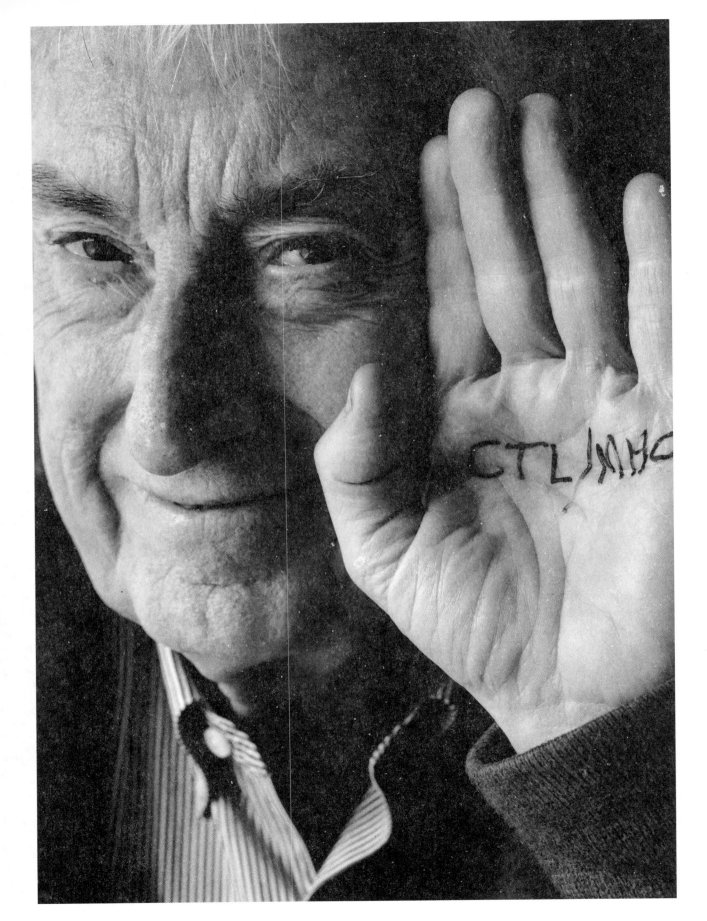

"EVERY KEY BREAKTHROUGH IN SCIENCE IS PART OF A MUCH LONGER STORY."

Peter Doherty | Immunology

Professor of Microbiology and Immunology at the University of Melbourne
Nobel Prize in Medicine 1996
Australia

Professor Doherty, I have heard that there is a lot of rivalry and jealousy in science. Do you find that is so?
Oh, yes, it is ferocious. Scientists are no better human beings than anybody else, especially when it comes to jealousy and rivalry. Someone may review your scientific paper and absolutely shred it for reasons that don't have a lot to do with the quality of the paper. It is a tough game, because science is based on data and evidence, and still reactions can be vicious. And there is no concept of kindness in science and no equivalent of the

Hippocratic oath. Do no harm? That's a medical idea, not a scientific idea.

Why did you decide to study science?

Both my parents left school when they were 15 years old. My mother trained to become a music teacher and my father joined the civil service. I grew up in an outer suburb of Brisbane, and it was a lower middle-class place of working people, which gave me a good understanding of fascism, because that's where it comes from. So, I was absolutely determined to get out of there, and that is the reason I went to university. Actually, I wasn't a very good student, as I knew very little about anything. I had a cousin who was in medical research. But apart from that, I knew only a handful of university-trained people, like the local doctor, the local dentist; not even all our schoolteachers were university trained.

You are the only veterinarian who has been awarded the Nobel Prize. How did this happen?

The reason for studying veterinary science was this idea of feeding the world and doing good. I was kind of altruistic, young, and naïve. I should have chosen medicine for that reason, but I didn't want to be around sick people; as a 16-year-old, I thought sick people were pretty awful. So, for nine years I worked on diseases of chickens, sheep, and pigs.

Once I was bitten by a pig, which was most unpleasant. I realized that if I was to understand better how infections develop, I needed to learn more about immunity. So, I went to a basic medical research institute and studied cellular immunity. And there, along with Rolf Zinkernagel, a young Swiss medical doctor, I made this big discovery, which won us the Nobel Prize twenty years later. And I never went back to veterinary medicine. I had switched from being a sheep doctor to an MD ("mouse doctor"), so to speak.

Did you make this discovery by accident?

You can't decide to discover something. But maybe we made the discovery because I had been working in pathology and Rolf in bacteriology, and when you combine two different areas, you sometimes find something unexpected. And the approach I was using wasn't the type other people would have used. So, when the results came off the counter, we immediately saw something unexpected. And that triggered our thinking: "If this is true, it would be a big finding." And that turned out to be true. Of course, we didn't know it was worth the Nobel Prize.

Could you explain what you found, in simple words?

We were looking at a particular part of the immune system—the cytotoxic T lymphocytes, which are programmed to kill other cells if those cells are abnormal or infected. We noticed that the T cells developed by infected mice of one strain were not able to kill virus-infected "target" cells from another mouse strain. And by following that unexpected result, we discovered that the T cells "check" a key molecule on the surface of the target cell—the major histocompatibility protein (or strong transplantation antigen)— before going into action. We suggested that the virus had changed the normal "self" MHC [major histocompatibility complex] molecule to make it an "altered self," thus differentiating an infected "self" cell from a healthy one.

Later, it was found that a small "bit" of virus (a peptide) binds to the MHC protein to make it "non-self." That causes the T cells to react as though they had seen a "foreign" MHC from a different individual, so they reject the infected cell in the same way that they would destroy a transplanted tissue graft or body organ. That realization is that the MHC is basically the marker of "self" changed thinking across the board concerning the basic nature of cell-mediated immunity as it relates (beyond infection) to transplantation, autoimmunity, vaccine development, and most recently, cancer immunotherapy.

The technology to understand the underlying molecular mechanisms wasn't around at the time we made our discovery, but in thinking it through, we developed a theory of how cellular immunity works, including the reason why we have the diverse MHC system. That has proved to be substantially correct. We made some good guesses.

You made that discovery in 1974. And then you got the Nobel Prize in 1996. Why did it take so long to get that recognition?

It is fairly common in biomedical science to wait twenty or twenty-five years. The average age for Nobel Prize winners is 58. That's because the Swedish Academy does not want to get it wrong—and they had gotten it wrong a few times earlier. Johannes Fibiger, for instance, got the Nobel Prize for the theory that worms cause stomach cancer; it was proved wrong later. So, now they want to be absolutely sure there is no mistake. With some things they can tell that fairly quickly, but for many discoveries they have to wait a long time to be entirely sure.

Did you immediately publish your findings?

It was in the early 1970s, so there was no email and no rapid communication. So, we had about six months to develop our story. And then we published three or four papers in quick succession. Nothing in science exists until it is published. I always tell the young people in the lab, "If it is not published, it is not done!" That is, it is useless to say later, "Oh, but I thought that, too."

Publishing your results is the basis of science. If you get a result you don't expect, you might be excited, but you have to go with the data. Forget about your girlfriend, or your boyfriend, and live with your data. In fact, love your data, commune with your data. That's your life now! *What is this that I have found? What does this mean?* Try to ignore what other people have thought about those things; you won't find something novel if you go down the same path as everyone else.

Do you have any advice for young scientists about how to write a good paper?

In science, it is an enormous advantage if you can write with clarity. And for most of us, writing is what clarifies the thought process. Research is bound by rules: publish, tell the truth to the best of your ability, and do good experiments. And if you don't do that, eventually people do find out. There have been quite a lot of scientific findings that were considered important for their time, and then people just moved in a different direction and forgot about them. This sort of death in science happens pretty often. Not, of course, with something like our research, which is now part of the scientific canon.

But you wouldn't have made your discovery if you hadn't been focused on your work, correct?

When we made that discovery, we were working all the time. And it was terrible for our wives, Penny and Katherine, because we both had small children. After that, I tried to restore some work-life balance, but the life of a scientist has periods when you are obsessed and your research keeps grinding on in the back of your head.

Quite often, this persistence delivers the solutions. It is an interesting phenomenon. Sometimes when you are off doing something else, like walking on the beach or skiing—something that takes all your attention—suddenly an idea pops up. The brain works in interesting ways.

So, a scientist needs some time off to get the best results?

I keep telling people in the lab, "Don't work all the time; that is counterproductive. Get some exercise, try to get some oxygen into your lungs and into your brain, and also have a social life." Great examples of this include top women scientists who, with family commitments, often work a shorter day but still are very efficient. So, a lot of the time spent in the lab seems to actually be rather unproductive.

Women often are very well organized and rather good at multitasking. But I don't care if someone is male or female, or whatever. The only thing I ask of colleagues is that they are good colleagues. I respect someone who is smart, gets the job done, and is pleasant to work with.

What advantages did you gain from winning the Nobel Prize?

I got a lot more invitations. There is a sort of sense of belonging in science, of being a member of the right club. I have tended to shy away from that, as I don't like it. And as for material rewards, I probably made

more money than I would have otherwise. Zinkernagel and I shared US$1 million, on which (living in the United States at the time) I had to pay income tax. As the Nobel Prize gives you a public voice, I try to speak up for science and to give people an understanding of how the subject works. I have absolutely no idea whether I have had much effect. But I never take money for public lectures in Australia, as I regard myself as a public servant in that sense. The only thing I ask for now is that I fly business class on long overseas flights, but that is partly because I have back problems.

What prerequisites should a good scientist have?

Science is about as meritocratic a culture as you can get. Still, some who are not especially imaginative claw their way to the top—not necessarily by being all that good at science but, rather, by taking the usual path to power: they are good managers or they are good at obtaining research money. In fact, that is increasingly true. But that kind of person is not necessarily someone I want to be around. They make my blood run cold.

Did you ever face a crisis?

We made our discovery at the Australian National University (ANU), then I went to the United States, and when I tried to come back at a senior level to the ANU, it didn't work out. Partly due to efforts I made as part of a group of reformers, we ended up in a crisis situation that damaged both me and my wife. I learned the hard way that it is difficult to change something in a system where a lot of people are comfortable but not doing much. That is only possible if you are not operating from a position of power. I was overly optimistic and naive. I had been looking forward to coming back home to Australia, but I wasn't welcomed. That was a tough experience. Returning after winning the Nobel Prize has been a much more positive experience.

What would you say has been your contribution to society?

I made a big discovery, which helped change the way medicine works. A lot of the modern drugs and therapies, including the most effective ones against rheumatoid arthritis and cancer, and auto-immune diseases of various types, are immunological reagents produced by T lymphocytes, or are based on manipulating the killer T cells that we worked on. So, our work was a step along the path that led to new treatments that are actually curing people with cancer.

Every key breakthrough in science is part of a much longer story. The great delight of science is to make the discoveries. Often these discoveries are small and don't attract much attention. Sometimes, though, you get lucky.

But the world seems to talk only about the best ones?

The discussion within science is much broader, but we can't expect the broader public will be interested in the minutiae. The Nobel Prize doesn't say you are the world's best scientist; rather, it recognizes discoveries that have been spectacular somewhere along that line. I could easily have ended up doing research on cows for the rest of my life. That would not have been such a bad way to spend my time!

"MY DRIVING FORCE HAS ALWAYS BEEN TO HELP PATIENTS."

Françoise Barré-Sinoussi | Virology

Professor Emeritus of Virology at the Institut Pasteur in Paris
Member of the French Academy of Sciences
Nobel Prize in Medicine 2008
France

Professor Barré-Sinoussi, does it ever give you pause to realize just how big an impact you have had on the lives of others?
I wasn't alone. They don't call it the HIV/AIDS community for nothing. We're scientists, activists, representatives of patients, doctors, nurses, all the medical staff. We are countless people who have been fighting for the same objective since 1981. We are all in it together, and we each make up a tiny piece of the puzzle. That's all I am: a piece of the puzzle.

That's very modest.

No, that's the reality.

You faced a lot of prejudice early on in your career. What were some of the things you had to overcome?

I was told that women had never accomplished anything in science, so I would be better off rethinking my career. Forget your dreams, they said, women should stay at home and take care of the children.

Good thing you didn't listen to them. You went on to win the Nobel Prize for discovering HIV.

That was the mentality when I became a scientist back in the early 1970s. Of course, a lot has changed since then.

What kind of a mindset did it take to overcome obstacles like that?

Motivation is key. So is patience and a willingness to give to others. This was critical for me. If you're only doing science for your own enjoyment, or for publishing papers and improving your CV, it won't be as motivating as if you are developing tools for the benefit of patients. For me, my driving force has always been to help patients.

You were so involved with your work that you nearly missed your own wedding. Tell me the story.

I was here at the Pasteur Institute. It was around 11 a.m. when my then-fiancé called me and said, "You know, the family's all here because we're supposed to be getting married today." I told him, "Oh, my God, it's already 11! I'm coming!" He wasn't surprised at all. I hadn't forgotten that we were getting married; I simply lost track of time.

Most of the time, it's male scientists who have the wife at home who takes care of everything. But for you, it was different: your husband has a wife who's the scientist. How did he handle this?

Very well. He loved freedom himself. That's probably why we got along so well. He knew that if I was going to be in a relationship, it would be crucial for me to continue doing what I love. He used to tell other people, "I know that on her list, I'm not number one. Number one are her parents. Number two is her cat. Number three is the lab, and I'm number four."

That was a progressive attitude for the time.

I can tell you that my father was the opposite. He often told my husband, "I don't understand how you can accept the kind of life she's giving you. If it were me, I wouldn't accept it. You don't have the courage to try and correct her." And my husband would say, "That's my problem, not yours."

You had trouble finding a lab to work in at first. Why was that?

At the time, labs were not accustomed to accepting students as young as I was. I had been at university only for two years. In the 1970s, it was not common for students to start working in laboratories before they got their master's degree. Fortunately, I found a lab, the Pasteur Institute, that kindly accepted me as a volunteer. They were working on a family of viruses called retroviruses.

HIV is a type of retrovirus. So, your early work as a volunteer at the Pasteur Institute was a springboard to your later success. What happened next on your path to discovering HIV?

AIDS was first identified in the United States in 1981. In 1982, a French clinician called us at Pasteur to ask whether we would be interested in trying to find the cause of AIDS. So, Luc Montagnier, who took the call, came to me, and asked whether our lab would be keen. I said, "Of course, I'll have to talk to my boss, but if he agrees, we can do it. We have the tools to at least try to find out whether a virus from this family is involved."

We tried to isolate the virus in a patient who did not yet have AIDS, but did have what we called at the time "pre-AIDS symptoms." The clinicians would describe to us all the symptoms of the patients—the evolution of the disease as they saw it in the hospital. It was through this exchange of information that we could design our experimental approach to identify the causative agent. Eventually, we got a lymph node biopsy, put the cell in a culture, and that was how we isolated the virus.

What was that moment like for you?

It wasn't one moment. It never is in science. It's several successive moments that build to a discovery.

The first sign that there may have been a virus in the culture came when I detected enzyme activity related to this family of viruses. But there was still a lot of work left to do. Eventually, we looked at the culture under the microscope and saw particles—viral particles the same size as retroviruses. But even then, we didn't have proof that the virus was the cause of the disease. It was a long process until we could say, "Yes, this virus really is the cause of the disease." That didn't occur until 1983, and it was confirmed in 1984.

What was it like for you to present your findings?

Some people didn't believe me. Some scientists thought the findings needed to be confirmed by others. We really had to keep working to convince the

scientific community. Eventually, another team in the United States, led by Bob Gallo, also managed to isolate the virus and confirm it as the cause of AIDS.

Speaking of Robert Gallo, after your discovery, his lab began claiming that they had, in fact, discovered the virus. An acrimonious legal battle ensued, and the American and French presidents at the time, Ronald Reagan and Jacques Chirac, even got involved. What exactly happened?

I'm not going to go into detail about that. It was a fight between institutions, and it's over. It's since been recognized that the discovery was made in France and not in the United States. I refuse to talk about it, though I'm happy to tell you why.

Please do.

When I gave public conferences during this, shall we say, Franco-American conflict, there would sometimes be patients in the room who would interrupt me and say, "Stop it, we don't believe you anymore, you scientists. The only thing you are interested in is fighting each other." Some patients refused to go to the doctor because they didn't trust the medical or scientific communities anymore. The conflict had a terrible impact.

Was it this impact that sent you into a depression?

My depression came later, in 1996. It was related to the fact that for more than ten years, there had been terrible pressure on the scientific and medical communities to do something about HIV and AIDS. For me, as a scientist, it was the first time I had been in direct contact with people who were affected by a disease as I worked on it. I became good friends with some of them, and I watched them die. As a scientist, I knew it would take time to develop a treatment. But as a human being, it was unacceptable to see people as young as 30 or 35 dying under such terrible conditions.

How did you finally pull yourself out of the depression?

I had to go to hospital and get treatment. It took me more than a year to fully recover. In the meantime, I tried to work as much as possible, even though I wasn't in good shape at all. I remember calling one

of my American colleagues and asking if he could come to Paris to help run my lab, and he did.

There's a story about a patient who held your hand. Would you tell it?

That was back in the 1980s. I gave a seminar at San Francisco General Hospital, and afterwards one of the clinicians asked me whether I would be willing to see a man dying of AIDS, who wanted to meet me. So, I went to the emergency room. He was in terrible shape. He had some trouble speaking. I could only guess what he was saying by reading his lips. When he said, "Thank you," I asked, "Why?" He said, "Not for me; for the others." That I will remember all my life. He died the next day.

When you have this kind of experience, it changes your motivation. You stop doing things for yourself and you try to give people the tools they need to stay alive. Just to be alive.

I've read that about 35 million people have died from AIDS.

Yes, and today there are 37 million people living with HIV. These people are alive, yet only 60 percent of them are on treatment. This is unacceptable.

How do you react when people say you're not just a scientist—that you're an activist as well?

Of course, I am an activist. So much work went into achieving a diagnostic tool and a treatment, and now we even have a tool for prevention. There has been enormous scientific progress—and yet people are still dying of AIDS. How can I accept this? I cannot. It's a matter of equality. Everybody has a right to live.

Back in 1985, you visited sub-Saharan Africa for the first time. What was that like?

The first thing I noticed was the suffering. Some people had polio and couldn't walk. They were walking on their hands in the street. Others were in bad shape, too, not from HIV but from other diseases. And yet, one thing stood out immediately: They were all enjoying life. They had smiles on their faces. They were playing music and dancing. That was my first shock. How could these people, in their condition, look happy? They had taken those small moments of happiness and made them their objective in life.

How were the HIV patients treated in Africa at the time?

We visited the hospital and realized that a lot of people were dying from HIV/AIDS and the hospital couldn't do anything for them. This was in the 1980s, so there wasn't a treatment, but they weren't receiving any care. Not even drugs to help them die. Not even palliative care. Nothing. The doctors could only hold the hand of a dying patient. Seeing this is why many of us—not just me—decided to start working in Africa.

Would you say that experience inspired you to work more intensively?

Well, I was already working quite intensively, so I don't know about that. But it prompted me to work even more with HIV, that's for sure. It was a nightmare for my husband, though; I hardly saw him at all, since now I wasn't only working a lot but also traveling.

I heard that when the people from the Nobel Committee tried to inform you that you had won, they couldn't find you. Is that right?

That's right. I was in Cambodia at the time, helping to coordinate France's and Cambodia's bilateral work on HIV/AIDS. We were in the middle of a meeting about a clinical trial when the call came in. It was an important meeting. My phone rang, and it was a journalist from the national radio network. I thought they were calling about yet another drama.

Because your husband, who worked for the national radio, had recently passed away?

Exactly. And the woman didn't immediately tell me why she was calling. She asked, "You don't know?" I said, "No, I don't know. What's going on?" And she started to cry on the phone. I told her, "Stop it! Tell me what's going on." When she finally composed herself, she said, "You got the Nobel Prize!" I said, "I don't believe you," and hung up.

You hung up?

I hung up. Then my phone rang again. It wouldn't stop ringing. We were in the middle of this meeting, so my colleagues said, "Françoise, give us your phone." Once we figured out what was going on,

people started bringing food and flowers. They even organized a celebration at the French Embassy in Cambodia. It was really a very, very moving moment.

What did it take for you to accomplish what you did?

Patience, for one. Extreme patience. One of my colleagues who knew I loved cats once said to me, "I wonder if, in another life, you weren't a feline yourself because you are so patient. You make your observations for months, years. You always have to be absolutely sure before you're ready to pounce." I thought that was a good comparison.

Did you ever doubt yourself as a scientist?

You have to; otherwise you're not a good scientist. A scientist must always question whether they're heading in the right direction. It's like a game, you know. You never know when you'll win, but you know that you can always lose. For me, this is doubt. If you're too sure of yourself, you're not a good scientist.

When you were doing your research on the HIV virus, were you doubtful?

In science, you make a hypothesis, decide on an approach to verify it, and then get your results. During that time, all our results were positive. Nothing like this had ever happened to me before. It was wonderful—too wonderful, somehow. I knew it had to stop. And, of course, it did. Particularly when we began working on a vaccine. That was a failure. That's when we started to realize that everything was much more complex than we thought.

Did it make you happy to finally discover the virus?

Happy? No. People were dying. How could I be happy when people were dying? My feeling was, *We must hurry. We can't keep seeing people die like this.*

How did you feel when an effective treatment finally had been developed?

That was such a relief. First for the patients, then for us. Ten years had passed between the discovery of the disease and the development of a treatment. Suddenly, we had the data that a combination of treatments would allow people with HIV to live.

Now that it's possible to prevent the spread of HIV, where do things go from here?

This will be an extremely difficult virus to cure. With the knowledge we have today, and with the existing tools and the technology, it won't be possible. But we must be able to achieve durable remission of treatment in the future. In addition, there are wonderful tools in the works right now, like implants that deliver antiretroviral treatment. This is wonderful, but it's not enough.

I am a bit worried about the future because we're starting to see resistance to treatment developing in Africa and Asia. I'm worried that resistance will spread. That would be a nightmare. A re-emerging HIV epidemic would be terrible. It would be the worst failure of my life.

How are you spending your retirement?

In France, once you reach retirement age, they close your lab. That's the regulation. But I'm still very busy. I'm the president of an NGO in France that supports scientists and communities involved in access to HIV prevention and treatment, plus I'm the honorary president of the International Institut Pasteur Network and a member of many scientific advisory boards.

What is your message to the world?

Life is short. And life is the only thing that matters. I would tell others to be tolerant because it is important for peace. It's also important to fight against inequality. Science can achieve all the progress it wants, but if people don't accept or help each other, that progress will be very slow.

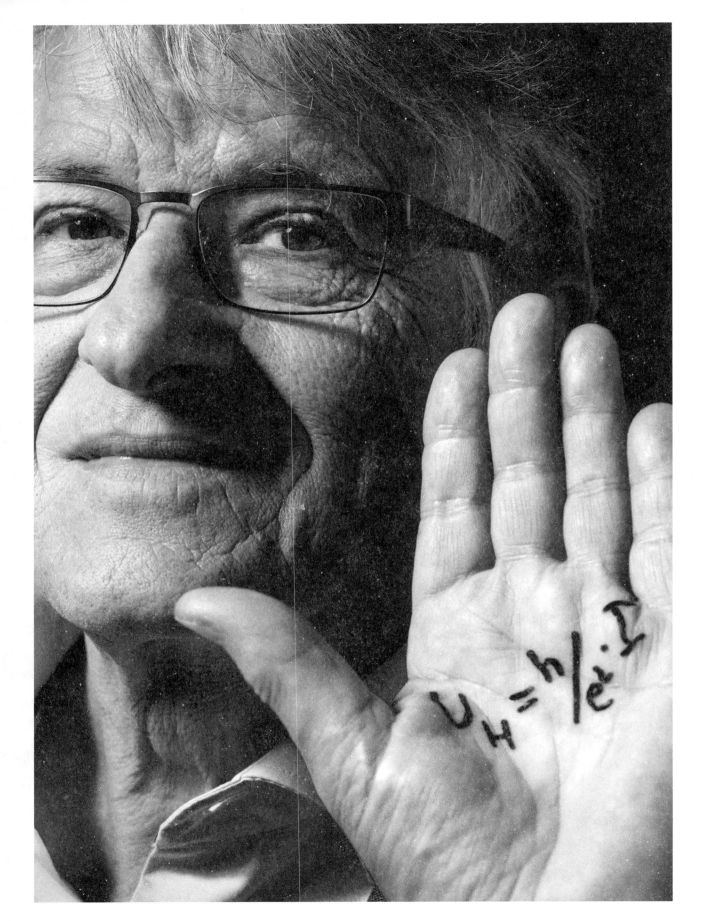

"THE WORST THING WOULD BE IF I UNDERSTOOD EVERYTHING."

Klaus von Klitzing | Physics

Professor Emeritus of Physics and Director at the Max Planck Institute for Solid State Research, Stuttgart
Research Member of the German Academy of Sciences Leopoldina
Nobel Prize in Physics 1985
Germany

Professor von Klitzing, on the February 5, 1980, at 2 a.m., you discovered the quantum Hall effect, thereby creating a universal reference value, the "von Klitzing constant," which was named after you. How would you explain to a nonscientist what you discovered?

I like to draw a comparison with speed. If I measure the speeds of a pedestrian, a car, and a plane, they're all different. But when I measure the speed of light, I always get the same result, because all electromagnetic radiation travels at the same speed. The speed

of light is a natural constant. And I discovered a natural electric resistance, which is also a fundamental constant.

The big surprise that night was when I carried out an experiment and saw that I got the same result for different samples from the UK, from the United States, and from Germany. That was unexpected. It was actually a coincidence that led to my discovery. However, I knew right away how to take precise measurements. Not everyone could have had such accurate data within an hour.

You also clearly separated which work was yours and which was the work of your doctoral student?

We always had several people working on projects at the institute. I covered a subsection, and my colleague worked on other trials. We'd established this beforehand because we needed to agree whose name would appear on a publication. Immediately that morning we recorded which of the results related to his field of work and which to mine, so that no complications would arise later on. That's why

"BECAUSE I WANTED TO BE AT THE FOREFRONT OF BASIC RESEARCH, A 90 PERCENT COMMITMENT JUST WASN'T ENOUGH. IT HAD TO BE 120 PERCENT."

my colleague's name disappeared from publications afterwards, but there were never any disputes.

When you were awarded the Nobel Prize in 1985, you were still a relatively young laureate at the age of 42. At the time, you said in an interview that your family saw you for only three or four days a year. You were obviously extremely obsessive about your research?

My wife knew when she married me that I was a fanatical scientist. We only met at all because the security guard at the university in Braunschweig discovered me working in the lab one night and threw me out. Then I went dancing and met my wife. Because I wanted to be at the forefront of basic research, a 90 percent commitment just wasn't enough. It had to be 120 percent. I did that voluntarily because I enjoy research. If something was going smoothly, I would work through the night. I also would tell everyone in top-level research that there's only one medal—the gold medal. The inventor in second place falls by the wayside.

Is science always about being first?

In scientific publications, the submission date plays an important role in establishing precedence. It used to be even easier. After my discovery, the first thing I did was to send a manuscript to all my competitors so they knew what I'd accomplished. This was reassuring too, because when I'd submitted my first article to a journal, it had been rejected. It was only when I met a reviewer by chance and showed him my results that he enthusiastically called the editor and said, "This has to be published." But this course of events didn't upset me then, because the citation index didn't matter at the time. The main thing was that I was recognized within the community.

Eric Kandel said that his wife stood in the laboratory doorway one Sunday and declared that things couldn't carry on like that. Have you managed to strike a balance between research and family life?

My three children were born at four-year intervals, so they always kept my wife busy. That's why I told her she should stop being a teacher and start raising our school-age children properly. She found that

fulfilling, too. From that point of view, I was lucky, but I certainly neglected my family. Today, I try to pay it back a little by every now and then taking my wife to international congresses that offer nice side activities; also, I try to catch up a bit on what I missed as a father when I'm with my grandchildren. But for the next year or two, I'm already fully booked up with appointments. Luckily, I like to travel.

How do you live with the uncertainty of whether an experiment will work?

That's the exciting thing—that the result of an experiment is open and I can learn something from it. In this respect, the experiment is not about success. What's important is that I ask the right questions and gain new insights from the experiments that I can build on. But we can never say that something

is the real, final truth. That's what motivates me as a scientist, though. The worst thing would be if I understood everything. But I'm optimistic that nature will provide us with sufficient questions.

Have you ever reached what you consider to be your limit?

I've always been successful. In experiments, I often reach the outer limits quickly, either because of the apparatus or because there isn't enough money to go on longer, or because my understanding doesn't stretch that far yet. But even failures have brought me further because they've provided me with new insights.

Have you ever gone through a phase of uncertainty?

My biggest crisis was when I'd finished my doctoral thesis and postdoctoral qualification. At the time, the prospects of becoming a professor weren't so good. I therefore applied for a job in industry, and one company rejected me on the grounds that I'd done too much research and would be unhappy there. It was the biggest low blow in my life: I didn't get a job because I was overqualified. After the Nobel Prize, I wrote a thank-you letter to some companies. If they had taken me on, I'd never have made my discovery.

What other goals did you set for yourself after the Nobel Prize?

After the Nobel Prize, things can only really go downhill. If you're put on a high pedestal, you easily fall down far, so I wanted to stay down to earth and continue to not do what others expected of me. My goal was to use my opportunities to create an environment that could give young students similar opportunities. I had enormous freedom as a young scientist, and it was entirely upon me if something didn't work out. Of course, the Nobel Prize also brings enormous responsibility, but for me the prize also represented liberation: I was more independent and could follow my own path.

Why should a young person study science?

We have many pressing problems in the world that can't be solved with money—only with scientific

"BUT IT'S THE HIGHEST HONOR FOR ME THAT MY CONSTANT IS THERE AND WILL OUTLIVE ME."

thinking. My contribution to society is to make real progress through new insights. However, a young person should only study science if he or she is enthusiastic about it. Students must also have something to contribute. Our prosperity is based on scientific knowledge, and it's precisely the connections between physics, chemistry, and biology that contribute significantly to progress. To be part of that process is just fantastic. Unlike in industry, where a problem is often only half solved before the next project comes along, in science we can deal with topics to the fullest extent and make unexpected discoveries.

Science is still a male-dominated world. How many women did you have in your group?

Not many women used to stay in science—about 10 percent at most. And most of them didn't get married but immersed themselves in science instead. The trouble with basic research is that you fall behind if you take a year off; that's how fierce the competition is. But now that women are no longer the only ones looking after the children, mothers can also remain involved in leading-edge research. I was still surprised the first time male employees said they wanted to take paternity leave. Since then, however, I've grown used to it and have adapted to this welcome development.

As a natural scientist, what responsibility do you have for the implications of your research?

You can't hold back the attainment of knowledge. The discovery of nuclear fission, for example, couldn't have been prevented, even by law. The fact that it makes the construction of atomic bombs or nuclear energy possible is a matter that, in my opinion, can't be resolved directly in research. For this, ethical limits need to be discussed at another level and political laws need to be developed for the applications of a discovery.

Shouldn't researchers speak up more instead of leaving the matter to politicians?

Scientists don't matter in elections. Even with climate change, where 97 percent of scientists agree about its impact, politicians disregard us. Our impact is limited. But we do need to thoroughly discuss which projects we want to press ahead with and make recommendations for legal regulations. At the moment, I can see the problem of nuclear armament with all its dangers returning, simply because we can't agree globally about the laws that we want to accept. That's a really bad development.

What's your message to the world?

More and more attempts are being made to manipulate people. That's why it's important to seek independent information and use different sources to get closer to the truth. And then you should use your own brain to ask your own questions and make your own decisions.

How do you satisfy your ego?

Like any human being, I want recognition. When I'm invited to speak somewhere and people are really keen to meet me, then that's a great experience. That's why I have to make sure I continue to gain recognition and set benchmarks. I was brought up Prussian, with a lot of conventions like punctuality and acknowledging one's fellow human beings and their different qualities. These virtues aren't always the norm anymore. Respectability has also always been important to me. After the Nobel Prize, I told my family I didn't want the children to become

physicists; otherwise, there might be the allegation that Dad had pulled some strings. My children then studied biotechnology, mechanical engineering, and computer science.

Why did you choose physics?

I studied mathematics first because my parents and teachers inspired me to. But it was too dry for me, and I realized I could apply my knowledge far better to practical problems in physics. So, I switched after two semesters. Nevertheless, my career shows how important good teachers are in motivating students. That's why I created the Klaus von Klitzing Prize—to show teachers who can still inspire lasting enthusiasm how valuable and important their work is. Parents, teachers, and even kindergarten teachers are the foundation for the future in science.

Did your parents nurture your curiosity?

I was certainly influenced by my mother, who was also interested in science. My father's family, on the other hand, was aristocratic and everyone was either a landowner, a forester, or in the military. Because my father was a forester by profession, from an early age I worked a lot in the forest, where I was confronted with scientific questions. I got into mathematics because I added up the measurement data for my father and I always got five pfennigs for a page of facts. When a forest is felled, the trees are measured according to length and diameter, and that's how the cubic meters of wood are calculated. So, as a child I learned how best to add up twenty numbers.

As a Protestant in a Roman Catholic environment, I was also ostracized by the children in the village and had to keep myself busy. This encouraged me to set up mathematical problems to challenge myself. Combating nature and its challenges proved to me that I'm intelligent and could solve problems. This ability was inherent in me when I was just five years old.

Some researchers say they feel like God. Do you feel the same way?

As a child, I always had to learn proverbs from the Old Testament for Advent; otherwise, there were no oranges. But religious feelings have hardly played a role in my life. I've distanced myself from religions because many problems in the world have arisen through their abuse of power. Nevertheless, I believe that society can't exist without religion. The man in the street needs a crutch, and I can offer no other panacea.

In 2018, the decision was made to approve the von Klitzing constant as a fixed value, and even to use it to redefine the kilogram. Has this made you somewhat immortal?

My discovery wasn't solely responsible for the fact that the kilogram is now redefined. But it's the highest honor for me that my constant is there and will outlive me. That's why I'm not panicking, like many others who are reaching the end of their lives. I'm not afraid of death because I know I'm leaving behind something that will always exist. So, I no longer have to strive to be remembered by future generations.

"EVEN KINDERGARTEN TEACHERS ARE THE FOUNDATION FOR THE FUTURE IN SCIENCE."

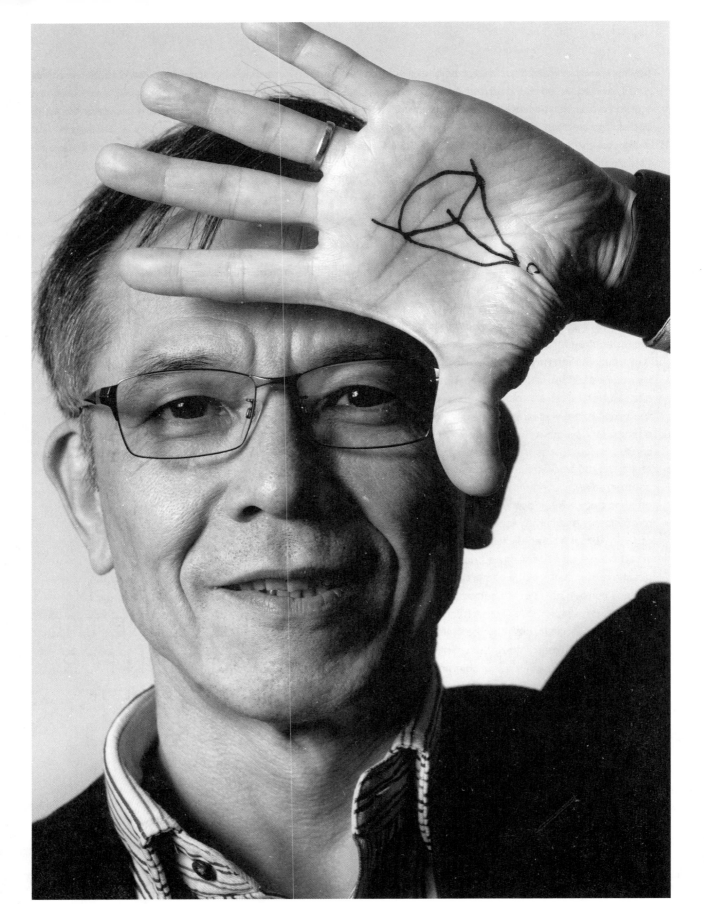

"BEAUTY IS NOT SOMETHING YOU'RE LOOKING FOR, BUT IT IS SOMETHING YOU WILL GET WHEN THE RESULT IS PERFECT."

Shigefumi Mori | Mathematics

Director at the Research Institute for Mathematical Sciences, Kyoto University Fields Medal 1990
Japan

Professor Mori, you were born in 1951 in Nagoya, Japan. Please tell me a bit about your family background

My parents ran a small company, selling textiles, where they both worked. Therefore, they didn't have much time for me, and they sent me to a preparatory school in the afternoon. In those days, people didn't mind strong competition, so there were a lot of exams and we kids were ranked according to our results. I never managed to be among the top thirty; I just wasn't interested in learning.

Mathematics was the only subject that ever touched me personally. We were given a quiz, and everyone who solved the problem correctly would get a piece of an enormous cake. And one day, somehow, I was the only one with the right answer. So, I won the whole cake. The teacher had to accompany me home and explain to my parents why I was carrying such a big prize. Because usually I was lazy and didn't do well. But this special quiz problem had somehow aroused my curiosity, and I had really tried hard to solve it. And when the teacher told my parents about my success, they praised me for the first time. That was a precious moment for me.

And so, you discovered your love of mathematics?

The event didn't have an immediate effect, but it did evoke some feeling within me that I might like to do something with mathematics. And later, when I was in high school, I was reading a book on mathematics and came across the number ∏ [pi]—a kind of magic number, which was called a transcendental number. And I wanted to understand how it was proven. So, I spent one long day at the school library reading about it and I got really intrigued. The way the mathematical proof was done was really beyond my expectation. I think this fascination pushed me further.

Then I found a monthly magazine called *Mathematics through University*. It also featured a monthly quiz, and I started sending my solutions to them; after a month or two, they put me on the list of people who did well. I really got hooked and I went from doing well to doing very well. Sometimes I was even first. And I decided I wanted to continue studying mathematics.

I told my father I had chosen to do mathematics. No one in our family had been an academic, so going into the sciences was something totally strange for them. My father must have expected I would succeed him in his business. The first thing he asked me was, "How can you make a living from that?" But when he realized he couldn't sway me, he agreed. And, of course, they supported me; they were really generous.

You studied in Nagoya and then you got an assistantship at Kyoto University, yes?

Originally, I wanted to study at the University of Tokyo, but the entrance exams were canceled because of student demonstrations. So, I went to Kyoto University. But the students were occupying the college there as well, and I couldn't take a regular calculus or linear algebra course. For about half a year the college was closed, and there were no lectures, then in the second half they gave some condensed courses. I really didn't have the chance to properly study mathematics during that time.

Did you take part in the riots?

I didn't do sports, and I didn't participate in student demonstrations, either. I just wasn't interested. Instead, with a few friends I started a seminar for ourselves. Everyone had to read a chapter of a book about mathematics, and then explain the subject to the others. We asked questions, pointed out mistakes, and had lively discussions. That was important to me, not the student demonstrations. We even managed to persuade a teacher to tutor our seminar.

After you earned your PhD, you went to the United States, to Harvard University. That was certainly a big step into a different world. How was it for you?

It wasn't my idea to go to the United States. My advisor, Professor Nagata, arranged that. I decided to give it a try, and if I didn't do well, I could always come home again. But I was relatively scared to make the move. I think my curiosity won in the end, and I started my life in Boston as an assistant professor.

I went back to Japan around 1980, and I found that didn't fit well into the Japanese system anymore. That is, I had too much pride, as we would call it in Japan. I moved to Nagoya, where they accepted my favorite style of doing research: in the cafeteria. Maybe I was a difficult professor for my students and I demanded too much from them. It took me quite some time to adjust, but then I got used to the Japanese style again.

Did you also demand a lot from yourself at that time?

At the time, I was pushing myself hard to do research, because there were things I absolutely wanted to finish. I was really working day and night. My research style is that I work with total concentration for a few months on my topic, and keep on thinking and thinking until it is finished, then afterwards I get lazy again for a few months.

At least, you found enough time to look for a wife, yes?

It was an arranged marriage. Somehow, my wife thought I was okay. We got married when I came back from Harvard in 1980. A few months later, I returned to the United States and my wife came with me. Our first boy was born when we were at Princeton University in 1981. Even our parents visited us in the United States for that event. But I was only interested in my research, and I didn't think much about my family. Now, looking back, I am grateful to my wife and I see how much I owe her for my success.

You were totally obsessed with your research?

That's the right expression. When I was at Princeton, I found a topic I wanted to pursue, and I kept researching it until 1988. I don't think I was a good husband during that time. I didn't pay attention to anything else, but somehow my wife always managed to drag me to museums and exhibitions. At first I wasn't really interested, but now I quite enjoy accompanying her on these trips. And when I go abroad, I always take her with me. While I'm doing business, she sorts out the interesting places for art, and when I have time we go there together so we can share the experience.

Once you said, "I'm not a positive person." Why did you say that?

Because it is true. It was only with the help of my wife that I learned how to appreciate life. It was a difficult process for me. But now, I understand there are various ways of looking at things, and I try to see the good points and appreciate them. My wife does some painting as a hobby. I still think that painting is just a lot of work, so it is not for me—but you never know, maybe one day.

Someone said that art is not just about reproducing what you see but also about making invisible things visible. And that applies to science as well. My field—algebraic geometry—studies figures by using equations. And to find adequate symbols, I also studied paintings. There is definitely some correlation between algebraic geometry and the work of abstract painters like Paul Klee.

Mathematical findings are often not easy to grasp. Can you nevertheless describe your research in an understandable way?

One of the things I researched was a simpler way of expressing algebraic variety in an algebraically defined figure, and I used something like a cone. This method was originated by Heisuke Hironaka, then I found that in this cone-like figure there are some edge-like shapes that have geometric meaning. Algebraic variety is something one cannot really see; it's a higher dimension. But in algebraic geometry, we express this in terms of a much simpler-looking cone that's shaped like an ice cream cone. That's why I compare the image to Cubist paintings. Cubism also presents objects as simplified figures.

And that's how you developed the concept of minimal models, for which you got the Fields Medal?

Algebraic variety can appear in many slightly different forms, and we want to study the essence of this variety. One way to do this is to get rid of the nonessential parts and then study it in its simplest form. That's what people call a minimal model. The way to obtain a minimal model is with use of this kind of cone. And I found something called an extremal ray. I cannot really touch algebraic variety directly, but I can see a cone and some extremal ray. Through this, I can recognize some geometric structure. And using this image, I can make some operation to the original one, then by repeating this over and over, I get the minimal model—the simplest shape.

The famous mathematician Heisuke Hironaka said of your research, "I'm not a genius, but Mori is! He is a discoverer who finds things that people never imagined."

Well, it was very nice of him to say that. He actually is the genius. I only got interested in this extremal ray through the notion of a cone that he himself discovered. I pursued this new object and I somehow arrived at the minimal model. Until then, the minimal model was only known in two dimensions, and it was considered impossible in three dimensions . So, when I started my research in 1981, I did not intend to prove the existence of the minimal model. I was just attracted to some question in front of me, and I couldn't stop working on it. And in 1987, I finally was able to prove the existence of the minimal model in three dimensions.

So, if everyone thought this was impossible, did you sometimes have doubts about your work?

At first, I did all the computations by hand. Then after a few examples, I couldn't finish the computations anymore. So, I learned programming. I bought a computer, and then I found many more examples. That was what convinced me that I was on the right track and so I just kept going.

When it comes to research, I have to be stubborn. Once I set a direction, I have to prove or disprove it. I have never followed fashion; I just follow my curiosity. That's when I am at my best, as this fits my personality. I always wanted to find my own way.

What was so fascinating about science for you?

That I can find the solution by just thinking hard. This applies especially to mathematics, and it is absolutely amazing. At least, that's what happened to me. Just by changing my way of thinking and looking at things, those things can become extremely simple all of a sudden.

A great mathematician was once asked about mathematical ideas. He said that he cannot define them. But he can judge whether something is a mathematical idea or not, because a mathematical idea equals beauty. Beauty is not something you are looking for, but it is something you will get when the result is perfect.

Do you think a good student should ask a lot of questions?

It's important to be curious and to ask questions. But I like students who don't listen to me all the time. It was the same with me. Once, when I was young and attending a lecture, I got interested in a special question, so I stopped listening; I had to keep on thinking about this one point, and so I totally forgot about the lecture topic. So, it is important that students know their own mind and don't follow the trends. That is how I've done it. My youngest daughter is a bit like me, as she is quite independent. I know I should not interfere, but I am a little worried. Of course, I will help her if necessary, but in the end, it is her life.

Were you a difficult child?

I was not good at listening to my parents. If I made a mistake, my parents got mad, but there was nothing I could do about it. In that sense, I was a difficult child. It only got better after they praised me for winning that quiz I mentioned earlier. That was a real turning point. But when I look at my own kids and grandkids, I see that maybe I was not particularly special. I keep telling other parents that they should try to find the good points in their kids, but in order to do that they have to observe them closely.

Do you have a message to the world?

Nowadays, people tend to want immediate results. But immediate applications sometimes also become immediately useless. In mathematics, it takes time to develop a useful application, but once you have one, it usually lasts a long time. So, it is important to be patient. But nowadays this is more and more difficult. Bureaucrats wants immediate results, because they have made huge investments in research, but that doesn't happen in mathematics. It is a rather slow field, and so am I.

What makes you happy in life?

That I have been doing what I wanted to do and was able to pursue my research. That's quite something. If I hadn't been able to do mathematics, I don't think I would have been happy. Mathematics is my life. And when I was offered the position of the first president of the International Mathematical Union of Asia, it was a chance to pay something back.

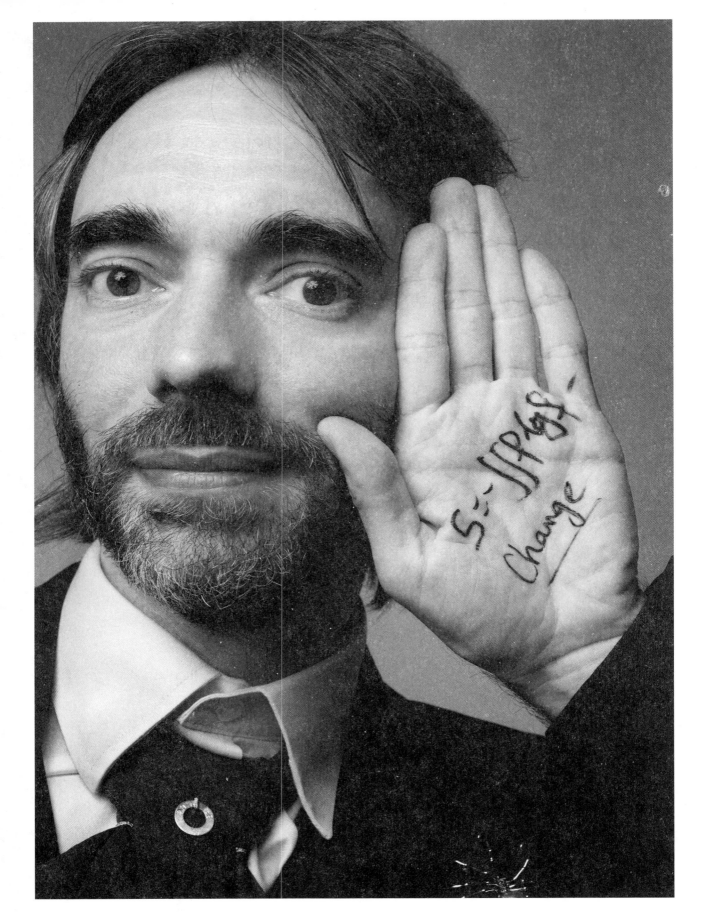

"ALLOW SOME ROOM FOR RANDOMNESS IN YOUR LIFE."

Cédric Villani | Mathematics

Professor of Mathematics and Former Director of the Institut Henri Poincaré, Paris
Fields Medal 2010
France

Dr. Villani, after a brilliant career in mathematics, including winning the prestigious Fields Medal, you moved into politics. What caused you to make this switch?

I've always been interested in opening up France to the world. I've traveled widely and have been involved in issues involving political commitments, even when I was working as a scientist. When I started promoting a strengthening of the European Union, I met people who were very much involved in politics, including Emmanuel Macron. He was

sympathetic to the cause of a globalized Europe, and very energetic.

At that time, Emmanuel Macron founded a new party, La République En Marche, and today you're a representative of that party [now Renaissance] in the National Assembly. This was quite a beginning to your political career.

Yes, I wasn't planning on being elected to the National Assembly. It came to me almost by accident, because I ended up supporting the party in a strong way. On the other hand, my decision to run for mayor of Paris was a conscious and determined choice.

Why do you want to be mayor of Paris?

Because I want to put all my skills, knowledge, and convictions to work for this city. I owe so much to Paris. It has made me what I am today, and I want to give back to the city now. My goal is to empower the city with the capabilities of science and technology, but also to put forth structural, key issues for the future of Paris that the traditional parties do not wish to address. A science-based approach involving environmental transition; an emphasis on knowledge, science, culture, and education; a more democratic governance; and first and foremost the strong belief that Paris has to grow to address the key challenges of the present, both for large-scale objectives and for day-to-day life.

Do you think you will have more influence as a politician than as a scientist?

It depends on whom you're talking to! There are many people who think that being a scientist is the highest calling in the world, and that there's nothing respectable in politics. And there are others who think the reverse. What is certain is that, as a former scientist, I can have an impact other politicians cannot have. People don't trust politicians. They want someone who's sincere and committed, and who had a solid career before entering politics. And they want someone who doesn't put all his energy into attacks and treachery, but instead who uses his energy to solve problems.

Your manner of dress is quite unusual—a bit nineteenth century. You're always wearing pins of spiders, too. Why is appearance important to you?

In fact, this outfit was made by a tailor of the twenty-first century, a young artist, so it's very modern! And that's how I am. I'm just trying to be myself.

But it's true, I have a connection with spiders. It's part of my identity. Many people offer me spider pins, and the one I have today was given by a Chinese friend, so when I put this spider pin on, I think of him.

In 2010, you received the Fields Medal, which is sometimes called the Nobel Prize of mathematics. The award was for your evidence of Landau damping and the Boltzmann equation. Would you mind explaining what that means?

First, let me comment on the prize. We like to think that the Fields is even better than the Nobel Prize because the decision is made not by an academy but by the members of the International Mathematics Union, for the mathematics community. The award is given every four years, typically to four laureates. It's such a beauty.

But yes, together with my collaborators, I worked on an equation for describing the properties of plasma. Let's say apply an electric field to the plasma, which creates a disturbance. The question is, once the electric field disappears, how will the disturbance disappear? It's a subject that has been investigated for a long time, and together with Clement Mouhot, our main contribution was to give a mathematical explanation of this so-called Landau damping, named after Lev Landau, a Russian physicist. The equation has consequences for physics and engineering, and it has also helped other mathematical physicists.

And could you explain briefly what the Boltzmann equation is?

The Boltzmann is an equation that describes the evolution of a gas. Suppose you have a gas in a box. We think we know what this gas is—it's a bunch of molecules. But that's a complicated thought, isn't it? After all, molecules have different velocities going in all

directions. So, how will it possible to predict the evolution of this gas? The Boltzmann equation tells us that the initial state of the gas predicts the future state.

This is an equation that goes back to the 1870s, when it was laid down by the Austrian physicist Ludwig Boltzmann, after the outstanding ideas of James Clerk Maxwell, who established the modern statistical theory of gases. The idea was revolutionary in those days. At that time, people who believed in atoms were considered crazy! Atomic theory was seen as just a theory, a dream. It was another forty years before the existence of atoms was proved, and then thirty years more before the atomic bomb was built. That shows you that theoretical science—which people often dismiss as impractical—can in fact have an enormous impact on the world.

As a child, you were already passionate about mathematics, correct?

Yes, I loved mathematics when I was young. I found it fun. When you work on a problem, it's a riddle, an enigma—and, what's so important, the solution can be found *inside you*. People always think that mathematics is abstract, but mathematics is concrete. Have you ever seen an atom? No. But have you seen a triangle? Yes! And we can do so many exercises with triangles, circles, and lines. We can draw a figure. We can think and prove things. In a sense, these ideas are much more familiar than what you've never seen with your own eyes.

Did your parents support this interest?

Yes, my parents liked the idea that children go and develop what they enjoy the most, and I've felt the same way about my kids.

What was your life like when you became a research scientist?

Research is a constant quest. You have to talk to people, discuss, read, travel, meet other people, read some more, and think. You have to think a lot! Research is international, and mathematicians are, especially, birds of travel, meeting people all the time, discussing and exchanging ideas.

So, would you describe yourself as obsessed?

Yes, but I'm the kind of person who has many obsessions. Currently I'm immersed in politics. At another time, I was all about running my institute. Yet another time, I fell in love with Africa and was obsessed with the development of science there. There was a time when, as a student, I would go every day to the movie theatre and see whatever was playing. And there was a time when I had to practice the piano at least one hour per day, or I would not be happy. And of course, I was often obsessed with solving mathematical problems, such as the Boltzmann equation.

How does that fit into your life nowadays? I don't imagine you have much free time for long hours of thinking anymore.

But I'm not in research anymore. Of course, a researcher needs an organized life—or rather, a researcher needs to have a lot of time for concentration. Research is a demanding task—beautiful and fantastic—but you need these long hours of concentration, deep thinking, and searching. It's a blessing when you can have them.

You were married, and you have children. You once said about your wife, "She accepted a lot without grumbling. I would be walking around in circles in a dark room while she prepared the dinner—that's a little too much." I imagine obsession can carry a personal cost, no?

At times it was very difficult, and at times she found it beautiful. There were ups and downs. The truth is that the ability to become obsessed with a project is one of the things that has been most helpful to me, not only in science. And now that I'm involved in politics, my children are teenagers already. I'm happy that I did spend a lot of time with them when they were younger. The countless hours I spent telling them stories is one of the most important things that happened to me.

As eager as you are now to become mayor of Paris, do you ever regret that you're not a researcher anymore?

Not for a single minute. You know, there are many great researchers in France and around the world. But scientific researchers who take the leap into politics—there are very few of those. It's quite

challenging to assemble teams and understand how institutions function, to work on different subjects and speak in front of an audience, not to mention going on TV regularly, where millions of people may be watching. It's a serious challenge—and I wish more scientists took this path.

You work with a team, but the public attention is all on you. Perhaps it satisfies your ego, no?

I love being useful to people, and I believe we all have our mission to fulfill. We each have our path, our character, and our mission. Perhaps that is my weakness: wanting the feeling that I am doing exactly what I am supposed to.

Perhaps it's also satisfying to take on such a big challenge?

Yes, I enjoy the constant spirit of challenge. Right now, I'm running this campaign day and night. A political campaign is massive. You have to think of the years involved, the effort and the training, the arguments, the media, everything.

But you know, it wasn't always my plan to go into politics, and when I asked people for advice, their response was always clear: don't do it! They gave me a whole list of reasons why I shouldn't. Their responses were precious to me, because then I had *objections*, and that allowed me to develop *counter-reasoning*. I took on those objections one after the other and examined whether they were valid. After I saw that, in fact, they didn't stand up, then I knew I could move forward.

You once said, "If you don't accept being vulnerable, then it's not the right life." Could you tell me about a situation that made you feel vulnerable?

This is one of the most important things I've learned from life. At times you have to expose yourself to become stronger. Running for mayor is such a situation. This campaign has particularly exposed me, with a fair number of coups de theatre, treachery, misunderstandings, miscommunications, and even calamities; now I don't even know whether the first round of voting was for real or not! On the other hand, beyond the difficulties, it has been an extraordinary human adventure and an outstanding

opportunity for learning! I'm exposed every day to criticism and insults and attacks. People comment about me, about my way of speaking, about the policies I'm proposing. This is also a dangerous situation! But I have to go for it, because it's an opportunity to test myself.

As a researcher, I would test myself often. Sometimes I would announce achievements ahead of time, putting myself under a lot of pressure to then finish. I would also change fields, constantly moving into areas where I was not an expert, and where I quickly had to become an expert.

What is your message to the world?

When I speak to young people, I always give the same advice: don't put yourself in a box. Keep moving. When you already know something, make the next step. And allow some room for randomness in your life.

There can be strong rivalry in the scientific community, but it's the same for politics. How do you handle that kind of environment?

You have to take what is good from the pressure, what makes you a better person and inspires you to achieve more. But when that pressure is negative, you have to resist it. Do you know what the inscription is on the Fields Medal? It's in Latin, but it means, "Rise above oneself and grasp the world." That means to go beyond yourself, and I think that applies to a large part of my life.

What's your strongest characteristic, would you say?

As a scientist, probably my strongest feature was the ability to synthesize. Synthesis is an activity I value and my best successes as a scientist were certainly in the synthesis stage, in both research and book writing.

You have a great deal happening in your life right now. Are you able to balance your interests?

Well, life is a collection of objectives. You have to keep fit, think about your appearance, your diet, your family life, everything. It takes a lot of discipline.

What four words would you use to you describe your personality?

Freedom, empathy, audacity, and curiosity.

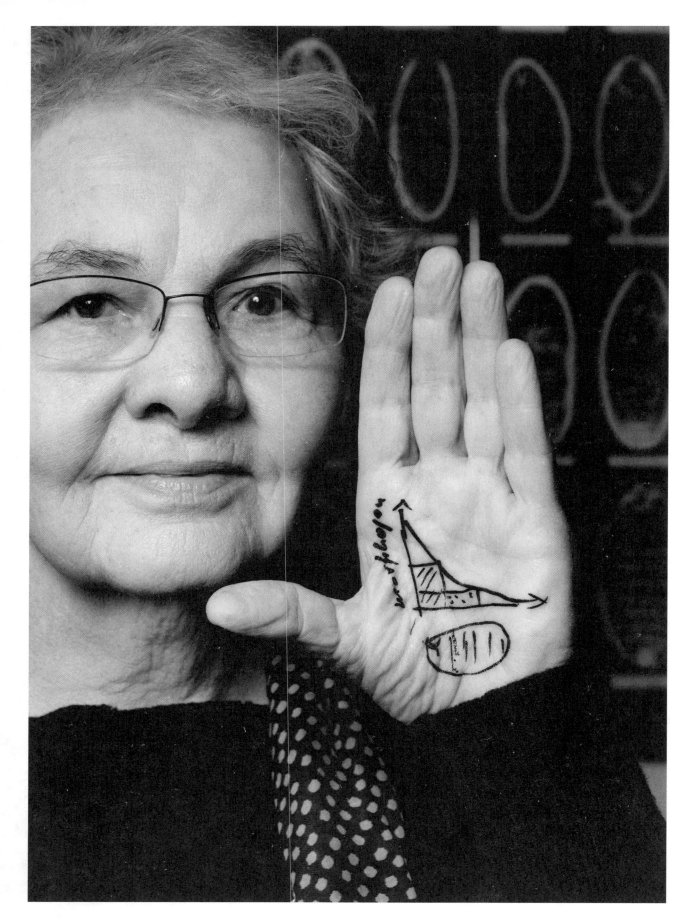

"I WAS OBSESSED WITH MY SCIENTIFIC PROJECTS."

Christiane Nüsslein-Volhard | Biology and Biochemistry

Professor of Biology and Head of the Emeritus Research Group
at the Max Planck Institute for Developmental Biology, Tübingen
Nobel Prize for Medicine 1995
Germany

Professor Nüsslein-Volhard, all your working life you've been labeled "difficult." Why is that?
At the start of my career, I was often the only woman in a department. I was often on the defensive, and I often felt disrespected. I was often far too direct and critical, and not very conciliatory when something annoyed me. I also didn't know many of the men's rules of the game back then. I don't shy away from unpopular decisions, and I assert myself when I have to. I've sometimes behaved like a bull in a china shop. There are certain approaches to business decisions I had to learn.

What are the men's rules of the game?

They protect each other, they don't criticize each other directly, and they are possibly even more polite to each another. You always have to make sure the other person doesn't lose face. If a woman tells a man he's talking drivel (even if it's obvious to everyone else), he'll never forgive her.

Have you learned those rules?

I haven't got them all down pat and I often can't keep my mouth shut. When I want to get my views across in the face of opposition, I often get quite upset, which isn't good because it's dismissed as being "emotional." I'm not tactical, and I'd prefer to be upfront about what I think is right, but a little more diplomacy would sometimes be helpful.

Even as a child, you proved to be an exception to the rule. Hardly anyone around you shared your interests in plants and animals.

For my siblings and classmates, friends and other people were important, but for me, getting my hands on a good book, or examining plants or animals under a microscope were equally important. At school, we had good teachers and interesting biology lessons; I really enjoyed those and they spurred me on, but I was missing someone who was really well informed and of whom I could ask questions.

Did your parents give you the necessary freedom to develop?

Absolutely. That was the most important thing. I'm addicted to freedom; even as a child I didn't want to be dictated to. I'm often obsessed with my projects, pursue them tenaciously, and don't like to yield to any attempts of external guidance. My parents were liberal, they gave us siblings a safe space, and we had many ideas and opportunities. My mother told us, "You know what you're doing." We weren't punished and we were given few rules; we were supposed to decide for ourselves at a very early age as to what to do and what not to do. That was important.

I was also quite sensitive, and I loved poetry and music. As a result, I was often lonely and felt misunderstood. I also sometimes skipped school when

"I'M ADDICTED TO FREEDOM; EVEN AS A CHILD I DIDN'T WANT TO BE DICTATED TO."

I wanted to do something else. My mother politely wrote letters of apology, and my father was sometimes surprised by my occasional bad grades, but he didn't put me under any pressure.

Your father died early, when you were just finishing high school. What did he see in you?

He was one of the few people I could talk to about my interests and who would ask me, "What did you do in school?" "What grabbed your attention?" What are you interested in right now?" I was reading a lot of Goethe at the time. We discussed my ideas and projects, and he also got some biology books for me—which was amazing for an architect with no special university education. But he was interested because I could offer him something he didn't know, and he enjoyed that. Perhaps he was also a bit ambitious for me and encouraged my thirst for knowledge.

Where does this thirst for knowledge come from?

It's innate, I think. After the war, my grandparents lived for a few years with farmers in Niederneisen, a small village where I often went to visit them as a child. My sister was sent home crying on the first day of a visit because she was so homesick. I, on the other hand, found it wonderful to be there with all the animals, plants, good food, and lovely people. I'm not sure if those visits shaped me, or if everything just fell on fertile ground. I was fortunate enough to be able to indulge my passions.

Who encouraged you in your studies?

At school, my teachers did, but during my studies and later on, there was no one in particular. I made my own decisions and I didn't have any mentors. I

was also never particularly sociable; rather, I was shy and found it difficult to start talking to people. Other people probably thought I was arrogant, but I always had good friends and often invited those friends to dinner.

You play the flute and sing. Was that the case even as a child?

I think I already sang as a baby—my mother hinted at this in her notes. I took singing lessons for seven years, with nice teachers who really helped me. It wasn't until later in life that I found an accompanist for my singing; I also took singing lessons again when I was 65 years old. Unfortunately, my last singing teacher quit and so I no longer take lessons, but I continue to sing with piano accompaniment,

especially *Kunstlieder*, or art songs, mostly by Schubert, Schumann, and Brahms—those wonderful romantic songs that are so abundant in German music. When I sing, I'm a completely different person. I'm in a completely different world, which is fantastic, wonderful!

Your road to the Nobel Prize in 1995 was full of difficulties. Did you suffer much humiliation?

Plenty. I switched topics during my PhD and picked a topic that no single student could have completed. My supervisor didn't like that, of course. Then I was ripped off when it came to authorship. We fell out, but I survived the crisis; it would have been a bit easier with a good publication. In my postdoctoral period, I had a boss who didn't think much of women. He said to me, "There are no female Einsteins." And when I was offered a professorship at the University of Würzburg, the chancellor at the time addressed me as Ms. Nürnberger during the interview process. He thought I was a lawyer and told me that 30,000 marks a year would probably be enough research money for me. I remember running out of that office crying, through pouring rain, into the garage where my little Deux-Chevaux was parked. I angrily turned the job down.

Do you consider the Nobel Prize your greatest success?

My directorship at the Max Planck Institute was possibly even more important. Before that, I was really scared about the future. I got the position as group leader in Heidelberg only because Eric Wieschaus, who was five years younger than me, also accepted, even though he wasn't looking for a job. They didn't trust me to do the job by myself, and I found that hard. Together, Eric and I did the work that won us the Nobel Prize. But the director didn't recognize that effort, and we weren't treated well at the end. They wanted to get rid of us because they didn't think flies were all that important.

You carried out research on fruit flies. In 1995, you received the Nobel Prize "for your discoveries concerning the genetic control of early embryonic development." Can you briefly explain that?

"IN MY POSTDOCTORAL PERIOD, I HAD A BOSS WHO DIDN'T THINK MUCH OF WOMEN. HE SAID TO ME, 'THERE ARE NO FEMALE EINSTEINS.'"

The question was, "How does a complex form develop in an embryo?" For each new generation, structures are always created in the right place during their development. Which genes control this process? We initially did a lot of basic work and then developed new methods to study this in the *Drosophila* fruit fly. In systematic experiments, we then discovered 120 genes that play a crucial role in this complex process.

Genetic engineering now enables targeted interventions in egg cells. Do you think that in twenty years babies will still be conceived naturally?

Definitely! Repairing genes is difficult, and you can't predict with sufficient certainty the outcome of an intervention in the genome of an egg cell. The human experiment that was unfortunately carried out in China was highly risky. No one knows exactly what affects a human gene. This is likely to be the case for a long time, so I don't think we'll ever see large-scale human genome editing.

I've campaigned on the Ethics Council for pre-implantation genetic diagnosis and stem cell research, and I defend the use of green genetic engineering for sustainable agriculture and nature conservation. So far, none of that has come to fruition. I've failed in these political missions so far, but I hope that at some point, common sense will prevail.

How did you celebrate your win of the Nobel Prize?

We had a drink at the institute, and they congratulated me lots, then I went home alone in the evening. My neighbor came over, gave me a hug, and also congratulated me—that was lovely. Then I was interviewed by a reporter, my first television interview! Back then, I used to speak a lot on the phone with U.S. geneticist Eric Wieschaus, and we congratulated each other.

My colleagues reacted differently. With some I had the feeling, *Oh, God, this is really bad for them*. My immediate colleagues were envious, while my international colleagues were really thrilled. The latter thought it was great that a prize was being awarded for developmental biology and genetics.

Did you ever think about going abroad?

I received offers, but I couldn't summon the courage to take them. Somehow, I felt that I wouldn't be able to hack it. It would certainly have been useful to mention a call from Harvard or Stanford at my own institution, the Max Planck Society. But I was never one for playing games.

Could you have pursued a career in the same way as a woman with a family?

Certainly not. I hardly had to make any compromises, and I had the time and freedom to devote myself entirely to my research. Of course, I also have a private life, and I take that into consideration, but not to the same extent as I would have with a family. That's why I think it's not right that other women in science are measured against me—that's not fair.

You were married to the physicist Volker Nüsslein for almost ten years?

That was the way it was supposed to be back then. When I was a teenager, a girl was expected to marry a suitable man and have children. You were afraid of "being left on the shelf" and turning into an old maid. I got married at age 25 as befitting my status, to a nice, handsome man who was also an academic, but

not of the caliber I would have liked. I never wanted a family, and I probably found my job more important than my husband. And then we got divorced, which was a good thing.

Why was your research more important to you?

Everyone strives to be happy in some way. I was ambitious; I wanted to reach for the stars and so I sought out the most exciting projects. I was obsessed with my scientific projects. But I kept asking myself, *Am I good enough?* Many women dropped out of science at that time, not just for professional reasons but also from lack of determination or because their partnership was more important to them. There were also women who held back so as not to offend their husbands, who couldn't stand it when their wives were more successful.

Did you once say that women shouldn't spend so much time in front of the mirror?

Every woman is vain and constantly thinks about how she looks. But some women get dressed up, which is time-consuming and a distraction, and this type of vanity has no place in a profession. It was important for me to be recognized not because of my looks but because of my scientific achievements. I also used to cut my own hair. The amount of time spent at the hairdresser's seemed excessive to me.

What are you like as a boss? Do you find it difficult having other people work for you?

I take a humorous, easygoing tone that doesn't intimidate people, and I dislike giving orders to staff. I've certainly supported my staff, but I've also challenged them quite a bit too, and I expect a lot of effort and high quality with their experiments. Maybe that's why I earned a reputation for being a strict boss. It was the women who didn't turn up then because they were afraid of having to work too hard. If you're a successful woman, that's not so appealing to other women. But the worst mistake you can make is to hire the wrong people.

You set up a scholarship for young female researchers: 400 euros for twelve months for their household help. Why was that important to you?

The main disadvantage for female researchers is that they don't have a housewife at home. Having that wife at home is what allows many men to carry out their cutting-edge research: Their wife has their back and takes care of everything else. When female researchers have children, they're nearly always pressed for time—they're being pulled in all directions. But with that bit of money, they can buy household help and thereby buy more time. That was my thinking.

What made you the person you are today?

Curiosity, obsession, versatility, talent, reason, honesty, and being true to myself. I'm naturally relatively well equipped, in that I have manual skills, I'm resourceful, I can multitask. As for intelligence, I'm not amazing, but I'm good enough. I've also been fortunate enough to successfully work with many talented young researchers and help them pursue scientific careers—it's kind of like family.

"I WAS AMBITIOUS; I WANTED TO REACH FOR THE STARS AND SO I SOUGHT OUT THE MOST EXCITING PROJECTS."

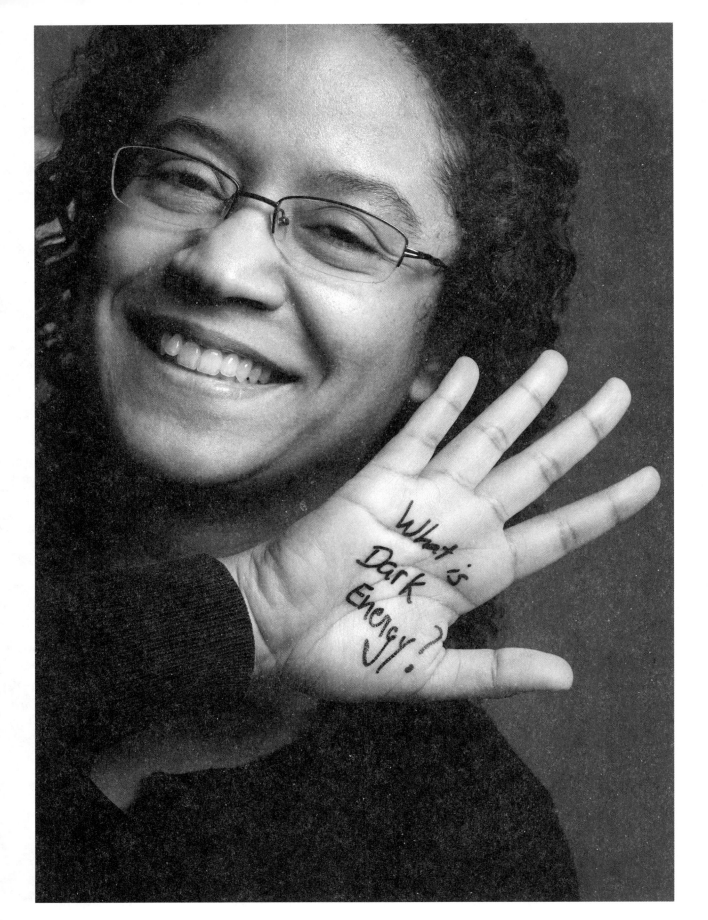

"FOR ME, IT'S NOT REALLY A QUESTION OF SATISFACTION, BUT ABOUT ASKING THE NEXT QUESTION ALL THE TIME."

Marcelle Soares-Santos | Physics

Assistant Professor of Physics at the University of Michigan, Ann Arbor
Member of the Dark Energy Survey
United States

Professor Soares, what inspired you to devote yourself to science?

I was a curious kid and asked questions all the time. I can even pinpoint the moment I discovered my passion for science. My father was working for a mining company at that time, and we were living in the middle of the Amazon forest in Brazil. When I was 6 years old, I was on a school visit to an open mine, and I was fascinated by a demonstration of detonating explosives, which were used to extract the iron ore. It was mind-boggling. I could see the explosion,

but did not hear the sound until several seconds later; I did not understand the delay until my teacher explained the difference between the speed of light and the speed of sound. That was probably the beginning of my interest in physics.

What did your father do, exactly?

My father was an electronics technician. His job was the maintenance and automation of the machinery that served the mine. My mother was a housewife, and she was dedicated to raising me, my brother, and my sister. One of the things I remember most fondly were our trips in summer, when we would travel from the north of Brazil all the way to the coast in the southeast. I think my parents were heroes to take a journey of about 3,000 kilometers with three kids in the car, but it was fantastic for me.

We also moved around during these years. I was born in Victoria, which is a city on the coast, and then we moved to a mine in the north. Years later, we moved back to Victoria after my father had retired.

Who has left more traces on you, your father or your mother?

I think I inherited characteristics from both of them. My mother used to have us spend two hours with studies to become as good as we possibly could. To this day, I'm not so much in competition with others, but I am in competition with myself, trying to do better than the day before. The main characteristic I took from my father is his persistence. He was the one who pushed me to read even before I began school. I would say that I act persistently in all parts of my life.

You did your PhD in Brazil, but then you went to Chile. What was the reason for the move?

Chile has some of the best conditions in the world for large-scale telescopes because of its very dry climate and high mountains. I was participating in a dark energy survey for the construction of the camera. And once that camera was ready to go, I had an opportunity to spend several months in Chile to help the team install it on the telescope. We're still using that camera today, and I'm very proud of it.

Was this move a challenging experience for you?

I was getting to know new people, expanding my network, and becoming part of a bigger community. Those were some of the serious challenges. It was a little bit of a physical challenge, too. We were very high up in the mountains and would go up even higher every day to set up the equipment. Sometimes we had to push ourselves to brave the cold and stay over till the next day. The environment up there is a bit wild, too. Tarantulas and small scorpions that the locals call "alacrans" are common. One morning during my first week there, I noticed one of them in my room. I left quickly and had to think twice if I would go back in. I continued working on the project, but I had to toughen up a bit to handle those experiences.

How difficult was it to find your place in this international group?

In a large international collaboration, there are differences in culture, but also differences in the length of time groups have been working together. If you're new, you have to get integrated and become part of it all. So, the first thing I did when I started this project was to follow around other people who were a little bit older; they had arrived the year before and were already integrated into the team. They were also extremely generous in sharing their experience and allowing me to help with smaller tasks, then later giving me more responsibility. It worked out quite well, and in my second year on that project I was fully part of the team.

There are still far fewer women than men working in science. Do you ever encounter gender bias?

I noticed that when I have to give a presentation, in the first two seconds after I step up, there's a bias—I sense it. I know that if I were a white guy, the audience would behave differently. This happens every day, so I have to consider how to penetrate this extra layer before I can communicate my message.

Sometimes I have had the impression that perhaps I would have been given a better project if I had been a man. But I can't really prove that. My strategy

is to convince everyone by my actions or by giving a good talk; and when there's a project I want to do, I interact with the supervisors early on instead of waiting for them to think of me.

Do you think you also have to make more effort to be respected as a woman of color?

It's rare for people to see women of color in my position, so it's unexpected and people sometimes react with surprise. But at the same time, I think my successes helped build my career, as people saw I was capable of taking on those challenges. But I also think it probably would have been easier for a white man. I have to prove myself over and over.

Now that you've got your own group, how is the experience of guiding people?

I had to learn how to be a mentor instead of a colleague. This is one small, but key difference when you've got responsibility. I also learned that I have to find ways to enable my students to gain visibility in that environment—from the perspective of a mentor instead of a postdoctoral student.

Do you detect any difference in thinking between the young generation of scientists you belong to and your older colleagues?

The career of a researcher, from PhD to faculty member, is typically longer now and involves several years as a postdoc. Nowadays, it's more common to work on huge collaborations in which your group is just one of many. That means there's more exchange between the team and the broader community. When, for example, a researcher is not part of a huge team but has a great idea for a new analysis and wants to use their search data, he or she is free to do so. You need to cooperate because the problems we're all trying to solve are so challenging that it's impossible to do that as an individual or as a small group. At the same time, there's competition in the sense that you want to show you have a unique role in something that was definitely your contribution. As a younger researcher, you must try to establish yourself and find the balance between these two extremes.

You're working on gravitational waves. Can you explain your research to a nonscientist?

Gravitational waves are waves that are propagating in space-time. If you imagine the surface of a lake, and you throw in a stone, there are ripples that generate outward. In the case of gravitational waves, there are objects that are massive in size—as massive as our sun—but very compact. So, you compress the sun, then make it collide with a twin system. That's the level of energy you need to produce the ripples that are generated in the vacuum of space-time.

We have very sensitive detectors capable of sensing these fluctuations as they pass along. When the gravitational waves are detected from one of the cosmic collisions, I point the camera that's installed on the telescope in Chile to that region of the sky and try to find the light associated with the collision. The idea is that when this collision occurs, there's a bright emission that will expand and cool down over time. And with the help of the gravitational waves, I will know where to look for the light information.

What was the most surprising experience you had as a scientist?

That was definitely the discovery of the first of these cosmic collisions. It was in 2017, and we had been preparing for this project for several years already, but I did not expect that it would happen so soon. I had thought that it would perhaps take another decade to make such a discovery. I was surprised, and it was extremely exciting.

You're known for working almost day and night, yes?

Being a professor means having several jobs in one. I have to do research, I have to mentor people, and I have to teach. Finding time to fit in all those components of the job sometimes simply means working day and night. But the boundary between working and not working can be a little bit blurry for many scientists; we make our passion part of our lives in such a way that it's hard to separate the two. For me, being a scientist is part of my identity in a such way that I can't leave my work at the office and it's over.

I may not be physically working, but my mind is always racing.

Would you take time off to have a baby?

I'm married to a partner who is a physicist, too, but a family isn't something I'm really planning right now. Having a baby would certainly be a life-changing decision, and right now I'm focusing on challenges at work. If I see the results of months, sometimes even years, of work coming forth in the form of a paper, that is really the moment that I would cherish.

Was there a time in your career when your ego was quite satisfied?

For me, it's not really a question of ego but about asking the next question. The reason I was motivated to pursue gravitational waves was my interest in learning about the expansion of the universe. This is a huge problem because we know that whatever is causing the expansion rate of the universe to accelerate must be outside of the realm of known physics. We call it dark energy, but that's just a label for something that's completely unknown. Contributing to our understanding of such a big mystery is what really pushes me, and I've been trying to figure out different avenues to approach this matter.

You established your career in the United States. Will you ever consider returning to Brazil as a scientist?

No, not in the near future. I'm prepared to be away from home for a long time. I think that there are more resources to pursue my type of science in the United States.

Why should young people study science?

If someone is fascinated by the exciting world, this passion shouldn't be wasted. It's a competitive field, and the time scales for developments in science are extremely long, especially when you're young and you have to apply for a position sometimes more than a year before you would go there. Those steps require time and planning. So, it's always useful to make a plan.

Another piece of advice would be to find a good mentor. A mentor can encourage you to develop your strengths and also be critical of your weaknesses. I had several good mentors throughout my career, and I also think that my family and my teachers as a child contributed to the development of my strengths.

What do you consider to be your contribution to society?

I need to motivate young people to do science. Most such efforts are often targeted at people who come from a certain privileged background. What I try to do is to focus a bit more on those from other backgrounds as well.

You're totally dedicated to science. Is there anything else that's important in your life?

I used to joke that the reason I became a physicist was that I have no other talent. There are quite a few physicists who are also musicians or artists, but this is not the case for me.

What is your message to the world?

I hope that the world is evolving toward a fairer society, where people have equal opportunities to pursue their dreams and fulfill their potential, regardless of where they come from or what they look like. Sometimes I think we take some steps backwards, but overall I think we are improving, and we need to improve even more.

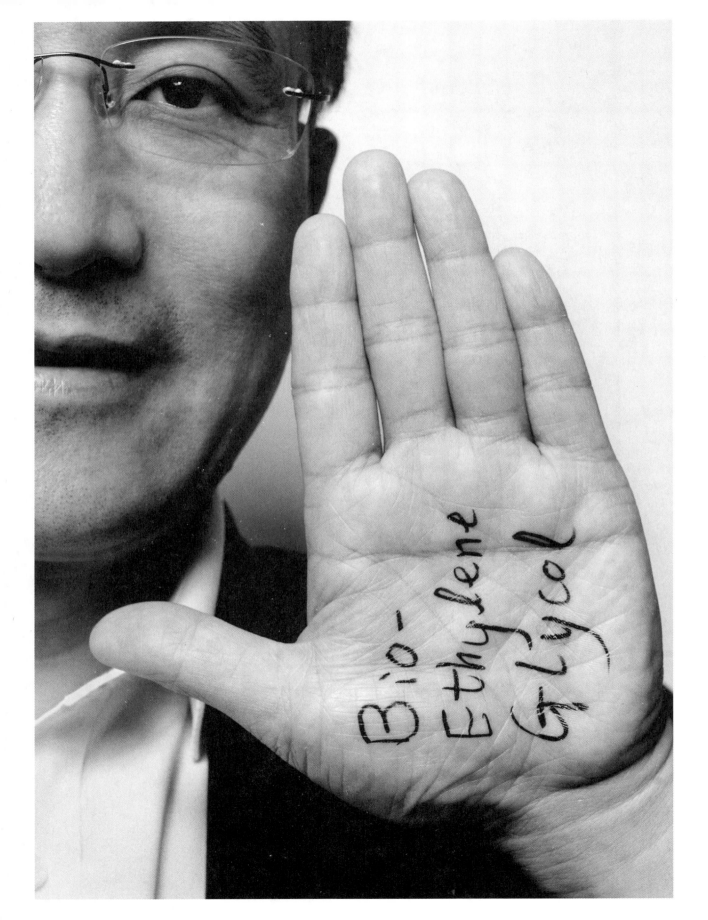

"YOU CAN'T FIND MORE HARDWORKING SCIENTISTS IN THE WORLD THAN IN CHINA."

Tao Zhang | Physical Chemistry

Professor of Chemistry and Director at the Dalian Institute of Chemical Physics, Dalian
Vice President of the Chinese Academy of Sciences (CAS), Beijing
China

Professor Zhang, you're in an important position as vice president of CAS. How did your childhood shape you for this success?

My parents had an important influence on me as a boy. My mother was a primary school teacher, and my father was a middle school teacher, and they both encouraged me to always learn more.

China at the time was very poor and so was my country school, with only four teachers for 100 students and five classes. My first through fourth years of school were in the same classroom, so this

"CHINA AIMS TO BE THE LEADING PLAYER IN GLOBAL SCIENCE, AND I ABSOLUTELY BELIEVE IN THE NEXT THIRTY YEARS, WE CAN ACHIEVE THAT."

allowed me to study the following year's material while I was in the earlier year.

So, this was during the Cultural Revolution?

I was born in Shaanxi Province in 1963, so I was just 3 years old when the Cultural Revolution was launched, in 1966. It nearly caused my school to close down and the quality of my education suffered; in short, it was difficult to learn. Luckily, my mother helped me.

How did your parents ease the problem of your schooling?

My mother managed to get another job in a primary school downtown, and I followed her there for better-quality learning. After that, I managed to pass a difficult entrance examination and got into one of the best middle schools in the city. Ironically, chemistry wasn't my main interest back then; I was keener on learning mathematics and physics.

Where did you receive the next stage of your education?

Deng Xiaoping opened China's doors to the world in 1978, when I was 15 years old. China was still very poor and needed to attract young talent, so Xiaoping reopened the universities, which had all been closed during Mao's time. High school was normally for three years, but managed to be one of only 2 percent of first-year students to pass the entrance exam and go straight on to university.

My exam score was good, but not good enough to attend a top university such as Beijing, where I wanted to study math or physics. I would have had to wait another three years to retake the exam for Beijing, but then a local university offered me a place in their chemistry department, allowing me to fast-track my higher education. I was only 19 years old when I finished university.

So, you studied chemistry by chance? Did you fall in love with the subject?

Yes, I learned to love chemistry. It was actually a mistake, though, that led me to it!

And now you're working in a new area of research. Tell me about it.

Plastic bottles are made of polyethylene terephthalate (PET), which is formed from a combination of terephthalic acid (TPA) and ethylene glycol. These chemicals are produced from oil, which as you know is in limited supply. So, how precisely could you make more ethylene glycol from alternative sources? My area of research and my mission is to use a catalytic process to make ethylene glycol from lignocellulose, a kind of renewable biomass resource. Unlike oil, biomass is sustainable, can be recycled, and comes from a regenerated source.

Of all the current and future challenges we face—of climate change, environment, medicine, and sustainability—which will China give its priority to solving?

Energy; developing green energy and sustainable energy are China's biggest challenges. China is a huge country, with a large population, so we need enough energy to sustain our economic growth, but we're poor in oil and gas and are limited to our coal supplies. That's why China needs to develop technology that allows us to use coal in a clean manner. This is the most important research area, which I worked on for over thirty years at the Dalian Institute of Chemical Physics (DICP). Of course, the coal resources will one day be used up, so our second most important area of research is renewable energy sources.

I should imagine your work at the DICP was well financed and well recognized?

Yes, we were fortunate in receiving good funding and we were lucky to find a new reaction that would produce the ethylene glycol from biomass. I think almost everyone in the catalysis field knows by now that bioethylene glycol comes from Dalian, in China.

My dream now is to commercialize the new bioethylene glycol technology to produce environmentally friendly bottles and fibers. It's not just about filing patents; we also need to commercialize the process so as to use this new technology for our country, and for the world.

If you commercialize this new technology, would the income generated belong to you, your university, or your country?

That's a good question. The new regulations state that 70 percent would go to our team and 30 percent to the research institute.

So, you could potentially earn a lot of money. Are you already rich?

I'm almost rich. The DICP has already commercialized many important technologies in China, including the well-known Dalian methanol-to-olefins process. As a result, the DICP has received a lot of money from industry and so its salaries are very high.

How has China managed to become a leading player in the science world in the last fifty years?

It's been over forty years since China opened its doors to the rest of the world. Up until now, the country has made huge progress, with fast economic growth. We have stable funding from the National Science Foundation of China to support basic research, and the Chinese Academy of Science is currently trying to attract young, energetic talented Chinese back from overseas to develop their scientific careers in China. We're lucky that academia and industry enjoy a close relationship in China, particularly at the DICP.

How important is a scientist's ranking in China? I believe you have 150 patents and over 400 peer-reviewed papers to your name.

Rankings are difficult to determine; some scientists are ranked according to how many papers they publish, while others are considered for how many citations they receive. Our government doesn't encourage such behavior, as it makes scientists more interested in their ranking than in their actual research. Besides, it's just a number; the most important thing is what you've done, what scientific contribution you've made to your country and the world, right? I always say to my colleagues, "You needn't bother telling me about how many papers you've published or patents you've filed. Tell me, instead, what's been your important contribution to society and to our country?"

So, how do you measure success?

If you want to carry out frontier research, then you need to develop something completely new. Being first is what counts. You then apply for patents and commercialize the discovery to produce a new technology for China. It's all about how many new products and how many new technologies you've commercialized. This is our indicator now.

Why is interest in science so strong in China?

You can't find more hardworking scientists in the world than in China. Everybody works hard. Our generation is particularly hardworking because we know how poor China was, before it opened its doors and a bit later when the outside world was so new to us. We need at least thirty years to learn and catch up with the West.

In addition, Chinese families pay more attention to their children's education. Even in school, you work hard. And there is particular emphasis on science. In China, unlike Europe and the United States, you're told that if you study math, physics, or chemistry, you can do anything you want.

Science is the driving force behind innovation and should therefore be the most important thing in our world.

What is your message to the world as vice president of the Chinese Academy of Sciences?

My message is that science needs more international cooperation; science needs to be a global activity. China is trying to work with colleagues from all over the world. In fact, China aims to be the leading player in global science, and I absolutely believe that in the next thirty years, we can achieve that.

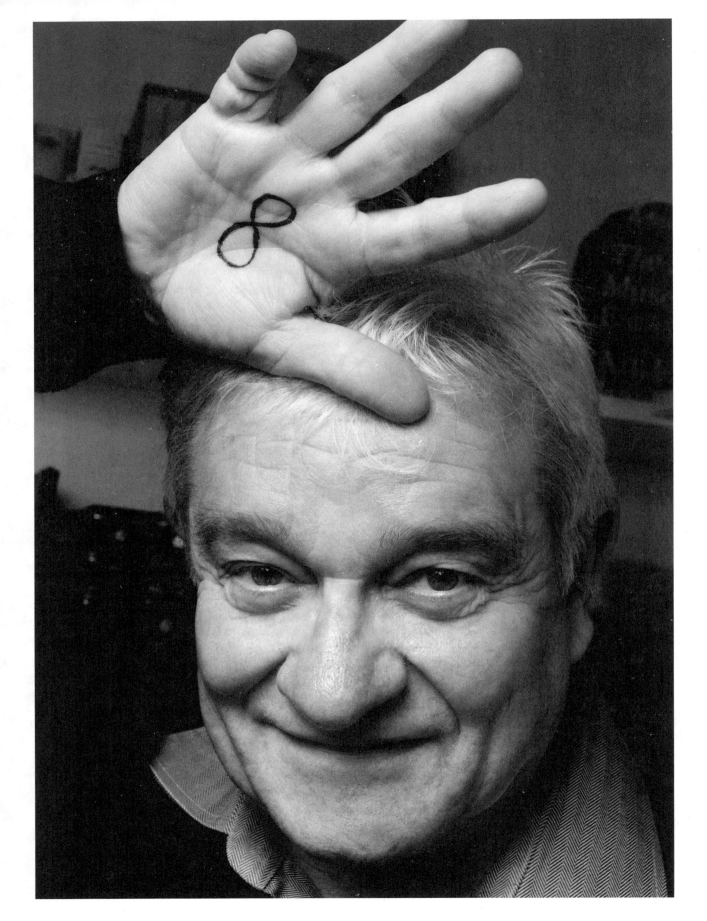

"BY DESTROYING AN IDEA, YOU ACTUALLY MAKE PROGRESS."

Paul Nurse | Genetics and Cell Biology

Director of the Francis Crick Institute, London
Nobel Prize for Medicine 2001
Great Britain

Dr. Nurse, you're known for having wide interests. For example, you've compared doing science to reading a good poem. What did you mean by that exactly?
Well, science is quite tough, and doing research is even tougher because you're at the cutting edge of knowledge—which means you often fail, and you're often walking in a fog. But sometimes the fog clears, and it's that clarity that I liken to a poem. When you read some poetry, suddenly you have a different view of the world—you understand something better—and science can be like that.

Surely it's not every scientist who reads poetry?

Well, I can only speak for myself. I do have wide interests, and I've done many other things. I'm a pilot, for example; I fly airplanes and gliders. And I like walking in the mountains. I'm interested in theater and museums, and I'm a trustee at the British Museum. Actually, I wouldn't mind having a bit more time for those other interests. My family says I work too hard, and that's probably true. This morning I was up at five, doing a couple of hours' work before breakfast, for example. But it's enjoyable work.

You once said that as soon as you entered university, you knew you wanted to become a scientist. How did you know?

Yes, it's true. When I went to university, I was 18 years old and suddenly the whole world opened up in front of me. I was being exposed to all sorts of things I had never thought about before, and I found this enormously stimulating. I mean, it wasn't just the sciences—it was also the humanities, the arts, culture, the social sciences. And it's probably that diversity that set me up for the rest of my life. I felt it was a privilege to be where I could learn about the world. And indeed, it's been a privilege all my life that people have hired me to satisfy my curiosity. I mean, it's almost unbelievable to me that I could be paid to do just exactly what I want to do!

Tell me about your background. What kind of family did you grow up in?

I came from a working-class, blue-collar family. So, it wasn't an academic background. There was nothing problematic about it, but I hadn't been exposed to books, to ideas, to culture.

Was your family religious?

Yes, I was brought up in a home that was Baptist. I went to Sunday school, and I was a committed believer. I thought I might even become a preacher! But I got exposed to more of the world at school, and when I learned about evolution, the minister was not happy about the things I was asking him. I remember saying, "Can we not think of Genesis as a metaphor?" He just couldn't cope with that.

That made me begin to doubt, and gradually I moved into my present position as a skeptical agnostic. An atheist is somebody who knows there is no God and no supernatural being. A skeptical agnostic is somebody who thinks it's very unlikely, but because it's supernatural and therefore beyond our understanding, how can you be sure?

You didn't go directly from high school to university, is that right?

Yes, that's true. I failed an entrance examination in French six times. Not once, not twice, but six times. I was trying desperately hard, and I couldn't pass! This was the late 1960s, and at the time that meant I could not get into any university in the UK.

That must have been quite a blow.

It was difficult, but in hindsight it was actually useful. I worked as a technician in the local Guinness Brewery, and that was important for me because I had a year of experience working in laboratories, which only strengthened my wish to work in that kind of environment.

And that break was critical for me for another reason. I had failed early in my life, so I was no longer frightened of failure. I have many excellent graduate students who experience setbacks in their work, and it's quite difficult for them psychologically. Because I had failed so early, accepting failure was no problem for me.

Speaking of failure, I heard that your student experiment with fish eggs didn't go very well. Can you talk about that?

Yes, yes! My project was to measure the respiration in dividing fish eggs. We put them in a bath that had an instrument to keep the temperature constant. Those fish eggs were dividing from one to two to four. I was measuring their breathing, and I concluded that they were changing their respiration rate. But it wasn't true! The change in rate had nothing to do with the dividing eggs, and it had everything to do with the thermostat on the water bath turning itself on and off. I found this out only at the very end of the project.

When you have a setback like that, does it cause you to have doubts about your calling?

Well, at the time I did think, *Maybe I'm no good at this. Maybe it's not for me.* And at one point, I thought I should do philosophy or history of science. In fact, I contacted the London School of Economics. Karl Popper was there, a very important philosopher of science. So, I read a couple of Popper's books, and these helped me plan my experiments better. Popper said to take observations, make a clear hypothesis, and then test the hypothesis to try and destroy it. In other words, by destroying an idea, you actually make progress.

So, reading Karl Popper's books helped persuade you to stick with science?

Yes, it changed my mind that maybe I wasn't a failure! But also, I was working in a small group at that time, and I was having limited conversations with others. Doing science is difficult, and you need help. Having a good collegiate culture in a laboratory is important to get people through those difficult patches.

Science is a high calling. It isn't just about producing papers for big, fancy journals. It is in fact the pursuit of truth, and sometimes that truth will be difficult to accept. Sometimes your hypotheses and ideas are dashed, but you must always remember it's the pursuit of truth. It's a high calling, and it should be seen as such.

I would imagine there's a lot of rivalry between scientists?

Yes, that's an interesting point. Science is both collaborative and individualistic. Of course, no person is an island, and even if you're a novelist working alone, you're influenced by the culture around you. Isaac Newton said, "If I have seen further, it is by standing on the shoulders of giants." He recognized that he was part of a community—though he was an arrogant, unpleasant person, it turns out!

In any case, if I'm doing a project that I know others are also doing, and all that matters is the competition to see who gets there first, I ask myself, *Why on earth am I doing this?* I'd rather do something where I and my colleagues have time to think and to experiment.

And once you began working as a scientist, you moved around quite a lot, correct?

Yes, I had to move to different places to stay employed. I worked for a while in Edinburgh and at the University of Sussex. Changing situations exposes you to different things. When you move, you become a baby again, with everything around you new. I sometimes think of Trotsky, who said you should break things up and reassemble them and look at them afresh.

Changing jobs frequently must have carried a lot of uncertainty, though?

Not uncertainty, but it's not knowing where the next year's salary might come from. In academia today, young people often worry about salary. But for some reason, I didn't worry about that. It may be that I'm a complete optimist, and it may be because I was so interested in what I wanted to do that I was prepared to tolerate the insecurity that went along with it.

What was it like to set up your first lab?

When I was a postdoctoral worker, I spent time in two laboratories, in Bern and in Edinburgh, and they both gave me a lot of freedom. Even though I was in somebody else's lab, I had a lot of control over what I did. So, by the time I was about 30 and setting up my own lab at the University of Sussex in Brighton, I was already used to running things. What I wasn't used to was establishing the infrastructure and raising money, so I had to learn that.

And what were you working on at that time?

What I was working on isn't so different from the problem I'm still interested in. We're all made of cells—billions and billions of cells; that's the basic unit of life. And growth and reproduction come from the division of one cell into two cells. I've devoted most of my life to determining what controls the reproduction of the cell and its subsequent division.

In fact, when you were awarded the Nobel Prize, it was for your discovery of protein molecules that control the division of cells. I imagine this was your greatest finding, no?

It was indeed the main discovery of my life, though in fact I'm still working on this topic because there remain things we need to know. But yes, what we discovered—my colleagues and myself, and also Lee Hartwell and Tim Hunt—was that there's a complex of molecules that make an enzyme, and this enzyme adds phosphate to other proteins. This can act as an important switch for different events in the cell.

Can you say more about the consequences of that discovery?

It meant that we now understood the basic process that controls growth and reproduction in the cells—in other words, the process that underpins growth and reproduction. Not just in humans but also in all every animal and plant you can see around you. And this has many applications, including those for cancer research.

You've also been knighted by the Queen. That must have been quite an experience?

It came as a shock, actually! In fact, the letter asking whether I would accept the knighthood was sent to the wrong address, so I never received it. Then one day, I had a call from 10 Downing Street, asking if it was my intention to refuse the honor? And I said, "I'm sorry, but I have no idea what honor you're talking about!"

It was about 10 o'clock on a Friday morning, and I responded that I needed to think about it over the weekend, but they said, "You have until 4 o'clock this afternoon." All right, so I phoned my family to talk it over, and they said of course you should accept it. And so, I did. Then they sent the invitation to the Palace also to the wrong address, so I nearly didn't get to the ceremony, either. I also received the Ordre national de la Légion d'honneur from France, and you may remember I failed the French O-level six times. I had to give a little speech in French, which was terrible, of course!

Receiving these awards must have been quite satisfying?

Well, yes. I don't think I'm vain, to be honest, but of course one is pleased to be knighted. And I've won quite a number of awards. The main satisfaction, however, has been in helping to understand how the division of cells is controlled. That's really what the honor is for me.

What would you like your message to the world to be?

I would like the world to be a more rational and forgiving and tolerant place, and I think science can contribute to that. Science is essentially a rational activity. We should learn from the values of the Enlightenment, and we should apply them, including a tolerance of other people's thinking and thoughts. At the Francis Crick Institute, 70 percent of our scientists are from other countries, and any change to

that means we're not utilizing the intellectual capital in the world. We need an openness to the world. Brexit, unfortunately, just represents putting up barriers, and those barriers will break down the values of science.

The community of scientists can be complacent. We are a bit of an odd lot, you know? Sometimes we're a little remote, sometimes we behave in eccentric ways. Scientists think, *Oh, I'm in my laboratory, I'm doing my investigation, just leave me alone*, but that's not good enough. We have to deal with the public, talk to them, and confront the issues if we're going to keep the scientific endeavor working.

And with the advent of CRISPR and other methods, there are ethical questions that need to be addressed, yes?

Absolutely. Now with medicine, we can do things we couldn't conceive of thirty or forty years ago. What right have we to manipulate the genome? There's still huge opposition to this, particularly in parts of continental Europe, but we are producing ways of changing the world through science that need to be fully discussed, to see whether we should apply them or not. We have to do it early on, and we have to be, in some respects, humble about it.

And that does not apply just to scientists: it's a social science problem, it's a religious problem sometimes. Different cultures and different societies may come to different answers to this question. But the only way forward is to be open, try to apply rational argument, and consider the evidence in order to come to satisfactory solutions for all people.

In 2003, you were president of Rockefeller University in New York, and you discovered something about your family history that changed your world completely. What was that?

Since I was living in the United States, I applied for a green card. The application was rejected because there was an issue with my birth certificate. When I got hold of a more complete birth certificate, I discovered that my mother was not my mother—she was my grandmother, and my real mother was the woman I knew as my sister.

Now, I hadn't known any of this. What happened was that my mother got pregnant at age 17, and she wasn't married. She was sent away to live with her aunt in Norwich, England, where she gave birth to me. My grandmother then pretended she was the mother of the child. The whole thing was kept secret. This wasn't so unusual at the time—the early 1950s—because illegitimacy was a big shame. It's nearly impossible to imagine today, and it was a bit of a shock.

Only a bit?

No, it was a big shock. I mean, of course, that my parents were somewhat elderly, and I would say, "It's like being brought up by my grandparents." Little did I know I was actually being brought up by my grandparents.

How did you fit into your family otherwise?

Well, I went to university, and nobody had ever been to university. There were differences between us, and I couldn't quite explain them. I'm a geneticist, remember, and what's amusing is that my own genetics was completely unknown to me. Anyway, my family did their best. My grandparents took me into their care when they were in their forties and never complained about it. My mother was devastated, I'm sure, having to give up her child and leave home. She then married when I was two and a half. She lived nearby and used to come and visit every week. She died before I found this out, as had my grandparents and nearly everybody in the family. It didn't disturb me very much at the time.

No?

My life was okay. It was normal. I was loved by my parents—my grandparents. Now, of course, with DNA, it could be that I'll discover who my father is.

Are you curious?

I am, maybe because I'm a geneticist. I'm curious about where half my genes came from. I'm not obsessed with it, but I'm curious.

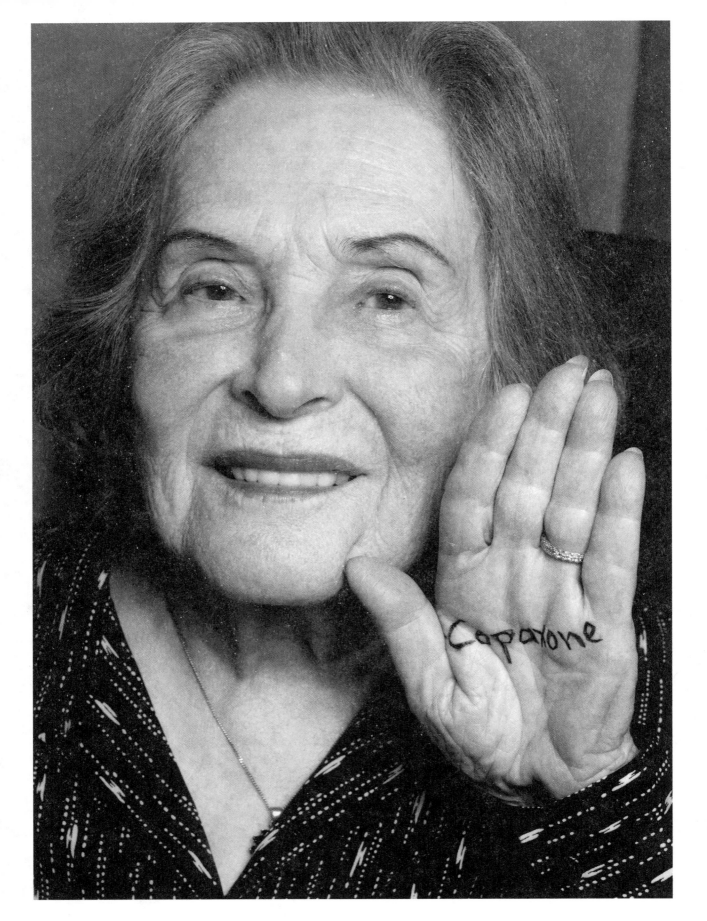

"I HAVE ALWAYS KNOWN I'M THE BOSS, THIS IS MY JOB, AND I AM DOING IT."

Ruth Arnon | Immunology

Professor of Immunology at the Weizmann Institute of Science, Rehovot
Robert Koch Medal 1979
Israel

Professor Arnon, in kindergarten you were already one of the best students. What motivated you?
I was curious, asking questions all the time, and I had a good memory. My older siblings saw that I was ready to absorb things and they enjoyed teaching me. So, I already knew arithmetic and how to read and write when I entered school. In fact, I was so good that I was able to jump straight to the second grade. Quite soon, I also discovered my love for science by reading the book *Microbe Hunters* by Paul de Kruit, which described the fascinating lives of great

scientists and their discoveries. I was particularly thrilled by Marie Curie, who was so curious that she went to the lab in the middle of the night to check on her experiments. I didn't even know yet that this was called research, but it was definitely what I wanted to do! When I was 15 years old, I decided to study the life sciences, biochemistry, medicine, but I also realized I was not interested in becoming a doctor, who only treats patients.

Did your parents influence your decision to go into science?

Both my parents always taught me that education is important, as it gives additional meaning to life. My mother was a teacher, and she was constantly pushing for education. I think she was also pushing my father to study electrical engineering, by telling him: "Don't complain; just follow your wishes and your dreams." My father was an unbelievable person and was important in my life, as he was knowledgeable about a lot of things, not just things of his profession. I think his example had an indirect effect on my life.

What kind of research do you do?

As an immunologist, I study the immune system. Our immune system is geared to recognize foreign materials and to eliminate them. Thus, it fights the diseases induced by viruses or bacteria. Normally, our immune system also recognizes our own body components and does not react against them. But if something breaks down in this mechanism of self-recognition, it can result in an autoimmune disease.

My team started researching multiple sclerosis (MS). We synthesized a polymer that is similar to the protein that induces MS, which would serve as a research tool to study the mechanism of the disease on animal models. What happened was that our polymer did not induce the disease; rather, it inhibited it. And this led to the development of a drug against multiple sclerosis, called Copaxone.

So, it was a discovery by accident?

Absolutely. We had treated guinea pigs with our synthetic polymer, and in the control group eight out of ten animals died, whereas in the treated group only two animals were sick and the others were completely cured. It was a revelation when we discovered that our synthesized material could prevent and even inhibit the disease. It was a fantastic feeling!

And then we had to continue, because you have to look for the mechanism behind the results. As a scientist, when you have a phenomenon, you are always interested: Why did this happen? So, it never ends. And tracking the mechanism is even more interesting than the discovery.

How long did the whole process take?

From the initial basic research to the FDA approval of the drug took twenty-nine years. We worked on the basic research, understanding the animal model of the disease, for approximately nine years. We tested it with different species, including primates. And then we spent about seven or eight years collaborating with clinicians who were doing the clinical trials with patients. It was only after we produced successful results in the clinical trials that a pharmaceutical company became interested and started development of the drug. It took another nine years until they got the approval of the FDA.

Can you describe how your research has made a contribution to society?

The development of Copaxone was a significant contribution. When we started our research, there was no drug at all for MS and the situation that patients faced was terrible. One year before Copaxone was approved by the FDA, the Interferon Beta drug came on the market, so unfortunately we were only second on the scene. But there had remained a great demand for a better drug against multiple sclerosis. Hundreds of thousands of patients are using our drug to this day, and they all have significantly less exacerbation. So, MS patients today can live an almost normal life. It is the highest satisfaction for me when patients tell me "Copaxone changed my life."

Wasn't it a big disappointment to be only second?

Partly. But that's life. There was some competition, as we knew about development of the other drug,

and so we were a bit disappointed when they got the approval some months before us. This was already at a stage when the drug was in the hands of the company and we didn't have any influence anymore. It took the company nine years to do the scaling up, to fulfill all the requirements of the regulatory authorities, and they had to do another phase 3 clinical trial. But it didn't really matter. Some patients are helped by our drug, and some are helped by the other drug. Both drugs are still selling today.

You are one of the pioneering scientist women in Israel. How was it for you as a woman in this field?

It took more energy because I also had a family—a husband and two children. As a woman, you have to have children while still young, but you also can't postpone your career until you have raised your kids. You have to do both at the same time. So, when my children were small, my life consisted of very, very long days. I was getting up at 4 or 5 o'clock every morning to do all my creative work of thinking and planning. This was my time of peace and quiet, until the kids got up at 7 o'clock.

We always lived close to work, so I could go home and have lunch with them. I stopped working at 4 o'clock in the afternoon, and often I went back to the lab at night, when the kids were asleep. This was my normal routine; I didn't see it as exceptional. My husband was very supportive, and when I wanted to study in Melbourne, London, or Paris, he took a leave of absence from his work to come with me on what we called our "mini-sabbaticals" for three or four months. And we both loved it. We always supported each other, and I think this is very important.

Some women prefer to work in industry because of the more regular working hours. Did you ever consider making that change?

Never. I always wanted to decide on my own what I research. And in industry, someone sets a target and you have to push in that direction. In basic research, you follow your curiosity and sometimes it will lead to something that can be applied, sometimes it will not.

So, how was your work-life balance during those years?

I love music, opera, and theatre, and I feel enjoying life is important, as well. But science and family always came first, and I invested in both the best I could. With six grandchildren and one great-grandchild, I have a full family life. I have always worked hard, but I hope I found the right balance among work, my children, and moments of pleasure with my family. Many years ago, we took a whole month off and went to the national parks of Africa. The children still remember this trip very fondly.

Why should young people study science?

They should always follow their instincts and their passions, and only study science if they love it. Because you will only do your best doing what you love to do. You can feel it in your bones if something is right for you. What fascinates me about science is that you can choose your own path. Of course, there is always the risk of being unsuccessful. Because sometimes you work on a project, and it just doesn't give any results.

I really don't say that lightly, but you also need to be lucky. I know many scientists who work very hard and simply have not been as lucky as my colleagues and I were. Sometimes you reach a dead end, and you have to make a switch in your mind and say, *Well, I thought this would be the way, but it is not.*

Have you experienced ups and downs in your research?

I always had doubts. That is why I constantly worked on more than one project at the same time, hoping that when one was down, there would be another that was up. So, I can still enjoy my work.

At the moment, I am also working on the development of a universal vaccine for influenza, which is now in a phase 3 clinical trial. Soon we will know the results. It may be a complete failure. It worked beautifully in animals. It worked in phase 1 and in phase 2. But there are many drugs that have failed totally in phase 3. I hope that won't be the case. It does not help if I am nervous all the time. So, I try to look on the bright side.

You have held a lot of high positions, both at the Weizmann Institute and on several scientific bodies. Did you find that women are treated differently?

I have worked with men; I have worked with women; I've had men above me and men under me; and I have never seen a problem in this. A scientist is a scientist, and the gender doesn't matter to me. I hope it doesn't matter to others, either. And even after my children were grown, I found being a woman changed nothing. I could evolve, and it was up to only me to decide what I wanted to do with my time. I never felt any discrimination, either as head of the department or as dean, or as vice president, or as president of the Academy. I have always known I am the boss, this is my job, and I am doing it.

But what can be done to get more women into science?

We have to attract girls to physics and to mathematics and chemistry, so that they will not be afraid of those subjects. And we have to improve the level of science teaching in high school. for both boys and girls. This is a development I strongly recommend and support, as science is our future.

Today, the wealth of a country is defined by its knowhow and its technology, rather than by its natural resources. So, it is important to devote more effort to educating and attracting young people to become scientists and engineers.

What characteristics does a good scientist need?

You have to be persistent and you need a strong will, in order to stick with your research and not stop working on it, even if you face failure. Not everything will happen according to what you have planned. If the results are more or less what you expected them to be, wonderful. If not, you have to be flexible and maybe even change the initial concept.

As for our discovery of Copaxone, in the beginning, for a research tool, we were synthesizing a material to induce the disease. But it didn't work; it inhibited the disease. So we switched and took a new direction. And if the experiment then succeeds in the way I thought it would succeed, this gives me the feeling of absolute satisfaction.

How was it for you to work with animals?

I didn't like the experiments, but I knew that without these experiments you cannot get anywhere. Many organizations are against doing experiments on animals. That is not only nonsense, it is also dangerous. Experiments with animals are absolutely essential if we want to develop new drugs to improve human health. Only when we get good results on animals can we try something to see if it also works on people. You can't start with experiments on people. But of course, you have to be careful not to be cruel to the animals.

As a scientist, you work in a group. Do you like this arrangement?

I always worked in a team. In the development of Copaxone, the team was Professor Michael Sela, Dr. Dvora Teitelbaum, and me. Especially in biology, working in a team is almost always necessary. You cannot be a lone wolf, because there is a lot of experimental work that has to be done simultaneously. And everyone plays his or her part so that together you solve the whole puzzle. You sit, you think, and you plan the experiment together.

Have you changed over the course of your scientific career?

I am still hungry, and I enjoy it. Maybe now I don't need it so much any longer, and I also do it for fun, as an added bonus. I was the president of the Israel Academy of Sciences for five years. And at that time, I spent three days a week in Jerusalem and only two days here in the lab. But when I retired from the Academy, I got the urge to do research again. So, when I get up in the morning, I still feel the joy of, *How wonderful; I am going to my lab!* And there is nothing more satisfying than planning another experiment. I will keep on doing that as long as I can.

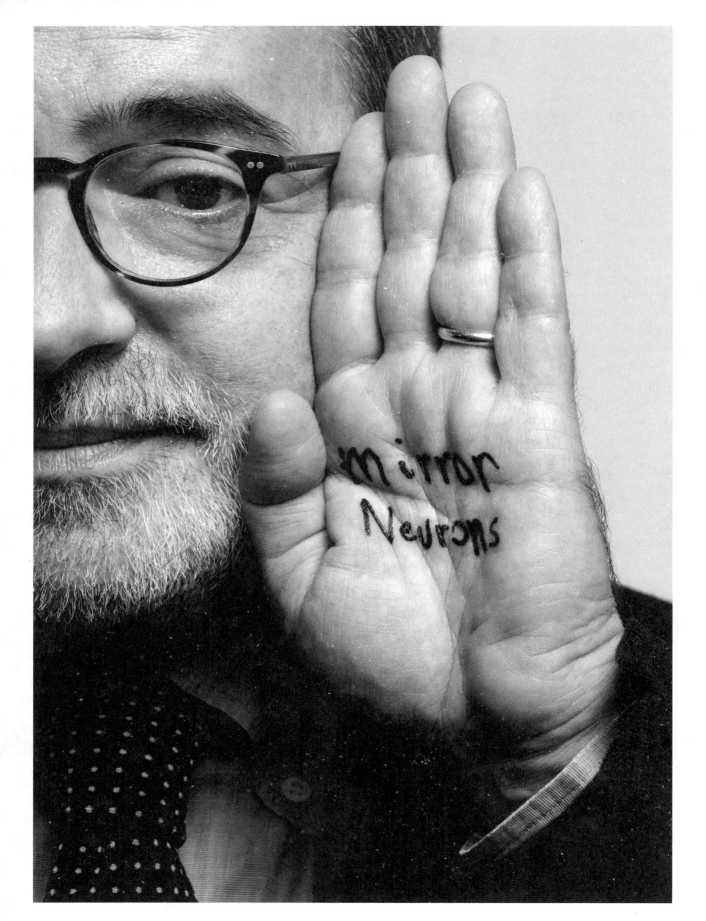

"YOU MUSTN'T BE AFRAID TO CROSS BOUNDARIES."

Vittorio Gallese | Neuroscience

Professor of Psychobiology at the University of Parma
Einstein Visiting Fellow since 2016
Italy

Professor Gallese, why should young people study science?
Because it is the best thing they can do. It is the most entertaining, inspiring, exciting work—excluding art for a moment. Every day is different, you don't know what will happen when you turn the corner. It is like hiking in the mountains instead of walking at the beach. You are challenging the unknown. Choose the topic that interests you the most. And put a lot of effort in it. In science, everything has to be conquered with a lot of work and effort, and there are

no set working hours. It's a mind attitude. I am flabbergasted by the dedication and enthusiasm of the people I am working with.

In 1991, you and Giacomo Rizzolatti, together with Leonardo Fogassi, Luciano Fadiga, and Giuseppe di Pellegrino, discovered the mirror neurons. Could you explain this finding?

We were already looking for visual properties in motor neurons. For that, we were recording "canonical neurons," which have a double property—that is, they fire, as we say, to explain that they discharge every time the macaque grasps an object. But we found they also become active when the macaque is merely looking at the object.

To do a clinical test on the neurons, we picked up objects and showed them to the macaque. What we expected to see was that nothing was happening during our grasping phase but to observe a discharge of the neurons when we looked at the object in our hands. To our big surprise, we discovered that some of the neurons were already firing when we grasped the object, well earlier. That is, they started firing when the macaque was simply looking at the object.

This was an exciting moment, but we were pretty quick to temper our enthusiasm and determine whether we were mistaken. But after a couple of months, it became pretty obvious that we had made a big discovery. And it was one of the most exciting times in my scientific career. The more we were able to eliminate alternative explanations, the more we became convinced that we had uncovered a sort of a neuro go-between operating between the agent and the observer. Of course, there are always doubts. Science is a constant enterprise of verification, doubts, and confirmation; it's also marked by excitement and frustration. So, there was no such thing as the one single eureka moment.

Does this discovery mean that my thoughts are mirrored in your thoughts?

Well, the discovery was made in the macaque monkey brain, so we were not dealing with thoughts or ideas—we were dealing with overt behavior. But that was just the tip of the iceberg, as we developed further research. In 1999, with the American philosopher Alvin Goldman, we proposed the hypothesis that this mirroring mechanism could be applied not just to action but also to emotions and sensations.

Our hypothesis was that the part of the brain that enables me to experience a given sensation, like touch or pain, is also active when I see that sensation being experienced by someone else. Empirical research that was guided by this hypothesis proved it to be correct. So, the notion of empathy came into being.

So, if we see someone cry, we feel compassion?

Empathy is one of the basic elements of our humanity; it enables us to directly grasp what the other person feels. But that doesn't necessarily mean we have compassion. Even a sadist can be empathic, in that he recognizes the pain in others, but he feels no sympathy. Unfortunately, often there is no clear distinction made between empathy and sympathy.

For example, I once read in a newspaper that a man jumped down onto the rails of a subway line to save a girl who was a total stranger to him. And the newspaper report said that now we know why he did this—because we have mirror neurons! But that is rubbish. Mirror neurons merely form the ability to understand what is going on in another person, they do not cause us to help that person. But this "experimental" form of understanding might enable us to decide to act compassionately.

Did you experience rivalry or jealousy in your field after your discovery?

Well, of course, when you discover something that changes the complex scientific landscape, it has consequences, such as confrontations with other scientists who are sometimes even harsh, or articles whose main goal is to demonstrate that our interpretation of the data wasn't correct. But that is part of the business. I would call it healthy scientific dialectics. Science moves forward because we confront different points of view, and a new discovery brings

with it discussions, contrapositions, rivalries, or personal issues.

Would you say there is more professional jealousy in the world of science than in other fields of study?

It totally depends on the degree of one's personal narcissism. In my experience as a student, I found that the professors who were more pompous were also those who usually had less to give. Narcissism comes along naturally in the world of science, because a researcher has to make people aware why that work is important. And for that kind of promotion, you need a certain level of extroversion. So, there is definitely a public dimension to science that may boost one's intrinsic narcissistic feelings.

In the world of science, one's reputation is currency. What is your *h*-index, by the way?

On Google Scholar it is 94, on Scopus it is 70. But I don't see a direct relationship between the *h*-index and the relevance of one's discovery. Much depends on the journal where you publish or on the institution from which you submit it. So, if you submit the paper from Harvard, people will view you differently than if you submit it from Chemnitz or Parma. I recognize that we should rate what people have done, mainly because we all live on public money. But science has become a sort of contest, about who has the longest h-index. On my team, there are only women, and I find this inspiring, as it helps dilute the alpha male fantasy about the *h*-index.

What mindset should a scientist have?

Enthusiasm, great curiosity, and the desire to work a lot. You mustn't be afraid to cross boundaries. Never take anything for granted. These are the key elements that I encourage in my students. And as a group leader, it is necessary that I create the best possible working conditions, under which all these qualities can freely grow. They should also be able to take a risk, but this is getting more and more difficult. Nowadays you have to promise to make pigs fly to get funding. There is a growing pressure to be immediately successful and to also guarantee a prompt technological application of your results. But

if you take a risk, the stakes are high; you might be unsuccessful and spend one or two years on a project that doesn't produce the expected result. This can be bad for your career.

How do you bear up under this pressure?

I smoke a lot. That is my way to cope with anxiety. In the background, there is a constant uncertainty as to whether we will receive sufficient funding to continue our work or whether we will be able to publish our results in the really important scientific journals. And there is always the risk that someone will refute our discovery just a few years later, saying "Mirror neurons, that's bullshit." You must live with it. There is nothing you can do about that.

How good is your work-life balance?

I am probably too extreme. Like most of the team members at the time of our discovery of mirror neurons, I wasn't paid by the university. Therefore, I had to work as a doctor on weekends and at night in prison just to earn a living. I worked around the clock for five years. I really wanted it. Only in 1992, after our discovery of the mirror neurons, did we received subsidies, and then I got a fellowship to do research in Tokyo for two years. That helped me a lot. I could prove myself in this completely alien work environment, and I was finally convinced that I was a good neuroscientist. I had never been totally sure before.

In Parma, it was more the stick than the carrot that ruled. So, you were always pushed to show how smart you were, starting from the assumption that people weren't necessarily smart. That was a terrible pedagogical approach.

How else has this important discovery changed your life?

To be honest, the major event that changed my life was becoming a father. If I'd known what incredible happiness it is to be a father, I wouldn't have started at the age of 45, and I would have three or four children instead of two. Apparently, I made a statement my wife keeps reminding me of: "Children are not compatible with our work." That was really silly of

me, but as a young man I was probably convinced of that belief. Sometimes I regret this.

But without your constant hard work, would you have been able to make this discovery?

I don't think so. We scientists tend to be obsessed with our work. Even when we are not working, almost everything else brings up an idea that connects to our experiments. We always wear the lab coat, so to speak. And after the discovery of mirror neurons, I expanded my range to social dimensional cognition. That was a major shift in my career and I had to delve deeper into philosophy, psychopathology, aesthetics, and later film theory. And that put a lot of extra work time on my daily schedule.

Normally I go to sleep at 1 a.m. and I wake up at 6:30 a.m. So, I basically sleep five hours. When everything is quiet at home late at night, I can spend time listening to music or reading something related to work while listening to music. Or, when the kids are away for a couple of hours, I will sit on the couch and watch an old *La Traviata* from La Scala, which makes we weep. It is beautiful to be moved by music and art. If you are emotional, you are richer. Actually, I am scared by people who are unemotional.

Did you love music as a child?

My parents were good at stimulating my interest in art, and my father was fond of music, so he boosted my interest in music, as well as art. So, the first time I attended a symphonic concert I was 7 or 8 years old. The overture of *Die Meistersinger* by Richard Wagner was an illumination for me. Both my parents were very loving, and we had a strong physical relationship. My mother in particular kissed me a lot and always told me how much she loved me. Today, I do the same with my kids.

I think physical contact is immensely important. For me, it was crucial as a child to experience so much closeness and love. And they never pushed me to do anything. My mother would have preferred that I become a rich psychiatrist rather than a poor neuroscientist; she told me many times. But besides that, they were always supportive. Until the age of 9, I was a very happy child. Then my mother became severely depressed and went through hell. That was pretty hard for everyone in the family.

Do you think that at some point all emotions can be scientifically explained?

In my opinion, the idea that neuroscience alone can do this is completely wrong. I think cognitive neuroscience is necessary, but it's not enough to learn more about who we are. And I embrace a model of science that has no truth with a capital T, only temporary truths that can be falsified with new evidence and new hypotheses. Science mustn't become an unquestioned religion; our only dogma has to be "Stick to the facts!"

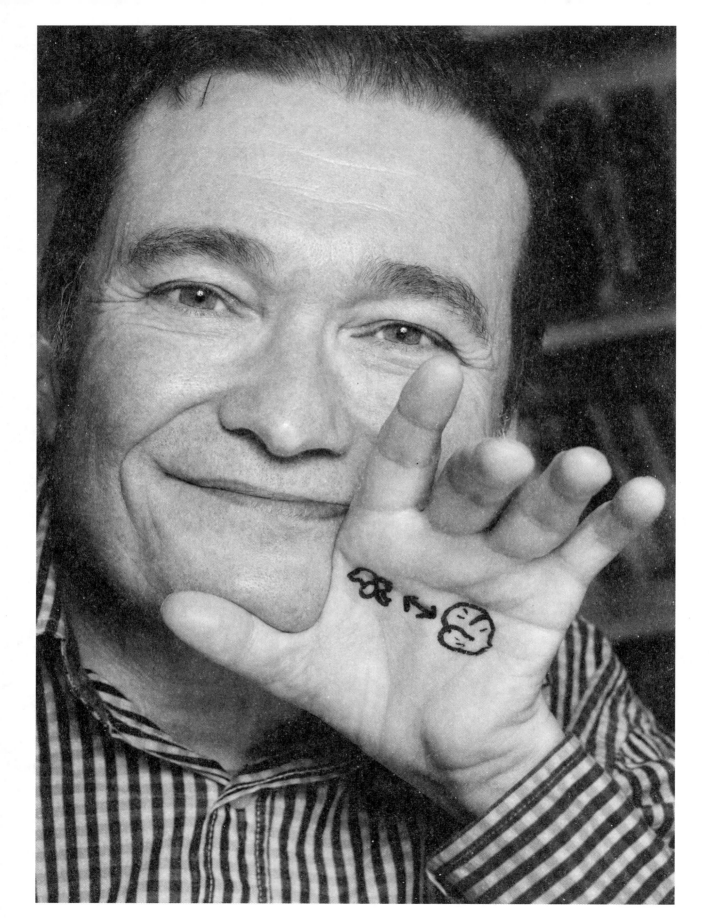

"WITH A LITTLE LUCK, I REACH A RAPTUROUS STATE OF MIND."

Onur Güntürkün | Psychology

Professor of Biopsychology at the Ruhr University Bochum
Gottfried Wilhelm Leibniz Prize 2013
Germany

Professor Güntürkün, you research the neural basis of cognition. What's your ideal state of mind and how do you reach it?
I can't summon it at the touch of a button, but it's often there. It's wonderful when the dark clouds lift and I can see clearly, and I understand. I zoom in on the small field of analysis and block out everything else. With a little luck, I reach a rapturous state of mind. This can go on for many, many hours, until I'm tired. Sometimes I search for a solution for days and weeks on end, then it ambushes me in the middle of

a conversation. Or I wake up the next morning and it's there. It's hard to predict.

You have conducted research on humans, dolphins, and penguins, but you now mainly work with pigeons. What are you researching?

I'm researching how thoughts are formed in the brain. For a long time, scientists assumed that only brains similar to our own were capable of complex thinking. That is, we assumed that the shape, organization, and wiring of the human or ape brain provided the only conceivable basis for higher intellectual faculties. However, the discoveries of the last two decades show that birds such as crows are capable of the same cognitive performance as chimpanzees. However, crows and all other birds, like pigeons, have brains that are organized radically differently from humans or apes, and are considerably smaller. This proves that idea wrong. Apparently, complex thought processes can also be generated in brains that are smaller and organized in a radically different way.

I'm studying pigeons to understand how thinking occurs in both bird and mammalian brains. My belief is that it doesn't really matter what the exact anatomy of a brain looks like. Far more important are the precise wiring principles of groups of neurons. The brains in which such groups of nerve cells are located may look different, but they still generate the same thought processes. This new scientific perspective will help us realize that many animals we previously thought were living robots instead have complex mental inner lives.

What has been your happiest moment in your research?

For my PhD thesis, I manipulated the hemispheres of pigeon brains, but the data didn't make any sense. When a Belgian colleague returned from a conference in Russia, he told me about an Australian who had discovered differences between the left and right brain hemispheres of chicks. Then the scales fell from my eyes, I reorganized my data according to the left and right brain hemispheres and I then had a crystal-clear picture. I'll never forget that moment.

"I HAVE ACQUIRED MORE SCARS IN THE STRUGGLE FOR SURVIVAL IN ACADEMIC LIFE THAN IN BEING IN A WHEELCHAIR."

You also discovered that women may think like men during menstruation. Why is that?

Human cerebral hemispheres are organized asymmetrically; language is mostly on the left, and spatial orientation is mostly on the right. These brain asymmetries are statistically less pronounced in women, and they can be modified by hormones. This affects cognitive processes. In mental rotation—a spatial reasoning test—men perform significantly better than women. But during menstruation, the female brain asymmetries more closely resemble those of men. During this phase, women perform as well as men on the mental rotation test. So, the differences in brain organization and cognition depend partly on when you test women. That's a fascinating discovery. Now, if you ask me if I fully understood why this is, I'd have to say no, at least not fully.

You were born in Turkey, contracted polio, and came to live with your uncle in Germany. While you were in the hospital, you were isolated from your parents. How did that shape you?

Actually, I should have been severely traumatized by all that. Back then, as a 6-year-old, I was confronted with an environment in which no one spoke a word of Turkish and, of course, I didn't speak a word of German. I have no memory of those first weeks

and months. Extreme childhood trauma can lead to memory loss, and for a long time I assumed the same for me too, until I met the nurse who cared for me and others at the time.

Many of these nurses were not married, so we were their children. They had breakfast with us in the morning and only left in the evening to go back to their dormitory. From what I can reconstruct, it was a pleasant environment from the child's point of view—a kind of family situation. That helps me understand why no psychological scars remain; after being in the hospital for eight months, I spoke only German and my parents could barely communicate with me. But a buried language can be unearthed relatively quickly.

Polio brought you to the brink of death. Do you still remember that?

When I came out of the ventilator—the iron lung—my mother put her ear to my mouth. I spoke as loud as I could, but only a whisper came out. The doctors thought I would die soon and probably asked my parents if they should shorten my suffering. I didn't find out about that until much later. My mother said no, and that was the end of the matter. Since then, I always say "Never give up on anyone!"

You returned to Turkey in a wheelchair, still a youngster. What was that like?

There are a lot of physical barriers, but puberty is a time when you don't need your parents as much. My mother wasn't overly protective, and I was able to spend whole days without their help because my classmates took turns (in pairs, in alphabetical order) to look after me in class. My teacher at the high school organized it. In fact, you just couldn't be shy. I developed character traits then that are very helpful for me now; I'm almost pathologically optimistic.

How was growing up and dating girls?

That was a difficult time. In Turkey, I went to an all-boys high school, so I didn't meet many girls; to a certain extent, my classmates also had to put up with this deficit—it was a shared suffering. But then at university in Germany, I couldn't socialize well, like going with them to a discotheque. But of course, there are many ways to love. I met my wife at a party when I was 19, years old and we're still in love. Sometime after we got to know each other, she decided we should get married so I wouldn't be deported. At least that was her official reason for starting that conversation. I found this very romantic and immediately accepted.

What further difficulties have you faced as a person with a disability?

I have acquired more scars in the struggle for survival in academic life than in being in a wheelchair. I'm used to life as a wheelchair user; it's part of who I am. The most important thing in science is to be enthusiastic and excited about your work. It's not a

"IT'S NOT A NORMAL PROFESSION; YOU DEPEND ON BEING NOTICED AND GETTING YOUR WORK CITED."

normal profession; you depend on being noticed and getting your work cited. You have a lot of setbacks. Sometimes you produce a result that you've worked years for, that you believe in, that's part of you, and then anonymous colleagues scour it and write a scathing verdict. Then you're left feeling completely exposed, thinking "Good grief!" You just have to deal with these things.

Was the path to an academic life particularly difficult for you?

Yes, of course, because I had fewer available options to get jobs where I was able to work at all. I can't spend three months in a semi-desert, wearing binoculars and working on an exciting topic, making observations about bizarre animals. Nevertheless, I tried to get the best out of it and not make compromises. After all, science is worthwhile only if you work on things you're passionate about.

Did you want to become a scientist when you were a child?

I've never done anything else, but now I do the science more professionally and with more resources. When I was in elementary school, I once found a decomposing sparrow that had probably fallen out of its nest. I dreamed it was an *Archaeopteryx* and became obsessed with dissecting that little corpse. I collected weevils, locked them in old cassette boxes, built mazes, and rewarded the weevils when they

found the exit. I conditioned fish in an aquarium to find out if they saw colors. So that I could afford a microscope, I made a deal with my mother: every time I dried the dishes, I would get ten cents. I'm sure that it meant more, not less, work for her, but my Neckermann student microscope was my greatest treasure.

But science turned into a profession only because of my professor at the time, Juan Delius. I studied psychology because I wanted to research the brain, but in my studies I constantly questioned what one thing had to do with another. It was brainless psychology back then, and I seriously considered quitting. Delius, on the other hand, did exactly the experiments that fascinated me. That's what I wanted to do—nothing else. He saved my academic life by giving me that opportunity.

What are you like as a university teacher?

I try to be like my old high school math teacher in Turkey; if I'm a good professor today, it's thanks to that school. The math teacher was on fire for his students, but he would never have given away even half a point. I thought that was great. I learned how to work properly from him. Every minute spent on the toilet, every minute spent daydreaming—we were supposed to write down the amount and deduct it from our work time at the end. On some high school days, with all the minus minutes, I totaled only eight hours of work, even though I felt like I had been working day and night. Over time, I improved, and my record was fourteen hours and twenty-five minutes of net work time. I don't think I've ever worked that much again in my life.

How do you balance your research with your private life?

It's not easy. I'm fortunate to be married to a woman who likes to go to bed early and get up early. I, on the other hand, am someone who likes to go to bed late and get up late. Our compromise is that we go to bed at my time, which means never before midnight, but wake up at her time, which means quarter past six. As a result, we both sleep too little; for about forty

years, we've been telling ourselves that this has to change. Also, I can work a lot and work fast, and I can make decisions. And I'm lucky that I can completely rely on the people who organize my professorship.

There are few women in science who have made it to the top. What's your experience been like with female scientists?

I have more women than men on the team because they're great scientists. Psychology is a women's subject—almost 80 percent of the students are women. But usually when things get experimental and technical, more men show up. You can see that in my group.

A scientific career is also a high-risk undertaking. On average, men are more willing to take these and similar risks. Moreover, it's difficult to combine a scientific career with having a family, which is the hardest time. Many women may assume it will be difficult to convince a man to be the main caregiver looking after the children and the household for this phase. Perhaps men are less willing to do that. If they have doubts, women may prefer to look after their child for the first few years. But I'm pleased to see that these differences between men and women are getting smaller.

What about your willingness to take risks? Have you ever chosen the wrong path in your research?

Oh, of course. Statistically speaking, a normal experiment is a failed experiment, so experiments for a dissertation have to be carefully planned and designed so there's a fallback position. Most big dreams don't come true. For young people, there's only one reason to become a scientist, and that's curiosity and freedom. Otherwise, who wants to tour the world on mini contracts, pull all-nighters, and have your work end up in the wastepaper basket? You don't earn much, and the competition is tough. And then you find out at some congress that someone else was faster. These are disasters! But you're rewarded with being free to go into the unknown, to discover new things, to find completely new explanations. Thank God *Homo economicus* doesn't exist; otherwise there would be no science.

How do you view your life, overall?

As a severely disabled person, I was forced to reflect on myself and to plan wisely. I was passionate about what I wanted to do, but at the same time I was chronically dissatisfied with my performance, insanely hardworking, and often willing to take bigger risks than perhaps I should. But performance isn't everything; there are also spheres of life where reliability, care, and concern count more. After all, scientists often work together and are friends. I've somehow managed all of that. I look back on my life with great joy.

What's your message to the world?

I believe in the strength of people—that they can build a better future. People can destroy a lot, but they can also create an incredible amount of good. If we look at the last 5,000 years, on average we've built much more than we have destroyed. I hope it stays that way.

"YOU'RE REWARDED WITH BEING FREE TO GO INTO THE UNKNOWN, TO DISCOVER NEW THINGS."

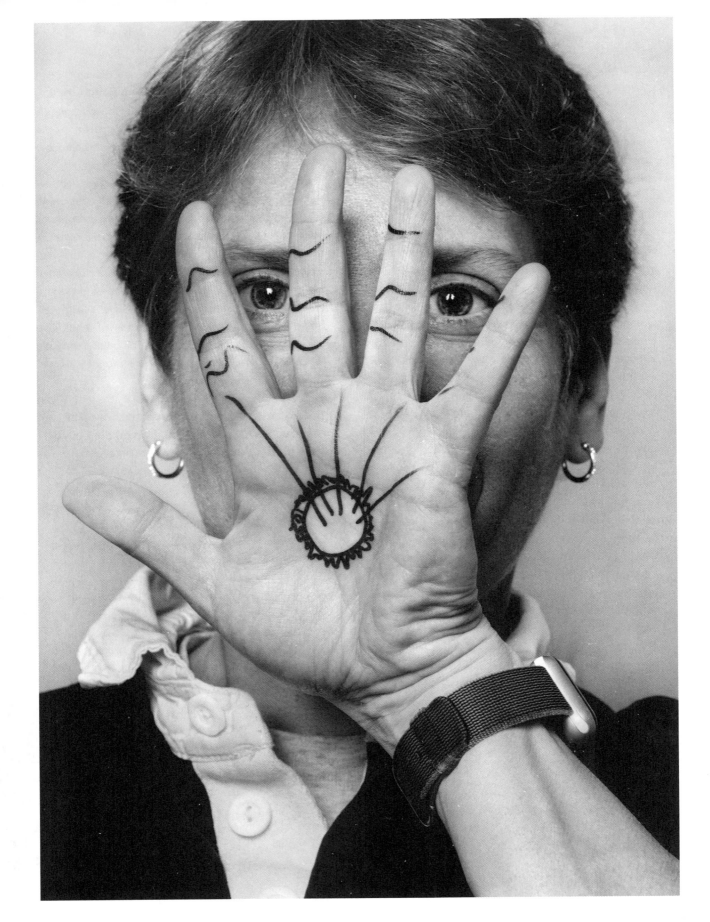

"GOING FROM AN IDEA TO REALIZATION, YOU NEED A TWENTY-YEAR RUNWAY."

Carolyn Bertozzi | Chemistry

Professor of Chemistry at Stanford University, Palo Alto
Lemelson-MIT Prize 2010
United States

Professor Bertozzi, at the age of 32, you were awarded the MacArthur "genius" Award. How was it to be called a genius?
Usually, I get a couple of chuckles from people when they hear about this award. When I was told that I had won the award, I thought they probably were looking for my older sister, as she is a real math genius. So, it took me a while to understand that they meant me.
In addition, you were the first woman and chemist to receive the Lemelson–MIT Prize, for which the winner receives $500,000. How did that feel?

That was a lot of money! This prize is for outstanding technological inventions, so being awarded it made me realize I might also be an inventor. I already had a couple of inventions and patents, and I had just started a company. And at the prize ceremony I had the opportunity to give a lecture at MIT, in Cambridge, where my father had been a professor his whole life. My parents even came to hear my lecture. That was pretty cool!

So, your family has also been involved in science. Was this the reason you went into this field, too?

People think if your parents are scientists you must have grown up doing science in your kitchen. But I wasn't particularly academically minded. Rather, I liked to hang out with my friends. Most of my activities were not concerned with science. Sports was a big one for me—soccer and softball. And music! I played the keyboard and piano in several bands; that's how I made my money in college. There, I learned how to control my nerves in front of an audience and do something during which I might screw up. One band member tempted me with the offer, "Let's all go to L.A. and make it in the music scene." My reaction was, "Oh, my god, I'd have to drop out of college. My parents would kill me." So, I just didn't have the courage to do that. He and his band became quite famous.

In the beginning, you studied biology?

Biology had been one of my favorite subjects in high school. But then, by coincidence, I discovered organic chemistry. I am a visually minded person, so organic chemistry really clicked with me. Every molecule has its quirky idiosyncrasies and its own behavior. Some of them are energetic and others are stable, some are dangerous. I loved it. It was the first time I found a subject that made me think, "There's a party tonight, but I'd rather stay home and study organic chemistry." I wanted to observe it and build a synthetic molecule, one piece at a time. When you have done that—when you have made something that never existed before—that's a rush! But organic chemistry is also tricky. Often, you

"WHEN I TRIED TO FIND A RESEARCH LAB, I HIT THE GLASS CEILING."

don't get what you want. It is more like taming a wild animal.

So, you really wanted to do organic chemistry?

Yes, but when I tried to find a research lab, I hit the glass ceiling. Unfortunately, there were professors who didn't want to educate women. And this was in the mid-1980s, not the Stone Ages! I noticed that every time I tried to get a research lab position, I was told they had no space. A week or two later, one of my male fellow students approached that same professor and got a job. That was the first time I realized there is discrimination in science. You start being aware that your life is different from all the men around you. You suspect discrimination, but you can't articulate it without sounding paranoid. That's what's so insidious about it. It was demoralizing. It made me question whether I had made a good choice, whether I would ever be able to practice organic chemistry. I even lined up for a position in a biochemistry lab.

You thought about dismissing your plans to study organic chemistry?

Absolutely! Then unexpectedly, a young assistant professor of organic chemistry whose class I was taking approached me and said, "If you're interested, I'd love to have you work in my lab." After all that no, no, no! It felt like I had just won the lottery. I had no idea what he did, and I didn't even care. It was great! It was the first time a senior scientist had treated me like a peer. He wasn't weird and awkward with me, like some men were. When I struggled with something, I could just walk into his office and ask for

help. I gained confidence and the belief that I could do challenging things. I felt if that's doing science—getting help and talking to people and figuring stuff out—I can do that.

Did you ever have the feeling you weren't good enough as a scientist?

Never! I never thought that I couldn't run a lab, or I couldn't contribute to science. Very early in my career at Berkeley, as assistant professor, I had some struggles because of a lack of support from a superior colleague. You need some mentorship. A senior person who is unsupportive of a junior person can completely derail that junior's career. To hit that headwind makes you reconsider your career choice. Those were tough years. But now I have more

influence in the department culture because I am involved in hiring and promoting people.

Is there anything particular that women can do to get more recognition in science?

I think we're doing everything we can do. Honestly, I think men have assumed no responsibility for this situation. I haven't seen much action. When women didn't have the right to vote in America, who would give them that right? The only way women got to vote is when men decided, "Yes, women should vote." So, what are men going to do now? If enough men care about the situation and are willing to be accountable, things will change. And this will only happen when the cost is worse than the benefit. And what about Hispanic, black, or Asian people? If science remains as monolithic as it is today, fifty years from now it will be a weird little cult of people who can't communicate with anyone else.

Could you explain your field of research, in simple terms?

I worked for three years in an immunology lab at University of California San Francisco to do a postdoctoral fellowship. That lab was studying sugars, which coat our cells like the sugar coating on M&Ms. Those sugars, called glycans, are important in the immune system, as they allow the immune cells to tell the difference between healthy cells and sick cells. We wanted to understand the "language" in which they communicate. But it was really hard to figure out the chemical structures of those sugars, as the tools we had available were quite primitive. So, when I started my lab at Berkeley as a professor, my goal was to fill this gap and be able to figure out exactly the structures of those sugars. The first ten years we developed new tools and invented some chemistry to do that, because it also turned out that the old chemistries couldn't work. That was one of our inventions for which we were awarded the Lemelson Award.

And how does this discovery contribute to society?

By finding therapeutic opportunities in glycoscience—the science of sugar molecules. We are trying to understand how sugars allow cancers to escape

"YOU THINK YOU WILL MAKE THE DEADLINE AND THEN YOUR KIDS ARE THROWING UP ALL NIGHT."

recognition by the immune system. It took twenty years for us to understand how they are pulling this trick and sending the immune cells away. And it will probably take us another decade to make a medicine to circumvent that. Developing a cancer medicine would be a really wonderful legacy.

We also try to develop tests for diagnosing tuberculosis by using techniques that can be employed in a low-resource setting—where there is no electricity, so you can't store things in a refrigerator. We have some funding from the Bill and Melinda Gates Foundation, and we are field-testing it in South Africa. If that works out, it could be incredibly useful because that's the big unmet need in medical diagnostics.

You have three children with your wife, Monica. How did you fare as a lesbian when you were studying?

For most of U.S. history, gay people were in the closet and many states had laws against homosexual acts, even in private. In 1986, the Supreme Court confirmed this, implying that being homosexual could be equated with being a criminal. People were regularly dismissed from their jobs for being gay. Around this time I moved to San Francisco for graduate school, and I was active in the growing movement for gay rights.

On campus, gay couples wanted to have the same rights as married couples, so the domestic partnership was created. But the University of California did not recognize the gay status for any marriage benefits, like health insurance for your partner or qualifying for married student housing. Married grad students and married postdocs had access to an apartment complex, but the gay couples were not allowed to live there. The married couples would say, "We don't want you in our housing because we have children."

How did this affect you?

It was a source of tension and stress. In November 2000, in California, a ballot initiative called Proposition 22 was passed stating that marriage was between one man and one woman. It was a weird schizophrenic time because, literally, in the same week as I received the MacArthur fellowship, which was a big recognition, there was this legal decision that reinforced the idea that I shouldn't have civil rights: "You're not good enough to get married. You're garbage." So, on one day, I was going to celebrate and the next day I was going to cry.

When were you able to marry Monica?

We got married during the three-month window in California that existed between the state supreme court's decision to overturn a previous amendment and before there was another vote to include a ban on same-sex marriage in the state constitution. In between those two legal decisions, there was a three-month gap when gay people had a legal right to marry in the state of California. We were pregnant at the time with Josh. So, we went to the Oakland City Hall, took a number, and sat in the waiting area for our turn. Asia, my assistant, came to be our witness; she was on her lunch hour. That was it. We got married and I went back to work.

How did you manage you career along with having three children?

I met Monica 2004 in Berkeley. For several years we were a couple with no kids. I had had a hysterectomy and I thought, *That was it*. Monica is five years younger than me, and she had the feeling that's what she wanted. She was adamant about it. Now, I'm really glad. Before we had the kids, I used to spend all weekend and all night at the lab. That was not possible anymore. I used to have my students

over to my house for parties or I would take them for retreats. I would help them on their papers the whole of Saturday. But with the newborn babies, I became unavailable to my group outside of the standard work hours. The students were frustrated and complained to each other. That was hard for me. But soon I became known as a good boss for people with kids, because I understood that people need flexibility in their lives. For example, you think you will make the deadline, and then your kids are throwing up all night.

"I would feel very satisfied if someone looks back and could honestly say: 'She stayed true to herself and true to her values.'"

Monica stayed at home and took care of the kids. So, you were following the stereotype—the wife supporting the career of the partner?

Not exactly. That was what I grew up with; my mom did everything and my dad just worked. It is not like that for us, because when I'm in town, I'm the one who gets the kids' breakfast and takes them to school. After school, I pick them up and fix their dinner. Last night, I was up until 10 p.m., working with our oldest son on his homework. On the weekends, I take them to piano or swimming lessons. Only when I travel does Monica have to do everything. When I'm in town, I do everything plus work. I go to bed at midnight. I get up at 5:00 a.m. The older the kids become, the easier it gets, though. Having kids makes you understand how precious time is. And I also realized that if I don't start projects in my lab now, I will run out of time, since going from an idea to realization, you need a twenty-year runway.

And what legacy will you leave?

Your product in academia is the human capital you produce. It's all the students and postdocs I have trained. And it's what they do with their students and their inventions, their ideas, their books. By the time I retire, I'll have a cohort of easily 300. That is my legacy.

You plant these seeds, they grow, and they produce an ecosystem of these people. I would feel quite satisfied if someone could honestly say: "She stayed true to herself and true to her values, and she pursued her interests and didn't let the voices derail her from the things that she wanted to do." That's my goal.

As Frank Sinatra sings . . .

"I did it my way!" Yes. So, maybe being a lesbian and an outsider made it easier for me. There was no script I had to follow. I wrote my own script, which was liberating.

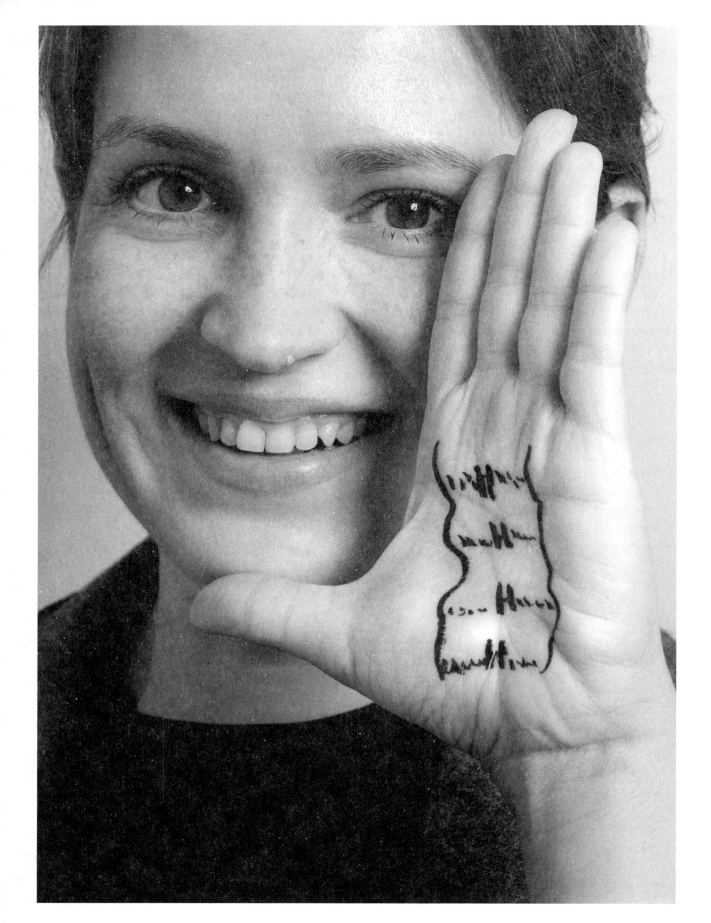

"IT'S HUMAN NATURE TO WANT MORE."

Ulyana Shimanovich | Biochemistry

Assistant Professor of Materials and Surfaces
at the Weizmann Institute of Science, Rehovot
Israel

Professor Shimanovich, what kind of nature should a young person have to want a career in science?
Curious and persistent—if they can take a problem and be persistent and eager to find the answer. Of course, uncertainty is always there, but the job is to find the solutions, the answers. This uncertainty is a driving force. I would define a scientist as a motivated person.

You have two children. How do you manage your work and your family life?
As soon as you have children, you begin to work more efficiently. I'm a single mom. My mother helps

me a lot, and my father also helps take care of the children. The children are small; one daughter is four and the other is one year old.

How would you characterize your style of thinking?

Probably you need to ask the people who know me. But it's complicated, that's for sure. Especially as a woman, because mentally you need to separate your tasks. When you have children, you need a certain order or plan for what you do. A daily plan. And you need to be focused. Even though, of course, it's quite difficult to focus when you're around children. You have to take care of them, comfort them, provide whatever they need. But you also need to think about your research. Some scientists have a hobby that helps them gain distance from their work, so they can approach it again with a refreshed or new perspective. For me, this disconnect is provided by my children.

Did you ever have doubts, such as, *This project is going wrong, I don't know how to go on . . . ?*

When I was pregnant with my first child, doing my postdoc in Cambridge, I was planning to return to Israel on my maternity leave, so I was trying to collect as much data as possible before I left, and nothing was working out. I was so disappointed. Then, after I had the baby, I had a little time to look at the data, and I suddenly found a way to the answer. So, sometimes when you are desperate and are too focused on a problem, it might be good to step back, take a deep breath, and look at the situation again from a different angle.

"I'M HIGHLY COMPETITIVE, BUT COMPETITION CAN BE NEGATIVE, AND IT CAN BE POSITIVE."

Is it more difficult for working mothers to maintain a career in science?

I think it's taken for granted that a wife will support the husband in his career. It's not taken for granted that the man would do the same for the wife. But when a man does, it is unusual and very appreciated: "Wow, he's making such a sacrifice." Women are good at multitasking, and this makes us uniquely suited to do science.

The Weizmann Institute is well known as a research center. You are a woman and still quite young; how did you end up in this position?

I had a quite supportive PhD supervisor, who was very encouraging and always full of energy. He is now in his eighties, but still more energetic than me. And Weizmann is also very supportive in terms of the science, of the financial help, of providing help with supervising students. And I have an amazing mentor.

There are a lot of hungry, eager young scientists at Weizmann. Is there a lot of competition?

No. We help each other. Of course, I'm highly competitive, but competition can be negative, and it can be positive. Since there's no full overlap in the fields and in the work, this competition is positive.

Have you experienced some moments when you were euphoric and said, "Oh, fantastic. I discovered something important"?

I can't isolate one event and say, "This was a turning point." But when you have more impressive data or a bigger outcome, of course you become euphoric. But it's not a one-time event. It's a series of events.

Scientists are judged by the papers they have published and those they have presented. How do you deal with this pressure to publish?

There are two aspects to this situation. The first is writing and publishing papers, and the second is presenting your work. With the first, I have had no problem. For me, what was the most difficult was feeling exposed at conferences and in the media, because I'm quite a shy person. At the beginning, it was scary for me to go on stage and talk about my research—and be judged. A good way to meet this challenge, of course, is to practice. When I spotted

this weakness, I tried to present papers as often as possible, as a way to overcome the shyness. When you get used to doing presentations, you can think about particular aspects that you want to present or talk about, and not think about the people who are looking at you or that you are standing alone on the stage and everybody has their eyes on you.

Have you felt a lot of pressure to publish quickly?

I am trying to find the balance between publishing small experimental data or observations earlier or waiting for the big thing and publishing the results then. If you wait, there's a chance someone else is working in parallel and might publish before you.

Would you say it's important to study abroad?

Yes, it's important to go to another country, to experience living in a different environment, to learn

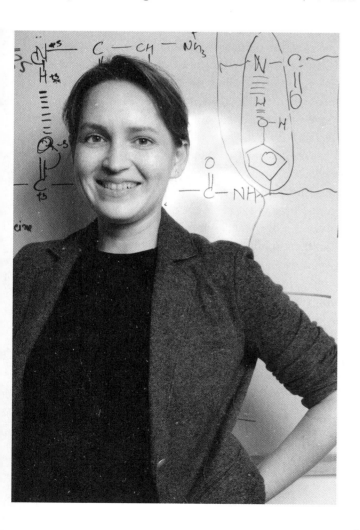

"I TRIED TO PRESENT PAPERS AS OFTEN AS POSSIBLE AS A WAY TO OVERCOME THE SHYNESS."

how to communicate with different people who don't have the same ways of thinking. I learned a lot from studying in Cambridge.

What was different about doing your postdoc there?

During the PhD work, you have a supervisor who is basically advising you. When you do postdoc work, you are to some extent an independent researcher. And in that way, you need to learn how to manage your own research project, to define your goals, and to solve problems that you encounter along the way. You learn how to lead and advise graduate students, too. Basically, you are learning management and research management skills. You learn also how to communicate and interact with people.

It seems you have a lot of self-confidence. Was that always so?

I don't think I have any self-confidence, to be honest. I've tried to do things right. I know what I want, and I try to do the best to get what I want; I am quite persistent.

Were you born in Israel?

No. I was born in Tashkent, Uzbekistan. My father is a meteorologist, and he worked on the construction of equipment for measuring the weather, so we lived basically everywhere, including Siberia. We moved to Israel from Uzbekistan sixteen years ago, when I was 20 or 21 years old. I already had a bachelor's degree, as I had started university at the age of 16. When I arrived in Israel, I had to learn Hebrew. The instructional books were in English, but I needed to understand the lectures, so I took a course in Hebrew. It was a difficult period, and I'm not sure I would be able to do

"SOMETIMES YOU CANNOT OVERCOME THE FAILURE, SO YOU JUST FORGET AND MOVE FORWARD."

that again. But I wanted to know Hebrew, like everyone else. What drove me was that I wanted to be at the same level as the others, maybe higher. I wanted to earn degrees and speak fluently, and I wanted it fast. In fact, I dedicated all my time to this. By the end of my master's work, I already knew I wanted to be a group leader and have my own research group.

How did your parents help you?

With constant support. Education for them was very important. My mother was also a role model to some extent. In Uzbekistan, she was a teacher of legal history. And she was always moving forward. I think it's human nature to want more. Some people want more money, some people want more power, and some people want more of what they have.

You are 36 years old, so in sixteen years you made your career in Israel. That's not so normal, correct?

No, it's not so normal. You need to stick to your goals and to your feelings of well-being, and do what you want, what makes you happy, because for some people it's not necessarily a professorship that will make them happy. For me, that's what makes me happy.

Do you sometimes make mistakes? And if so, what do you then?

Of course, I make mistakes. All the time. In research and in life. You need self-control not to take the easy route, not to give up. I think about the solution. There is a possible scenario whereby you go and cry in the corner; and there's another scenario whereby you move forward and try to work on the failure.

Sometimes you cannot overcome the failure, so you just forget and move forward. Of course, every person has these moments when they feel down and just want to quit. I'm a human being. But quitting is an emotional thing. Then there is a rational part, when I think about the consequences and what I would gain from quitting. I think about the problem and try to do my best to get out of the situation.

Would you say that you're a rising star?

I think I would never say that about myself. I'm a researcher who is doing research in the best way I can. I also think it's very female that I always look for what I can fix and do better, rather than think about how good I am. I also try to correct or overcome limitations.

Did being an immigrant in Israel contribute to your success?

Being an immigrant causes you develop the sort of characteristics or driving force that pushes you to succeed and move forward. As an immigrant, you're always trying to integrate into society as best you can. I think that if I weren't an immigrant, I wouldn't have cared much about moving forward so fast with my career. Maybe an immigrant thinks differently.

But you're not part of the crowd even now; is that sometimes a lonely feeling?

Yes, sometimes it's lonely feeling and sometimes it's a good thing not to be part of the crowd. You can develop your leadership qualities. My advice is to not think about the crowd. Do whatever you like, and when people see how you're having fun with your work and how good you feel doing what you are doing, they will probably follow you.

Why did you choose to study science?

I had an amazing chemistry teacher. She delivered material in an interesting way. It was in a practical way, so we didn't just write down formulas; we could also try them out in the lab. And if we wanted to, we could come to the lab for extra hours to practice or to discover something more—to prove some more experiments or do something in addition to the regular classes.

Could you explain your research in a simple way that nonscientists can understand?

My group's research is concerned with protein self-assembly. Proteins are chemicals that provide fuel for our body. Under certain conditions, protein molecules interact and form ultrafine fibers. We can observe this phenomenon just like we can watch spiders spin webs. The same phenomenon might occur in human neural cells, which are located in the brain. In such a case, when the fibrils are formed, they become extremely toxic and they trigger suicidal behavior (apoptosis) in the cells, which leads to the development of Parkinson's, Alzheimer's, and many other neuro-degenerative disorders.

We are investigating the differences and similarities between the functional fibers that spiders produce and the toxic fibrils that the human body produces. We are trying to distinguish between the formation of "bad" fibers and "good" fibrils, and are trying to find a way to change this fibrillation process. Some specific questions we are currently investigating are: How can we change the pathway by which the toxic fibers are formed? How would these changes affect the physical properties of the fibers (for example, toughness)? Would the change in the physical properties have a completely different effect on the response of human neuronal cells? Can we "turn on" the cells' self-defense mechanism and enable the cells to destroy the toxic fibers?

How would you describe your contribution to society? How far along are you already?

My group's ongoing research, as well as that of other research groups around the world, is progressing in steps to reveal the underlying mechanisms of some neurodegenerative diseases. However, I do not want to claim that we are close to discovering a cure for Alzheimer's or Parkinson's. I hope that will occur in the near future, but of course, I must be realistic. At least some of the side effects and especially the deleterious effects could be reduced, and the patients' life spans could be extended. Further research is needed, though.

There are three stages in this kind of research. Could you explain that?

Stage one is when you try to identify the effect of something or try to refute the effect and to see whether it is consistent. Stage two is when you try to improve whatever you have observed and make the technology available for more complex systems. For example, if you observe a certain effect on the proteins, you might not observe this same effect when the proteins are placed inside the cells and the cells are placed inside mice, for example. And stage three is when there are clinical trials to see if the results work in a fully functional human body. Of course, you can observe a positive outcome from the therapy, but then the side effects might be worse than the positive outcome. And those side effects might be only after years in the human body. So, you need to make sure you are not damaging the human body.

Did you ever consider working in industry and having more regular hours?

No, not even for one day. The energy that the research gives me is way more than I would get working in industry. I use some of this energy to take care of my children. For example, I sometimes bring them to the lab and allow them to play with the microscopes. I think it's fun for them, and it's also enjoyable for me. They see how much I like my work, and I think that's also good for the children. I am sure they'll be happier and more self-confident in the future if they see their mother succeed and be happy.

"THE ENERGY THAT RESEARCH GIVES ME IS WAY MORE THAN I WOULD GET FROM WORKING IN INDUSTRY."

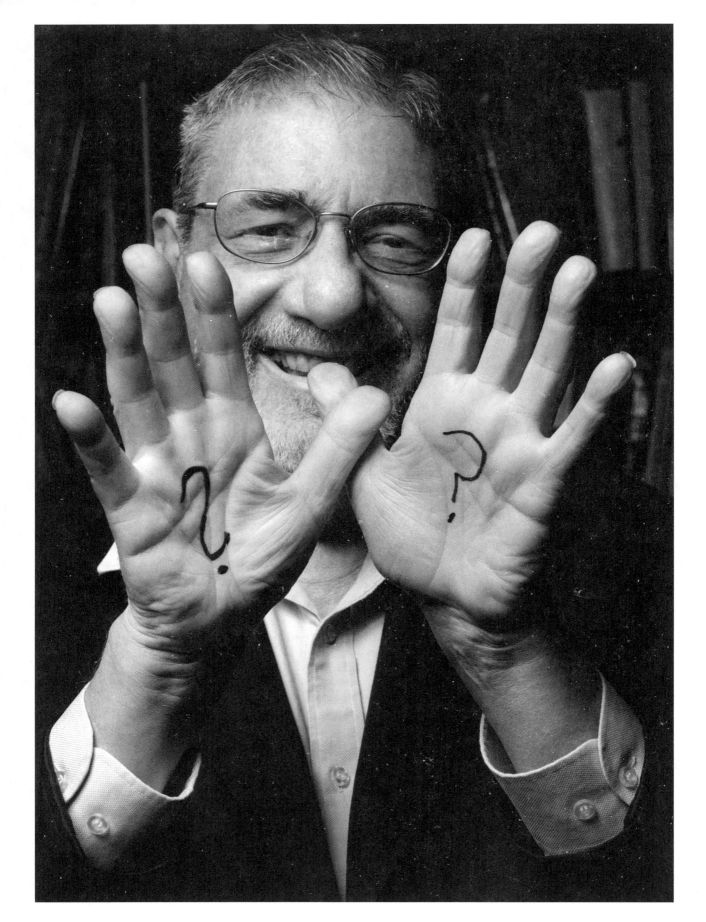

"I TRY TO KEEP AN OPEN MIND AND BE AN EXPLORER. I'M AN ADVENTURER, I EXPLORE."

Richard Zare | Chemistry

Professor of Chemistry at Stanford University, Palo Alto
Wolf Prize in Chemistry 2005
United States

You're known as a strong advocate for women in science, which is unusual in such a male-dominated sector. How did that come about?
I wasn't born that way. It's developed over time. It's partly because of my three daughters, who all enjoy professional careers, and my wife, who is a strong advocate for women.

Can you tell me more about your wife?
Falling in love with my wife was sublime. Over fifty years later I'm still happily married. She's somebody I can talk to and listen to. We make a good team. It's all about getting your expectations to match reality.

Several scientists have said that it's difficult for a woman to resume a successful career after having had a baby. Do you agree?

Absolutely not. You really can have it all. Society has to support you, though, by providing adequate childcare and parental leave. When I became chair of the chemistry department, I introduced twelve-week paid maternity leave, which was unusual back then. It was a win for everyone. By becoming a family-friendly department, we could attract more top people.

It's important that women have an equal chance to excel in their chosen field. Over half of the population is women, and if we exclude them, we risk throwing away a huge amount of talent and creating an asymmetric world.

The world needs to listen. Women hold conferences advocating women's rights and then only invite other women. You need both men and women to hear what is being said and to talk about it.

What else motivates you, besides women's rights?

I'm driven by a desire to share my joy of discovery with everyone. Peter Pan was right: never grow up. Remain childlike and keep that sense of wonder and curiosity you were born with. I do.

When I was younger, my main motivation was trying to win my father's love and becoming a person he would admire. I later learned that he simply wasn't capable of expressing much love regardless.

How else did you father influence you when you were a child?

My father tried to obtain a PhD in chemistry at Ohio State University, Columbus. Sadly, he didn't complete the work. This meant lots of chemistry books were left lying around the house. My parents told me to not to touch them, saying "Just leave them alone; they only lead to unhappiness." But I was a rebellious and obnoxious child, so this just encouraged me all the more. I would take the chemistry books to bed and read them under the covers by flashlight.

When I was a child, I asked my father if I could buy a chemistry set, but he said no. Luckily, I convinced the pharmacist to give me all kinds of things, including charcoal, sulfur, and potassium nitrate. He asked me if I knew what I was doing because those were the ingredients for making gunpowder.

You enjoyed doing chemistry experiments as a child?

I was about 3 or 4 years old when I started carrying out my first chemistry experiments. The experiments were inadvertent—not planned—so my father spanked me. This made me unhappy, so I went and urinated in his aquarium. That killed the tropical fish, which led to another spanking. But I was seriously impressed by the power of chemistry. I had no idea my urinating would affect the fish like that. I regard this as one of my earliest chemistry experiments.

I enjoyed burning magnesium, which led to bad smells and my setting fire to the basement during one of my experiments, as well as to a certain degree of notoriety, which I enjoyed.

You didn't find life easy as a child, then?

I found childhood difficult from the start. I came within a week of failing kindergarten. The kindergarten had one requirement—being able to tie your own shoelaces. I quickly learned that if you didn't tie your laces and you waited long enough, other people would tie them for you. As far as I was concerned there was no need to learn.

And so, it went on. I failed reading in first grade. They used to read out loud from a book about Alice, Jerry, and Spot the dog. I've a strong memory, so whenever they asked me to read, I simply recalled the next part from memory. At some point, the teacher realized I had no idea how to read.

I was really unsocial. I was the type of child who hid in the school cloakroom. I had trouble making friends and so I was very much an outcast. In seventh grade, I regularly provoked a newly qualified teacher, who had been told never to admit he was wrong. He used to give us the wrong answers, so I would go down to the library for some books and then quote from them to prove him wrong. The other kids loved our arguments. I was sent several times to the principal's office, and eventually I was kicked out of class. They decided I was too disruptive and should leave public school. We were poor, my father

was in between jobs, but luckily I ended up winning a scholarship to a private school.

Where did this rebellious attitude come from?

It's partly because of my Jewish background. My parents were Jewish, and I grew up in a Jewish community. I was told that Christians believed in Santa Claus, but that it was a lie. From an early age I started to doubt what people told you was true.

My family joined another community, where we were the only Jewish family among Christians. I entered third grade, where the class was singing Christmas carols. The teacher asked me why I wasn't joining in. I said I didn't know the words and anyhow they weren't true. So I had to stand in the corner, wearing a dunce's cap. Later my classmates

beat me up. I didn't want to go back to school after all that. My mother had to go in and talk to them.

It was a deeply traumatic event, which taught me to question everything. For example, the Rabbi agreed to give me a bar mitzvah when I was 13 years old if I would quit asking him for proof of the existence of God.

Luckily, this questioning attitude is important for science and research. To make progress in science you need to be a "contented schizophrenic"—you put forward an idea, believe it, and then immediately question how true it is.

This questioning approach is what helped you secure top university posts, true?

I was awarded my first faculty appointment when I was a PhD student. My professor, Dudley Herschbach, asked me "Would you like to stay in the Boston area?" and I replied yes. So, he picked up the phone, called up A. C. Cope, the head of the Massachusetts Institute of Technology (MIT) chemistry department, and said, "I have the perfect physical chemist for you." I was asked to give a lecture at MIT and then I got the job.

Unfortunately, Cope was an alcoholic and left without telling people he'd hired me. When I arrived, I didn't have an office or laboratory, so I couldn't conduct any research. They put me in an office, but it was too far away from the rest of the chemistry department. I wanted to work on something that involved the machining of stainless steel, so I gave my drawings to the physics department, which had a machine shop. Nothing happened. After a while, I asked why nobody was working on what I'd given them, and they said it was because another senior chemist had told them not to work on anything for me, as too many chemists were using the physics department's machine shop.

I didn't know what to do, so I made an appointment to see the provost. I told him I'd had an offer to go to the University of Colorado, but he dismissed it. "No one leaves MIT to go to the University of Colorado. That's not a credible offer." But I resigned and joined JILA, the physics research institute at the University of Colorado Boulder campus.

"YOU NEED A QUESTIONING MIND AND A WILLINGNESS TO LIVE WITH UNCERTAINTY AND AMBIGUITY."

Stanford has been my home since 1977. It's easy to interact with other departments there, and there's a wonderful attitude of working hard and playing hard.

Early on in your career you started researching laser-induced fluorescence. Can you tell me about it?

When lasers were first developed, people didn't know what to do with them. They were called a solution in search of a problem. I decided to use lasers to study chemical reactions at a molecular level. I found that once molecules were in an excited state, they would give off light, and there would be a fluorescent spectrum.

Since then, we've used laser-induced fluorescence to study reaction dynamics, molecular collision processes, and even the human genome. It has many applications, from differentiating cancerous from non-cancerous cells to examining the molecules in the atmosphere, which is important in terms of climate change.

Is it true you used the technique to search for alien life?

I wanted to see if there was life on Mars. We used a focused laser to heat up a meteorite and then another laser to excite and ionize it. I saw some molecules with benzene rings and with alternating single and double bonds, which caused great excitement, as its chemical composition showed it had come from Mars. I was told, "You've found the first organic molecules and maybe the first signs of primitive life on Mars."

It's still an open question as to what it all means. I try to keep an open mind and be an explorer. I'm an adventurer, I explore.

What are you currently exploring?

Right now, I'm passionate about the chemistry of water droplets; they're far more reactive than a large quantity of water. I'm also looking at collisions in ultra-cold conditions, determining the difference between cancerous and normal tissues, and trying to release drugs from nanoparticles and plant them in people.

Are your experiments always successful?

What are you talking about? Most of the time we fail! But the right attitude is to let the failure guide you to success. If you don't fail often enough, you can't possibly succeed.

In the public eye, you've been successful, though. You've got fifty patents, for example. How often are your findings cited in journals?

Scientists often are measured by the number of times their work is cited. I personally don't find that a good measurement. When we look at a new candidate for Stanford, we prefer to ask instead, "How has this person changed people's ideas about their field of work?"

As for patents, I haven't counted them. I've had some great business successes but haven't been smart enough to translate them into personal financial success. For example, we were involved in capillary electrophoresis—namely, separating molecules in liquid. I passed on my discovery to a company called Beckman, which financially supported my research. They've since sold millions of dollars' worth of units using my process, although I've never collected any royalties.

I've been rich and I've been poor. Rich is better, it's true, but mostly I'm interested in knowledge and sharing my excitement about the world with other people. I'm become more successful than I ever imagined, though. It's been a stochastic process, a matter of blundering around. I've just let myself explore.

You've won various awards and public recognition for your work. How do you feel about that?

Yes, I've won the Fresenius Award, the Welch Award, and the King Faisal Award, among others. I used the money to offer scholarships at Stanford. What's the use of money if you can't do something you want with it? Years ago, I won a scholarship to Harvard, and I'm grateful for that. I wanted to give something back to others.

I've even received a lifetime achievement award, although it's a bit early; I've no reason at this stage to stop what I'm doing. I love my work. I'm a workaholic, but for me it's not really work—it's play.

What do you enjoy doing besides work?

I lead a full life. I like going to the theater, for example. My eldest daughter is a professional French horn player in a symphony orchestra, so I go and listen to her playing. I also enjoy travel and food. Political science is another one of my hobbies; IBM added me to its scientific advisory committee as their token chemist, which has allowed me to see things with different eyes.

Learning German is another of your interests?

My father's family was destroyed during World War II, and there were strong anti-German feelings in my family, so inevitably my parents were opposed to my learning German. But it became a hobby. As a kid I read *The Diary of Anne Frank* in German and I've continued to learn German. This has encouraged all my daughters to learn German, too.

It's unusual for a scientist to lead such a full life. So, do you consider yourself special?

Well, I'm different, it's true, but I don't know about being special. I'm happy with myself. What you see is what you get.

And you love teaching, as well?

Yes, teaching allows me to share my excitement about discovery. It's also a secret weapon for my research—I always learn something new when I teach. Students evaluate your teaching. I try to learn from any criticism and see how I can do things better.

What advice would you give a young person interested in learning science?

Find something that interests you—something you're passionate about—and pursue it. There's no perfect job; everything has unpleasant aspects that you have to put up with. I like to cook, for example, but I don't like to wash up afterwards.

Science offers the thrill of discovery, of learning something new and of sharing these ideas—there's nothing else like it. There's room in science for all types of people doing all types of things. Overall, though, you need a questioning mind and a willingness to live with uncertainty and ambiguity.

Science can also ease upward social mobility. I come from a relatively poor family, but I went further than anybody expected. I worked hard for it, though.

How else does the pursuit of science benefit society?

Science has changed the world, from how long we live to our quality of life. And science and technology drive the economy. Unlike the United States, China understands this; many of the current politicians in China have backgrounds in science. Fortunately, science isn't a zero-sum game. If there's a win somewhere in science, ultimately it helps the entire world.

The world faces a lot of problems, such as the excessive amount of nonrenewable energy we're using and the amount of meat we consume, both of which are unsustainable in terms of land and water use. I believe, though, that science will find a way to solve these problems. Maybe we'll develop a new food that tastes like meat. In 1798, Thomas Malthus proclaimed that overpopulation would cause people to starve, that there would be nothing but wars and famine. Instead, we developed fertilizer. Chemistry came to the rescue. Technological advances do happen.

What does the future hold in store for us?

In the future I believe we'll change the nature of what a human being is and does, and we'll increasingly incorporate people with machines. In a couple of hundred years, people will look back on our time and consider us primitive. There will be positive developments, but of course bad things may happen, too. Scientists and society share a responsibility not to misuse our advances and instead use them to create a better life. We should both simultaneously fear and desire the future that lies ahead of us.

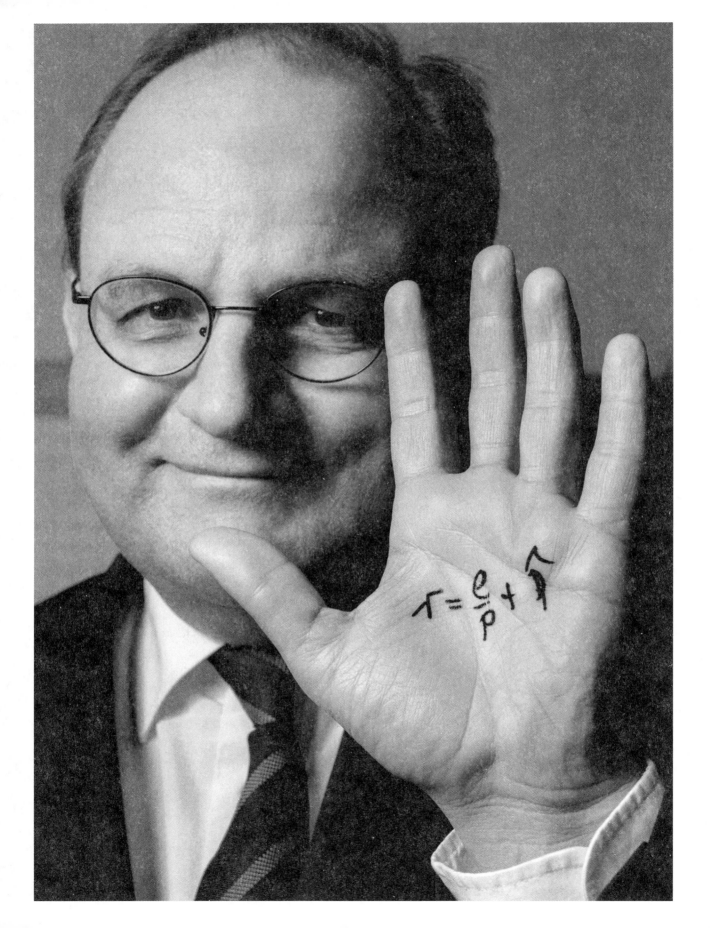

"I COULD ACHIEVE INDEPENDENCE ONLY BY BEING WILLING TO ACCEPT THE END OF ANY SOCIAL LIFE."

Ottmar Edenhofer | Economics and Climate Impact Research

Professor of Climate Change Economics at the Technical University of Berlin
Director of the Mercator Research Institute on Global Commons and Climate Change, Berlin
Director of the Potsdam Institute for Climate Impact Research, Potsdam
Nobel Peace Prize 2007, as Co-Chair of the United Nations' Intergovernmental Panel on Climate Change
Germany

Professor Edenhofer, you grew up in the small Bavarian town of Gangkofen. How did that influence your interest in science?

From an early age, I took an intellectual interest in nature, and Darwin and Marx really fascinated me. My father was a businessman, and I gradually surmised that he was forcibly exploiting people. Even as a child, I wanted to make the world a better place. I looked for ways to effectively change things and soon became convinced that I could achieve more with knowledge than by banging my fists on the table.

So, you quietly made more of a difference?

I wasn't unconventional in the classical sense; in fact, outwardly I was rather conventional, although not always quiet. It was only when I started to show resistance to things that I started to experience others' displeasure. Fortunately, early on I learned to be on my own and I discovered the world of books. As I delved deeper into biology, I came across a biography of Darwin. That's when I understood that the processes of mutation and natural selection make up the laws of life, and that nature is tough. That got to me, as did my involvement with science in general.

In kindergarten, I imagined that I could come up with a huge number by always adding 1 to it and never reaching the end. That was my first conception of infinity, which I connected to the question of whether the infinite could, in fact, be God. I was a devout child, but I wanted to know what true knowledge is, so I got into science.

You studied economics first and then philosophy. Why wasn't the study of economics enough for you?

If I hadn't grown up in an entrepreneurial household, I might not have studied economics at all. But back then I already thought that there can be no unlimited growth in a finite world. That was all the more so, when it became clear to me that humanity wasn't embedded in a particular order but, rather, in chaos. But the view of life represented by economics was too narrow for me; that's why I also took on philosophy.

Why did you become a Jesuit, as well?

When I was young, I was driven by the question of a humane economic model. At the time, the Jesuits seemed to be an order in which these things could be integrated. Most of all, I was fascinated by the Jesuit Father Oswald von Nell-Breuning. He was a lawyer, economist, and ethicist, and with these tools he advised trade unions and politicians, and he tried to influence the social design of the market economy. I could imagine a life like that.

Later, doubts arose because I was moving away from my real goal: I wanted to be where the conflicts were being fought, not a mere observer. When I was sent to the war in Yugoslavia to set up an aid organization, I saw how quickly civilizational standards can crumble. The veneer of civilization is so thin that it doesn't take much to remove it.

What happened when you left the order after seven years?

Leaving the Jesuit order means losing one's peer group, career, and prospects. Back then, even people who were previously well disposed to me completely broke off contact. I survived this difficult situation because I learned to accept the end of any social life. Living with rejection and contempt isn't a nice feeling. But I also knew that it wasn't the end of the world. Today, I'd say that the best thing was my enduring the situation and turning it into something productive.

When did you start getting involved in the problem of climate change?

The first time I read about the climate problem was in the book *The Imperative of Responsibility* by Hans Jonas, after which I intensively studied thermodynamics. This made me understand that the burning of coal, oil, and gas changes the radiation balance, which touches on ethical issues. That's when all my interests suddenly came together, and I got completely involved in the question of how economics and climate change affect each other.

In 2000, I went to the Potsdam Institute for Climate Impact Research as a postdoctoral researcher. At the time, hardly anyone was interested in climate change issues; it was almost an obscure subject. My first research results weren't successful, but I believed that my results were correct. It wasn't until 2004–2005, when we turned models into solution strategies, that the economics of climate change became an academically accepted subject.

Beginning in 2008, you have worked with decision-makers from 194 countries to develop a report on climate change. How did you manage that?

I became one of the co-chairs of the Intergovernmental Panel on Climate Change (IPCC) that year.

The institution's task was to clarify three central questions, with 2,000 pages devoted to each topic: (1) Are humans really responsible for climate change? (2) What are the consequences of climate change and why should we be concerned about them? And (3) What are the solution strategies? As an international nobody, I was tasked with the third of these questions. This gave me eight years of contact with the most important scientists on the planet, but also brought me to the limits of my mental and physical capabilities.

It's exhausting to get two hundred alpha personalities to work together and to motivate and entertain them. We also had to thrash out our differences to write the report and finally to submit it to the member governments. Of course, you wrestle with the facts, but there are also conflicts of values and worldviews. It's not easy for anyone facing change to fundamental values that comes from the pressure of facts.

As a scientist, what insights did you gain from this experience?

Nothing spectacular: We have too many fossil resources in the earth measured against the limited absorption capacity of the atmosphere, and we must limit use of the atmosphere through international cooperation. If nature won't do it for us, and God won't do it either, then we must solve the problem through international agreements. Humanity is yet to distribute global human goods fairly and efficiently through a legally binding agreement. Now, we have to define the rights to use of the global atmosphere; in time, we'll also have to limit use of the oceans, forests, and soils. So far, we've taken tiny steps forward and have been able to cooperate only with great difficulty and on a small scale. How we'll achieve this change on a global scale is a difficult political and ethical question.

What political instruments are available to start actions?

Not by dos and don'ts; only by putting a price on CO_2. We need to create market awareness of the limited absorption capacity of the atmosphere. To solve the problem, market economies need a global framework, and they don't have that yet. There is no world authority that can force states to comply, and that's a big problem. My ideal for how states can cooperate corresponds to what Immanuel Kant described in his essay "On Perpetual Peace" and is linked to the question of whether there has been progress throughout human history. At the end of the day, climate policy is also a policy of curbing violence and securing peace.

You also share your thoughts with the Roman Catholic Church, and you were an advisor to Pope Francis on the 2015 encyclical *Laudato si'*. It was even said that it was your idea that the atmosphere is the common property of humankind. True?

"MANY PEOPLE ABANDON THEIR FAVORED VOCATIONS BECAUSE THEY THINK THEY HAVE TO FOLLOW THE NORMS."

That would be too much of an honor because Thomas Aquinas had already formulated the question: Can humans own elementary goods, such as air and water, as private property? He then had the ingenious idea of the universal destination of the goods of creation. All humankind has the right to these goods—the property system must take this into account. I simply promoted the idea that the atmosphere is a common property of humankind.

To what extent does your faith still play a role in what you do today?

I'm still a believer: I agree with Kant that one has to assume the existence of God, individual freedom, and immortality in order to act ethically. We'll all stand before God in the end, and then and only then will human life know perfection. Like a child, I still have a naïve trust in God. I can't prove God's existence, but I can bet that hell on earth can be avoided, even if I can't know whether my actions will bring forth the desired fruits. I pray that I'll persevere.

You also meditate for an hour every day. How essential is that for you?

I wouldn't be able to stand life otherwise. The person who meditates silently places themself in the presence of God. By meditating, I can gain distance from my own feelings and impulses. It's an experience when I can say yes to something universal that goes beyond science. After meditating for an hour, I can then carry on. I usually get up between 4 and 4:30 a.m. I start the day by writing. I'm obsessive about that, too, but then when I feel I've written an important piece, I try to meditate for an hour. As great as science is, it's not everything.

What else is fundamentally important to you besides science?

My wife, my family, friends, and the people I can trust implicitly. There aren't many of them. My wife would like me to be more sociable and enjoy being with friends instead of just sitting at my desk. She says I forced her into being alone, and my children once said I wasn't exactly helpful to them for the first ten years of their lives. But by puberty, they found me useful and important. My son is obsessed with science, like me, and my daughter is pursuing artistic ambitions. It's a great gift to be able to share life with my family. I wouldn't want to miss my family, even though my life is centered on work. Unfortunately, I haven't always managed to balance my work and life and have had repeated health problems as a result.

Why should a young person study science?

Science, with all its limitations, is a noble endeavor. However, because of the power it gives us, it can also be dangerous and we must be aware of this responsibility. There must be certain limits to its application, and we must constantly review the relationship between these limits and their dissolution. If we allow dangerous climate change to continue, modern society will fall apart. Therefore, whoever wants to become a scientist should possess a superior intellectual talent. It takes deep intuition, more than quick thinking, and a certain asceticism. You have to be able to endure a great deal of frustration. But science is also like a magnet: once you've tried to reach a scientific finding, you're drawn back to it, again and again.

What obstacles have you had to overcome in your life?

Ultimately, we have to somehow come to terms with life's limitations and with the fears we carry with us

from childhood. For me, it was a fear of failure and the experience of being ostracized as an oddball. The most important thing I learned when growing up was that it doesn't matter what other people think of you. I could achieve independence only by being willing to accept the end of any social life. But even if we can do without some form of recognition from the whole human community, we can't completely do without recognition from important people.

Would you agree that you received the greatest recognition by winning the Nobel Prize?

The IPCC was awarded the Nobel Peace Prize as a scientific community. This is also a positive message, because while we'll always need great individual scientists, it's just as important for there to be scientific communities that work together to produce something.

What would you tell a young child is the most important thing in life?

When you're young, you need to find out what kind of person you want to be. The important thing is to follow your own dreams. Many people abandon their favored vocations because they think they have to follow the norms. But to affirm your role in life shows great wisdom and strength. I'd like to tell my grandchild, who hasn't yet been born, not to let conventional thinking too soon dissuade him or her from dealing with the big questions.

How do you view your role in life?

I've always seen myself as a cartographer who maps the viable paths out of a dilemma for the decision-makers. The image of the guide fascinates me. I always wanted to play that role, and I've been able to do so on the international stage through the IPCC. Also, I definitely want to write another textbook in which I pass on my knowledge so that the next generation of scientists has an easier time carrying out interdisciplinary research in this field.

What's your message to the world?

The most important thing is to establish institutions that curb violence. Every generation has to take a

fresh step toward cooperation, and there'll always be opposing forces. I felt the trauma of violence as a child. I can still acutely remember watching a boxing match when I was 3 or 4 years old, and being disgusted by someone beating someone else's face until it was bloody, while everyone sat around cheering. I realized very early on that life is something sacred. When I was 7 years old, I shot a bird with a slingshot and it was horrifying to watch it fall and know that it was dead. I immediately confessed to the priest.

In 2018, you received the Romano Guardini Prize and gave an impressive speech at the ceremony. Can you explain?

I'd been given a cancer diagnosis just before, after I'd already finished the first draft of the speech. I had entitled it "The End of History?" and wanted to reflect on the question of whether we're at the end of the Enlightenment period and what would come next. In the course of writing it, however, I realized that I'd also been thinking about the end of my own story. I narrowly escaped cancer once again; the diagnosis came just at the right time. It changed my life. I don't work any less, but I'm now more aware of the finite nature of my life.

What legacy would you like to leave the world?

The Carthusian monks supposedly say that if a person dies with a reputation for holiness, he or she has done a good job. This isn't false modesty; it boils down to the insight that it takes all you've got to do a good job. If people remembered me as trying to do a good job, that would be enough.

"THE IMAGE OF THE GUIDE FASCINATES ME."

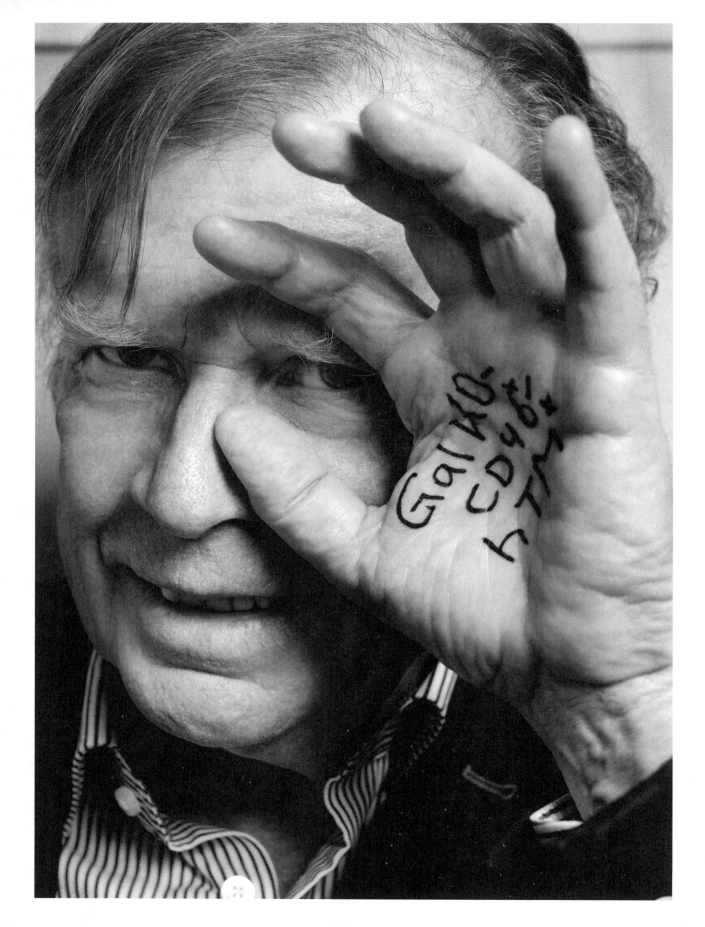

"I'M FIRMLY CONVINCED THAT LIFE IS PREDETERMINED."

Bruno Reichart | Surgery

Professor Emeritus in the Department of Cardiac Surgery, Ludwig Maximilian University of Munich
Spokesman for the Research Network Xenotransplantation of the German Research Foundation, Bonn
Germany

Professor Reichart, you work on xenotransplantation. For this procedure, you transplant pig hearts into baboons. What exactly is involved in this procedure?

Xenotransplantation means that organs from different species—that is, organs not from humans—are used for transplants. Since we eat about 50 million pigs a year in Germany, this led to the idea that their organs could be used for transplantation purposes—of course, only after genetic modifications. Without these modifications, this type

of organ transplantation wouldn't be possible; pig hearts would be rejected by baboons within an hour.

Since 1998, you've progressed so far in this research that a baboon with a pig's organ has lived for 195 days. What were the decisive steps that brought you this far?

I've done preclinical trials for over twenty years in order to arrive at clinically relevant results. These trials had to be repeatedly successfully and the animals had to survive. For this work, I also sought the advice and support of biochemists, virologists, and veterinarians. The organs of genetically modified pigs look morphologically similar to those of humans, especially the kidneys and hearts. These will then be the first organs that can be transplanted into humans.

Science has made great strides with the discovery of CRISPR/Cas9. How does this affect your research?

The gene-editing tools that are used with film to cut out snippets of DNA and then recombine them have been around for a long time. But when I started, it was work that took one or even several years. With the CRISPR/Cas9 method, we can now precisely target and cut genes, and the process has become cheaper, too. As with everything else in life, innovation is about the risk–benefit ratio; the benefit now is greater than the risk.

You implanted pigs' hearts into three baboons, two of which you had to put to sleep. Why did you also do that to the pig that had already survived 195 days?

All our transplants are agreed in detail with the authorities. When we take out the animal's heart and replace it with a genetically modified pig heart, the animal mustn't bleed. The recipient must accept the organ immediately, breathe on its own, and survive. That's because we don't have a blood bank, and we can't just get a liter of blood when we need it.

This is just one example of how difficult it is to care for animals under laboratory conditions. With the baboons, we got initial approval for a three-month period, after which we had to end the treatment by euthanizing the animals. The goal we've been given is a series of ten transplants of gene-modified pig hearts. Of these, six baboons must survive at least three months. Not so easy to achieve.

How long will it take before you can carry out clinical trials in humans?

We've just transplanted pigs' hearts into two baboons again, and they also have to survive at least three months. We'll then have successfully performed enough transplants on animals. That would be sufficient to prove that it's possible to take this to the clinical stage. For this, we need the approval of the Paul Ehrlich Institute. For this approval, we have to describe the procedure down to the last millimeter—for example, what the pigsty looks like. Hygienic conditions for the animals have to be right, the air in the stalls has to be filtered, the food needs to be prepared, and the water has to be sterile. All in all, I think we'll be ready in three years.

Does the Paul Ehrlich Institute also provide you with moral and ethical guidelines?

We have two ethicists in our consortium for this who help us to follow moral and ethical guidelines. The Christian denominations agree with our xenotransplantation goals. I've also had meetings with a rabbi and an Islamic religious scholar, and for these faiths the transplants with pig hearts are also not a problem. While Jewish people and Muslims don't eat pork, it's acceptable to both to use the pig hearts or kidneys to prolong a human life.

The question of whether it's permissible to sacrifice an animal for a human being depends for them on the hierarchy of creatures in this world. Humans are the highest beings, and the animals are all below us. This is especially clear in the Old Testament, which is why Jews and Muslims, who recognize only this part of the Bible, have an easier time with our research. It's more difficult for Christians and their New Testament thinking. But they have nothing against the research either, as long as the animals are respected and don't suffer unnecessarily. The slaughter process for food production is often more brutal.

Are you sure you're on the right track with this project, or do you sometimes have doubts?

It's taken staying power and a certain amount of self-confidence but being busy with this project seven days a week makes me happy. I'm happy when a baboon survives for months or when we publish something good. It satisfies my curiosity, something which I've had since I was a boy and then a young man.

When I started out, there were still many doctors who were "demigods in white" and appropriately authoritarian. I was lucky with some of my teachers, who helped me in difficult situations. But many others thought that nothing would become of me. I came from nothing, and my parents were simple people. But I didn't give up.

I went to a big clinic in Memphis, Tennessee, and worked like a slave—nonstop from seven in the morning until eight at night, plus nights and

weekend duty. And only fourteen days of vacation a year. Everything I was supposed to be able to do was shown to me only once; after that, I had to do it myself. Speed didn't matter, but I had to be good. I was responsible for all the diagnostics, prepared patients for their procedures, assisted in operations, and then also operated. That's how I got my education. When I returned to Germany at the age of 31, I was a well-known surgeon.

Did you ever want to boast to all those who doubted you?

No. For me, they were respected people who were never wrong. They spoke the truth. I had to deal with it somehow, and the long hours only toughened me and shaped me even more. It made me realize that I wasn't a failure and that I wasn't doing everything wrong, as I had often heard, especially from those who were seconds in command. That's when I could feel the power of hierarchy. Ultimately, I was competing with these doctors; they didn't want me to reach their level.

You've devoted yourself to cardiac surgery and research. Was there anything else important in your life?

I had little personal life. As happens with many surgeons, my first marriage went to pieces. Even my second wife, Elke, who is a journalist and very independent, quickly realized that the clinic always comes first for me, and the family was second. But she accepted that and hasn't fared too badly.

I admire her for going to South Africa with me in 1984, when apartheid was still in operation and civil war was raging. I'm also grateful to her because she still makes sure that I don't go gaga, and that I'm aware of what's happening in the world outside the operating theater and the laboratory.

Your time in South Africa marked a milestone for you. When there, you wanted to implant baboon hearts into baby twins. Everything was ready, but then the baboons were poisoned. What did you learn from that?

We had a big transplant program at Groote Schuur Hospital, in Cape Town, but we didn't have enough organs, so I came up with the idea of using baboons as organ donors. Because they're lesser apes—not great apes such as chimpanzees—they're not a

protected species. And because these animals are small, heart transplants were an option for babies with congenital, nonrepairable heart defects.

In the clinic, we had two of these patients, whose parents quickly agreed to xenotransplantation. We'd prepared everything, but one morning we found the two young baboons dead in their cage. It was a signal, a warning. It was then I realized that Western societies don't want transplants from nonhuman primates to humans, for ethical reasons. But also, it made me realize that one doesn't have to do everything that is possible.

After your South African experience, were there new ethical limits you wouldn't cross?

Of course, there are limits. Don't forget that even surgeons are human beings, with brains and a moral code. I don't have many limits, though, when it comes to patients' lives—that's where I always try everything. There always have been and always will be headwinds, and even with xenogeneic heart transplants, the biggest hurdles will be people saying these operations shouldn't be carried out.

But life always comes to an end, and you have to accept that. If there's a high risk, I have to expect that one day the surgeon won't be successful, even if everything has been properly thought out. Death is always a loss. It shakes my self-confidence, but the best thing to do is to get going on the next operation. Success is the best psychotherapy.

You successfully performed your first heart transplant in 1981. How did you feel afterwards?

I felt happy. However, at the time, after ten hours of work, I was tired and a bit dazed, so I didn't really take it all in. But I clearly remember how impressed I was a few years earlier when I first witnessed a heart transplant at Stanford. I saw the organ being implanted, the clamp being released, and the heart beating. I was so impressed by that.

But in 1981, when we started our sequence, I didn't realize that it was something special. The first heart transplants in Germany had already been carried out in 1969, unfortunately not successfully. The media interest took me by surprise.

South African surgeon Christiaan Barnard is recognized as having performed the first human heart transplant in 1967, using a technique developed in 1958 by U.S. surgeon Norman Shuway, in a heart transplant on a dog. Barnard's name is forever linked with heart transplants; no one talks about Shumway, the inventor of the technique. With xenotransplantation, are you also competing with other research groups that might grab the world's attention?

You can't make a comparison here. Emotions played a much bigger role back then, because it was about a human-to-human transplant, in which one person dies and gives his heart so another can live.

The heart is the pump that makes life possible; the only thing more critical to life is the brain, where the human soul sits. Shumway was saddened, to be sure, when he found out about the successful transplant in South Africa, after having developed the techniques for doing it years earlier. But he kept on researching and eventually was given credit.

Now, there are three teams in the world (including ours) working on cardiac xenotransplantation, and as far as I'm concerned, my American colleagues can be the first to reach the goal. My ambition is to do the work well and to pass on the results. Consistency is important, and so is the team. Because this development can only succeed with teamwork.

You've said that you would like to see more interest and work in science. What would have to improve in Germany for that to happen?

The present generation in Germany pursues a different set of priorities, such as family, free time, and limited working hours, and this comes at the expense of education and therefore also at the expense of science. A scientific field can't develop further without basic research and innovation. Cardiac surgery is a perfect example of this; there has been no major progress made in Germany for ten years. Cardiologists, on the other hand, are achieving more and more with their interventional valves and catheters, taking work away from the cardiac surgeons.

What advice would you give to a young person who wants to study science?

They should just do it and find a really good institution, which is familiar with the latest methods. The teachers are also very important. They shouldn't be too old—ideally, between 40 and 50 years old for the 25- to 30-year-olds, so they can blaze a trail for the young researchers. Under these conditions, the young students should then work hard and be ambitious, and they should read and compare themselves with others. They should also be flexible and curious, never rest, and sometimes get on each other's nerves. And they should balance all this by doing something they can quickly start and finish. Sport, for example.

What fascinates you about what you do?

I have the opportunity of doing something new—making discoveries that no one else has come up with yet. Patience is important, as is the belief that a new discovery will be made. You have to start somewhere, and then the topics come naturally. Basically, surgery is a wonderful and not at all hard profession, which by the way women can also practice well.

How many female surgeons have worked for you?

Few, which I find a shame. As I've mentioned, I consider women to be talented surgeons—and are more skilled at manual work than men. But it's my experience that women struggle in cardiac surgery, and unfortunately often give up quickly. That's either because they are too ambitious and wear themselves out owing to the clinic's daily grind, which can indeed be stressful, or because they're too friendly and allow themselves to be pushed to the sidelines during surgical programs.

What we haven't solved here—as in many other hospitals—is the challenge of how to reconcile family and career. A surgeon can hardly afford to take off a year and a half on parental leave. If, however, she resolutely places her career in the foreground, she has the option of taking advantage of new fertilization technologies—for example, preserving her own eggs to have them available later for in vitro fertilization.

How much does your work drain you of energy?

I don't have a limit. Sometimes I'm tired, and then I just lie down and get some sleep. At some point, I've slept on nearly every operating table, lying somewhere in the corner. I also have no regrets if I don't manage to achieve certain things in my professional life—I'm firmly convinced that life is predetermined.

When I look back at my career, at the particularly critical points, I still don't know why things worked out in the end. Basically, the important thing is to let events run their course, and to keep things moving. If you make an honest effort, you'll be shown the way.

What made you the person you are today?

I belong to the generation that grew up after the war, and to have a sense of freedom and think pragmatically. That had a huge impact on me, at school and elsewhere. Apart from that, there was my aspiration to become a good doctor. At first, I wanted to become a general practitioner, not a surgeon, but fate played a role.

What is your message to the world?

I don't have one for the world, only for my fellow human beings, particularly adolescents and students: work hard, be curious, try things out, don't give up right away, and know that successful work requires strength.

"WITH XENOGENEIC HEART TRANSPLANTS, THE BIGGEST HURDLES WILL BE PEOPLE SAYING THESE OPERATIONS SHOULDN'T BE CARRIED OUT."

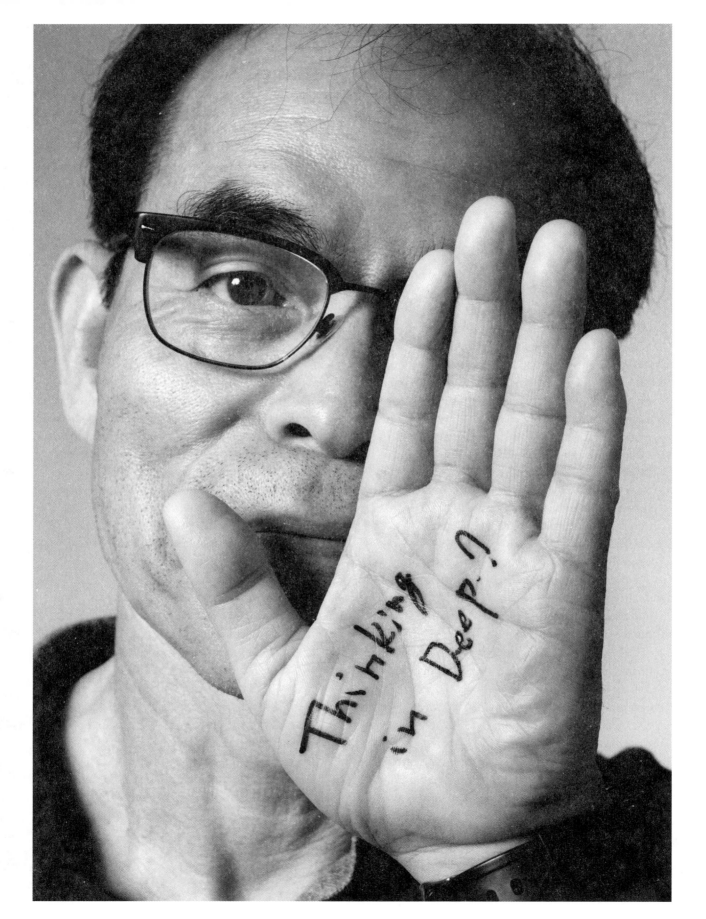

"MY MOTIVATION IS ALWAYS SOME MIXTURE OF ANGER, MAYBE EVEN FEAR AND DISSATISFACTION."

Shuji Nakamura | Electrical Engineering

Professor of Materials Science and Electrical Engineering at the University of California, Santa Barbara
Nobel Prize in Physics 2014
United States

Professor Nakamura, you grew up on the smaller island of Shikoku in Japan?
Yes. My father was working in Shikoku on the maintenance staff of a local power company. It was an idyllic and quiet place to grow up. I would play outside every day, and I could climb nearby mountains or swim in the ocean. So, I felt connected with nature. And by watching nature, I started getting curious: Why are flowers growing so rapidly? Why is the sea breeze coming from the ocean? Why? All those things triggered my interest in science.

But your older brother constantly fought with you?

I had three brothers, one older and one younger. And since childhood we were always fighting. But even when defeated, I would never give up and I would think, *But tomorrow, I will win!* I believe that's the reason I am constantly fighting. In life, we often get defeated by other people, but if I was defeated, I took it as my incentive. Once at university, we had strange results in the data, and everyone had a different theory for that. Mine was rejected by the professor and the other students. But I didn't want to accept that, and I kept on thinking. I sat in bed and was thinking and thinking. So, my motivation is always some mixture of anger, maybe even fear and dissatisfaction, and that may very well derive from my childhood battles.

You studied electronic engineering at your local university, Tokushima. Did you want to leave the island of Shikoku after that?

When I was a high school student, we went to Tokyo on a school trip. And I thought, *Wow. This is a crazy city.* It had too many people, and it was terribly crowded, especially on the trains. I hated it, as I was used to the quiet countryside, and I decided never to go to a big city. Never! UCLA and Stanford University tried to hire me when I was looking to change jobs, but I preferred to go to Santa Barbara, as it is a small and quiet city.

So, you stayed on Shikoku and found a job on your peaceful island?

After getting my master's degree in electronic engineering at the University of Tokushima, I started looking for a job, but no company on the island seemed to need my skills. So, I asked Professor Tada, my former advisor at the university, if he could find a position for me. Anything would be okay; I would refuse nothing. A friend of his was the owner of the local chemical company Nichia, and so I finally got a job in their research and development department.

You once mentioned that you had to create your own tools for your research. Can you explain?

Yes, I loved that. My father had taught us kids to make our own toys from wood or bamboo. That's how I learned to make everything. Just one year before I joined Nichia, there had been a big layoff because profits were way down. I didn't know that, though, and I asked my boss to budget for a furnace, which I needed for my work. He asked me if I was crazy. So, I went to the garbage dump, picked up the necessary materials, and made a furnace myself.

At the beginning, I was working on high-quality materials for the conventional red and infrared LEDs. It was a quite dangerous time. I started working on gallium phosphide crystals, which ended several times a month in a big explosion. Then I switched to gallium arsenide, which isn't inflammable, but the gases set free during an explosion are quite toxic. After some time, my colleagues got used to the explosions in my lab.

And when did you start your research on the blue light?

The products of the red and infrared LEDs that I developed didn't sell well, as we were late coming onto the market. I often suggested jokingly that research on blue LEDs would make us first on the market. But the answer from my direct boss always was, "You are crazy. You know our company: no money and no backbone." So, I walked directly into the office of the president, Nobuo Ogawa, and I asked him if I could do blue light research. He was almost eighty years old, and he said. "Okay." I kept on asking if he could give me US$5 million as research funding and if I could go to the University of Florida for one year for research, and he also agreed to that. I almost couldn't believe my luck.

You were 35 years old when you went to the University of Florida. What was your situation there?

I had to work together with the PhD students, and as soon as they realized I had only a master's degree, and hadn't yet published a single paper, they started treating me like a technician and stopped asking me to join their papers or meetings. So, I found myself on the outside, and I wondered, *Wow! I don't want to allow myself to be beaten by these people.*

When I returned to Japan, I focused on obtaining my PhD, so fellow scientists would treat me equally.

I always need some kind of unhappiness or anger to develop strong motivation. If I am happy, I feel no incentive. And I was angry then and determined to work very hard.

For years, you worked every day from 7 a.m. to 7 p.m. You came home in the evening, had dinner with your family, took a bath, and then went to bed. You didn't take one day off, besides New Year's Day. Is that correct?

I didn't take any phone calls and I didn't attend any company meetings because I had to focus on my research. I didn't talk to my assistant, as that would be a distraction. I totally isolated myself. And I didn't even talk to my family, as I was always thinking about my research. I had spent over US$2 million on a MOCVD [metalorganic vapor phase epitaxy], crystal

growth equipment I needed for growing crystalline layers to create complex semiconductor multilayer structures. And after modifying the equipment into a "two-flow," the quality of the crystalline layers became the best in the world. But for one and a half years, it was every day the same procedure: in the morning I modified the MOCVD reactor, and in the afternoon I grew some crystals and started analyzing the results.

But you had to wait a long time for the breakthrough. How was the wait for you? Did you have any doubts about what you were doing?

I love solving problems, and so I enjoyed that time a lot. That attitude had already started when I was in university. The first three years I was there, Just I had classes. But that was so boring that I stopped attending them and studied at home. Then we did start doing research projects, and wow! Everything was so interesting. Research and data! I loved to go through every data detail by myself.

And when I was at Nichia, I had all those failures and explosions, but I loved it! And then I had the big breakthrough. My first prototype of the blue LED was actually very dim, as the crystalline quality of the first gallium nitride crystals wasn't very high. I left the light on in the evenings, dreading that it might not still be emitting light in the morning. But amazingly it was still lit—and it already had a lifetime of over 1,000 hours!

In 1993, Nichia announced the groundbreaking discovery—that you had succeeded in creating the first bright blue LED light. How was that?

Actually, I had developed the first high brightness blue LEDs in 1992, and I wanted to do the press release immediately. But the chairman told me, "Our company is a tiny company and if we do the press release, we have to be able to fulfill orders. Otherwise, the other companies will copy it and we will go bankrupt. So, we have to prepare the mass production facility first." Thus, for one year, we had to keep it totally secret. Finally, we did the big release in Tokushima, as we expected that nobody would believe our tiny company on a small island had developed such a big

innovation. And after watching the blue LED at our offices, they all exclaimed, "Wow!"

Did your discovery get recognized outside of Japan as well?

In 1996, I received a letter of invitation to be plenary speaker at a conference in Berlin, but I at first rejected it. When I asked a friend about this conference, he said, "Wow! This is a prestigious conference. You rejected it? Unbelievable!" So, I went there. There were many Nobel laureates present, among them Reona [Leo] Esaki, a Japan laureate. It was amazing. We just had developed a prototype blue-violet laser, which is needed for data storage, and I presented it the first time at this conference in Berlin. I actually used it as a laser pointer in my presentation. Everybody said, "Oh, my gosh!" And I received a standing ovation. Wow, for me, that was like climbing Mount Fuji.

During all those years, you had two competitors—Isamu Akasaki and Hiroshi Amano. How did your work differ?

They had started with their basic research on the blue LEDs in 1980, whereas I started in 1989, so they were almost ten years ahead! I had heard rumours about their research, but there was no collaboration. They also knew about me, but they didn't take me seriously, as they already had a lot of patents and I had none. Then, in 1990, I built the "two-flow" MOCVD, which was the biggest breakthrough in my life.

After that development, my group always had way better results than they had, because devices such as LEDs and laser diodes grown with our "two-flow" MOCVD equipment were the best in the world.

In 2014, you shared the Nobel Prize with them. How did your discovery mesh with theirs?

Akasaki and Amano were the first to produce high-quality gallium nitride, the basis for the LEDs. Before their development of the high-quality element, gallium nitride materials were inferior. In 1989, they also developed the first positive-type gallium nitride. So, that was their contribution. But gallium nitride cannot emit blue and green. The key material for doing that is indium gallium nitride, and they

weren't able to grow it. So, I was the first to use indium gallium nitride to produce blue and green LEDs, and I invented the first high-brightness blue LED, which enabled the white LED.

As you were an outsider in the academic world, was winning the Nobel Prize especially satisfying for you?

I had always been the outsider, someone who had studied at a local university and had worked for a small chemical company. So, getting the Nobel Prize was indeed a big satisfaction in that sense.

All Japanese academy people, and even the government, said that Akasaki and Amano had done a high percentage of the research for the blue LED, and that I had just made a product. They got all the recognition in Japan; I was just a technician who happened to have made a product. That hurt, as I had worked really hard. But nobody gets the Nobel Prize for just making a product. It is only awarded for an invention or a discovery of critical importance. So, yes, getting the Nobel Prize made me very happy.

Are you still a happy man?

No. The Japanese academic community keeps on saying that I only made a product. Just a couple of days before our talk, the Japanese government made its annual science report. And again they wrote, "Nakamura just made a product, using the technology developed by others." I hate it. So, I corrected it. I said, "If you don't correct it, just delete my name, just delete everything." So, it still is a big wound. But I view it as an incentive. As I said, unhappiness is an important engine for me.

You had a big fight with Nichia, your former company. You sued them in 2001. In the end, you settled for US$8 million. Is that correct?

Yes. I quit Nichia in 1999 to become a professor at the University of California, Santa Barbara. Nichia had asked me to sign a nondisclosure agreement, but the university lawyer made me ask for an English-language version, so he could check it for me. As they provided it; I left Nichia without signing the NDA. Then, they initiated a lawsuit against me for infringement of trade secrets. I had left all my inventions of blue and green LEDs and laser diodes at

Nichia. Now, they were suing me because I did not sign the NDA. At that point, I was so busy with the legal steps, including discovery and deposition, as well as my teaching at university. I was so angry that I countersued Nichia one year later.

In Japan, if you invent something while you are working for a company, the patent rightfully belongs to the inventor, not to the company. Only Germany and Japan have this kind of patent law. Normally, the inventor signs over the patent rights to the company by signing an agreement to do so, but Nichia was such a small local company that I had never been asked to sign such an agreement.

So, the lawsuits proceeded through the courts. The Tokyo local court said there was an implicit agreement, so all patent rights belonged to Nichia, but that I should get compensation. The Tokyo district court said I have a right to US$200 million in royalties. And the Japanese high court finally ordered Nichia to pay me US$8 million in compensation as the settlement.

Do you use LED lights in your home?

I am a lazy person at home, so I still have some conventional lighting—I would say it is almost 50/50. Actually, I like sunlight. In my office, I never draw the curtains. All my U.S. colleagues have blinds and complain they can't keep their eyes open in my office, as it is too bright.

What did you experience as the biggest differences between academic life in the United States and in Japan?

In Japan, the professor is treated like a king and the students are the servants, who have to take care of everything, even restaurant bookings. And the students are afraid of saying something wrong or making the professor mad. As a professor in the United States, I can't ask those things of a student—everyone is equal here. If a professor has a meeting with a student, it often isn't obvious who is the professor and who is the student. In Japan, though, this would be easy, as the professor is the only one who is talking. So, concerning equality, the United States is much better; Japan is still a more bureaucratic system.

In the science world, there are not many women at the top. What could men do that would encourage more women to reach the top levels in science?

That is a difficult question. In the United States, we have to hire more minority professors, and that might include women. But, I think, the brains of men and women work differently, and their curiosity is different. Men are more interested in engineering and women are more interested in things—like fashion, for example. So, hiring a woman or a man means hiring different curiosities and different ways of thinking. Hiring is not really equal. We should be more open-minded.

You have three daughters. Did you spend much time with them when they were kids?

They are daughters, and I don't have a close relationship with them. My wife took care of the kids. Back in Japan, I also never helped her at home, but when we came to America, I was amazed how totally different family life is here. Everyone is equal; there is no difference. In Japan, the man is supposed to concentrate on work, whereas in the United States, family life is of equal importance. So, now that I am living in the United States, I try to take a different approach. In Japan, we are very bad at those things, but nowadays even there you have to stay home on the weekends.

Do you have any other interests besides science?

No, my hobby is thinking. That started in childhood, and it hasn't changed. Already at the age of 3 or 4, I was sitting alone in front of the ocean, watching the ships pass by. And in the photographs from my time at elementary school, I was always standing on my own, thinking deeply about some problem until I had found a solution. One month, two months—however long it took. And for thinking you have to be alone, and it has to be quiet.

Do you plan to return to Japan when you retire?

I lived in Japan for forty-five years. And I have to say, I miss the Japanese food! It is much better for me, and also the Japanese culture is better for me. As long as I am still working, though, I won't go back. But after retirement, I don't know.

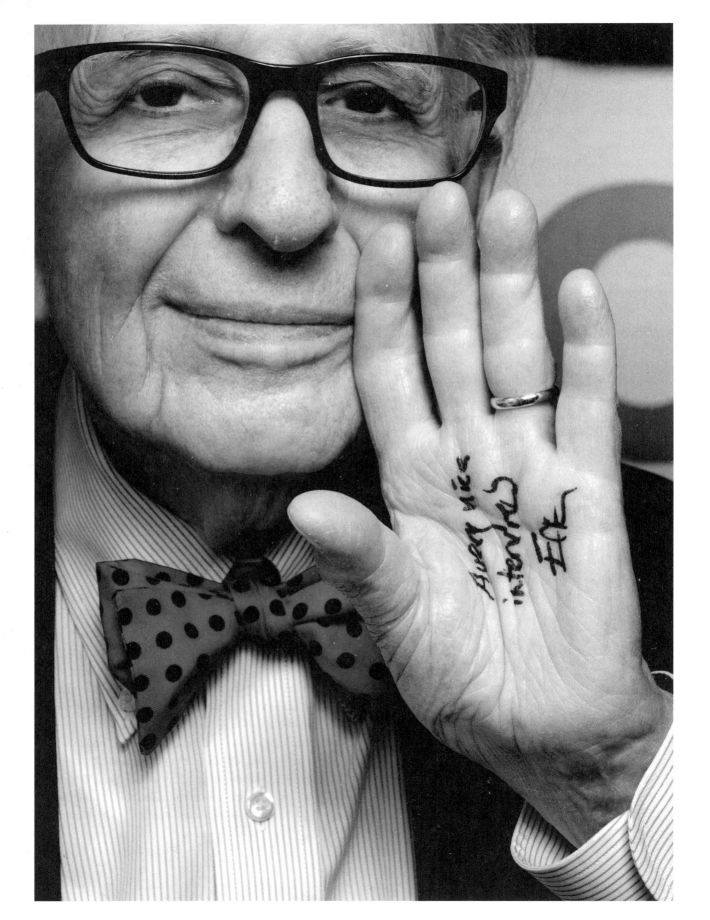

"COUNTRIES THAT INVEST INTELLIGENTLY IN SCIENCE DO WELL."

Eric Kandel | Neuroscience

Professor of Biochemistry and Biophysics at Columbia University, New York
Nobel Prize in Medicine 2000
United States

Professor Kandel, as a Jew born in Vienna, you fled Austria at the age of 9, after it was annexed by Germany in 1938. How did you react to this change in circumstances?
I will never forget my experiences in Vienna those last days. People who'd been our friends suddenly turned their back on us and didn't protect us. In fact, they actively turned against us after the Nazis knocked on our door on November 9, Kristallnacht. The Nazis told us we had to leave the apartment for a few days. My mother said, "Take a few things."

So, I took some toiletries and some underwear. My brother, who was five years older, used his brain and took his stamp and coin collections, and all his prize possessions. When we returned five days' later, nothing of value was left in the apartment. And November 7 had been my birthday, and my father had given me a toy train. It was gone. All my presents had been taken.

Did this traumatic experience alter your outlook on life?

I presume I've always been interested in the brain and in memory because of what happened to me in Vienna. It fascinated me how people who were your friends one day could become your enemies the next. When I went to the park, my former friends would beat me up. My father had to scrub the sidewalk with a toothbrush—it was before the elections and Jews were forced to scrub walls and sidewalks clean of any propaganda about Kurt Schuschnigg, the Austrian Chancellor whom Hitler replaced with himself. It was just awful in Vienna after Hitler came. My memories of that time are very painful.

But you managed to leave the country?

We left without our parents. In 1938, my parents took my brother and me to the train station and we left for Brussels, where we then boarded a ship bound for the United States.

Arriving in the United States for us was like a breath of freedom. My father used to say, "It's difficult being a Jew in Vienna." That wasn't true in the United States. My grandparents had preceded us to the United States by about four months, so when we arrived, we stayed with them in Brooklyn.

Describe your upbringing. What was the atmosphere like, especially after your parents joined you?

We were very poor. My father started out as a door-to-door salesman. Then he opened a shop, and ultimately earned enough to buy the small building, which in addition to the store had two apartments above it. We occupied one apartment as our living quarters and we rented out the other apartment, which was on the top floor.

My upbringing in New York was wonderful. I felt a real sense of freedom living in the United States that I had not felt in my years in Vienna.

Where did you go to school and how did that influence your thinking?

My uncle Berman registered me in a school in Brooklyn, near where we lived. But I felt uncomfortable there. Nobody else looked Jewish, so I thought some of the students might beat me up. My grandfather, an Orthodox Jew but very progressive, helped me learn Hebrew, which allowed me to transfer to a Hebrew school, the Yeshiva of Flatbush.

Asking questions is a wonderful Jewish tradition. Jews are very curious and emphasize education. They excel in intellectual areas requiring intellectual commitment. For example, although only 0.2 percent of the world's population is Jewish, 22 percent of Nobel laureates have been Jewish.

Afterwards, I attended a high school called Erasmus High School. In my senior year, Mr. Campagna, my history teacher, asked me, "Where are you applying to college?" And I said, "Brooklyn College. My brother's going there." He said, "Why don't you apply to Harvard?" So, I discussed it with my father, who said, "Look, we have just spent five dollars for you to apply to Brooklyn College. . . . I've never heard of Harvard, so Brooklyn College is just fine." I went back to Mr. Campagna, and he gave me the five dollars I needed to apply to Harvard. I ended up winning a scholarship to go there. I mean, this is the United States for you. It's absolutely fantastic.

What influenced the direction of your university studies?

When I first went to Harvard, I wanted to understand what had happened to me in Vienna. So, I majored in history and literature, studying the works of three German writers: Carl Zuckmayer, Hans Carossa, and Ernst Jünger. These writers held different positions on the political spectrum of National Socialism.

While at Harvard, I fell in love with Anna Kris, whose parents were the psychoanalysts Marianne Rie and Ernst Kris. Ernst Kris said to me, "Look, you're not going to understand how the mind works

by reading literature. You have to study people; you have to study the mind; you have to turn to psychoanalysis." So, I started to read Sigmund Freud and found him fascinating. That motivated me to go on to medical school, with the idea of becoming a psychoanalyst.

When did you start to focus on the brain and memory?

In 1952, I started at the New York University Medical School. My chosen elective was on the brain. I studied the hippocampus because I wanted to understand memory, which is so critical to human beings.

Later, at the U.S. National Institutes of health, I was the first person to electrophysiologically record successfully from the mammalian hippocampal pyramidal neurons. I studied these cells for six months with a colleague, Alden Spencer. We learned a bit about how these cells functioned, but we didn't learn anything about how memory functions occur.

It took a long time until your research found success. Did you ever experience any doubts?

At first, I thought about dropping out, that I wasn't getting anywhere with the work and it wasn't the right direction for me to take. But then I grew in self-confidence. The first few times things went well I thought I was lucky. After about the fourth or fifth time that happened, I realized that maybe I was good at this, maybe I could do this for the rest of my career.

What change in your thinking allowed you to reach that pivotal moment in your research?

I started to take a reductionist approach to doing science. I selected to work on a simple animal, a marine slug, *Aplysia*, with a simple nervous system. In this sea slug, not only are there relatively few nerve cells but the nerve cells are gigantic and visible to the naked eye. I was able to work out a neural circuit of a simple reflex behavior in terms of specific identified cells.

I found that this very simple reflex in the sea slug could be modified by learning. In this way, I discovered that when an animal learns something, the connections between the nerve cells change. I could actually see the anatomical change, and said, "Wow."

In 2000, you received the Nobel Prize for Physiology or Medicine for your research on the physiological basis of memory storage in neurons, sharing the prize with Arvid Carlsson and Paul Greengard. Was this your eureka moment?

My eureka moment was when I first realized that learning produces anatomical changes in the brain. I wanted to go one step deeper, not just to a descriptive level but down to a mechanistic level to see what happens in the brain. With short-term memory, there is a functional change but no change in the anatomy. But if you do something that produces a long-term memory, there is an anatomical change in the brain; you grow new synaptic connections. If you forget, you lose those synaptic connections.

"I PRESUME I'VE ALWAYS BEEN INTERESTED IN THE BRAIN AND IN MEMORY BECAUSE OF WHAT HAPPENED TO ME IN VIENNA."

That is why I won the Nobel Prize. I was the first person to work out the basic biological mechanisms of learning and memory. Neural biology and psychology belong together—neural biology is a biological underpinning of behavior.

You also were teaching at the time. Were you a good teacher?

I loved to teach, and I was a good teacher. I wanted the classroom to be like a theater—that the students would listen to me, not just sit there, and take notes. So, I gave the students an outline of my lectures so they could just sit back and enjoy it. I ultimately turned those lectures into a textbook, *Principles of Neural Science.*

You've dedicated your life to this research. Do you have any regrets?

I've worked most days and part of many a night, and I derive great pleasure from doing the research. People watch television at night. I hardly ever watch TV; I write most nights. As I say to my friends, "How can I know what I think unless I read what I write?"

Science is so engrossing. I have on occasion been offered attractive leadership jobs, such as chairman of the Department of Psychiatry at a Harvard-affiliated hospital. But my wife, Denise, could not see me doing that. She would simply say, "Throw your career away for an administrative job?" Denise has always thought I have a good mind and should dedicate my time to research. Whenever a chairmanship offer would come along, Denise always pulled me back.

Her only objection to my research was that I often spent too much time doing it. I remember her once standing in the doorway of my lab, with one of our children. "Eric," she said, "you can't keep on doing this. You're ignoring us, and you're only paying attention to your work and not paying any attention to your family." I felt terrible. I didn't feel I was ignoring them, but I wasn't spending as much time with them as I should. And I improved a bit.

Despite our disagreements about my time distribution, I wouldn't have won the Nobel Prize without Denise's help. She has had tremendous confidence in me. She thinks I have a good mind. She may be wrong, but I'm not going to disabuse her of that at this point in our life together.

How has your research changed over the years?

When I started out, few people studied the brain. It was just too complicated. Now, there are more people working on the brain than any other organ of the body. There are powerful imaging techniques, so you can study effectively different kinds of learning processes, both in people and in experimental animals.

We know that different regions of the cerebral cortex have different functions, so we can focus on one region when we study visual perception, for example, and another when we study hearing.

The Howard Hughes Medical Institute supports you. How does that arrangement work?

Investigators supported by the Howard Hughes Medical Institute have to be re-examined every five years, which is demanding. You have to write an essay on your scientific accomplishments and submit the list of relevant publications. You then have to give a talk on your work of the past five years, and then they quiz you thoroughly.

You have to take it all very seriously. I think it's fair, though. Why should different people be subject to different standards? Everyone's only as good as

their last movie. I'm going to be 90 years old this year. I could stop, but I really like to work. In America, you can go on working as a professor, as long as your work is good. You're reviewed every few years, and if you pass the review, you can just carry on.

What are you researching now?

I'm researching age-related memory loss—that is, how you can best prevent or counteract memory deterioration in older people. I've found that a hormone called osteocalcin, released from the bones, is a very effective memory booster. When you walk, you release osteocalcin, and it helps your memory. So, one of the best things aging people can do is to walk. Every day I walk to work and back in the hope that this will help me manage age-related memory loss. It's been effective in experimental animals, so maybe it will work for me as well.

What will happen after you die?

When you're dead, there's nothing else. Your soul doesn't live on. What will live on is my children, my grandchildren, my contributions, my books, and my papers. I'm proud of what I've achieved. I've had a good career. In terms of my contribution to society, I was able to tackle certain problems at the molecular level that at the time people thought couldn't be tackled, like learning and memory, and I showed that they could be studied in depth.

What advice would you give a young person considering studying science?

You should have an inquisitive mind and go to a good school. It's such a rewarding and satisfying career. You play with your ideas, you find ways to test them thoroughly. It's never boring.

It's important to choose a profession you enjoy. A career doesn't turn out well unless you work hard at it, and you will not put a lot of work into it unless you enjoy it.

How does science personally make you happy?

It's extremely gratifying to make a new finding, a new discovery, no matter how modest. Constantly solving problems and understanding how things work are very satisfying. In some cases, you may be the first person in the world to have seen this little part of the universe.

You are now an honorary doctor in Vienna. Have you made peace with the past?

When I won the Nobel Prize, I got a lot of calls from Vienna claiming that this was a Viennese Nobel Prize. I said, "You've got this wrong: this is an American Nobel Prize, an American-Jewish Nobel Prize." So, the Austrian government wrote to me and asked, "How can we make things right?" I asked them to hold a symposium in Vienna about Austria's interaction with Hitler's National Socialism. The symposium was then published as a book. We compared Austrian attitudes to German attitudes. It was a productive interaction, and I made friends, which made visiting Vienna more enjoyable.

And I was able to convince the Austrians to do something for the Jewish community—they paid the Jews to compensate for some of their losses from that terrible time.

Why is science so important?

Science is our hope for the future. We have so many problems haunting society that need a solution, and science is one way to find those solutions. Countries that invest intelligently in science do well. It's important for a country to be serious about science and to encourage its growth.

Can you describe your typical day?

I meet with the people from my lab and discuss their work with them. Healthwise, I walk to and from work most days. I love our apartment. We have a lot of art in it. I like to swim and play tennis on the weekend. I eat reasonably well. I never eat meat. I much prefer to eat fish and vegetables.

You are a scientist, yet you're interested in art?

Art and science aren't worlds apart. Artists can be experimental and adopt the same techniques and approaches as scientists do. Scientists can be creative and have artistic sensibilities.

I've been interested in art ever since my days at Harvard, when I took a wonderful course in fine arts in my first year. That really motivated me to go to

museums. When I travel to a new city, one of the first things I do is visit any interesting museums.

I'm very interested in works of the Vienna Secession movement that occurred at the end of the nineteenth century—artists such as Klimt, Schiele, Kokoschka. It was a special period, which really influenced me. I saw a Kokoschka exhibition the other day, which was wonderful; and I realized once again how extraordinary Kokoschka's work is.

What has been your main guideline in life?

To do the best I can. I mean, I didn't want to starve but money has never been my major objective. My main objective has been to do something interesting intellectually that I enjoy.

Working hard has been a main guideline in my life. I don't give up easily. Nothing gets done unless you stick at it. Practically nothing that is important is easy.

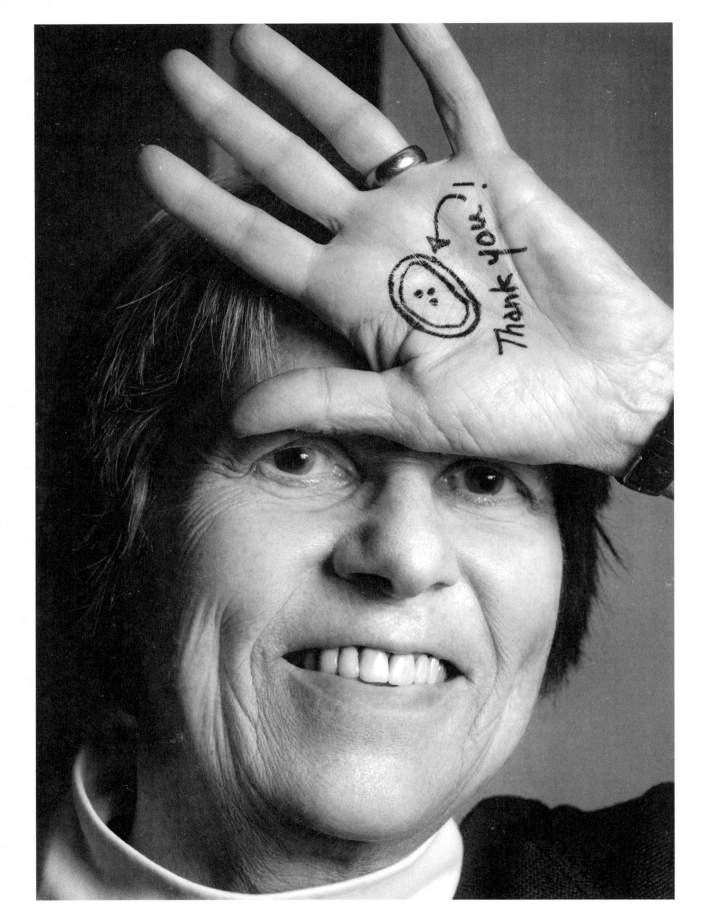

"THE MORE ANSWERS YOU FIND, THE MORE QUESTIONS YOU'LL HAVE."

Sallie Chisholm | Marine Biology

Professor of Biology at the Massachusetts Institute of Technology (MIT),
Cambridge Crafoord Prize 2019
United States

Professor Chisholm, when you first started at MIT, you were the only woman in your department. How did that feel?
Growing up, I'd always been in an environment dominated by men. All my parents' friends had boys. So, I was used to being surrounded by boys early on and then by men in my career. I just did the best I could and didn't notice the barriers until a little later.
What made you notice the barriers?
When I came up for tenure, I became cognizant of the different ways men and women approach their

careers and aware of some of the micro-inequities. I began to understand that the way I was experiencing my environment was fundamentally different from that of some of my male colleagues.

How so?

It's like in football—there's a playbook and the players all know the game. I always felt like the men had the playbook for how to succeed in academia, whereas I was always struggling to figure out the rules of the game. There were some things that just came so naturally to them, like going to a department head and asking for all kinds of stuff. I rarely asked for help, thinking it would be a sign of weakness.

Did the university treat you differently?

I think it's fair to say that in those days, and sometimes today too, women were not taken as seriously on average as were the male faculty. I mean, I was hired in 1976, right after universities were mandated to hire more women in order to get federal funding. So, throughout my career, though it's never been articulated, I know certain things have happened because I'm a woman.

Like what?

Getting hired, for one. There was pressure for universities to have women faculty members. In my generation, so few of us women were considered for prizes or things like that. So, while I'm sure I benefited from affirmative action, I know that the micro-inequalities along the way have balanced that.

Did you get the same access to equipment or office and lab space as your male colleagues got?

As a junior faculty member, I was supported by my department. Well, not always. On average, women did not have the same amount of space and or equal salaries. On several occasions over the course of my career, for instance, I realized that my salary was not as high as some of my male colleagues, and that was corrected.

How did your male colleagues treat you?

In a way I was lucky. Not only was I the only woman but I was the only biologist. So, if I felt slighted in any way, I could never tell whether it was because I was a woman or because I was a biologist. I felt isolated, but I wasn't constantly attributing this to being a woman. I was used to marching to my own drum because I was the only biologist there.

Did you ever experience humiliation along the way?

Humiliation is a strong word. I remember someone once saying that if you're a scientist in an engineering department, then you must be a mediocre scientist who's just hiding. That made me so mad that I basically just said, "I'll show you." I think that motivated me for the rest of my career.

Did you feel that people expected less of you because you're a woman?

I think a woman is motivated to be better than men just to stay at the same level as them. The feeling is that the students sort of assume you're not up to par until you prove it. With male faculty members at MIT—highly accomplished people—it's just assumed that they're really smart. Women, on the other hand, have to prove themselves a little bit more.

Well, you've certainly done that. And then some, correct?

Yeah, the good thing is you reach a point where you realize it doesn't matter. People are going to think what they're going to think. So, you begin to do things for yourself. Otherwise, the imposter syndrome will kill you. A lot of us women suffer from that.

Were there specific moments when you felt like an imposter?

I mean, it's this tension, right? You know you're good, because you get frustrated if somebody who's not as good is reaching great heights and you're not. On the other hand, it's not like it was easy in the beginning. I came to MIT on a lark, and I was an oddball in this department at the beginning. It took a lot of luck along the way and the help of some good people. I keep thinking how lucky I've been. Especially now

"I NEVER EXPECTED TO SUCCEED TO THIS LEVEL."

that there's this organism, *Prochlorococcus*, that is the love of my life.

How does your husband Don feel about that? You once joked that he had to compete with *Prochlorococcus* for your affection

I think it's a healthy balance, yeah. He does compete for my attention often, but he's very tolerant about it, which is good. He's not a scientist, and I've found that works well for me to be with someone who is supportive and interested in my career, but who can help me not take it all too seriously, so I lead a more diverse life.

Do you have kids?

No.

Was it a conscious decision not to have children?

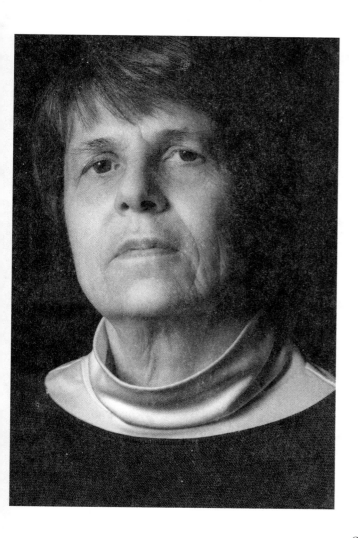

Not an active decision, no. Life just unfolds in different ways. Very few of the women at MIT had children when I got here. It was really hard in those days for women in academia to have families. And I married late. I was in my forties. I probably could have had a child, but it seemed too late, so we didn't. It saddens me that we don't have any children. Well, it saddens me when I'm with friends who have children and they are happy; it doesn't sadden me when I'm with friends who have to worry about their children all the time.

There was a long period at the beginning, several years or so, before you had any success. What made you persist?

Yeah, we studied *Prochlorococcus* for five years without any funding. It was just so interesting, and I had people in the lab who were just as keen as I was. In science, you have to be curious and able to tolerate failure. You can't have high expectations day to day. You have to enjoy the quest more than finding the answer. We used some money that had been allocated for something else and we found enough means to keep us going.

Could you explain in a few words what *Prochlorococcus* is?

Prochlorococcus is genus of very small microorganisms that are extremely abundant in the oceans. And they are photosynthetic. They are the smallest and most abundant photosynthetic cells on the planet, basically. There's an estimated several billions of them in the global oceans. So, the organism is extremely abundant and important for the metabolism of the oceans and is the base of the food web there.

Why is this organism so important?

Prochlorococcus microbes remove CO_2 from the atmosphere and keep it concentrated in the oceans. If all the phytoplankton were to die, and if all the CO_2 in the oceans were suddenly released into the atmosphere, there would be two or three times as much CO_2 in the atmosphere. That demonstrates how important that living film of photosynthesis in the oceans is for keeping the system in equilibrium.

"I REALLY, REALLY LOVE DOING THAT: JUST BEING THERE FOR MYSELF, BEING IN MY HEAD. IT FEELS LIKE I'M GOING INTO MY OWN BRAIN."

Is your research now more important than ever owing to climate change?

Well, in order to understand climate change, one needs to understand the role of the oceans in the climate system and the global carbon cycle to do that, and that's where understanding the role of phytoplankton is key.

What drives you about this research?

About once a month, we discover something new about these little organisms. They've got secrets. They are so beautiful and simple, and yet are so incredibly complex in terms of its global distribution. The more we learn about these microbes, the more their story comes out. It's like opening a present every day. What we learn about *Prochlorococcus* obviously has applications to other forms of life, and so this makes me think about the world in a different way. It allows me to develop a new lens for looking at life on the planet.

Can you give me an example?

Typically, when you study a microbe, you extract a single cell, grow it, and study it. But what we found when we tried to isolate *Prochlorococcus* is that the microbe has other bacteria that it brings along with it and it grows better with them. So, what we're doing now is trying to figure out what it is about this companionship that makes them, let's say, happier.

It makes you realize that most of what we know about biology has been studied in isolation. And if you're studying a living creature in isolation, you're getting a distorted view. So, I'm trying to develop what I call cross-scale biology, in which we try to really understand organisms across all these levels.

How did you feel when President Obama awarded you the Medal of Science?

That was exciting. I was astonished. There I was, working away at what I would call a rather esoteric topic, and so receiving the award meant that somebody out there had actually been reading my papers and understanding the bigger picture of my work. I don't think a Medal of Science has ever been awarded in the field of biological oceanography, so it was thrilling for *Prochlorococcus* to be recognized in that way.

So, it was a sublime feeling?

Oh no, it was terrifying. I'm shy. Being on stage like that is thrilling, but it's a little nerve-wracking. I'm not entirely comfortable being the center of attention like that. I wish my team could have been up there with me. I always feel so indebted to the talented people in my lab. I feel like I'm the conductor and they're the musicians. Without them, I'd be nothing.

Do you think that's a typically female thing to say?

I don't know if that's female. It is my style because those people really are an integral part of what I do. Since I bring together people from different fields, I have to be comfortable not knowing just what I'm talking about half the time. That's often misinterpreted as humility, but I'm not being humble—I'm being honest. I've put together teams of experts, and I can take credit for keeping my eye on the big picture, but it's hard to take credit for all their hard work.

You've reached this wonderful position of Institute Professor, and yet there still seems to be some insecurity on your part. How can this be?

I never expected to succeed to this level. I thought I'd jump through the hoops and get tenure, but I

never expected this level of recognition. The other day, I got an email from someone congratulating me on some honor, and he said he remembered reading my papers as an undergraduate; I was thinking, *I had no idea undergraduates even had a reason to read my papers*. It's hard to have a sense of how the world sees you, I guess.

Where do you think that comes from?

I grew up in a patriarchal family. As a kid, I realized a lot of the light shone on my older brother and there were no expectations for me—and so I didn't expect anything of myself. But all along, I had this drive to be noticed, so I tried to do things right. And I just kept getting things right again and again, and eventually . . . somebody noticed.

What got you hooked on science?

My father was a businessman, and my mother was a frustrated homemaker. She was smart, but back in those days a career was pretty much out of the question for a woman. Me, I took a biology class in college, and I remember realizing that if you did experiments, you could publish a paper and people would believe what you said. And I thought, *Well, this is amazing*. As a young woman, it was a way to find a voice and prove that I knew something. That's what got me hooked on science.

What advice would you give a young person interested in science?

I would just say, if you enjoy it, follow it. It's a field that is constantly renewing itself and the more answers you find, the more questions you'll have. It's a way of understanding the world—of understanding life. What could be more exciting than that?

Do you have any plans to retire?

I don't want to retire because I don't want to miss anything. We're on to some pretty exciting things right now. And I really want to make sure that *Prochlorococcus* is distributed throughout the scientific world before I retire, because we have strains from all over the world and there aren't that many labs studying it. It could easily be lost to obscurity after all this work. I want *Prochlorococcus* to have a future.

When you're working, how do you get into the zone?

I work at home a lot because I can get a lot done there. To shut out the world, I put on noise-canceling headphones—the kind machinists use when they're working with loud machines. I tell my husband, "Okay, I'm going into lockdown now," and that's how I get some of my real deep work done. I really, really love doing that: just being there for myself, being in my head. It feels like I'm going into my own brain.

You grew up quite far from any ocean and didn't even see an ocean until you were 14 years old. Why did you choose oceanography, of all fields? What's your relationship with water?

Well, I grew up on Lake Superior, which is like a freshwater ocean. And when I was in college, my own research project was also on a lake. Then when I went to graduate school, I studied freshwater phytoplankton, though I quickly realized that much of the action and funding was in oceanography because the U.S. Navy was funding a lot of it at the time. So, as a postdoc I went into oceanography, and that's when I got into saltwater phytoplankton.

So, water has been your passion all along?

It wasn't like that. I don't have a particular connection to water, nor was I ever especially passionate about the ocean—or any specific path, for that matter. This is something I try to tell many of my students who wonder, *What is my passion?* or can't decide what they're really interested in. I tell them, "You don't have to know that now. Just put one foot in front of the other and it will find you." That's really what happened to me. I didn't look for it.

What's your message to the world?

I guess it would be that we need to appreciate what nature gives us every day. We need to think about the natural world and all the other species besides humans that we depend upon. *Prochlorococcus* is one of them. We take the living earth for granted and assume it's always going to be there and support us humans. We can't just keep doing this because it's not going to be there if we keep going the way we're going.

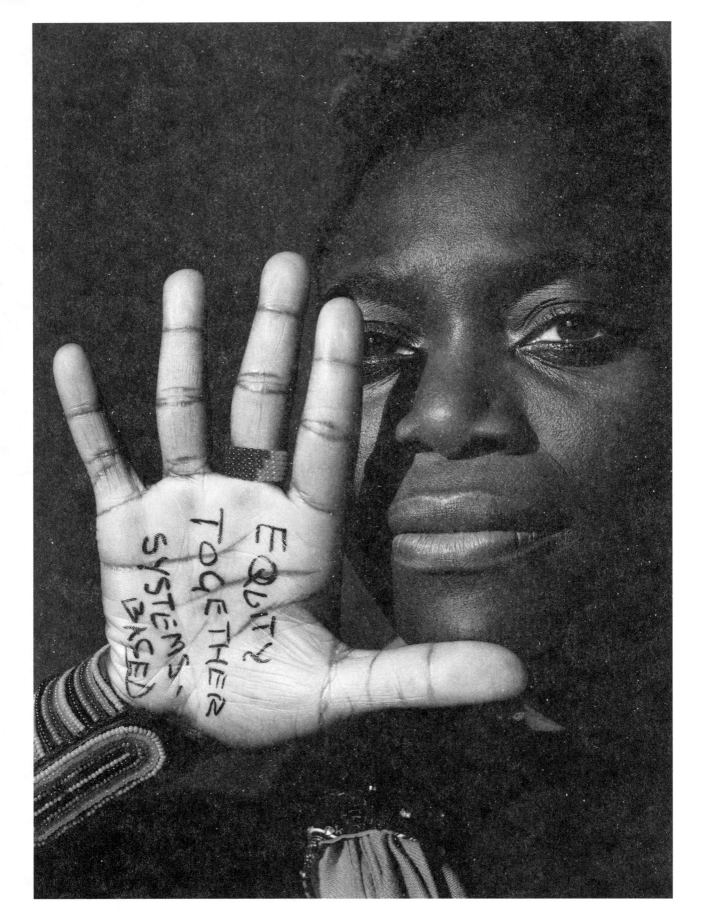

"REMEMBER YOUR ULTIMATE GOAL OF WHY YOU DO WHAT YOU DO."

Tolullah Oni | Medicine

Assistant Professor of Epidemiology at the University of Cambridge
Former Co-Chair of the Young Global Academy
Great Britain

You were born in Lagos, Nigeria. How did you manage to make it big in the West?
Well, I would argue that I'm still making it big. Fundamentally, I think my parents instilled a sense of drive and ambition in my siblings and me from the word *go*. As a result, we've been blessed with a sense of purpose and a feeling of unlimited potential—the belief that we can achieve whatever we set out to do.
Your parents were clearly a positive influence on you. What were their jobs?
My father's background was in food science and technology, and he worked for a multinational

corporation. My mother was a French lecturer at the university. She shielded me from society's sense of female inferiority and instead made me feel that there wasn't any glass ceiling. I guess I was lucky in that respect, given the gender inequality a lot of women face today. With hindsight I can see that this was a deliberate action, and my upbringing was unusual, but at the time I thought anybody could do anything they wanted, regardless of whether they were a girl or a boy. I used to wait at the university for Mum to finish her lectures, and it never struck me as anything unusual—it was just what she did. And if she did it well—well, why shouldn't I?

Were you one of the brightest and best at your school?

I've always been ambitious, and I strived to be one of the best. I tried hard and didn't just rely on natural talent. I'm naturally competitive, so my siblings and I would compete to see who would be top of the class by the end of term. I was a mixture of just sheer stubborn ambition and drive, which made me a fighter.

You say that you were ambitious. Can you remember your earliest ambition?

Yes, even as I child I knew that I wanted to be a doctor, as I wanted to do something that would positively impact other people's lives. When I was about 7 years old, I watched a documentary about open-heart surgery performed on a child, and I was fascinated by the heart—it just looked so alien. I decided then and there that I wanted to be a pediatric cardiologist, as I was really struck by this sick child who should be running around playing or at school. I realized, *I could do something to help children, just like me. That's what I want to do!*

So, how long did you live in Lagos when you were growing up?

I stayed in Lagos until my mid-teens. My parents wanted me to be schooled in a globally competitive education system, so they sent me to a boarding school in Surrey, on the outskirts of London, to finish my schooling.

After school, I took medical studies at the University College of London, before completing an internship in medicine and surgery in Newcastle upon Tyne. Then I spent a year down under, working in internal medicine in intensive care in Sydney, Australia. When I returned to the UK, I worked in a London hospital, and I focused on infectious diseases.

I believe you were particularly interested in HIV medicine even at that early stage?

Yes, I grew interested in HIV following my bachelor's degree in international health, which I completed after taking a year off during my medical studies. This fed my desire to understand the drivers of ill health—how factors outside the country impact something locally. It was a real wake-up call.

I wrote my thesis at Médicins Sans Frontières [Doctors Without Borders] about adherence to anti-retroviral treatment—namely, the treatment for HIV. It was the year 2000, and back then there was a (misguided) perception that people in poor countries couldn't take HIV treatment, as they didn't own a watch so they couldn't know when to take their treatment. Médicins Sans Frontières wouldn't accept this excuse and decided, "We're going to start providing this treatment in low-income countries and show that this is possible." They began pilot

"AT THE TIME I THOUGHT ANYBODY COULD DO ANYTHING THEY WANTED, REGARDLESS OF WHETHER THEY WERE A GIRL OR A BOY."

programs in various countries, including South Africa, where the government was still in denial about HIV, and they provided the first free treatments in a township called Khayelitsha, Cape Town.

And how were you personally involved in this project?

My job was to gather information from the nine pilot sites around the world, at intervals of six and twelve months after treatment had commenced. Unsurprisingly, the results showed overwhelmingly good adherence rates.

It was my first research project, and I found it an incredible experience. So, when I returned to London I thought, *Right, this is what it's all about.* Instead of simply treating HIV, I wanted to find out, via research, how I could improve the mortality rates from HIV. But people in London had access to HIV

treatments and were no longer dying, unlike in other places around the world.

So, you decided to go to South Africa, where they were in desperate need of HIV research?

Yes, I spoke to a professor and told him I wanted to carry out HIV research. He put me in touch with a contact in South Africa, and off I went. I thought I would go out there for twelve months, but I ended up staying for eleven years. It was fantastic.

You enjoyed great success in South Africa, but what hurdles did you face at the start?

Actually, personal doubt and fear of regret were my biggest hurdles. Medicine is such a conservative profession; you're told after completing your training that your whole life is mapped out for you. But I'd jumped off the path mid-trajectory and was constantly told, "You're wasting your career and you're wasting your training." I wasn't certain it would all work out, and I was worried I would fall behind my colleagues.

I decided to ignore those feelings as best I could and I stayed to complete a research doctorate in epidemiology, a higher research degree.

What about working as a woman of color in South Africa? Did that present an additional hurdle?

That was an additional, complex dynamic I had to navigate. I grew up as one of a majority of black Africans in a country full of inequality, but not necessarily of racial inequality. South Africa has a majority of Black residents, but I encountered a huge amount of racial ignorance, with huge legacies of apartheid and structural racial inequalities.

How did you react to this form of prejudice?

Quite frankly, it was something I wasn't equipped to deal with. I had a privileged background and received a good education. Sure, I was in a minority when I was studying in the UK, but that was never a problem; I still had access to good education and training. I loved Cape Town, but the city remained segregated in terms of where white and black people lived. There, I was a visible minority in a majority black country.

"BEFORE I EVEN SPOKE, THERE WAS A SENSE OF ASSUMED INFERIORITY BECAUSE OF THE WAY I LOOKED."

So, what did your patients think of you?

In the first few years, I did a lot of clinical work to accompany my research, and as I'd learned some of the local language, Xhosait, it took a while before my patients realized, "Oh, you're not South African."

I walked in with the attitude, "Yeah, I'm here to do stuff; I'm smart and I'm capable," but before I even spoke, there was a sense of assumed inferiority because of the way I looked. When you engage in ways that challenge the notions that people have, then it confuses them. Basically, people didn't know what to think.

Did you learn to live with their wrong assumptions?

Frankly, it was debilitating encountering that prejudice day in and day out. I used my inner strength to ignore it, and blocked it out by thinking *You might feel this way but I don't accept it and I'm not going to deplete my inner resources by trying to convince you you're wrong and fight these daily battles.*

What about gender inequality? Did you encounter sexism in regard to your professional abilities?

My saving grace was a professor I met while in Cape Town. He was on a mission to build and grow a cohort of academics, predominantly made up of women of color, who would take the lead in health science in South Africa. I immediately applied for a research position and got the job. I had very little experience, but I ended up running a large multisite study on tuberculosis. This professor relied on gut instinct and told me, "Even though you didn't have experience, I just know you're capable of the work."

You ran your own lab. Did you enjoy managing a clinical research team?

A lot of research is about people—the people you're investigating and the people you work with. So I had to quickly learn management and leadership skills, which I hadn't studied in school. At first, I found it difficult because of cultural reasons; even though I'm extroverted, I always compartmentalized my work life and my home life. It was hard motivating my team, so after a few months a South African colleague explained it to me. "It's people related. They don't know anything about you." I realized that I had to open up to them to build rapport. It was a big lesson for me.

What motivated you to work in the area of public health?

When you practice clinical medicine, you have a clear impact on particular individuals and that's a rewarding feeling. But at the end of the day, you are just helping a limited number of persons. I turned toward public health, as I wanted to contribute to society as a whole and try to prevent more people from getting sick. Fundamentally, I wanted to increase the scale of my impact.

So, how did your work develop during your time in South Africa?

I initially went to South Africa to understand how HIV and tuberculosis interact and what factors drive the outcomes of people suffering from those two diseases. But then I started to notice how many people suffered from high blood pressure, diabetes, and obesity, so I looked at how these noncommunicable diseases interact. What became clear to me is that these are preventable conditions, driven by external factors such as nutrition and exercise, particularly in urban environments. In Africa, 62 percent of city dwellers live in slum conditions, where there is real potential for disease. I was working in a slum area, in an informal settlement. You tell a patient there

that they need to eat better, and then you walk out of the hospital and see the reality, and you realize their choices are limited.

So, you wanted to look at the far bigger picture?

I've been looking at the bigger picture my entire life! Yes, so I decided to look further upstream—at the environmental exposures that were making people sick, such as food, housing, settlements. This wasn't just about health care anymore. I decided to set up a research group called the Research Initiative for Cities Health and Equity (RICHE), and in fact I still lead the initiative today, trying not only to treat the illnesses but also to alter the conditions causing those diseases. We form partnerships with sectors that wouldn't normally consider themselves responsible for public health matters, and we try to get them to understand the health implications of what they're doing.

Africa is one of the continents with the fastest-growing population. What do you think can be done to improve public health?

Africa needs a good long-term strategy in terms of disease prevention and health creation. We mustn't forget that disease is not inevitable; it's preventable, especially among young people. Some people say we can't afford to offer both health treatments and prevention; I say that we can't afford not to. The cost of treatment is far higher than any amount of economic growth we could hope for.

Recently I've been focusing on young people, as the behaviors and preconditions for these diseases start when people become independent.

What should the West specifically be doing to help Africa?

If the West is serious about disease prevention and health creation, then it needs to pursue coherent policies and not be duplicitous. At the moment, one hand gives while the other hand takes away. The West has to stop acting so superior and begin to engage in meaningful, equitable partnerships, not paternalistic, "We know what's best for you" approaches. Those never work out in the long term.

We're all connected, and we need to start acting like we're all part of the same ecosystem. We have to address the significant inequalities among countries and regions. Ultimately, doing so will bring us a collective increase in well-being.

How do you personally stay healthy?

That's a long-term goal I struggle with on a daily basis. On the one hand, I find it difficult to turn down things that I'm interested in doing, and I tend to want to do everything. I strongly believe that I can have my cake and eat it, and I regularly try to do both. I go running a lot, and that's how I maintain my mental well-being and my physical health. It's how I create space for myself and clear my head.

What words would you use to describe yourself?

Energetic, stubborn, curious, a runner, optimistic.

So, what's your advice to anyone interested in studying science?

There's so much that we don't know; science is a study of the unknown that allows you to contribute knowledge and understanding of the world. Sometimes in your pursuit of science you're discouraged from forging new paths. My advice is this: Don't fear the path less trodden; rather, choose it because that's what science is all about. In terms of personal qualities and mindset, you need sheer persistence and the ability to remember your ultimate goal of why you do what you do.

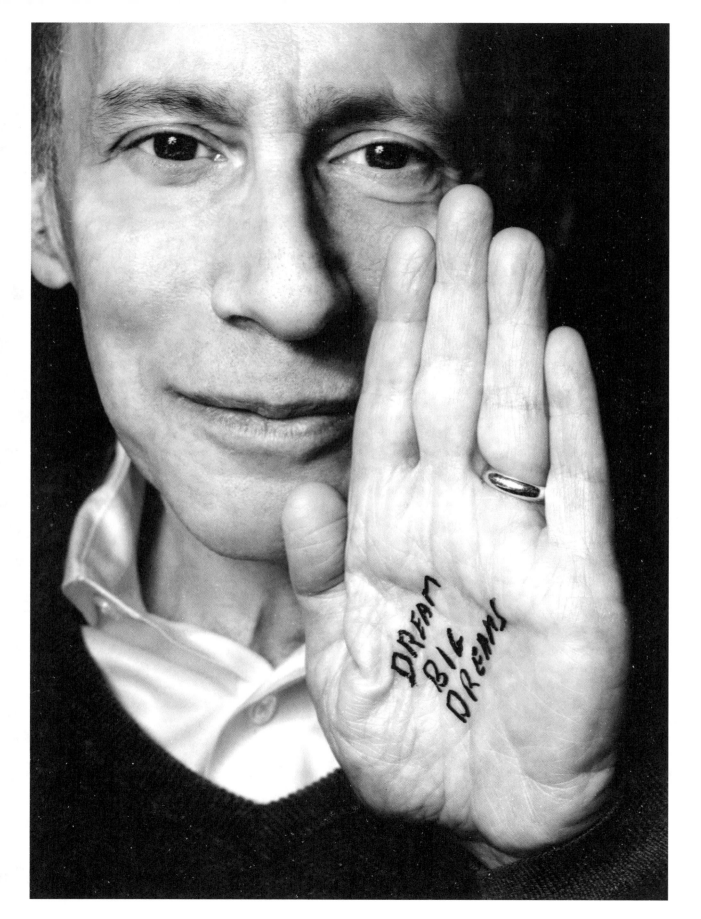

"YOU CAN CHOOSE TO ASK EITHER VERY IMPORTANT QUESTIONS OR LESS IMPORTANT QUESTIONS."

Robert Langer | Quantum Physics

Professor of Chemical Engineering at the Massachusetts Institute of Technology (MIT), Cambridge
Breakthrough Prize in Life Sciences 2014
United States

Professor Langer, you have thirty-three honorary degrees. You have registered 1,350 patents, and your *h*-index is over 260. You are the most cited engineer in history. What has shaped your thinking? What is behind your incredible drive, your positive attitude?
For one, I think science and engineering are fascinating. Some of the things you can do are almost magical. But what's really important to me is my impact on the world. I am driven by the things we can do now to make the world a better place, save lives, improve people's health, and make them happier.

Now you're very successful and influential, but when you finished graduate school, you ran into problems. You were rejected for positions at many universities and colleges. Nine research grant proposals were rejected. You applied to medical schools, but were not accepted. Could you explain a bit about this period?

In my career I have experienced a lot of rejection. After finishing graduate school, I became a postdoc in a hospital, Boston Children's Hospital. I was the only engineer in the hospital. It's a challenge finally being out on your own, after having had the structure of high school, college, and graduate school. Since I was an engineer, it was also hard for me to learn biology and immerse myself in biochemistry. I still haven't had a biology class since tenth grade. But I just kept at it and finally learned enough to do okay. The first six years as a postdoc were difficult.

Then I tried to get grants and to find a job after the postdoc. I had a vision of wanting to apply engineering to medicine. But I had a hard time obtaining a faculty position in a chemical engineering department. When I finally did, it didn't go so well either, because I had difficulty getting grants for research. Then the department head who had hired me left, and a lot of the other people in the department didn't want me to stay. But you just have to push through these problems.

Would you describe yourself as stubborn?

I'm not sure I really had great alternatives. I believed in what I was doing. But I guess I am stubborn.

After you earned your graduate degree in chemical engineering from MIT, you had the choice of going into research or working in industry. What made you to go into medicine instead of getting a job at an oil company and making money?

When I went to my interviews at various oil companies, I felt that the things they were doing weren't that impactful—at least the jobs that I would have been doing. Yes, I would have made a lot more money, at least initially. The kinds of things they would have asked me to do would have been something like: "Well, we want you to increase the yield of this chemical by a very small amount." And, of course, that can make a lot of money, but I didn't feel it would have much of an impact.

Was there a particular mentor or role model who was important to you in your early career?

Yes, during my postdoctoral work at Children's Hospital, Judah Folkman, a famous surgeon, was my boss. He was the kind of guy who believed that almost anything was possible, and he wouldn't give up. He was visionary. He had big ideas. All those things were wonderful for me to experience as a young scientist. I clearly saw that if we could do the things he wanted to do, they would be really important contributions. This included finding substances that could stop blood vessels from growing in the body, which would ultimately lead to new ways of treating blindness and curing cancer.

Tissue engineering and creating drug-delivery systems—these were new fields at the time?

Right. The first two things I worked on were angiogenesis and drug delivery. Actually, tissue engineering came later, when I met a young surgeon named Jay Vicante. He started talking to me about transplantation issues, and that's how we came up with some ideas for tissue engineering. This was just another great advantage of being in a hospital and being in a surgical environment where I met these great people.

Did working with Dr. Folkman influence how you later worked with your own students?

I think to a certain extent it did. When I teach students, I hope they see to what extent science can do an enormous good. There's a tremendous amount one can learn by doing science and engineering. And I do believe that almost anything is possible, too.

"LATER ON IN LIFE, YOU'RE REALLY JUDGED BY THE QUESTIONS YOU ASK."

You've also talked about trying to stretch students, helping them do bigger things.

Yes. One of the philosophies I have developed over time is this: if you are a student—whether in grammar school, high school, or college—the way you're judged by the world is how well you answer questions other people ask you, right? How well do you do on a test? But later in life you're really judged by the questions you ask. You can choose to ask either important questions or less important questions. I try to figure out how can I help my students make that transition from someone who gives good answers to someone who asks good questions.

You have now become an expert in your field—specifically in drug delivery in the brain. Could you explain this process to nonscientists?

Together with Henry Brown, another friend of mine, we developed little wafers that can be implanted and then that slowly deliver an anticancer drug. So, if someone has brain cancer, the surgeon first removes as much of the tumor as possible, and then inserts one of these little discs—these little wafers—and closes up the patient. The disc delivers the drug to the tumor for at least a month, if not more, and it is hoped that it will kill a lot of it. The point is that the wafer targets the same spot, over and over. It's still not a cure, but by reducing the tumor, the patient's life is prolonged and suffering is relieved.

Can you control the disc remotely?

Yes. We've come up with little chips and other technologies that allow us to regulate the delivery of the drug by remote control.

There were many years between the time you developed this idea and when drug delivery was implemented. Why such a delay?

As with anything in medicine, it just takes a long time from the initial discovery to the time doctors widely use it. The process involves animal studies, clinical trials, and the approval of the FDA or other regulatory agencies. It also takes a lot of money—not just to fund the research but also for the companies working to provide the drug.

We published the first paper on the angiogenesis inhibitor in *Science* in 1976, and the first angiogenesis inhibitor received approved by the FDA twenty-eight years later, in 2004. With the drug-delivery systems, things happened a little faster. I think the first paper appeared in *Nature* in 1976, and the first system got approved by the FDA in 1989, thirteen years later.

How far along has your other field of tissue engineering come? Are you creating and replacing organs? Is this engineering being used in human beings?

Together with Jay Vicante, we came up with some basic ideas for combining plastics and cells to create new tissues and organs. So, we developed a lot of basic methods and principles, and then different companies have taken things a step further toward development; we've been involved in some of those companies.

"WE'RE ALSO EXPLORING HOW TO MAKE ORGANS ON A CHIP . . . WHETHER YOU CAN MAKE A HEART OR AN INTESTINE ON A CHIP."

For example, if someone suffers a burn, we can now make skin for that burn victim. If someone has diabetic skin ulcers, we can now make skin for that, too. A lot of other applications are in clinical trials, such as making new cartilage and making new spinal cords. We're currently working on hearing loss. We're also working on an artificial pancreas, on new intestines.

We and other people are also exploring how to make organs on a chip—whether you can make a heart or an intestine on a chip, for example. I have students who are exploring whether it is possible to make meat or leather this way. So, the field has gotten pretty big.

Do you consider yourself a successful businessman?

I don't know if I'm a successful businessman, but certainly it's important to me to see that what we do in the lab gets out into the world. So, I've gotten involved in businesses that help do that. That's been a rewarding intellectual experience. Science itself is great, but I want to go further. I want that science to have an impact on people's lives. So, the companies have done that.

Some of my students have loved starting companies and seeing the work they did in the lab get out into the world. It's been a dream for them. That's

wonderful. I want to help my students live their dreams.

How are the competition and rivalry in your field?

Well, there's always some rivalry. But I just think all boats rise together. Here is an example: I was an advisor for Gentech, which was a great company; their rival, of sorts, was Amgem. So, when Amgen folks would publish a paper in *Science* or *Nature*, and then company's stock would rise twelve or fourteen points because of the article, the people at Gentech would be upset. But I'd say to them: "Look, your stock went up eight points because of them, and you didn't even do anything." I think that if your competitor does well, you're going to do better yourself.

You seem totally dedicated to the work you're doing.

That's true. Absolutely.

How do you manage your private life, your marriage? You have three children. How did you keep it all together?

My wife, Laura, is a PhD and a scientist. She's also a straightforward person. When my kids were little, she said to me, "I want you home at 7:00 p.m. every night, so you spend time with them." I didn't think of that as pressure.

I would work at night, even sometimes with the children alongside. I still have pictures of my oldest boy when he was about 6 months old, crawling over me and eating my chemistry books. I would play with all the kids and help put them to bed.

During this time, how much sleep did you get?

I need sleep. Probably six or seven hours. But even now that I'm older, if I have to go to the bathroom in the middle of the night, I take my iPad and answer five or ten emails. I'm always thinking about stuff; I'm always working. But then again, I don't view what I do as work. I'm 70, and I could easily retire. I've done well financially. I don't need the money. But I love it. I can't think of anything else I'd rather be doing than going in and talking to my students, coming up with ideas and ways of inventing something, and seeing the ideas work out. I travel the world and help different countries, and I meet interesting people. It's not a job, you know. It's almost a dream.

You are also in good physical shape; I hear you spend two hours a day exercising. And you have been doing this for some thirty years, right?

We have a gym at home. I lift weights. I ride a recumbent bike, and I can work while I do that. I can be on the phone and do things at the same time. I also read papers, but my students probably don't find my handwriting so neat.

The reason I exercise so much is that my dad died of a heart attack when I was 28 years old. He was 61, and it scared me tremendously. So now I'm 70, and I just want to live as long as I can for my children, my wife, and the people that I work with. Of course, I also love to eat. So, if I didn't exercise, I'd probably be gigantic.

What made you the person you are now?

I'm not exactly sure. My dad would play math games with me. My mom is just a lovely person who cares a lot about people. My parents got me those Gilbert chemistry and microscope sets. With the chemistry set, I could mix chemicals, and it was almost magical. They would change color; and I could make rubber—things like that. But I also did a lot of sports. I loved playing football and baseball and basketball with the guys in my neighborhood. I had a pretty standard middle-class upbringing in Albany, New York.

In terms of my education, I was a reasonably smart kid. I wasn't top of my class, but I was usually in the top 10 percent. When I did pretty well in school, I'd get praised for that. But my parents didn't pressure me to excel; I think they just wanted me to be a happy kid. I think about that for my children today.

Why should young women or men study science? What advice would you give to those who want to?

There are a number of reasons to study science. First, I hope you love it and you're curious. Second, almost all the advances we've seen in the world have come from science, whether it's computers or medicines. You can play a role in making the world a much better, safer place.

My advice to young people is to dream big. Dream big dreams that can change the world and make it a better place. At the same time, recognize that you'll come across a lot of obstacles. Don't give up. Keep persisting. Try to follow those dreams.

Some scientists have told me that out of ten attempts at something, they fail nine times.

Absolutely. I feel like I fail a lot more than I succeed. Looking back at my PhD thesis, which took me three years, I realize that if I had known at the beginning what I knew at the end, I probably would have been able to do it in one or two months.

What dreams do you still have?

My personal dreams are to come up with more good ideas and get them out into the world as much as I can. Also, I want to keep training the very best people in the world in bioengineering and biomedical engineering. That's the beauty of MIT—you get to work with such wonderful people. We have over 300 students who are professors now, working all over the world. We have hundreds and hundreds more who have started companies, who work at other companies or in government, who are lawyers, who have become venture capitalists—all kinds of things. That's been really important to me.

How do manage to keep your positive attitude?

I think it's a genetic thing. It's just my nature to look on the bright side of things. That's worked for me.

"MY ADVICE TO YOUNG PEOPLE IS TO DREAM BIG. DREAM BIG DREAMS THAT CAN CHANGE THE WORLD AND MAKE IT A BETTER PLACE."

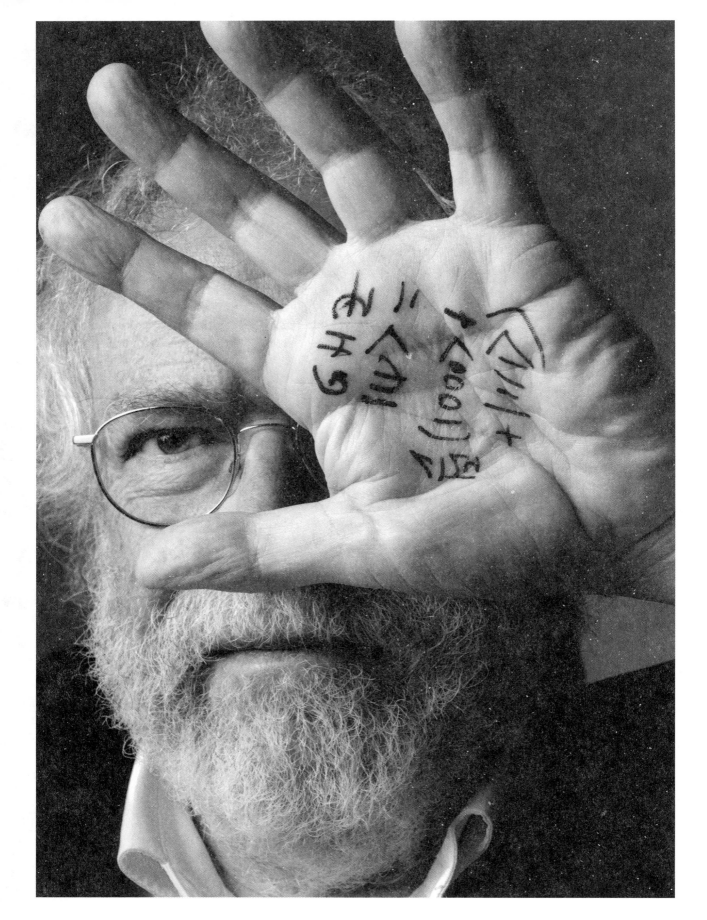

"STAY TRUE TO YOURSELF, NOT IN THE SENSE OF WHAT IS MOST BENEFICIAL TO YOU AT THE CURRENT MOMENT, BUT WHAT IS TRUE TO YOUR INNER SELF!"

Anton Zeilinger | Quantum Physics

Professor of Experimental Physics at the University of Vienna
President of the Austrian Academy of Sciences
Austria

Professor Zeilinger, when you were at school, one teacher told your mother that you were a hopeless case. How did he reach this verdict?
I was lazy as hell and learned just enough so as not to fail. I also occasionally rubbed teachers up the wrong way when I knew more than them. On the other hand, I had a fantastic physics and math teacher. He was enthusiastic about his subject, and that's the most important thing a teacher can bring to the table.

You once said that your father was a role model for you because he was headstrong and stubborn. Explain?

My father showed me I can achieve a great deal by being headstrong and by pursuing my own goals, which you could also call stubbornness. I won't allow myself to be dissuaded from a content goal in science, no matter how often others call it nonsense. I've always done what I find exciting and have dropped out of research subjects when they became fashionable. That was often "outsider physics." When I applied for professorships, there were lots of universities that rejected me, but they would be patting themselves on the back today if they had accepted me.

Have you always been so self-confident?

That self-confidence was actually always there, and that's why I was able to put up with all the negative feedback I received. The only thing that counts in science is to that you go your own way and not let yourself be sidetracked.

"MY FATHER SHOWED ME I CAN ACHIEVE A GREAT DEAL BY BEING HEADSTRONG AND BY PURSUING MY OWN GOALS, WHICH YOU COULD ALSO CALL STUBBORNNESS."

Have you always consciously pushed your boundaries?

I often didn't respect boundaries. Independence has always been important to me. You shouldn't make yourself dependent on social factors, especially at the age of 16 or 17. Fortunately, I had a classmate who was just as interested as I was in fundamental things. While others were out partying, we were discussing the Big Bang. It's important to know that others like you.

You went to MIT when you were 32. What was it like to leave Austria?

That was a key experience because I learned that even at the leading universities of America, your colleagues are just the same as they are everywhere else. MIT was already prestigious back then, and there were lots of good people there, not just one or two. But I soon saw that I could keep up with them scientifically. That encouraged me for the rest of my life.

You've been working on quantum physics. Have you ever had a eureka moment in the process?

That would be saying too much. I didn't attend a single class in quantum physics in college—no lectures, nothing. That was possible at that time, when universities weren't as regimented as they are today. But for the last, big final exam, I went to the professor who examined students in theoretical physics and asked him to especially ask me questions about quantum mechanics. I had learned it from books and immediately saw a beautiful mathematical theory, but that no one really knew where it was going. That uncertainty fascinated me, and I've stayed that way my entire life.

In 1997, you conducted a special experiment with teleportation. What was revolutionary about it?

It wasn't my most important experiment, but it certainly was the most popular one. It involved transferring the properties of one photon to another without any link between the two. Six colleagues had formulated the theory for it in 1993, and at the time I thought it was a nice idea but completely impossible—not knowing that we had already developed the means for doing the experiment in my

laboratory. Einstein had spoken about "spooky action at a distance"; that is, when two particles are entangled, a measurement on one can affect the other's state, without any contact between them. In teleportation, you can use this entanglement by transferring the properties of a third particle to the other side. Thus, without a link between the two places, information can be transferred.

This was a point of great interest to our American colleagues, too. At that time, we won the race because my group had secured the finances. It was my strategy from the start to have high funds in reserve. That way, I could start immediately and didn't lose a year making applications.

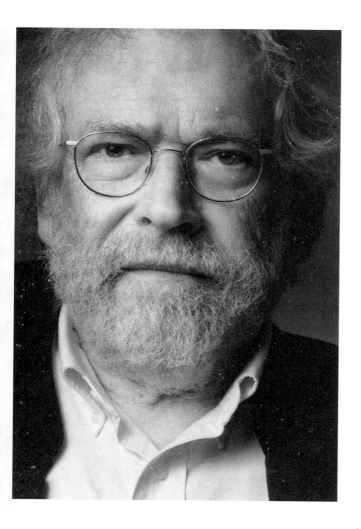

Your student Jian-Wei Pan is now one of the leaders in quantum cryptography; in 2016, he launched the *Micius* quantum satellite. How do you feel about his now being such a leader in this field?

It should be every teacher's goal that their students are better than they are. In this case, we also work together. It was a good feeling when the satellite was launched, and I knew that a lot of it was due to my own work. At the start, there was rivalry between Jian-Wei Pan and my coworkers, though not with me. I don't compete with my students, but I won't hold my own young people back, either.

The satellite transfers not just the matter of the object but also the information. Can you explain how that happens?

I'll start with myself. I consist of all kinds of atoms. If I exchanged these atoms for other atoms, I would still be the same—meaning that it's not the matter that counts but, rather, how it's organized. That organization is the information. Through our experiments, it became clearer that the basic concept in the natural sciences is information, not matter.

In addition, the transmission is secure. This makes your research of value to anyone interested in secure information, correct?

You shouldn't mix them up: teleportation and cryptography are two separate applications of the basic idea of quantum physics. When it comes to secure information, many think of military use first, but the majority of applications are for commercial or private uses. Ultimately, it's about security for everyone—for example, online banking.

I'm optimistic and believe that we'll not solve the problems we currently face by being hostile to technology but, rather, by adopting more technology.

Do you agree that Europe is falling behind in this field of science while China is gaining more ground?

Europe is structurally incapable of defining major strategic goals and then following through on them. That's because of its decision-making processes. The satellite is a good example of that. I began to launch the competition for it in Europe in 2003, but

"A CONTINENT LIKE EUROPE, WHICH HAS NO RAW MATERIALS, CAN ONLY SURVIVE WITH RESEARCH."

it didn't stand a chance. So many countries have to take part, and industry's interests have to be satisfied, too. Then in 2008, I got a call from Pan offering to collaborate, and I agreed on the condition that all the results would be published. So, Europe got left behind, and it still is behind today.

Europe also seems to be falling behind the United States in some areas, while China has become a major player. How do you see Europe's technical future?

In the long term, it's about where there are the best opportunities for unusual ideas. That's why I advise my Chinese colleagues to introduce more opportunities for young scientists to work independently. That's the prerequisite for long-term success. The Americans are strong at this while we in Europe are only moderately strong.

When I initiate a project today, I shouldn't start from the current state of play but, instead, from what will happen in five, six, seven, or more years. In that respect, Europe is far behind. But a continent like Europe, which has no raw materials, can survive only with research. It needs more resources and needs to focus them better. Europe is very good at the scientific analysis of complex situations, and we should build on this strength.

You say that you have to think differently to understand quantum physics. What does that mean?

That I shouldn't try to solve problems using previous ways of thinking. By this I mean, for example, the fundamental cause-and-effect principle or the idea that our description of nature assumes the existence of something independent of our observations. Once more, there are promising approaches in using information as a fundamental basis of physics.

What significance to our world view and consciousness do you attribute to quantum physics?

I believe quantum physics really has the chance to fundamentally change our view of the world. It's about information, about knowledge, about the role of the observer in the world— and that's largely wide open. Understanding the world mathematically is fantastic, but philosophically we haven't got there yet. Maybe I'll be lucky enough to live to see someone young manage to really grasp quantum physics. I don't think I'll be able to do that myself anymore.

You once said that as a scientist, you're an agnostic, but as a human being, you're neither agnostic nor atheist. What did you mean?

Since I'm neither an agnostic nor an atheist, I'm a theist. I was fortunate in that I didn't grow up in a family that was heavily oriented toward one particular church. My father was Roman Catholic, my mother Protestant. I was baptized Catholic because my family lived in Austria, and on Sunday I sometimes went to church with my father, sometimes with my mother. Going to church had positive connotations, even though neither my father nor my mother went every Sunday.

What values did your parents instill in you?

It was significant that money was never of great importance to my family. My parents also taught me the importance of true loyalty to other people. My mother was driven out of Silesia, and she passed on to me her ability to bounce back.

What do you see as important to be successful in life?

The most important thing is to follow your nose. If young people have ideas, let them follow them. Children of friends occasionally come to me for advice. I always tell them, "Forget the ifs and buts! If there is something that excites you, you will beat the others."

How have you satisfied your ego?

Recognition is an important motivator. At the start, my doctoral advisor Helmut Rauch only recognized my work by constantly arguing about quantum physics. That made me realize that he took me seriously as a partner. Later, at MIT, it was the same with Cliff Shull—namely, recognition between equals. The international recognition came slowly, and very late. The gratifying thing about winning prizes or being elected to a prestigious academy is that these become possible only when colleagues take the trouble to make a proposal.

Some say that after a successful day in science, you've created something that wasn't there before. Have you ever felt like that?

Teleportation made me feel that way, as did the proof that certain forms of quantum mechanics are possible, and others aren't. And nothing can replace the great feeling of working with lots of young people who are equally enthusiastic. My most interesting new discovery was that of the crazy properties of multiple particle entanglement. I worked it out with two colleagues, Daniel M. Greenberger and Michael A. Horne, that the way particles behave is completely crazy [GHZ experiment]. Being able to show that in the laboratory was the greatest scientific success of my life. With that, we opened a door also toward technological applications. The Greenberger-Horne-Zeilinger states (GHZ states) are now central to quantum computers.

What responsibility do scientists have for what they do?

[U.S. physicist] John Archibald Wheeler did a lot for the foundations of quantum mechanics and also collaborated on the Manhattan Project. I asked him about the implications of the atomic bomb, and he gave me two answers. One was that the largest hospital ever built in human history was never put into operation; that was an American hospital on a Pacific island intended to treat the wounded in the planned invasion of Japan. The second answer was that he had a massive stack of letters and postcards from Americans, thanking him for the bomb that saved their lives and the lives of their sons. There's not much more to say about that. I once asked the Dalai Lama what he thought of basic research and its dangers. He said that there should be no limit to basic research, because ignorance is a source of suffering. I fully subscribe to that.

What is your message to the world?

Stay true to yourself, not in the sense of what is most beneficial to you at the current moment, but to what is true to your inner self! For example, the moment I do something bad to another person, I can't claim that I'm remaining true to myself.

Why do you think studying the classics is still essential today?

It promotes openness to deep questions. When I read texts in ancient Greek, and I realize that the important questions were the same three thousand years ago as they are today, it instills a certain humility. That's why there should be at least some high schools offering a classical education and you can't opt out of Latin and Greek.

"MAYBE I'LL BE LUCKY ENOUGH TO LIVE TO SEE SOMEONE YOUNG MANAGE TO REALLY GRASP QUANTUM PHYSICS. I DON'T THINK I'LL BE ABLE TO DO THAT MYSELF ANYMORE."

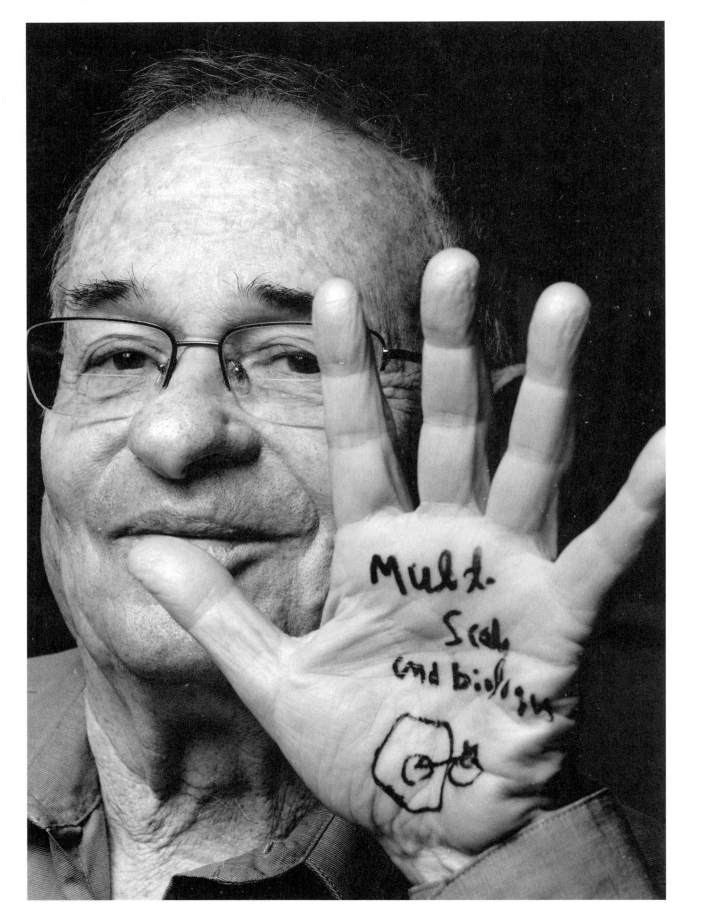

"ONE WAY I SUCCEEDED WAS BY DOING THINGS FIRST AND BEING THE BEST."

Arieh Warshel | Chemistry

Professor of Chemistry and Biochemistry at the University of Southern California, Los Angeles
Nobel Prize in Chemistry 2013
United States

Dr. Warshel, do you have a quarrelsome spirit?
People used to say that I enjoyed getting into fights. But really, I don't. Especially before the internet, when I would get back from a trip and find a rejection letter in my mailbox, it was like I needed three days to relax after the trauma. I used to not even respond when I was attacked scientifically, but then I realized this created an even bigger problem because people started believing my naysayers' arguments.

What do you mean, "attacked scientifically"?

Often somebody would use a problematic method, reach a different conclusion than I had, and attack my findings and my method. Eventually, in a responding paper, I would explain why the attacking paper was wrong. This happened repeatedly. Then the author who attacked my paper would become really hateful, resentful, and demand how dare I attack him.

So, you're saying that you always have acted out of self-defense, so to speak?

I don't think I picked the fights. I'm like Israel; I always respond when I'm attacked, but I very rarely am I the one who starts the attack.

You've lived in America for many years. At this point, do you feel more like an American or like an Israeli?

Israeli, definitely. I feel like an Israeli, I behave like an Israeli. . . .

You spent your early years in a children's house in a kibbutz, in British-mandated Palestine. What impression did this communal life have on you? Did you see your parents much?

I remember the children's house very fondly. I've heard people say in recent years that the experience was traumatic for them, but I had a strong connection to my parents. There was a small group of kids in the house and we played together a lot, and then our parents would come to put us to sleep. For me, it seemed like a perfectly natural way to live.

Were there any disadvantages?

I can imagine the mothers didn't love having their young children taken from them so that they could go to work, but from my point of view, it was a nice way to grow up. We kids got a bit scared when we heard the coyotes howling at night, but it would have been just as scary if we had been sleeping in our parents' house.

Your parents moved to the area that would become Israel in the early days of the kibbutz movement. What was that like for them?

Yes, they moved there from Poland, though my father is from what is now Belarus. They left in the early 1930s, and their kibbutz Sde Nahum was founded in 1937. It was guided by socialist and communist ideals: the women should work and not have to stay at home with the kids, since it's more efficient to have one woman looking after twenty kids than every mother caring for just her own child.

You once said that the period 1957–58 was the happiest time of your life. Why?

I had moved from my kibbutz to a large class in a more established kibbutz nearby. It was a joint class, full of kids from three kibbutzim. We were very tight. It was the last year of high school, so there were lots of activities in the evenings. I did acrobatics and we also played volleyball and other things. We also had several very good teachers. I really liked the atmosphere.

When you were young, you liked to experiment. You even once built your own handgun.

We had a lot of free time, and I pursued different interests. I built balloons that were propelled by fire, and I also tried to parachute cats off buildings, but always relatively low ones. I read books about building different stuff, and one of them was an instruction manual for building guns. So, my friends and I went to the shop for the materials, came back, and tried to assemble a very primitive handgun.

What drove your activities? A deep-seated love for science and discovery?

I don't think so. It was more curiosity for things that were interesting. None of my endeavors in my youth had that much depth. Well, besides the holes I sometimes dug just to try and find gold or antiques. Those holes were relatively deep.

Were you a precocious child?

At some point, I knew I wanted to go to university. I couldn't directly matriculate, because the kibbutz did not allow it, and the system doesn't favor people who, let's say, went to school in the city. City kids were told what would be on the entrance exam, but I had no idea. Take Bible studies, for instance; I had to know the entire Bible, front to back, while they were told what the questions would be.

You must have studied a lot.

I carried my books for the matriculation with me everywhere. Even during my time in the army, when I was in a tank, I had my books alongside. I had them with me so much that once I noticed mice had started eating some of the pages. But they were probably just looking for the rugelach (*baked confection from the Jewish communities of Poland*) I had with me.

Clearly things worked out for you?

I succeeded, yes. Already in my first year of university, I was getting high marks. And then I got close to perfect grades my last three years. I also got the best student award in my third year from then Prime Minister Levi Eshkol. That was very satisfying. I've always had this theory that if you're the best student in a small village, you could easily be the best at a higher level somewhere else.

And in 2013, you received the Nobel Prize in Chemistry for the development of multiscale models for complex chemical systems. Can you explain about that?

That's right. We found a way, with a computer, to look at and understand the structure of proteins and in particular, what they do exactly.

What was it like to receive the call from Sweden?

My wife expected it. She put some flowers out. I knew my name was under consideration, but it wasn't clear who would get the prize. The suspense was so intense that I took half an Ambien so that I could sleep until 3 a.m., then I could see who got the award.

How did you feel when you heard you had won?

I felt very. . . . Yes, I felt very happy and so on.

You were awarded the prize along with two other scientists, one of whom was your archrival. How did that feel?

Yes, that was Martin Karplus. [Michael Levitt was the other winner.] He was always an unfair competitor. Here's an anecdote that may help you understand my feelings toward him. When I was admitted to the National Academy of Sciences, a friend called and asked, "Aren't you happy that he's still alive?" He meant Karplus and wondered whether I was happy

that he was alive to see my admission. My answer was, "I'm happy that I'm alive to receive it." I try to be above such things, but I'm only human.

What obstacles have you had to overcome in your career?

First and foremost, there's always been major resistance and competition. For a long time, people claimed there was no way my results were valid and that I was probably lying. It took time for people to realize that almost everything I had done was being adapted by other scientists who were trying to take credit for it. It wasn't easy to defend my work, but one way I did succeed was by doing things first and the best. Eventually, I got the credit I was due.

It was common for people to steal your ideas?

This sort of thing happens all the time. I was never smart enough to name my methods after myself. I chose the worst names, like QM/MM and EVB. My daughter once told me, 'Dad, you choose really terrible names. Have you learned nothing from advertising?'

Did you have a strong mentor?

A strong mentor? No. My PhD mentor was a great person. He was at the Weizmann Institute, and he was the scientific director when I joined. He was a cultural, intelligent, and conscientious person, but he was never a fighter. I didn't have anyone to protect me. But hey, even if you have a strong mentor, things don't always work out. My postdoc mentor, for example, eventually became my enemy. And he was strong.

Would it be fair to say that you feel underestimated by your colleagues?

Yes, at least until the Nobel Prize, but I overestimate myself, so there's no problem.

Speaking of fighting, you were in the Israeli army during the 1967 Six-Day War. What was that like?

That was a short war. We won quickly and didn't have much time to digest anything. Now, the 1973 Yom Kippur War, that was a different story. Our regiment made a decisive opening to dislodge the main Syrian force. Many people got killed. Our tank drove

over a mine and some of our guys got wounded. It was a very, very different war. For the first time, I wasn't sure whether we would win.

And that was traumatic for you?

It took me a while to understand what was happening and for it to sink in, then it became traumatic. When I first saw an Israeli tank destroyed, I didn't believe it. One night, we had a Syrian prisoner say to us, "Oh, Syria completely wiped Israel from the Golan Heights." I thought he was crazy. But gradually this feeling emerged that maybe Israel wasn't invincible after all. We also lost maybe twenty or thirty people, plus wounded. We weren't in the regular army that initially encountered the Syrians—we were the reserves—so we entered the battle later and had fewer casualties.

Did you have any lingering problems from that fighting?

I had some posttraumatic stress for about a year after the war.

And then you went to the Medical Research Council (MRC) in Cambridge, correct?

After the Yom Kippur War I decided to focus more on biology. I collaborated with Mike Levitt, who was at the Weizmann Institute, and we started working on the issue of protein folding. When I moved to the MRC, it was all molecular biology all the time, and with some very distinguished people. Essentially, they had Nobel laureates on every floor. It was a productive year. We published several major papers that year, including the one on enzymes that would later win us the Nobel Prize.

At that time, computers were changing the nature of your research in a big way. Could you talk a bit about this?

Computers have always been important in my research. Rather than write complicated analytical formulas that would not be applicable to complex molecules, I became increasingly confident that I could probe the atomistic world with the help of computers. Furthermore, I found I could work fast that way, making fewer mistakes when I compared the results I got with the formulas I tried to implement in the computer program versus those I got by numerical computation. When the results matched, I knew the programed formulas were right. I used it as a guide.

And now you're at the University of Southern California, where in addition to teaching you continue your research?

In America, everybody who works at a university must also teach at some point. But I continue to advance my research. I developed new approaches for modeling biological molecules in a physical way, for instance. But I don't always get credit for everything. Other people call my methods by other names. But that's the story of my life: I come up with a theory that is instantly attacked, though eventually it's adapted.

Did you ever struggle to publish your research?

Oh, yeah. My way of doing things—that is, using intuition to figure out where to go rather than writing formulas—hasn't always been well received. If you instantly go to the solution by intuition, people often reject your findings out of hand. I've gotten used to it. My way has allowed me to solve a lot of problems that other people were unable to solve. And I turned out to be right 98 percent of the time.

Is this kind of rejection widespread in the world of peer-reviewed science?

Once human beings are involved, egos affect people's judgment. Sometimes your competitors will dispute your paper and reject your findings. Anyone who has ever had their paper sent by a journal for review to the competitors in that field knows that those competitors will try to disparage it.

Did this bother you a lot?

I usually got upset when reading misleading reviewers' reports. But after a few days of being upset, I would write my rebuttal and then I could relax.

How's your life-work balance?

I think I was always a relatively good parent. I came home around 5 p.m. and stayed until 8. I read to the girls and put them to sleep, and then sometimes I

would go back to work. We also did weekend trips, like going camping somewhere. But yes, sometimes I would go back to the office at night to submit jobs to the computer team, because the turnaround time back then was so long.

And your wife accepted that you had to work so much?

Yes. It was easier in those days than it is now.

Why?

Because back then, women were used to supporting their husbands. Take my daughter and her husband, for example. They're both professors, but I think he does more for the family.

Compared to how much you did for your family?

No, compared to how much she does.

I see. But this must have been a fairly difficult time for your wife as well.

Perhaps, I don't know. I don't recall.

How important was your wife in your life and to your career?

I think she was very, very important. She was a stabilizing element. If I had another wife who wouldn't let me do anything or who even refused to come with me to America, it would have been much more difficult.

What made you the person you are today?

Clearly, I have a lot of curiosity. I also have a lot of stubbornness and perhaps some talent, but I'm not sure exactly.

Has there been one constant driving force in your life?

To try and be the best.

What else are you interested in besides science? Do you have any hobbies?

I'm interested in a lot of television. I watch television nonstop. I draw a little, though not too much. I'm also interested in politics. In some respects, politics is my strongest interest.

What's so special about science? Why should young people go into this field?

Science is about discovering how the universe works, how the brain works, or how the body works. You have a chance to understand things that nobody has understood before. It's extremely fascinating.

What advice would you give to young people?

First, to learn the tools of the trade. That means doing the homework and taking the learning part seriously. It's important to study hard—even if it seems like it's a waste of time. Just pretend you're having fun.

What's your message to the world?

To try to live in peace. This can be difficult, but it's a good message. Also, to spend significant resources on science. Look to the past and you'll quickly realize that all our advances in medicine, machinery, aviation—everything—started with a scientific discovery. Our future entirely depends on science.

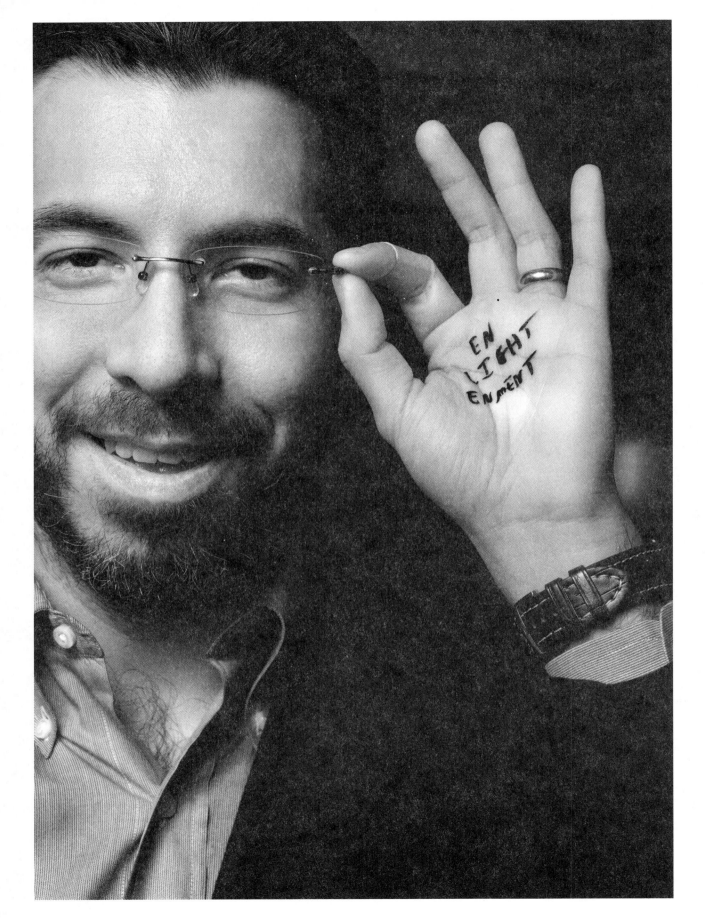

"ONE BIT OF ADVICE THAT I GIVE IS . . . THAT WHATEVER ADVICE YOU GET, CONSIDER DOING THE OPPOSITE."

Edward Boyden | Neuroscience

Professor of Neurotechnology at the Massachusetts Institute of Technology (MIT), Cambridge
Breakthrough Prize in Life Sciences 2016
United States

Professor Boyden, what do you do exactly?
I try to understand how the brain generates thoughts and feelings. Over the last twenty years, my focus has been on inventing tools to map the brain, watch it in action, and control it. It's different from the way a lot of classical neuroscience has been done.
You've been interested in science since you were very young. What prompted this interest?
When I was 8 years old, I went through a philosophical phase. I really wanted to understand the meaning of life. I concluded that I needed to spend my life

understanding human existence in terms of science. In college, I worked on a project to create life from scratch. Then I went to MIT and worked on quantum computing. Both were topics where philosophy and science collide. Finally, twenty years ago, I entered neuroscience, where I've been ever since.

Did your parents support you in a meaningful way?

My mother studied biology and my father was a management consultant. Both of their ways of thinking have been helpful in my career. Science was part of my upbringing, but so was management. As I'm sure you know, biologists usually work in a team.

Some kids like to play sports. What did you play at as a child?

I loved math puzzles and reading about science topics like space, rockets, chemistry, and machines. I spent a lot of time in the library. I would read the encyclopedia, volume after volume after volume.

Seriously?

Oh yeah, the *World Book Encyclopedia*. I remember it vividly.

Sounds like you were quite precocious.

I was thoughtful. I liked to think a lot. I would read or create my own worlds with Legos, Q-tips, and paper towel rolls. I had an imaginative childhood. I also skipped a few grades, so I started college pretty early. I was only 14 years old.

Did you have any particularly formative experiences in school?

I remember that in second grade, they would pull five of us out of class and give us big problems to work on. Like, could you solve poverty? Or drug abuse? And the five of us would then have to come up with some kind of strategy. It was a lot of fun.

There was also something in your past involving underwater research, wasn't there? What was it?

Oh, the submarine! In 1998, after I transferred to MIT to finish my undergraduate studies, several of us decided to enter the International Autonomous Underwater Vehicle Competition. We built a submarine out of a plastic tube, a computer that we put inside, and motors we found at a boat shop. The sonar we used to navigate was actually from a fish finder. The simplicity of the design was what made it work. Eight weeks later, we won!

Have you always been willing to take risks?

I like risks that I can manage by de-risking them. In real science, you have no idea what's going to happen next. There are strategies for reducing risks that I teach as a professor, however, such as pursuing multiple ideas in parallel or thinking backwards from problems, so you know you're on the right track.

How does that approach apply to the work you do today?

A lot of our work looks high-risk to outsiders, but we have a way of thinking backwards from problems and trying to think of every way to solve them. We then try for what I call "constructive failures." A constructive failure is a failure that shows you a better path, and if you try enough of these failures in parallel, you can find the path to success.

Have you ever had moments when you felt unsure of yourself?

Of course! When I first applied for a faculty job at MIT, they rejected me! That's why my home department is the MIT Media Lab, though I now work also in the Biological Engineering and Brain and Cognitive Sciences departments. The Media Lab hires misfits who don't fit in elsewhere. I only got the job

"I CONCLUDED THAT I NEEDED TO SPEND MY LIFE UNDERSTANDING HUMAN EXISTENCE IN TERMS OF SCIENCE."

out of sheer luck. They had done a job search and they couldn't fill the slot, so they hired me. Rapidly, of course, our technologies took off and that's when I got joint appointments in two other MIT departments. So, I've been very, very lucky.

What did that luck teach you?

Again, I think if you can pursue enough failures in parallel, you'll eventually find success. But one can also engineer luck, in a way, by being strategic—by trying the opposite of what other people are doing.

Would that be your main advice to other people? To engineer your luck?

Well, one bit of advice that I give, which of course is sort of half a joke because it seems to contradict itself, is that whatever advice you get, consider doing

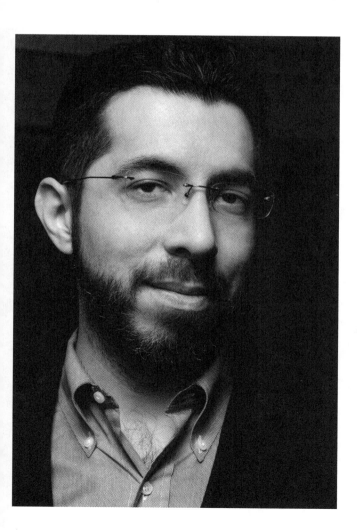

the opposite. A lot of my success has come from people giving me advice like, "Don't just build tools. You should study one very specific scientific question." And so, I thought, "What if I built the first group that just focused on tools for mapping, watching, and controlling the brain?"

When you say "tools," what do you mean? Can you give some examples?

"Solving" the brain will require being able to watch brain activity, perturb it, and then make a molecular map of the brain. Right now, about half my research group is working on a technology we call "expansion microscopy." We take a piece of brain tissue and infuse it with a chemical that's a lot like the stuff in baby diapers. For example, add water to the diaper, and the diaper material swells, making the diaper bigger. So, with the brain swollen, you can see nanoscale objects, such as neural connections or neural wires, with a regular microscope.

Another technology we've developed is called "optogenetics"—it lets us control brain cells with light. We take microbial proteins that convert light into electricity and move them into brain cells. Then we shine light on the brain to activate the brain cells, which is important since brain cells compute with electrical pulses. With this in place, you can activate the brain cells and figure out if they trigger a behavior or a pathology. Or, you can turn the brain cells off and figure out what they're needed for.

Where could this all lead?

Thousands of groups are using these tools to study the brain. People are activating brain cells and figuring out what patterns of brain activity might, say, mitigate the symptoms of Alzheimer's. One group, after using optogenetics to discover a pattern of activity that treated Alzheimer's in mice, went on to discover that they could use stimuli delivered to eyes and ears to cause the same pattern of activity. I co-founded a company, with neuroscientist Li-Huei Tsai, who led this study, and we're doing clinical trials now of, effectively, playing movies to treat Alzheimer's. We've already begun human trials.

"I LIKE RISKS THAT I CAN MANAGE BY DE-RISKING THEM."

The "movie treatment" sounds like it would be widely available?

The beauty of these movies for Alzheimer's is they that could be so cheap and so deployable. I worry a lot about medical treatments being too expensive or inaccessible.

How do you manage your expectations?

I think of neuroscience as a long game. It's a marathon, not a sprint. I think of my career as a fifty-year journey.

What does the end of those fifty years look like?

If we get to the end, I would like to enter philosophy, then augmentation. Where do we want to go as a species? Where do we want to take our minds and our brains? Is it to enlightenment or empathy? Do we want to become smarter?

You share a lot of the results of your research with other people. Why share it?

It's partly out of self-interest that we give away our technology to all university and nonprofit groups that ask for it. If people don't use our technology, what's the point of developing it?

Is it not proprietary information?

We work in the field of neurotechnology, which is new, so there aren't many other groups doing similar work. We don't have much competition. But I also think it's about self-selection. If you build a tool and give it away, your tool will thrive. If you build a tool and hide it under a rock, nobody will know about it and your tool will fade away.

Speaking of time and labor, how's your work-life balance?

I wake up early, but I go to bed early as well. I have two kids, and we all go to bed around nine o'clock or so. My wife's also a neuroscientist. We spend the afternoons and evenings together. And now on the weekends, I spend my time with the family. We do lots of fun things together.

What was it like to become a father?

Amazing. The thing about being a neuroscientist is that you're in this dual state of constant emotional fascination and intellectual fascination. Here are these children, who are living, breathing humans like you, and yet you're also wondering, *What's going on inside? How did they suddenly learn language effortlessly? How did they suddenly figure out how to solve a problem that was impossible the day before?*

One of your teachers mentioned that, as a student, you took notes about everything, wherever you went. Do you still take so many notes?

Yeah, I still do that a lot. I take notes on paper, then I photograph them using my phone; in the old days I used a regular camera. Then I classify the notes on my computer, attaching keywords to each photo. I think of my computer as my prosthetic memory. I can look back ten, fifteen years, even longer, and return to a specific conversation sometimes, and realize, *This is what we talked about, at 11 o'clock that day.*

But what's the benefit of being such a prolific note-taker?

In neuroscience, you're trying to connect ideas across many, many different domains. It's hard to hold all that in your head. But if you can store your thoughts and memories, and even look at them, and think about them from an external point of view, they can sometimes help you make those creative connections between ideas.

But aren't other branches of science just as complex?

If you think about the history of science, chemistry had a map of the atoms—the periodic table—and that's when chemistry really started to take off. The same was true for physics: there was the list of the particles, electrons, protons, neutrons, and the ways they interact—the forces. But in biology, there isn't a

parts list for the body. How many cell types are there in the human body? We don't know. How many kinds of biological molecules are there in a single cell? We don't know.

What advice would you give someone considering becoming a scientist?

I would suggest learning the fundamental sciences very well. Learn chemistry. Learn physics. Those are the sciences that are foundational. The brain is a chemical circuit. It's an electrical circuit.

What makes science so fascinating to study?

People love adventure stories. People love mystery stories. I think of science as the ultimate adventure, the ultimate mystery. The mystery we are trying to solve is that of the universe itself. I've been lucky to have been involved in a couple of projects in which we saw something that, in the history of humanity— to my knowledge anyway—no one had ever seen before.

What would you like your legacy to be?

Well, if we can understand how the brain generates the mind, my hope is that it helps us as humans to become more enlightened. Maybe we would make decisions for the right reasons, and not have this tendency to do things that cause so much suffering.

But doesn't that ultimately eliminate free will?

Well, in the brain there are so many processes. How do you know what's free of what? If we have a complete description of how all the information is flowing and transformed in the brain, we could hunt down the neural signals that occur one second, five seconds, or an hour before a decision is made. Then that would tell us what free will really means.

When scientists analyzed Einstein's brain postmortem, they discovered it was larger than the average brain. Do you suspect your brain is bigger than most people's?

I think my brain is just normal size. The size of the brain is different from the circuitry in the brain. The size of the brain may not matter at all but, rather, how the brain is wired.

Do you consider yourself smart?

I think I'm good at certain things. I think I'm good at connecting the dots between different fields, to make new ideas.

The impression one gets of you is of a rational and level-headed person. Would you describe yourself this way?

I think I'm emotional. But the way I express emotion, I think, is through action. I want to see things happen. I guess what I do is try to channel my emotion through strategy and thinking.

You won the Breakthrough Prize in Life Sciences, a renowned award with a substantial cash prize. What did you do with the money?

Some of the money we put into funds for our children's education. We also bought a house, because Boston is an expensive place to live. But we've also been using some of the money to support scientific projects and help foundations that support young scientists. I think it's important to give back to science, because science is not as much a part of society as it used to be.

What do you mean?

Science used to be cool, right? It was all about landing on the moon, lasers, and computer chips. But now, for many reasons, I think science has receded from public view. This is partly because science is harder to understand and longer term in its goals. A moon landing or a computer chip are things you can see; you can visualize them. But a tiny nanoparticle in a cell? That might be important, but it's not tangible to many people.

"THE MYSTERY WE'RE TRYING TO SOLVE IS THAT OF THE UNIVERSE ITSELF."

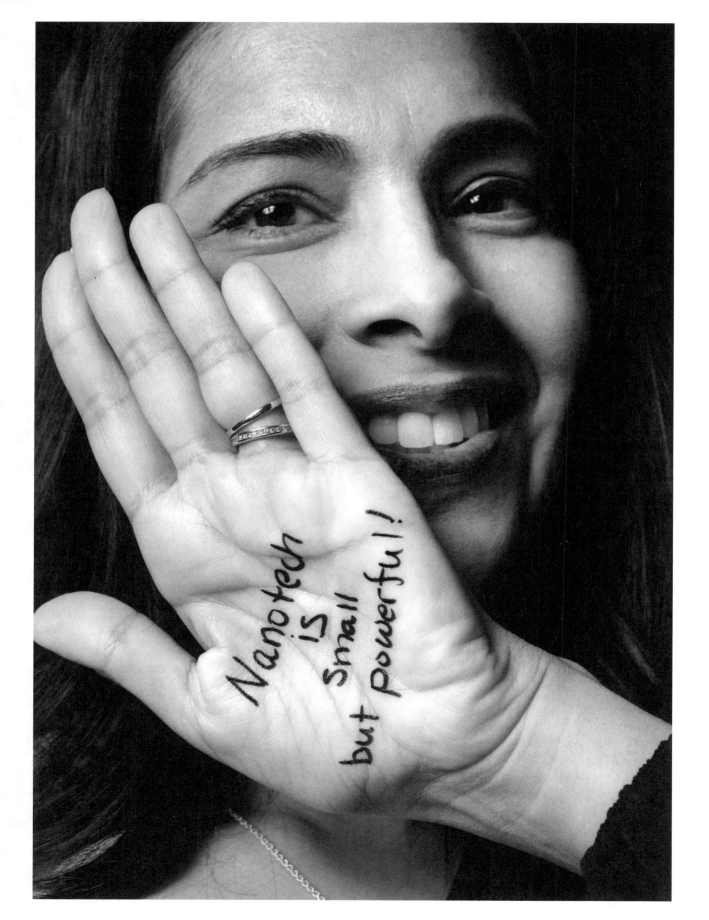

"THE WHOLE POINT OF ACADEMIA IS INTELLECTUAL FREEDOM."

Sangheeta Bhatia | Bioengineering

Professor of Medical and Electrical Engineering
at the Massachusetts Institute of Technology, (MIT), Cambridge
Lemelson-MIT Prize 2014
United States

Professor Bhatia, what was your first impression of bioengineering at MIT?
My father took me to MIT when I was in tenth grade. He thought I'd make a good engineer because I was good at math and science. I also liked biology, and he'd heard of a field where biology and engineering were merging. So, he introduced me to a friend who was using ultrasound machines to focus a beam on tumors. It really captured my imagination, and I was hooked!

How old were your parents when they immigrated to the United States from India?

They came in the 1960s, when they were in their early thirties. That was their second big move; earlier, they were refugees from the partitioning of Pakistan from mainland India in 1947, and they met at university in Bombay, now Mumbai.

My father was an engineer and a businessman, and my mother studied accounting. In fact, she was the first woman to get her MBA in India. She arrived in New York with eight dollars in her pocket. Then they moved to Boston, started working, and had me.

Did they plan on returning to India?

Yes, they always thought they would go back, but then they had my sister and me and changed their plans. They wanted us to have a good education, so they moved to a town outside of Boston, called Lexington, where there were good public schools. That's where I still live and am raising my two daughters, ages 16 and 13.

Immigrants typically work very hard to succeed in their new country. What about your parents?

They worked hard and pushed us hard, too. They believed in the power of education and expected us to be the best. If I came home with a math test score of 96 out of 100, my Dad would say, "What did you get wrong?"

Your father was an entrepreneur?

My father quit his management consulting job when we were babies and started his own company from our garage. He used to import goods from India, and later from Brazil and Belgium. My mother was the accountant, and we kids would quality-check some of the goods.

He subsequently started other businesses as well. When I became a professor, he would ask, "Okay, but when will you start a company?" He couldn't be prouder of me now, though.

But he challenged you all the time?

Yes, he always pushed me out of my comfort zone. It was true of my later male mentors, too; they would see more potential in me than I could.

You received two higher degrees, a PhD in biomedical engineering and an MD. Was that the result of a lot of pressure?

Yes, although it was self-imposed pressure more than anything else. My parents always said there's no reason why I shouldn't be the best, and after a while this view becomes internalized.

Are you and your sister similar in nature?

She's also successful but chose to go into business instead. We lead full lives, both of us have children, and we are similarly close to our families. We were both taught to excel, and we try and teach that to our children.

Have you put your kids under pressure to excel, then?

We try not to, but they feel it all the same. They see what we've accomplished and our values and then it becomes internalized.

So, what are your personal values?

I believe in doing what I can to make this world a better place. I want to open the door to other female scientists. It's important to be visible and vocal about what an amazing profession this is, how it should be welcoming to women and what women can achieve.

I also believe in the value of family. In addition to my family of four, we live just two miles from my parents, so we have a huge extended family. The house is always full on Thanksgiving.

You run your own lab at MIT, as well as your own business. Despite being so successful, do you suffer from imposter syndrome?

When I started at MIT, I thought I would never be good enough. But then I worked hard, got good grades, and started to feel I belong here. There are still moments when I feel less qualified than others with the same credentials. People underestimate me, as I'm a woman and look young.

You're beautiful, too.

Thanks. There's often this disconnect between beauty and intellect. When I was younger, I hid my femininity. Now I feel comfortable just being myself, wearing high heels and having my hair done.

Have you ever suffered prejudice as a woman of color?

I identify more with my gender than with my color. Indian immigrants are actually well respected as innovators in Silicon Valley and here at MIT. Besides, I was born in America and consider myself American.

What about bias against a woman in your field?

It's depressing, but there is systemic bias. While there have been men who have crossed the line and behaved inappropriately toward me, overall I've been lucky in having supportive male mentors and bosses. My graduate advisor encouraged me to be a professor, saying, "You can do it." Being a woman has actually been beneficial for my career, because there weren't many other women around; the ones who were around were paving the way forward.

I sometimes feel, though, that I have to prove myself as a woman. When I'm in a room full of people who don't know me, I may deliberately ask a question or make a comment early on, so that it's understood what I know or who I am or why I'm there. It's a struggle, because that's not my nature; nevertheless, it feels like a necessary strategy to make people rapidly respect me.

Do you encourage the other women in your lab?

Out of the twenty-three people in my lab, thirteen are women. I don't know whether it's better to tell them they can do anything they dream, because that's what I believed while growing up, or to tell them they'll encounter systemic discrimination but can achieve in spite of that. My message is that this is still an amazing profession and that they have so much to offer the world, including making it better for future generations.

Do your female students want to be professors like you?

Most have chosen not to become a professor. I don't really know why—I thought I was being a good role model, showing them it was an attractive profession; also, that it is a way to combine work and family. But somehow the graduate students haven't chosen my path. One told me that she thought I was "special" and that it might not be the same for her.

Was it easy for you, then?

No, not at all; and it still isn't easy. I still work hard, but if you want to make a difference, you must do that.

That said, I try to strike a balance. When I was in graduate school, I once went to the lab at 3 a.m., after going out with my friends on a Saturday night, and I found it full of people. I realized that if this is what it takes to do top science, then I'm out of there.

So, how do you manage to juggle your work, marriage, and children?

My husband and I have made a lot of career decisions over the years to ensure that we keep working in the same city. And every Friday night we have a mini date and meet at 6 p.m., before going home to our family!

When I had children, I decided to take Wednesdays off to be home with them. Plus, I limit my travel

"IT'S AN INCREDIBLE GIFT OF A PROFESSION."

schedule; we try to have a family rule of one trip a month. And I'm constantly reprioritizing. I'm a people pleaser, so it's hard; but then again, you can't help anybody if you're broken, right?

I was taught to give my whole life over to science, but I decided instead that I also wanted a family and a life outside of science. I almost didn't become a professor because of that, but it's all worked out—which just shows you really have to live your life by your own rules. The whole point of academia is intellectual freedom, so if you let expectations trap you, then surely you're defeating the whole purpose?

Do you think male scientists think differently?

Many of my male colleagues have a different support structure. Many have a partner who is running the household, raising the kids, and doing everything else. I have an incredibly supportive husband, but I'm still the one who fills out all the school forms, takes the kids to the doctors, etc., meaning my time is limited to create new knowledge.

I suppose you have to be well organized, then?

I'm super-organized. It's one of the first things people say about me; it'll probably be on my gravestone! I also have a lot of help. My director of research is an amazing woman who shares my intellectual values and tastes.

Is money important to you?

I was raised with the idea that you have to make enough money to support your chosen style of living. I want to make money with the companies I've set up, but what I want most of all is to change the world.

Can you explain your lab work?

I invented these tiny tools called nanosensors, which are 1,000 times smaller than a human hair. You inject them, like a vaccine, and they circulate throughout the body. These nanosensors are activated when they find diseased cells and they send out a signal, which passes through the kidneys and into the urine.

The idea is that you get a shot, wait an hour, and then perform a urine test on a paper strip to see if you have a cancerous tumor. The process works on mice, and we are now doing clinical safety studies. The next trial, in which we study whether it can monitor disease, will start next year. Science developments can take quite some time. We invented this method in 2013, but it can take ten years for a good idea to reach patients.

So how did you make this discovery?

By accident! We were trying to make smarter nanoparticles for a magnetic MRI scan. The idea was to give a shot of a magnetic particle that would become active when it found a tumor. Every time we performed the experiment on animals, and it identified a tumor, we saw something in the urine.

What about your work on the liver?

Our work on the liver used the same ideas of microfabrication. We print chips on silicon with small features and put them in petri dishes. The lines I draw can be used to pattern cells. With certain cell patterns, the liver cells thrive, and we use that to try to make them grow.

What would be the applications of this process?

Right now, we're studying malaria, which is exciting because malaria affects the liver before it becomes a blood disease. We're also growing forms of malaria that have never been grown before in the lab. My students transport livers to Thailand, infect them with malaria from patients there, then we grow these liver forms in the lab, study them, and find out whether we can kill the parasite.

We also want to encourage livers to regenerate more in the body. For livers that can be implanted, we use techniques from 3D printing to create a network of places where we want artificial blood vessels to grow into, and we printed those in 3D out of sugar. Then we surround them with cells that you would like to create the organ, such as a liver, out of.

Do you ever feel like you're playing God?

No, I feel like a scientist who is trying to provide better medicine for doctors to administer. At first there was controversy about liver transplants, but there isn't anymore. It's basically the same situation.

Can your work increase life expectancy?

I'd say my work is more about improving the independence and quality of life rather than longevity. I was raised Hindu, and we believe in reincarnation—the belief that there are lives that come into the world and lives that go out of the world. Personally, I would like to live as long as I can remain independent and capable, and then die in my sleep. When I was younger, I used to say that I wanted to die in a plane crash when I was in my sixties, but now that I'm 50 years old, I don't say that anymore.

Are you changing the realms of what is normal about life?

You mean if I can make a liver, then maybe I can make a super liver? This sort of human augmentation is in much discussion right now. If we're going to intervene, then perhaps we can improve it?

Suppose you have opened a Pandora's box?

Any new capability in science can be used for good or not, as we've seen throughout history. Scientists can self-regulate whenever there is a new capability, and try to come up with a collective set of guidelines. I think one way to stop bad actors is via the development of a framework that allows collective social pressure.

How do you see your personal responsibility toward society?

I want to focus my earned visibility on things I'm passionate about—namely, biomedical engineering, nanotechnology, and interdisciplinary science, as well as training the next generation. I've taught myself a lot about the role of women in science and technology, so that's also my self-appointed role.

How do you envision the future for your field of research?

I would like engineers and physicians to work more closely together. There are 500 engineers here at MIT, and they all have something to contribute to the medical field. I'd also like to see more women involved; only 19 percent of the faculty here are female, and there are very few women company founders or CEOs. We're losing a lot of talent; women scientists and engineers can contribute much more.

Why should young people study science? What advice would you offer them?

For me, it's like art: in science, you can create something that's never existed before that can help people, which is incredibly gratifying. It's also varied. In short, it's an incredible gift of a profession.

You must excel, though, at every stage along the way—there's no avoiding the hard work. And you must allow yourself some intellectual freedom to move beyond the expected path. Follow your dreams.

Did you follow your dreams?

At first, I thought I'd go into industry and be a leader. I didn't know until I was about 30 years old that I'd love being a professor.

What is your vision for other aspects of your life?

I'd like to continue to evolve and learn. I would love to see my girls grow and find passions of their own. I would love to see my husband continue to thrive professionally, for us to stay close, to maintain my friendships, to travel, to make an impact on the world but remain personally fulfilled.

Is your husband ever jealous of your professional success?

We trained together, and it is a privilege to have a partner who not just understands but also values my work. When you are working in similar fields, there are always rough waters to navigate. He's just left his position as a professor at Harvard so he can follow his passions in biotech. It's been important for him to have his own world, separate from mine. And we always agree that public visibility doesn't equate to value and impact. We want our two girls to be successful and shine as bright as possible, but to also have a fulfilling home life—and so inevitably we are their role models.

Of course, it's hard as a woman. If friends visit and the sink is full of dishes, I still think it reflects badly on me as woman of the household. I'm hoping it will get easier with each generation.

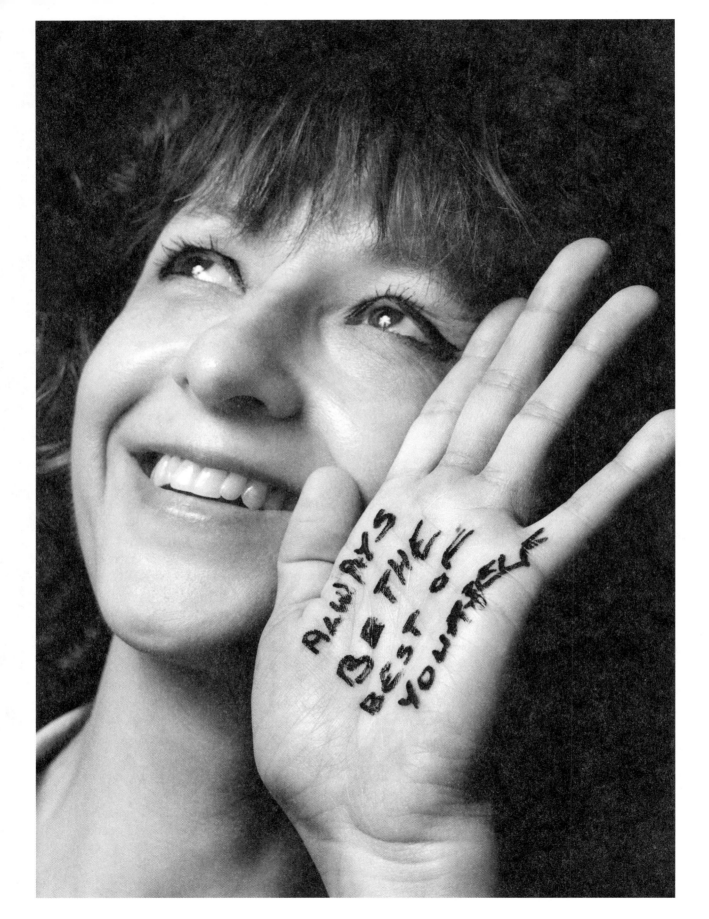

"THERE ARE SO MANY INTERESTING THINGS IN LIFE."

Emmanuelle Charpentier | Microbiology

Professor of Microbiology and Director of the Max Planck Research Unit for the Science of Pathogens, Berlin
Gottfried Wilhelm Leibniz Prize 2016
Germany

Professor Charpentier, you were born in France. Can you tell me a bit about your formative years?
I was educated in the suburbs of Paris. It was a quiet place. We had a house with a garden in a city, which for a long time was governed by mayors from the Parti Communiste [Communist Party]. My parents both had a farming background, though they were very interested in the arts, culture, and politics. They were active in labor unions and Catholic associations, and they engaged politically with the Parti Socialiste [Socialist Party]. I have certainly

been influenced by my parents' extreme energy and curiosity. I think they're the reason I'm always on the run.

What was it like having two older sisters?

For my parents, it was great. They never had to take care of me—I just followed my sisters around. My oldest sister is twelve years older than me, so I think this always pushed me in a way. By the time I entered primary school, she was already attending university. It became my goal to also go to college. I understood that as a professor or researcher, a person could effectively stay in school—in the field of knowledge acquisition and transmission, as well as elevating one's mind—their entire life.

So, you've always had a curious mind. What else were you like as a kid?

I think I was too nice at times. Of course, I didn't realize it at the time, but I think I had a tendency to live in my own bubble and not realize when people were taking advantage of me. I was protecting myself by only believing that people were good.

What about now? Do you still view the world through rose-tinted glasses?

Well, for instance, I tend to not think too much about the fact that I'm a woman in science. Each time I think about it too much, it disturbs me. Women absolutely face additional hurdles. When I was a PhD student, I had to listen to, shall I say, certain comments from my PhD supervisor. I was also never interested in applying for funding that was designed specifically for female scientists. I wanted my grant applications to be judged on merit, not sex. And don't get me started on pregnancy. When I realized for the first time that my colleagues viewed pregnancy as a kind of disease, I was shocked. "Oh, she's pregnant, you can forget about her for the next three years."

A lot of women scientists have told me that men often doubt the quality of their work. Has this been your experience?

I think women are expected to be more perfect in general, not just in science. If a woman makes a

"WOMEN SHOULD FIGHT MORE. . . . THE YOUNGER GENERATION OF WOMEN DOESN'T SEEM TO FULLY APPRECIATE THE HUGE PROGRESS THAT HAS BEEN MADE."

mistake, it's pointed out right away. Me, I try to ignore certain aspects of gender issues; I find that easier. For example, I try to ignore the fact that I'm a woman mostly surrounded by men and instead focus on the task at hand. I've learned to accept the fact that I'm often invisible, or that if I say something, I'll be considered "in the way."

Do you think women need to stand up for themselves more?

I think so. Women should fight more. I'm a bit disappointed that the younger generation of women doesn't seem to fully appreciate the huge progress that has been made in recent years. That progress has allowed them to choose whatever path they want. It's not easy to change society or people's mentalities. I regret that this luxury has led to a feeling of complacency. We still have a long way to go. Women who want to have a baby and continue working don't have it easy, logistically speaking, in a system that doesn't provide the flexibility to do that.

What about you? Do you still harbor aspirations of one day having a family?

No, I don't plan to have a family. I think it's too late. I used to, but not anymore. I'm not saying I ever actively tried to have a kid, but when I pictured my life, I always thought I would at some point have a family. But I was picturing someone who wasn't me. This may sound strange, considering what I do, but I have absolutely no interest in seeing my genes propagated to the next generation.

How long have you felt this way?

I've been certain all my life that I would feel fulfilled by something I would develop. I couldn't always explain what, but I just knew it. During my adolescence, I always imagined myself as, let's say, a free woman, this kind of free spirit—a free electron on

this planet, if you will. There are so many interesting things in life. I find this drive a bit stressful. I want to do so much! Whether it's in my research or my daily life. I'm extremely frustrated by days only being twenty-four hours long.

By now, you've lived like a nomad for twenty-five years. That is, after your PhD, you lived in the United States, Austria, Sweden, and Germany, first in Hanover and now in Berlin. What was it like to pack and unpack, pack and unpack all those years?

I enjoy it very much. I used to read detective novels and imagine myself as one of the heroines. When I was 10 years old, one of my aunts was working as a missionary in Africa. I remember her telling me—she was extremely insistent—"Emmanuelle, you will be attracted to adventure." I can confirm that she was right. I have difficulty being stuck in one system.

Moving around helps refresh my mind and lets me feel free. The feeling of being put into a box is something I find scary. And I have to say, doing research is a bit like being a female detective.

And in your heroic pursuits as a detective-scientist, you discovered CRISPR/Cas9, a breakthrough technology capable of modifying DNA. Could you explain for nonscientists just what CRISPR/Cas9 is capable of?

Indeed, CRISPR/Cas9 is a technology for modifying genes. This alone isn't new—scientists have been able to modify DNA for forty, fifty years. But CRISPR/Cas9 adds simplicity and versatility to the way this is done. Not only that, it's also cheap and it allows modifications to be performed at a precise level that was not possible before.

This discovery was very exciting for scientists because it allows them to ask biological questions they couldn't previously ask. DNA is the language of life, and to understand this language and how it's translated, you need to be able to modify a gene and study what happens next.

What are some examples of the way this technology could be used?

The technology will have a profound impact on agriculture and biomedicine, for starters. For example,

it will afford us the ability to develop new targets for therapeutics. We'll also be able to develop models of diseases that will play an important role in validating the medicines under development. The technology will also be used as a direct medicine to treat certain types of diseases. In agriculture, CRISPR/Cas9 will make it possible to develop new plant crops that have been engineered more precisely than ever before. This will allow for a wider diversity of crops.

This all sounds interesting, even optimistic. What about potential dangers in working with genes?

The technology can be used one of two ways: there's the positive way that I just described and the negative way, in which DNA could be manipulated to create new humans. History has shown us that if a technology exists, it will be used somehow. I'm sure there will be parents who will insist on using this technology to produce designer babies and private clinics that will cater to them. This will be difficult to control. I find this notion disturbing—it's one of my biggest concerns.

Do you think it's possible to mitigate the risk of such misuse?

It's absolutely critical that there should be strict regulations for the application of this technology on the human gene line—that is, on producing designer babies. Regulations must come from as many countries as possible, and countries must be especially careful not to allocate public funds to this misuse. We need to make it clear that there is no reason whatsoever—no clinical justification—to use this technology to edit the human gene line as of today. CRISPR/Cas9 is beneficial for research purposes and for the production of farm crops, but it should not be used to edit the human gene line, at least until further justification for doing so is established.

How was it that you discovered such a revolutionary technology? How did the idea come to you?

I don't think I'm the only scientist who would say that traveling can be incredibly productive, because you're not always connected to the internet or able to receive email. And you're protected from colleagues coming and knocking on your door. Travel is useful because when you travel, your mind can travel as well. And it was in this mindset, while I was traveling from Vienna to Umea, Sweden, that I had the idea to combine two biological systems that ended up being CRISPR/Cas9.

I had accepted a position in Umea at the beginning of 2008—a decision my friends and colleagues had trouble understanding. How could a person who loved living in New York so much decide to uproot and move to a small city in northern Sweden, where a good part of the year it was dark and cold. It was during this time, when I was frequently traveling to Umea to set up my lab, that I developed what would become the discovering principle. It was a step-by-step process, but the eureka moment came on that trip from Vienna to Umea. It further developed mostly in Umea, where I was finding myself able to focus my time better on science and where I was not disturbed.

Yours is the only name on the patent. How did this come about?

The reason why only my name is on the patent is that I was working in Sweden at the time of my discovery, and Sweden is one of the very rare countries where the ownership of an invention belongs 100 percent to the scientist.

You first presented your discovery of how CRISPR/Cas9 could be used to edit genomes at a conference in 2010, but you needed help understanding just how the system worked on a structural level. Did you approach Jennifer Doudna or did she approach you?

I met Jennifer at a conference in Puerto Rico, shortly after publishing the first part of the CRISPR/Cas9 story in the journal *Nature*. I approached Jennifer because I was interested in the structural aspects of this bacterial system of defense against viruses, though I had already been working on this project for about three years by that time. I asked Jennifer—who had expertise in structural biology, proteins interacting with RNA including proteins of CRISPR systems other than CRISPR/Cas9—whether she'd be interested in collaborating.

I was already collaborating with another structural biologist in Vienna on the structure of CRISPR/

Cas9 but he could not continue the collaboration for funding and logistics reasons. Initially, I wasn't looking to work together on the biochemistry of the system or developing this system into a technology, as this was planned for my lab members, but then her team joined us on this path and we ultimately published a second paper in the journal *Science*.

It was in this article that the potential of the system as a genetic technology is described. This is also the paper that a number of scientists have used as a basis for applying the technology to modify genomes and their expression in cells and organisms, and for developing it further in multiple versions of this gene editing and engineering tool.

How long did you and Jennifer work together? And how well did it go?

We collaborated for a year on this project. I was living in Sweden at the time, so there was a nine-hour time difference. I communicated with her team at very odd hours. Sometimes I would ride my bike home or to the lab without even realizing what time it was. In Sweden, whether it's winter or summer, people often develop a weird sleeping rhythm because there's either too much light or too little.

But I mean, how did you two get along? You seem like very different people.

One thing that Jennifer and I had in common was that we both think very logically. We both placed a high demand on the quality of the experiments. So, in that regard, we were very similar.

So, you and Jennifer made the most important discoveries, but some of the patents were awarded to other scientists. I'm specifically thinking of Feng Zhang from the Broad Institute. How did that happen?

The patent situation is a bit different now that some of those other claims have been aborted. But look, the technology was applied quickly by a number of scientists. And when you look at the literature, you see a number of publications in early 2013 showing that the technology was working well in human cells, plants, and yeasts. These were all based on the paper that Jennifer and I had written.

Regarding the patent issues specifically, I can't really comment except to say that this happens all the time. But, yeah, I was a bit surprised.

Did you suspect that CRISPR/Cas9 would have such immense potential?

Early on, I had an inkling that this system could be harnessed to treat human genetic disorders. It may have seemed farfetched at the time, and maybe it was because of my background in research or the topics I had studied in the past, but I was confident that my suspicions were entirely realistic.

I read that you have received something like ninety prizes and awards. Is that true?

If one counts awards and honors like election to academies and honorary doctoral degrees, yes. There's been a lot of recognition.

You were awarded the Breakthrough Prize. For scientists, that's like winning an Oscar. How did that make you feel?

That was a bit surreal. You must understand that some scientists wait twenty to sixty years for that kind of recognition. Sometimes they never get it. And there I was, only two or three years after the publication of the 2011 *Nature* and 2012 *Science* papers, getting the prize. This was extremely, extremely fast.

Did you ever imagine you would be so successful?

This may sound strange, but I often had these flashes of myself being not so much recognized as exposed. I always wondered why. I would think about it, and suddenly envision myself being exposed in full light. Maybe I felt that something big would happen.

Do you think the Nobel Prize will follow?

I am 100 percent certain that the CRISPR/Cas9 research will be awarded the Nobel Prize at some point.

Is all this recognition more of a blessing or a curse?

It's important to mention that I never did science for the recognition. For me, recognition is absolutely unnatural. I don't need it. It's not a goal. I feel humbled. But this recognition has brought me a certain liberty, a sense of freedom to be myself. I'm not saying it's brought me more self-confidence, but I do feel that people accept me more for who I am.

Do people ever stop you on the street?

Being a public person is not natural for me. Thank God I live in Berlin, where even on campus people don't know who I am. But here's a nice story: Around three years ago I was in a lounge at Frankfurt or Munich airport, and I asked a man whether I could join him at his table. He said yes, and I began working on my laptop. Then he asked me if he could ask me a question. He said, "I'm curious; what do you do for work?" I said, "I'm a scientist." He replied that he was a retired mathematician.

He wanted specifics, so I said, "I'm a microbiologist, a geneticist. I work on bacteria and gene technologies." He mentioned that he had just read an article about an extremely powerful technology that he found puzzling. I asked him to show me the article. He handed it to me and then I turned the page and said, "Oh, yeah, that's me." There was a picture of Jennifer and me. He had just been reading the article and didn't even realize the person sitting next to him was one of the women in the photo.

What have been some negative aspects to your success?

I'm aware that there may be some jealousy, and this often triggers more hurdles.

And now you have your own institute. What's that like?

My institute is small. It was supposed to be different, but I had to jump a number of hurdles. The institute is only as big as a department; the difference is that the institute is run completely independently.

One must be organized, which I am. I like management; it's like a puzzle and you have to bring the different pieces together. Except that the pieces are human beings with different personalities.

What is it exactly that you find so fascinating about science?

What I find most fascinating about science is the unknown, the possibility to ask a lot of questions. Take the life sciences, for instance; most of the mechanisms are unknown. It's this fascination with the complexity of the world in which we live, with our own complexity as human beings.

What kind of person does a scientist need to be?

They need to be curious. Resilient. Persistent. A bit obsessive. And positive, because there are a lot of hurdles. A certain naiveté may also be good to have—not pure naiveté, but a childlike spirit. It also helps to be patient. Be impatient sometimes, be hungry, but also be patient.

And maybe also have a willingness to be sleep deprived?

It helps to be a bit obsessed, too. I still sometimes wake up in the middle of the night, eat something, and then go to work. But the good thing is that, now I do sleep. I'm someone who needs enough sleep to regenerate.

Do you have any advice for young people considering careers in science?

I would tell any young person, whether they want to be a scientist or not, that the most important thing in life is to know yourself. Know your limits. And be open. It's not always easy to give yourself permission to seek out what's most interesting for you, but it's worth it. I'd also advise the younger generation to not overthink things. In life, there's not just one path. Most older people tell you that their lives turned out different from what they had expected. Just be open, curious, and live your life to the fullest.

Would that also be your message to the world?

My message to the world would be to be yourself. Try to find in yourself a reason to be on this planet. And work on that reason. And challenge yourself. Push your limits, your boundaries, to provide yourself a meaningful sense of why you are on the planet. You might be surprised by just how much you can contribute to the world. Even if it's just helping your neighbor who is in need—it will be so rewarding.

"THE MOST IMPORTANT THING IN LIFE IS TO KNOW YOURSELF."

"WITHOUT THE PAST, THERE IS NO FUTURE."

Hermann Parzinger | Prehistoric Archaeology

President of the Prussian Cultural Heritage Foundation, Berlin
Professor of History at the Institute for Prehistoric Archaeology at Freie Universität Berlin
Germany

Professor Parzinger, scientists try to influence the future with their research. As a prehistorian, you've researched the history of humans before recorded events. Does this period start with the first evidence of human cognition?

Indeed. Thinking humans first appeared 2.7 million years ago, as *Homo habilis* in East Africa, and these early ancestors of humans made stone tools. This coincided with a transition from a vegetarian species to hominid, or those consuming meat, presumably carrion found in nature. But as they couldn't cut the meat with their jaws, unlike animal predators, they needed tools for this—and developed the first tools.

What was new about this was that they didn't use objects as found in nature but, rather, worked on rocks in a purposeful way to obtain sharp edges suitable for cutting. This is the first evidence of problem-solving thinking, and the beginning of humanity's urge to make life more productive and easier.

Where did the cognitive ability to change or shape something come from?

Early humans were keen observers. The mastery of fire some 1.5 to 2 million years ago was another significant step. With fire, meat could be prepared for eating and preserved for future use. From very early on, entire herds of animals were hunted. This hunting style required knowledge and the ability to plan. It also required a charismatic person to take command and a form of communication—that is, language.

Those communication skills played a central role in passing on knowledge—for example, in making hunting weapons from certain types of rock. Even tiny implements, such as a sewing needle made from bone, could have an epochal effect. Humans were able to use these tools to sew thicker, better-fitting clothing made of fur, which protected them better from the cold. And, as a result, this skill significantly improved people's chances of survival in cold periods.

But humans have also always closely observed their environment, especially animals and plants, and they certainly made many attempts to experiment with them, finding out which animals could be tamed, which plants could be eaten, and so on. This knowledge was the prerequisite for another new course in the history of humankind: the transition from a foraging mode of society to one of agricultural production. Instead of being hunters, gatherers, and fishermen, people domesticated plants and animals, thus making it possible to plan their diet. This then led to a sedentary culture.

How does the invention of the wheel relate to a sedentary culture?

The wheel and cart were important innovations made by humans when they were already settled. By the late fourth millennium B.C.E., four-wheeled carts for transporting goods, probably pulled by cattle or oxen, already existed in the Middle East and in parts of Central and Eastern Europe. The first evidence of riding horses dates from the third millennium onward, and from that moment on, it was possible to cover huge distances at a speed not previously known. Humans have been quick to understand the ways in which various domesticated animal species could be used to improve their living conditions.

How did writing affect human evolution?

Writing developed in different regions of the world at different times, but the process that led to it was always similar: cities with complex societies formed and those large populations of people had to be managed, whether they were in the Middle East, in China, or among the Aztecs in Mesoamerica; this need always led to the invention of some form of writing.

The oral tradition prevailed for a very long time. The first written records were lists of goods, presumably for trade. In addition, seals were used to mark property, or ownership. It also became apparent early on that owning metals, for example, or having control over resources led to greater prosperity.

How did the emergence of power and status influence ways of thinking?

As village life grew and developed, there emerged a division of labor. That is, when hundreds of people were living together, not everyone had to make pottery or operate a loom; it was more efficient to distribute the work and trade goods. Metallurgy in particular required extensive knowledge and appropriate equipment, which inevitably led to specialization. Control of the metal supply and its distribution then usually led to a social stratification. The formation of elites in these settlements was most obvious in some houses more prominent than others, but also by richly decorated graves. In civilizations that were advanced at writing, political control was often anchored in individual families, allowing dynasties to develop.

Did abstract thinking also arise with greater prosperity, perhaps expressed in cave paintings or music?

Art, such as sculpture, painting, and music, originated with the earliest *Homo sapiens* in Europe.

Wonderful extant cave paintings there have been dated to more than 30,000 years ago; the first ivory carvings have been dated to 20,000 years ago, as have the first flutes made from animal bone. Not only did this early art depict animals and the famous female Venus but also showed human-animal hybrids, such as the ivory Lion Man from a cave in the Swabian Jura; this indicates an enormously developed capacity for abstraction.

Is there something fundamental that has driven all people, even early ones?

Humankind has never been satisfied with what it had achieved; there has always been the drive to optimize life. At some point, stone tools were no longer enough, and metallurgy was developed for greater possibilities. When the oldest metal, copper, was no longer hard enough, people learned to alloy copper with tin or arsenic, inventing an even harder metal, namely bronze. And iron was later discovered.

This urge to optimize life affected not only technology but also all other areas of life, including social institutions. Other far-reaching human developments, on the other hand, can be traced to radical upheavals and/or catastrophes, such as changes in climate, which humans had to overcome in order to survive.

How extensively have past environmental changes advanced the development of humankind?

Parts of the Eurasian Steppe were scarcely populated in the second millennium B.C.E. because those areas were almost desert-like and thus hostile to life. In the ninth century B.C.E., however, the climate cooled and became wetter, and a covering of nutrient-rich vegetative growth developed, which was ideal for raising livestock. This was the time also when nomadic horse culture developed, introducing a new way of life and economy with diverse changes in art, religion, weaponry, and death rites; these changes spread from southern Siberia to the Great Hungarian Plain.

How would you define this steady progress that was made throughout history?

The development of humankind from the Stone Age to the Iron Age has been a story of progress that involves breaking free of the limitations of nature and shaping life for greater comfort and security. This required steady observation, experimentation, and trial and error, and there were certainly many failures, periods of regression, and collateral damage. The thinking was characterized by an urge to optimize life, but the search for ways to do this has no comparison with today's methodical research. Much was discovered by accident, without explanations or reasons. This freeform growth is what distinguishes early problem-solving thinking from modern research, although there are some parallels.

What parallels exist between those developments of early humankind and the discoveries of modern times?

Early on, the invention of writing was crucial for the ability to record things, while much later the invention of moveable type made it possible to mass-produce and distribute texts. The invention of electricity had an impact on human culture that is similar to the mastery of fire because both produce light and heat. Horse riding revolutionized human mobility, just as the automobile later did. The industrialization of the nineteenth century would have been inconceivable without the very early division of labor when the first labor specializations developed.

A discovery like nuclear energy, with which humankind can destroy itself, didn't exist in earlier times, true?

Yes, but nonetheless there was extensive environmental damage very early on. We know the earth's first greenhouse effects began with the Neolithic period's agricultural practices and we acknowledge the health-endangering heavy metal pollution that was the by-product of early metalworking centers. Of course, these early manifestations were not so extensive as our present-day manifestations.

What's your message to the world?

We should always be aware of the temporal depth of our existence and behavior, and practice humility. Progress and knowledge have built on each other over the millennia, as in the metaphor of dwarfs standing on the shoulders of giants. We have always built upon knowledge gained from the past. Without the past, there is no future.

Maria Schuld | Quantum Informatics

Computer Scientist in the Field of Big Data Analysis
at the University of KwaZulu-Natal, Durban
South Africa

Dr. Schuld, you research quantum technology and artificial intelligence. What is new about your research?

In quantum computing, I'm mainly thinking about what can be learned with quantum technology—that is, how it can handle data and how computers can be made intelligent. For example, we're trying to understand what happens when you train a quantum computer to act like a neural network—does it learn different patterns? The idea behind my work is a new kind of computer technology that is on its way up—that could change a lot of things about how we compute. That's why money from industry is flowing into this knowledge field at the moment.

Right now, there are only small prototypes of quantum computers. What is it like not being able to put your ideas into practice yet?

In the beginning, we studied algorithms only theoretically. But that doesn't work for machine learning, which is what I'm working on, because our theory is too limited. So, we've started testing a lot and working empirically. We run an algorithm on the computer and observe what happens. But the results are limited because they are not the computers we want to use one day.

So, I realized that I needed to develop new theories for quantum computing. The core problem is generalization: How can I teach the computer to generalize about things it has never seen before? The new theory must include that ability. In the early years, everyone was excited, convinced that we were working on something completely new. Now, we're more cautious. It could be that the areas in which

quantum computers are better suited than classic computers make up only a specific part of machine learning. Quantum computers won't be faster in general, just for certain problems.

How do you feel about researching algorithms that are designed to influence people?

It's a big source of tension in my life that I can't clearly see the societal benefits of my research area. I'm skeptical about the idea that technology will make everything better. In South Africa, where I work, the social aspects of machine learning have become important to me. For example, I've noticed that my students are empowered because they can program and analyze data.

Your career path is unusual. You were born in a small town in the Rhineland, studied in Berlin, and chose a branch of work that many older scientists advised you against. Why did you go ahead anyway?

Mostly, they advised me against studying political science and physics at the same time, but I did that anyway. I was incredibly hungry for knowledge, and I wanted to leave all my options open. The strange thing is that science attracted me, but I often don't see the social impact of my discipline, other than educating and mentoring young people.

Where did you find the energy and courage to go your own way?

It had a lot to do with the self-esteem and clear morals I got from my parents. My mother is a bundle of energy, and my father is calm and focuses on clear communication. That's an important combination for me, as well.

Why did you choose South Africa, and not the United States, where you could have made a lot of money?

Many young scientists become rich but don't understand the power they have gained. For me, the impact on society was more important than earning a lot of money. I came to South Africa for an internship, and after an hour or two, it was clear that I felt comfortable in this place. Here, life goals are not as

"AS FAR AS I KNOW, I HAD THE FIRST PHD IN THIS FIELD."

abstract as they are in Germany, and that helped me overcome major inner conflicts.

A few years after that, the Canadian start-up company Xanadu was looking for specialists in my field. As far as I know, I had the first PhD in this field. In that respect, I had great market value. It's nice to be young and be seen as someone who knows the field well. Fortunately, Xanadu agreed to let me work from South Africa and fly to Canada for consultation only every few months.

What distinguishes your thinking from that of older scientists?

In any scientific community, there are seemingly irrefutable things that have stood the test of time. In my field, this was the idea that quantum algorithms are interesting only if you can prove they are much faster than classic algorithms, so I've moved away from that with my approach. Also, like many of my young colleagues, I'm more flexible. We don't want to just stay at university and comply with published methods; instead, we want to sometimes go into industry or reinvent ourselves.

Can you describe your personality in five words?

Dedicated, energetic, critical, thoughtful, and confident.

Where do you see yourself in five or ten years?

Definitely in South Africa, involved in many national and global bodies dealing with new technologies, data, fast learning, and quantum computing. And I'll continue with my projects involving this triangle of data analytics, city, and people. Social engagement remains my goal.

Katharine L. Bouman | Computer Science

Assistant Professor of Computer and Mathematical Sciences
at the California Institute of Technology, Pasadena
United States

The picture of you beaming at the world's first image of a black hole went viral. How did that feel?

It was crazy. We'd been keeping our work a secret. I hadn't even told my family. And we were just really excited to finally tell the world, to show them the first visualization ever of a massive black hole. The public's reaction was more than we could ever have imagined in our wildest dreams.

You became a role model for young women but also a victim of harassment for being singled out as the face of the project. Was that painful?

People like to connect a face to a project, but it's important to realize that the project was the result of a large international collaboration of 200 scientists. I believe the media put me on a pedestal because I was young and excited, but I never wanted to take the spotlight away from the many other people who deserved to be recognized for their efforts as well.

At the same time, there aren't many women in my field, so it was meaningful for young female students to put a face on a success in science and engineering. Ultimately, though, I want to be defined by my work and not by the fact that I'm a woman.

What was your specific role in the Event Horizon Telescope project?

The idea behind the Event Horizon Telescope (EHT) was to join eight different telescopes at different locations into a single virtual telescope; it's an old idea but we pushed it to the extreme. I helped develop the algorithms that were used to merge the astronomical data collected by the telescopes into the first-ever image of a black hole. I then led efforts to verify this result. My background was in computer

science and electrical engineering, not astrophysics, so I approached this project from a different angle: how to reimagine new approaches to analyze the data and create the image.

Which proved more important—math or imagination?

Both! We used our imagination to come up with creative ideas to mathematically prove that something was right.

What are you working on now?

There's a lot of work left to do with EHT; we released only one image from the data we collected. For example, there's a closer black hole at the center of our own Milky Way galaxy, and we want to image that one. But that's really challenging to do, as it's smaller so the gas can spin around it far faster. Over the course of a night, we collect sparse data relating to different snapshots of the black hole evolving in time. Therefore, I've been developing tools to extract information about a black hole that's evolving quickly. It is hoped that one day we'll be able to show a movie of a black hole as the gas falls toward its event horizon, rather than just as a static image.

Then there's the next generation of EHT. Now that we've proved it's possible to see the direct environment around a black hole, we want to improve our data to extract even more science. To do this, we plan to build new telescopes here on earth, and potentially even extend our plans to space. My group is developing machine learning algorithms to help design the next generation EHT instrument.

How is your approach to science different?

I like to figure out how to merge our understanding of physics with new computational tools in artificial intelligence (AI) and machine learning to help us better extract hidden information from the data. I like to approach many different problems in this way, including my work in black hole imaging, civil engineering applications, medicine, and more recently seismology.

Science is becoming more interdisciplinary; we need to bring together lots of different people with different expertise, so we can come up with creative solutions that lead to new, transformative results.

What's been the most important factor in your life that got you this far?

Not letting people tell me I can't do something! I have had many people tell me along the way that I wasn't good enough; and although it's sometimes hard to ignore these voices, I'm glad I stayed stubborn and proved them wrong.

What are your personal ambitions for the next five to ten years?

I want to help transform science by developing computational tools that can aid scientists in their quest to discover the unknown. I believe computer-aided discovery can help scientists design new, perhaps unintuitive, experimental methods that outperform what we can develop with human ingenuity alone. I also like teaching and mentoring students, and watching them grow into their own independent creative researchers.

I want to keep developing AI techniques to help scientists both ask and answer the right questions. I want to continue bringing ideas from machine learning, computer vision, and imaging to different disciplines.

How did your parents influence you?

It definitely helped that I came from an academic family. I was fortunate enough to have the opportunity to work in a lab in my hometown when I was a high school student. This experience introduced me to the excitement of research. My father, who is also an engineer, always told my siblings and me "Smart is cheap," meaning there are lots of smart people in the world, but being hardworking is more important than being smart.

Can you describe your personality in five words?

Stubborn, kind, curious, hardworking, and creative.

"SCIENCE IS BECOMING MORE INTERDISCIPLINARY."

Moisés Expósito-Alonso | Evolutionary Genetics

Assistant Professor of Biology at the Carnegie Department of Plant Biology,
Stanford University, Palo Alto
United States

Professor Expósito-Alonso, how is your research different?

I'm an ecologist who uses biomedical and evolutionary genetics techniques to inform conservation. The breadth of topics my lab pursues is unconventionally broad, which may have partially contributed to our success. This scope was born from the realization that I could merge my two passions: the fundamental study of evolutionary and genetics principles, and biological conservation.

At what stage is your research?

In our research, we use statistics and advanced computation to screen the millions of genetic mutations between natural populations of a plant species that may make it more or less susceptible to climate change. We are currently at the stage at which we have used this data to create risk-assessment maps for the model plant species *Arabidopsis thaliana* [mouse-ear cress] in 2050, and hope to replicate it for important trees in the United States. One day, we may even be able to use gene therapies mediated by CRISPR/Cas9 to readapt endangered species.

When do you expect to be able to prevent a species from becoming extinct?

Preventive measures such as natural parks can be (or are being) effective in saving species right now. What I worry most about is future species extinctions caused by climate change. Technically, we are already at a stage where we could genetically improve a wild species to make it more resilient in certain climates—this is the basis for much crop plant breeding. However, I think we still need more

research to ensure that the specific gene modification we think may be positive for a species will not have unintended negative consequences. Furthermore, there are ethical issues about any intervention in nature that need to be discussed by our society as a whole.

You focus particularly on *Arabidopsis thaliana*? Why that plant?

It's very small, so it can be grown in the laboratory. Also, it is one of the plants with the smallest genomes, so it's easy to read. Geneticists love it! The use of *Arabidopsis thaliana* in ecological conservation research is quite uncommon, but we chose it because we can innovate with genetic methods that will be useful in the future, when we know more about the genomes of other plant species.

In what way is your work important to society?

I hope it is! I started working in biology because I wanted to contribute to reforesting the native habitats of southern Spain, where I grew up. We cannot have a healthy society without a healthy natural world.

Do you ever have doubts about your being on the right track?

What's beautiful about science is that it doesn't matter whether or not we are on the "right track." Our approaches are based on the latest scientific discoveries, but as we learn more about how species adapt to climate change, we will "adapt" our tactics, too!

You come across as humble. Is that your true nature?

I try to be humble. Science is a team effort, and we stand on the shoulders of intellectual giants. And being collaborative, nice, and helpful to others ultimately pays off professionally.

Addressing the biodiversity crisis we face will require diverse and interdisciplinary thinking. That's why for my team, I'm trying to recruit computer scientists, as well as molecular biologists and field ecologists.

How can older colleagues support the younger scientists?

I think it's a great loss for science when the large number of early career researchers leave the field when they do not find enough financial support for their work. I think creating opportunities for partnerships between senior and early career scientists to fund and establish young new labs, for example, would lead to great improvements in the field.

But you've been lucky so far with funding?

Yes, I studied in the Spanish education system, which is really quite socialist and where a large proportion of the population has access to public university education. In fact, the public universities in Spain are considered better than the private ones. Later, I was lucky enough to receive research grants and fellowships to study abroad, and my lab now is funded by the Carnegie Institution for Science. Indeed, I feel very lucky, although it took a lot of work and perseverance to get this far.

In your opinion, which country offers young scientists the best career prospects?

I have done research in four countries—Spain, the U.K., Germany, and the United States—and each has its pros and cons. I am now in the United States, and it seems the professor-student relationship is flatter, which I think promotes a highly creative and engaging environment.

What is your personal goal in life?

To make fundamental scientific discoveries that help preserve nature and our ecosystems. That's what helps me wake up every day and go to work for twelve hours.

How would you describe your personality?

I'm an extroverted introvert, happy, curious, focused, and passionate!

What kind of influence did your parents have on you?

My parents spent a lot of time with me as a child. My father has the strongest will of any person I've ever met, and he helped me be so focused on my career. I intensively studied the violin when I was younger, but I chose to pursue a career in science in the end. I think all that made me a full individual and led me to Carnegie and Stanford, where I'm living out my dream.

Elaine Y. Hsiao Microbiology

Assistant Professor of Biology and Physiology at the University of California, Los Angeles
United States

Professor Hsiao, the influence of the human microbiome in brain, behavioral, and neurological diseases is a new scientific field. Why did you choose it?

During my PhD in neurobiology, I was fascinated by reports from parents of autistic children that their children's behaviors were improved with changes in their kids' diets. Also, the human microbiome had just been sequenced, so I was interested in whether the gut microbiome could influence behavior and neurological disease. At the time, this was a radical idea that was met with skepticism, so it was difficult to find a lab where I could pursue my curiosity. I was motivated to create my own path by skipping the standard postdoctoral period to form my own lab that would study how the microbiome interacts with the nervous system.

Can you explain how the microbiome is connected to the brain or the nervous system?

The microbiome modulates many neuroactive molecules, like neurotransmitters and neuropeptides, as well as molecules important for immune and metabolic health. These together impact neurons that control many complex behaviors. One pathway from the gut to the brain is the vagus nerve, which has long fibers that directly connect the gut and the brain. Microbes can also interact with the numerous immune cells in the body that impact responses in the brain.

Tell us a bit about your exciting lab work.

We start with questions and let the questions drive the science. Right now, we're really interested in how the maternal microbiome during pregnancy can influence fetal development. We're also asking if the microbiome can play a role in areas of science that have traditionally relied on human genetics to reveal answers. For example, we are interested in how the

microbiome impacts aging-related diseases like Alzheimer's and Parkinson's. We are also exploring how we can use the microbiome to uncover better ways to treat diseases like epilepsy and depression.

What determines whether the microbes are good or bad?

Some microbes are opportunistic—they're good or bad depending on the context. According to intriguing research, our microbes are always part of us, evolving with us and even cooperating with us. For example, our own cells can't digest complex fibers, so we need microbes to digest them for us. Having a diverse microbiome is important, and it is thought that eating a varied healthy diet helps support a variety of microbes.

At what stage of development are your discoveries?

We have experiments in every stage of development. Many are still in the early phases and others are more developed. We are hopeful that some of our more advanced discoveries on potential interventions for neurological disease can one day be tested and developed for the benefit of society.

You seem so bold and courageous, forging this new path alone! Does this ever make you feel scared?

I'm excited about trying out new things and pursuing new methods, maybe doing things that other people might consider uncomfortable. I sometimes suffer from self-doubt about being on the right path, but I have never yet felt too intimidated to try something new!

How did you parents influence your outlook on life?

My parents were interested in the arts, which passed on to me a love of being creative and enjoying the freedom to explore new ideas. As an undergraduate, I worked as the glassware washer and media maker for a bacteriology lab, which was my first exposure to a science lab. I later realized through research that science is creative too, which really drew me to it!

My father passed away when I was very young, and my mum worked hard to raise me and my sister, which made me appreciate the importance of working hard. My father's early passing made me realize

"I'M EXCITED ABOUT TRYING OUT NEW THINGS AND PURSUING NEW METHODS."

that even though life is short, knowledge can last forever. I hope that my discoveries will outlive me!

Though you encountered early skepticism about your work, you now receive recognition and funding, correct?

It's still in the early days, but now it seems that the scientific community recognizes the importance of this area of research. I hope we can lay the groundwork and set the principles for this new field of science that will inspire a new generation of scientists.

What do you do to satisfy your personal aims?

I'm driven to discover new things about nature that may seem unusual now but could one day be written in textbooks that inspire new scientists. I'm also passionate about challenges that require interdisciplinary research: my lab has lots of diverse people with different expertise and multiple perspectives. I also enjoy collaborative science—it would be great to see more collaboration between senior scientists and early-career scientists in the future.

Where do you see yourself in five or ten years' time?

I'm currently an associate professor, and the next natural step in my career is full professor. But whatever the title, I'm just focused on making sure we're doing the best science we can. It's amazing for me to think of how far we've come already!

Can you describe your personality in five words?

Persistent, neurotic, caring, fearless, and a good mentor (I hope!).

Karl Deisseroth

Is one of the pioneers of the new field of optogenetics, which uses laser light to study changes in neurological functions and behaviors in mammals. https://web.stanford.edu/group/dlab/about_pi.html

David Avnir

Discovered how to make ceramic materials and glass at room temperature and how to incorporate biomolecules into metals so that they can glow. http://chem.ch.huji.ac.il/avnir/

Robert Laughlin

Found an explanation for the fractional quantum Hall effect and shared in the 1998 Nobel Prize in Physics; he also discovered a type of quantum liquid. https://profiles.stanford.edu/robert-laughlin

Peter Seeberger

Researches biopolymers such as sugar molecules in order to produce medicinal agents, and in 2012 was able to synthesize the antimalarial agent artemisinin for the first time. https://www.mpikg.mpg.de/biomolecular-systems/director/peter-seeberger

Alessio Figalli

Achieved a long-sought-after mathematical proof in the field of optimal transport, for which he was awarded the Fields Medal, the mathematical equivalent of the Nobel Prize. https://people.math.ethz.ch/~afigalli/

Bruce Alberts

Contributed significantly to the elucidation of chromosome duplication during cell division and seeks to increase science education in school systems. https://brucealberts.ucsf.edu

Stefan Hell

Further developed fluorescence microscopy to enable resolutions below light wavelengths, which earned him the 2014 Nobel Prize in Chemistry. https://www.mpg.de/323847/biophysical_chemistry_wissM11

Jennifer Doudna

Studies the structure and functions of ribonucleic acids (RNA) in cells and, with Emmanuelle Charpentier, in 2012 developed the groundbreaking CRISPR/Cas9 technique for modifying genomes. https://vcresearch.berkeley.edu/faculty/jennifer-doudna

Viola Vogel

Researches the nanotechnical tools of bacteria and cells that help them sense their environment. She co-founded the new field of mechanobiology.

Antje Boetius

As a marine biologist, researches bacterial life in the deep sea, deals with deep-sea ecology, and is publicly engaged in the climate debate. www.mpi-bremen.de/en/deep-sea-staff/Antje-Boetius.html

Tom Rapoport

Researches how the components of cells, especially proteins, are differentiated and how cells pass on information for these processes. https://cellbio.med.harvard.edu/people/faculty/rapoport

Pascale Cossart

Is the scientific authority when it comes to the common pathogen *Listeria monocytogenes*, and she has been instrumental in decoding it at the molecular level. https://research.pasteur.fr/en/member/pascale-cossart/

Thomas Südhof

Played a key role in revealing how neurons form synapses and how cells exchange signals, for which he was honored with the 2013 Nobel Prize in Medicine. https://med.stanford.edu/sudhoflab/about-thomas-sudhof.html

Tandong Yao

Was able to prove on the basis of ice cores that the past 100 years have been the warmest in 2,000 years. He is a strong advocate for the preservation of the Tibetan Highlands glaciers.

Brian Schmidt

In the 1990s, he used the light from distant supernovae to demonstrate that the universe is expanding at an ever-faster rate, for which he was awarded the 2011 Nobel Prize in Physics. https://www.mso.anu.edu.au/~brian/

Avi Loeb

Researches the formation of the first stars after the Big Bang, and is involved in the search for evidence of the existence of extraterrestrial civilizations—for example, in the atmospheres of exoplanets. https://www.cfa.harvard.edu/~loeb/

Bernhard Schölkopf

Is one of the leading German researchers in the field of machine learning, but also works on exoplanets and gravitational waves. https://www.is.mpg.de/~bs

Dan Shechtman

In the 1980s discovered the previously unknown class of quasi-periodic crystals, which earned him the 2011 Nobel Prize in Chemistry. https://www.nist.gov/nist-and-nobel/dan-shechtman

Wolfgang Ketterle

Was one of the first to succeed in creating a Bose-Einstein condensate, for which he received the Nobel Prize in Physics in 2001. From this, he was able to construct the first atom laser. https://web.mit.edu/physics/people/faculty/ketterle_wolfgang.html

Martin Rees

Researched cosmic background radiation as an astrophysicist and today warns of threats such as climate change or nuclear weapons that could lead to the extinction of humankind. https://royalsociety.org/people/martin-rees-12156/

Aaron Ciechanover

Discovered the mechanism by which cells dispose of superfluous proteins, and in 2004 was awarded the Nobel Prize in Chemistry. He also advises companies and nonprofit organizations on scientific issues. http://taubcenter.org.il/aaron-ciechanover/

Ron Naaman

Investigates how ultra-thin layers of organic molecules on semiconductors generate new electronic properties and uses them to develop novel sensors. https://www.weizmann.ac.il/chembiophys/naaman/home

Tim Hunt

Discovered, with Paul Nurse, the molecular basis of cell division, for which he was honored with the 2001 Nobel Prize in Medicine. https://www.bioc.cam.ac.uk/about-us/history/nobel-prizes/tim-hunt

Jian-Wei Pan

Researches the phenomenon of quantum entanglement of light particles, so as to enable new, more secure communication channels. He has been proclaimed the "Father of Quantum." http://quantum.ustc.edu.cn/web/en/node/32

Faith Osier

Is dedicated to the mission of "Make Malaria History" and is trying to develop a vaccine using some people's resistance to malaria. https://www.faithosier.net

Carla Shatz

Researches how the brain changes during the transition from childhood to adulthood, and is hoping to provide new insights into autism and schizophrenia. https://profiles.stanford.edu/carla-shatz

Detlef Günther

Works on quantitative analysis methods for laser aerosols and nanoparticles, and has developed a mobile device for this purpose, which is also of interest for archaeological field research. https://guenther.ethz.ch/people/prof-detlef-guenther.html

Helmut Schwarz

Significantly improved mass spectrometry, a common analytical technique in chemistry and forensics, and contributed much to the understanding of the unusual carbon molecule group of fullerenes. https://www.chem.tu-berlin.de/helmut.schwarz/

Patrick Cramer

Was the first to elucidate the three-dimensional structure of the RNA polymerase II enzyme, conducts research on how the genome works, and advocates for more study of the natural sciences in Europe. https://www.mpg.de/7894444/biophysical_chemistry_cramer

George M. Church

Has developed new, inexpensive gene sequencing technologies and has advanced the field of synthetic biology since the 2010s. https://wyss.harvard.edu/team/core-faculty/george-church/

Frances Arnold

Is a pioneer in the field of "directed evolution," a genetic engineering acceleration of random mutations. She was awarded the Nobel Prize in Chemistry in 2018. She is also a co-founder of Gevo, a biofuels start-up company. https://cce.caltech.edu/people/frances-h-arnold

Shigefumi Mori

Works on three-dimensional algebraic varieties, proved the Hartshorne conjecture in 1978, received the Fields Medal in 1990, headed the International Mathematical Union for several years, and is the namesake of an asteroid. https://kuias.kyoto-u.ac.jp/e/profile/mori/

Paul Nurse

Discovered the cell division gene cdc2, for which he was awarded the 2001 Nobel Prize in Medicine together with Tim Hunt. He is also active in cell research at the Francis Crick Institute. https://www.crick.ac.uk/research/find-a-researcher/paul-nurse

Robert Weinberg

Has been researching the development of cancer at the genetic level for decades, and he defined six factors that cause cells to become cancer cells in an epoch-making paper in 2000. https://biology.mit.edu/profile/robert-a-weinberg/

Cédric Villani

Has developed innovative approaches in the field of differential equations, in particular the Boltzmann equation, for which he was awarded the Fields Medal in 2010. He has also been an active politician in France for several years. https://cedricvillani.org/

Ruth Arnon

Works on synthetic vaccines against influenza and cancer, and has developed the drug Copaxone, which has been used against multiple sclerosis since its approval in 1995. https://www.weizmann.ac.il/immunology/sci/ArnonPage.html

Peter Doherty

Is one of the pioneering immunologists of the present day, having elucidated the mechanism for how T cells of the immune system fight viruses; for this, he was awarded the Nobel Prize in Medicine in 1996. https://www.doherty.edu.au/people/laureate-professor-peter-doherty

Christiane Nüsslein-Volhard

Discovered genes that control embryonic development in humans and animals, and was awarded the Nobel Prize in Medicine 1995. She also advised the German government on current research issues and other matters, as a member of the National Ethics Council. https://www.mpg.de/459856/entwicklungsbiologie_wissM2

Vittorio Gallese

Researches the interplay of locomotor systems and cognition in primates and humans to elucidate the origins of empathy, aesthetics, language, and thought. http://unipr.academia.edu/VittorioGallese/CurriculumVitae

Françoise Barré-Sinoussi

In 1982 isolated the HIV virus for the first time as the cause of AIDS, which was still a new disease at the time. In 2008, she was awarded the Nobel Prize in Medicine for her work. She is an active campaigner for better health policy in developing countries. https://www.pasteur.fr/en/institut-pasteur/history/francoise-barre-sinoussi-born-1947

Marcelle Soares-Santos

Explores the accelerating expansion of the universe, searches for optical evidence of gravitational waves, and is involved in projects to elucidate dark energy in the universe. https://mcommunity.umich.edu/#profile:mssantos

Onur Güntürkün

Researches the functioning of the prefrontal cortex, where actions are planned and emotions are regulated. He is also involved in German-Turkish research cooperation. http://www.rd.ruhr-uni-bochum.de/neuro/wiss/sprecher/guentuerkuen.html.en

Klaus von Klitzing

Discovered the integer quantum Hall effect, and with it, a new natural constant named after him, for which he received the Nobel Prize in Physics in 1985. In addition to his research work, he tirelessly promotes the importance of basic research. https://www.fkf.mpg.de/342979/Prof_Klaus_von_Klitzing

Tao Zhang

Works on new methods for catalyzing materials, including using nanostructured materials, and aims to obtain chemicals from biomass using new catalysts. http://english.cas.cn/about_us/administration/administrators/201612/t20161226_172885.shtml

Carolyn Bertozzi

Studies processes on cell surfaces, has developed a new gentle method to visualize structures within cells, and at only thirty-three years old became the youngest researcher to receive the prestigious MacArthur Fellowship. https://chemistry.stanford.edu/people/carolyn-bertozzi

Ulyana Shimanovich

Investigates the chemical self-organization of cell molecules such as proteins and investigates why mistakes sometimes occur that can lead to serious diseases such as Alzheimer's. http://www.weizmann.ac.il/materials/shimanovich/home

Eric Kandel

As a trained psychiatrist, he turned to brain research at an early stage in his career, investigating the neuronal basis of learning and memory, as well as the protein structure of memory, for which he was awarded the Nobel Prize in Medicine in 2000. https://neuroscience.columbia.edu/

Arieh Warshel

Develops computer models to simulate the workings of proteins and enzymes, for which he was awarded the Nobel Prize in Chemistry in 2013 and is considered one of the pioneers in the field. http://chem.usc.edu/faculty/Warshel.html

Richard Zare

Developed pioneering techniques to study chemical reactions in real time using laser light. He has worked with NASA on questions of astrobiology. https://chemistry.stanford.edu/people/richard-zare

Sallie Chisholm

Researches the biology, ecology, and evolution of the most abundant phytoplankton species in the world's oceans to elucidate ocean microbial ecosystems. https://biology.mit.edu/profile/sallie-penny-w-chisholm/

Edward Boyden

Researches optogenetics, develops methods with his research group to map the structure of the brain at the molecular level over the long term, and is an advocate of sharing research findings. http://syntheticneurobiology.org/people/display/71/11

Ottmar Edenhofer

Worked with his group on the concept for a transatlantic carbon market; he also studies economic aspects of climate change and advises the German government on energy and climate policy. https://www.pik-potsdam.de/members/edenh

Tolullah Oni

Turned to improving the public health systems in rapidly growing cities after her medical studies, seeking to address the multiple external influences on the health of urban populations. http://www.mrc-epid.cam.ac.uk/people/tolullah-oni/

Sangheeta Bhatia

Builds tiny model organs like "micro-livers" to better understand metabolism; also uses nanomaterials to develop systems for diagnosing diseases. https://ki.mit.edu/people/faculty/bhatia

Bruno Reichart

Successfully performed the first heart transplant in 1981, and did the first heart-lung transplant in 1983 in Germany. He is researching the possibilities of xenotransplantation, such as using pig hearts for human transplants. http://www.klinikum.uni-muenchen.de/SFB-TRR-127/de/members-neu/PI/C8/ReichartBruno/index.html

Robert Langer

Develops technologies, including using biopolymers, to deliver targeted drugs in the body—called "drug delivery"—and holds more than 1,000 patents worldwide. https://be.mit.edu/directory/robert-langer

Emmanuelle Charpentier

Researches the molecular basis of infections and, with Jennifer Doudna, developed the groundbreaking CRISPR/Cas9 targeted genome modification technique in 2012.

Shuji Nakamura

Developed the first light-emitting diode that emits blue light, which earned him the 2014 Nobel Prize in Physics. After a patent dispute, he turned his energies toward conducting research in Santa Barbara, California. https://ssleec.ucsb.edu/nakamura

Anton Zeilinger

Succeeded in teleporting light particles using quantum entanglement in the 1990s, earning him the nickname "Mr. Beam." He works on concepts of quantum informatics and quantum cryptography. https://www.oeaw.ac.at/m/zeilinger-anton

Hermann Parzinger

Conducted numerous excavations in Europe and Central Asia until he became known worldwide with the discovery of a Scythian tomb in 2001; he headed the German Archaeological Institute for many years. http://www.preussischer-kulturbesitz.de/ueber-uns/praesident-und-vizepraesident/prof-dr-hermann-parzinger.html

Afterword

The project *Fascination of Science* isn't only a hymn to science; it is also a tribute to the power of art. Herlinde Koelbl once again succeeds in fascinating people with her photographic works. At the same time, she builds a unique bridge between science and art.

With her 60 portraits of outstanding research personalities, she also shows a human side of science. The work impressively documents that science and art are related in nature and are rightly under the special protection of our constitution. As a physicist, I'm fascinated by the way Herlinde Koelbl makes this connection tangible. I'm also convinced that *Fascination of Science* will motivate many young people to become enthusiastic about science and research.

—**Dr. Roland Busch**
President and CEO of Siemens AG

Acknowledgments

The *Fascination of Science* project was made possible only with the generous support of the Förderfonds Wissenschaft in Berlin and with funding from the Friede Springer Foundation. This enabled me to explore the exciting and diverse world of science and to conduct insightful discussions with its most prominent innovators. My special thanks go to the foundations.

I would like to thank Ernst-Ludwig Winnacker for his personal commitment to opening doors for me and advising me on this project, as well as assistance from Helmut Schwarz, Jürgen Zöllner, and Detlef Günther. This support was a great help to me. Marion Müller also added energy and foresight to the project; many thanks for that.

The invitations to the annual Falling Wall Conference, for which Sebastian Turner is responsible, were a decisive motivation for realizing this project.

My thanks also go to Stephan Frucht, from the Siemens Arts Program, who supported the realization of the book and the exhibition at the Berlin-Brandenburg Academy of Sciences and Humanities (BBAW).

For discussions, advice, suggestions, and arranging contacts, I would like to thank Bruce Alberts, André Alt, Claudia Anzinger, Karin Arnold, Yivsam Azgad, Elke Benning Rohnke, Antje Boetius, Christina Bracken, Steffi Czerny, Matthias Drieß, Markus Ederer, Sonja Grigoschewski, Johann Grolle, Martin Grötschel, Enno auf der Heide, Ingolf Kern, Matthias Kleiner, Susanne Koelbl, André Lottmann, Christian Martin, Steffen Mehlich, Achim Rohnke, Anett Schlieper, Harald Singer, Christine Thalmann, Franz Schmitt, Bernhard Schölkopf, Ute Schweitzer, Beate Weber, Detlef Weigel, Anne Zöllner, and Emilio Galli-Zugaro.

I would also like to thank Jörg Hacker and Ruth Narmann, who made my contacts in China possible.

I would like to thank Judith Kimche and Hal Wyner for their helpful support in Israel.

For good editorial cooperation, I would like to thank James Copland, Chris Cottrell, Lois Hoyal, and Marius Nobach.

My thanks also go to Margot Klingsporn for her friendly guidance and inspiring exchanges during the project. My gratitude also goes to my wonderful collaborators Cornelia Albert and Michaela Plötz. I would like to thank Thomas Hagen and Fabian Arnet from Knesebeck Verlag for their dedicated collaboration in the realization of this book.

I would like to thank all the scientists for their trust, for their openness in the discussions and their willingness to contribute artistically with drawing on their hands. Finally, I thank all my friends who have patiently listened to my stories and supported me over the years.

This book was set in Benton Sans by New Best-set Typesetters
Ltd. Printed and bound in the United States of America.

Library of Congress Cataloging-in-Publication Data is
available.

ISBN: 978-0-262-54557-0

10 9 8 7 6 5 4 3 2 1